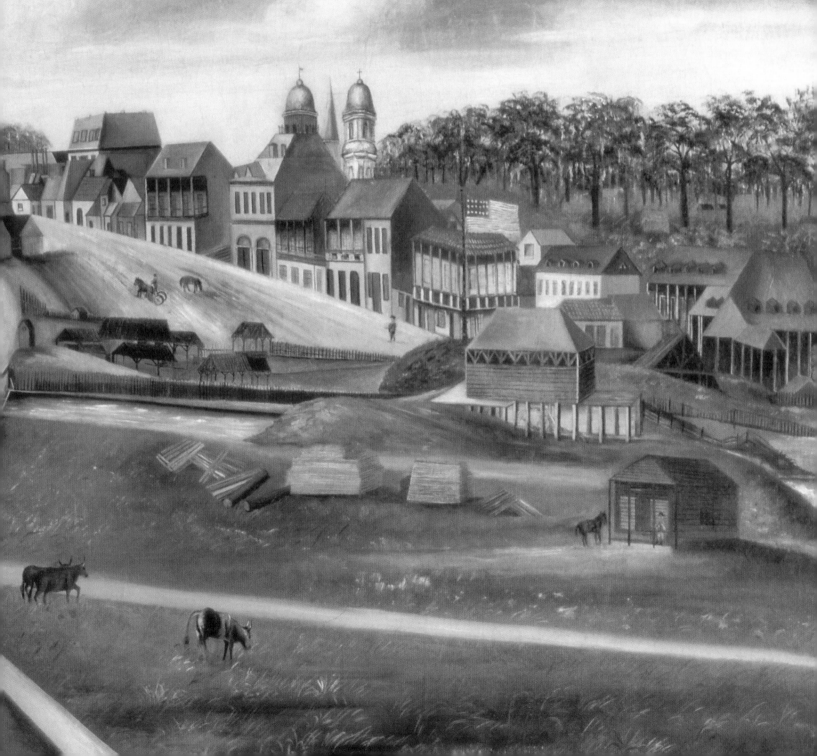

Jefferson's AMERICA & Napoleon's FRANCE

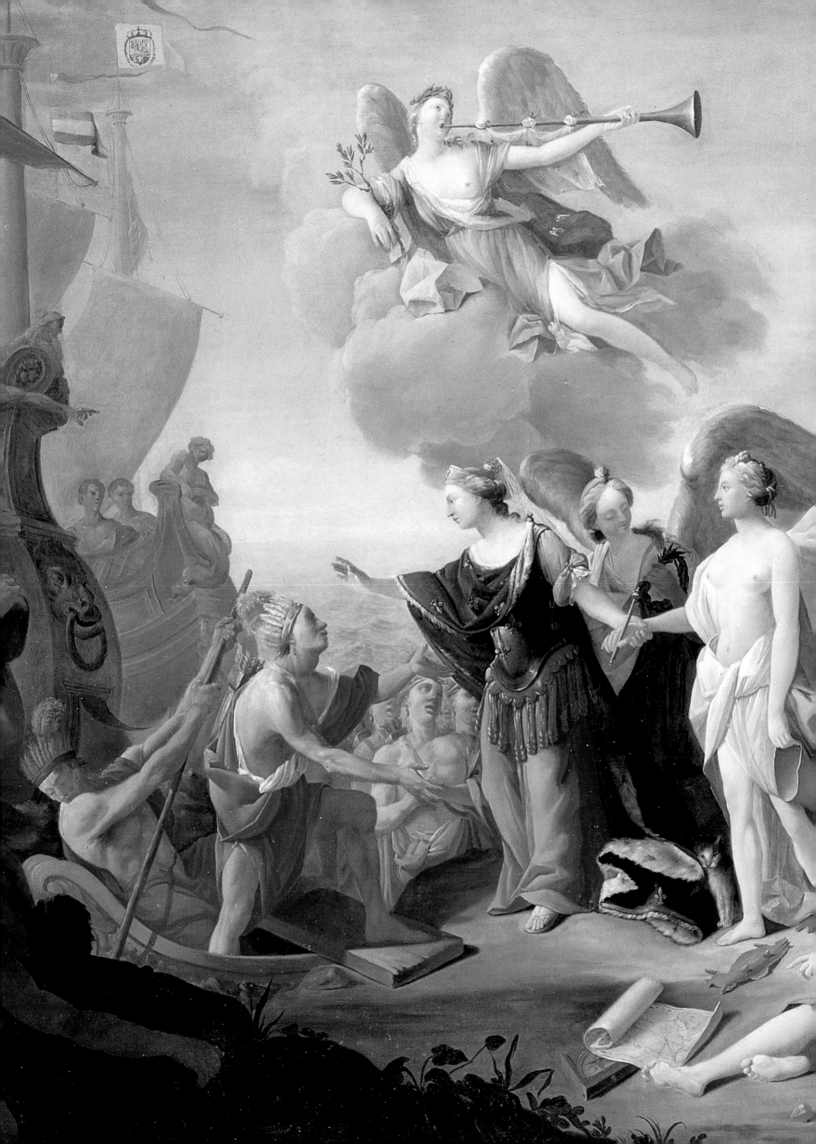

Jefferson's AMERICA & Napoleon's FRANCE

An Exhibition for the Louisiana Purchase Bicentennial

Gail Feigenbaum

Essays by

Victoria Cooke
Patrice Higonnet
Bill Mercer
David O'Brien
Jessie Poesch
Paul Staiti
Susan R. Stein
Paul Tarver
Susan Taylor-Leduc

Edited by

Victoria Cooke

NEW ORLEANS MUSEUM OF ART

In Association With
University of Washington Press
Seattle • London

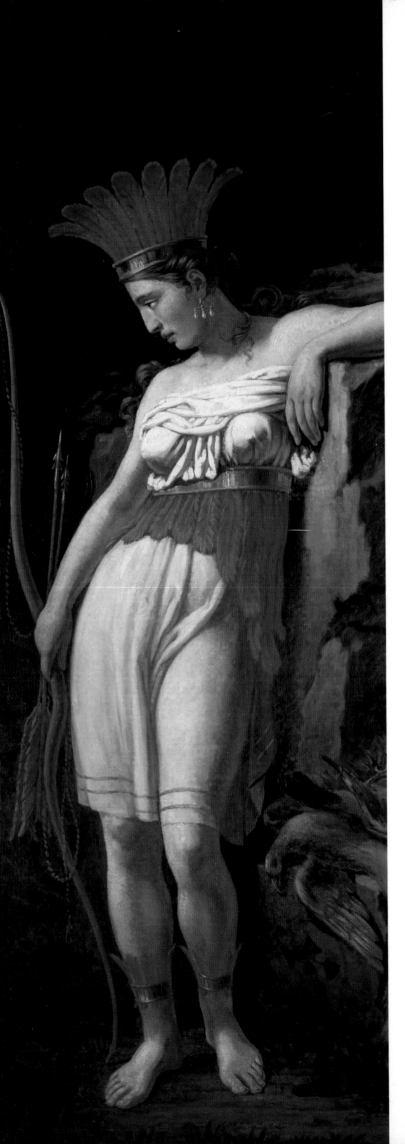

This publication is funded under a grant from the Louisiana Endowment for the Humanities, the state affiliate of the National Endowment for the Humanities. Additional funding has been provided by the Louisiana Department of Culture, Recreation and Tourism and the Florence Gould Foundation.

10,000 copies of this book were published in conjunction with the exhibition *Jefferson's America & Napoleon's France: An Exhibition for the Louisiana Purchase Bicentennial*, organized by the New Orleans Museum of Art and presented April 12 through August 31, 2003.

Library of Congress Control Number: 2002117590
ISBN 0-89494-091-0

Distributed by University of Washington Press
P.O. Box 50096
Seattle, Washington 98145-5096

Designed by Michael Ledet Art & Design,
New Orleans, Louisiana
Produced by Michael Ledet Art & Design,
in cooperation with the Publications Office
of the New Orleans Museum of Art,
Wanda O'Shello, Coordinator
Print management by Kaye Alexander,
Westford, Vermont
Color separations by Garrison Digital Color,
New Orleans, Louisiana
Production coordination by Kolleen Herndon,
Metairie, Louisiana
Digital production by Michael Lauve,
New Orleans, Louisiana
Printed and bound by Sfera International,
Milan, Italy

CONTENTS

THE HONORARY COMMITTEE

Chair

Mrs. Laura Bush
First Lady of the United States

The American Committee

The Honorable John B. Breaux,
United States Senator

The Honorable Mary Landrieu,
United States Senator

The Honorable M. J. "Mike" Foster, Jr.,
Governor of Louisiana

The Honorable Kathleen Babineaux Blanco,
Lieutenant Governor of Louisiana

The Honorable William J. Jefferson,
United States Representative

The Honorable David Vitter,
United States Representative

The Honorable C. Ray Nagin,
Mayor of New Orleans

The Honorable Howard H. Leach,
United States Ambassador to France

The Honorable Donald B. Ensenat,
United States Chief of Protocol

The Honorable Corinne Claiborne Boggs,
former United States Ambassador to the Vatican

The Honorable Robert L. Livingston,
former United States Representative

Stephen E. Ambrose (deceased),
Professor Emeritus, University of New Orleans

James H. Billington, Librarian of Congress

Douglas G. Brinkley, Director,
Eisenhower Center for American Studies

The Honorable John W. Carlin,
Archivist of the United States

Edward C. Carter II (deceased),
Librarian, American Philosophical Society

Derek Gillman, President and Director,
Pennsylvania Academy of the Fine Arts

Alida Hainkel

Daniel P. Jordan,
President, Thomas Jefferson Foundation

The French Committee

His Excellency Jean-David Levitte,
Ambassador of France to the United States

La Princesse Napoléon

Mme Jean-Paul Anglès, President,
American Friends of Blérancourt

M. Pierre Arizzoli-Clémentel,
Directeur Général du Musée National
de Versailles et de Trianon

Baronne Bernard d'Anglejan-Chatillon,
Founder and Chair,
American Friends of Blérancourt

Mme Martin Bouygues

M. William Christie,
Director, Les Arts Florissants

Baron Gourgaud,
Président, Fondation Napoléon

M. Arnaud d'Hauterives,
Secrétaire-perpetuel, l'Académie des Beaux Arts

Princesse de La Tour d'Auvergne,
President, French Heritage Society

M. Henri Loyrette,
Président-directeur, Musée du Louvre

M. Stéphane Martin,
Le Président-Directeur général,
Musée du Quai Branly

M. Jacques Perot,
Directeur des Musées Nationaux et du Domaine
des Châteaux de Compiègne de Blérancourt

Marquise de Ravenel, Board Member,
American Friends of Blérancourt

Mr. Miles Morgan, Board Member,
American Friends of Blérancourt

The Honorable Patrick Rolot,
Consul général de France à la Nouvelle Orléans

M. Pierre Rosenberg de L'Académie Française

M. Jean-Pierre Samoyault, Administrateur général
du Mobilier National de France

LENDERS TO THE EXHIBITION

Albany Institute of History & Art,
Albany, New York

American Antiquarian Society,
Worcester, Massachusetts

American Museum of Natural History,
New York

American Numismatic Association,
Boulder, Colorado

American Numismatic Society, New York

American Philosophical Society,
Philadelphia, Pennsylvania

Ash-Lawn Highland Museum,
Charlottesville, Virginia

Baltimore Museum of Art, Baltimore, Maryland

Bibliothèque Nationale de France, Paris

Bowdoin Museum of Art, Brunswick, Maine

Brooklyn Museum of Art, Brooklyn, New York

Mr. and Mrs. Carl Hawley Butler, III,
Columbus, Mississippi

Chicago Historical Society, Chicago, Illinois

Dalva Brothers, New York

Destrehan Plantation/River Road Society,
Destrehan, Louisiana

Detroit Institute of Arts, Detroit, Michigan

Richard L. Feigen & Company, New York

Fine Arts Museums of San Francisco,
San Francisco, California

Fondation Dosne-Thiers,
Institut de France, Paris

Fondation Napoléon, Paris

Sharon Halton, New Orleans, Louisiana

Harvard University, Fogg Museum,
Cambridge, Massachusetts

The Henry Francis Du Pont Winterthur Museum,
Winterthur, Delaware

High Museum of Art, Atlanta, Georgia

Patrice Higonnet, Boston, Massachusetts

Dr. and Mrs. Jack Holden,
Baton Rouge, Louisiana

Howard-Tilton Memorial Library,
Special Collections, Tulane University,
New Orleans, Louisiana

James Monroe Museum and Memorial Library,
Fredricksburg, Virginia

The J. Paul Getty Museum,
Los Angeles, California

John Webster Keefe, New Orleans, Louisiana

Ms. Beryl Kendall, London

Alexis and Nicolas Kugel, Paris

James Lamantia, New Orleans, Louisiana

Library of Congress, Washington, D.C.

The Library of the Jewish Theological Seminary,
New York

Library of Virginia, Richmond, Virginia

Lilly Library and Art Museum,
Indiana University, Bloomington, Indiana

Dr. and Mrs. Alfredo Lopez,
New Orleans, Louisiana

Louisiana State Museum,
New Orleans, Louisiana

Maison de Chateaubriand/La Valée aux Loups,
Château-Malabray, France

Maryland Historical Society,
Baltimore, Maryland

Massachusetts Historical Society Museum,
Boston, Massachusetts

Metropolitan Museum of Art, New York

Middleton Place Foundation,
Charleston, North Carolina

Milwaukee Public Museum,
Milwaukee, Wisconsin

Ministère des Affaires Étrangères, Paris

Mobilier National, Paris

Montgomery Place, Historic Hudson Valley,
Annadale-on-Hudson, New York

Monticello/Thomas Jefferson Foundation, Inc.,
Charlottesville, Virginia

Musée d'Art et d'Histoire, Palais Masséna,
Nice, France

Musée de l'Armée, Paris

Musée des Arts Décoratifs, Paris

Musée des Beaux-Arts, Lille, France

Musée des Beaux-Arts, Nantes, France

Musée de Beaux-Arts et d'Archeologie,
Besançon, France

Musée Carnavalet-Histoire de Paris, Paris

Musée de la Coopération Franco-Américaine,
Château de Blérancourt, France

Musée Girodet, Montargis, France

Musée de l'Histoire Naturelle, Lille, France

Musée du Louvre, Paris

Musée Marmottan-Monet, Paris

Musée du Monnaie, Paris

Musée du Nouveau Monde,
La Rochelle, France

Musée Napoléon, Schloss Arenenberg,
Salenstein, Switzerland

Musée National de Céramique, Sèvres, France

Musée National du Château,
Compiègne, France

Musée National du Château de Fontainebleau,
Fontainebleau, France

Musée National du Château de Malmaison,
Rueil-Malmaison, France

Musée National du Château de Versailles,
Versailles, France

Musée National de la Légion d'Honneur
et des Ordres de Chevalerie, Paris

Musée des Tissus, Lyon, France

Museum of the City of New York, New York

Museum of Fine Arts, Boston, Massachusetts

National Academy of Design, New York

National Archives, College Park, Maryland

National Gallery of Art, Washington, D.C.

National Gallery of Scotland,
Edinburgh, Scotland

National Museum of American History,
Smithsonian Institution, Washington, D.C.

National Museum of Natural History,
Smithsonian Institution, Washington, D.C.

New Orleans Museum of Art,
New Orleans, Louisiana

New Orleans Public Library, City Archives,
New Orleans, Louisiana

New York Historical Society,
New York, New York

Oak Spring Garden Library,
Upperville, Virginia

Octagon Museum, Washington, D.C.

Old Sturbridge Village, Sturbridge, Massachusetts

Pennsylvania Academy of Fine Arts,
Philadelphia, Pennsylvania

Roger Prigent, Malmaison Antiques, New York

Phoenix Art Museum, Phoenix, Arizona

Private Collection, Montreal

Private Collection, New Orleans, Louisianaa

Private Collection, Paris

Residence of the American Embassador, Paris

Royal Academy of Arts, London

Royal Institute of British Architects, London

Saint Louis Art Museum, Saint Louis, Missouri

The Speed Museum, Louisville, Kentucky

Senate House State Historic Site,
New York Office of Parks,
Recreation and Historic Preservation,
Kingston, New York

Southeastern Architectural Archive,
Howard-Tilton Memorial Library,
Tulane University, New Orleans, Louisiana

The Toledo Museum of Art, Toledo, Ohio

Tulane University Art Collection,
New Orleans, Louisiana

University of Virginia, Charlottesville, Virginia

Ursuline Academy Archives,
New Orleans, Louisiana

Wadsworth Atheneum Museum of Art,
Hartford, Connecticut

Ridley Wills, II, Franklin, Tennessee

PATRON'S PREFACE

As we continue to raise the curtain on events being held statewide in observance of the two hundredth anniversary of the Louisiana Purchase, we focus on the city of New Orleans. The New Orleans Museum of Art presents the exhibition *Jefferson's America & Napoleon's France*. It is the signature show of the yearlong Louisiana Purchase Bicentennial Celebration.

The exhibition, the largest ever organized by the Museum, will give visitors a sense of the lives and times of Thomas Jefferson and Napoleon Bonaparte, the central figures in the extraordinary land purchase that doubled the size of the United States and instantly made us a world power. On display will be paintings, sculptures, prints and drawings, historical documents, weapons, American Indian artifacts, furniture and decorative arts that define the character of the United States and France at the time of the Purchase in 1803.

We also wish visitors to understand the long and rich cultural exchange between France and the United States, an exchange that began in French colonial Louisiana, grew with the Louisiana Purchase, and continues today.

This exhibition, which runs from April 12 through August 31, 2003, is the result of the combined efforts of the Louisiana Department of Culture, Recreation and Tourism, the New Orleans Museum of Art, museums, schools and historical organizations around the country and museums from France, England, Scotland and Switzerland.

We welcome America and the world to this fascinating exhibition and to the other artworks at the New Orleans Museum of Art.

Kathleen Babineaux Blanco
Lieutenant Governor of Louisiana

FOREWORD

It seemed natural, since New Orleans was the city that started it all, that it was entirely appropriate for the New Orleans Museum of Art to mount a significant exhibition to commemorate the two hundredth anniversary of the Louisiana Purchase. After all in Louisiana there is an island and a Parish named for Jefferson and a town for Napoleon, and in New Orleans there is both a Jefferson Avenue and a Napoleon Avenue. In our research, we became fascinated by the faraway events that shaped the destiny of the vast Louisiana Territory and concluded that the Louisiana Purchase needed to be considered as a defining event in international history, not just Louisiana or American history. In the theater of the greater Atlantic world in 1803, the starring roles were played by Thomas Jefferson and Napoleon Bonaparte, who inevitably represent not only their remarkable selves, but also the complexities and contradictions of their respective nations. Franco-American relations and preoccupations emerged as the key themes, and these are richly manifest in the outstanding artworks and historical documents that our generous lenders have entrusted to us for the exhibition.

Without the support of the Louisiana Department of Culture, Recreation and Tourism, under the inspired leadership of Lieutenant Governor Kathleen Babineaux Blanco, which awarded our Museum an unprecedented grant for this purpose, we could not have undertaken this project. With this support we were able to organize an exhibition that illuminates the art and history surrounding the Louisiana Purchase. It will appeal to visitors to Louisiana as well as residents, experts and amateurs, and to all who are interested in art, history, war and the military, politics, fashion, furniture, or science. With the initial support from the Louisiana Department of Culture, Recreation and Tourism, we were fortunate to gain the generous support of many other organizations. AmSouth Bank is the lead corporate sponsor of the exhibition. Additional support has been provided by the State of Louisiana Legislature, The United States Government through the Library of Congress, The Federal Council on the Arts and the Humanities, the Parish of Jefferson, the City of New Orleans, BellSouth, The Patrick F. Taylor Foundation, The Florence Gould Foundation, the Port of New Orleans, WDSU-TV, New Orleans, The Louisiana Endowment for The Humanities, the New Orleans Tourism Marketing Corporation, The National Science Foundation, Stewart Title of Louisiana, the Sheraton New Orleans Hotel, Delta Air Lines, Inc., Hotard Inc., and the Cudd Foundation.

I wish to especially mention our collaboration with the University of Virginia, which received a major grant from the National Science Foundation to fund the application of an experiment in the digital recreation of a specific place. Under the leadership of Professor David Luebke of the Department of Computer Science at the University of Virginia and Professor Anselmo Lastra of the Department of Computer Science at the University of North Carolina, Chapel Hill, visitors to our exhibition will be able to experience, for the first time, a "virtual" Monticello. This cutting-edge technology in the service of art would have greatly appealed to the inventive mind of Thomas Jefferson.

An international loan exhibition of this scope will always present challenges. An unsuspected one came when our esteemed Curator of European Painting, Gail Feigenbaum, who had originated the exhibition concept and spent two years researching it and negotiating the loans, left our Museum in January 2002 to become the Associate Director of the Getty Research Institute in Los Angeles. While Dr. Feigenbaum continued as guest curator of the exhibition, we were fortunate that Victoria Cooke, who had been assisting her, assumed the duties of Curator of European Painting and willingly rose to

the occasion and worked long distance with Dr. Feigenbaum for the past year to bring the catalogue and exhibition to completion. In Paris we were equally fortunate to have the remarkable curatorial and organizational assistance of Susan Taylor-Leduc. Jamie Stephens, curatorial assistant to Ms. Cooke, has worked diligently for the final year and a half of this project, providing valuable assistance. A group of devoted interns and volunteers also have contributed their help and support over the past two years, particularly Aila and Andrew Hietala, Susan van Scoy, Adam Shapiro, Candace Weddle and Catherine Wilkins. For this exhibition we also have had the remarkable assistance of Marilyn Dittmann, who has served as Exhibition Coordinator.

Many other staff members at the New Orleans Museum of Art have made important contributions to the success of this project including Jacqueline Sullivan, Deputy Director; Clem Goldberger, Assistant Director for Development and Communications; Steven Maklansky, Assistant Director for Art; Allison Reid, Assistant Director for Education; John W. Keefe, Curator of Decorative Arts; W. Anne Williams, Public Relations Officer; Wanda O'Shello, Publications Coordinator; Beth Millbank, Grants Officer; Judy Cooper, Photographer; and Emma Haas, Executive Assistant to the Director. Special recognition must be given to the Museum's Registrar, Paul Tarver. Not only did Mr. Tarver expertly prepare our successful application for Federal Indemnification from the Federal Council on the Arts and the Humanities, which greatly reduced the insurance premiums, he and his able colleagues Michael Guidry and Jennifer Ickes coordinated the packing and transportation of over two hundred fifty loans from more than one hundred lenders throughout Europe and the United States, many of which required accompanying couriers.

Once again our Museum has been blessed with the immense skill and expertise of Elroy Quenroe, one of the finest exhibition designers in America. He has used his artistry to give order and coherence to a diverse group of artworks thereby bringing to life the intellectual ideas and artistic aims of our curators. The catalogue that accompanies the exhibition was handsomely designed by the award-winning New Orleans artist and designer, Michael Ledet, under the supervision of Wanda O'Shello.

As can been seen from the preceding list of our Honorary and Scientific Committees, we were privileged to have the advice and support of a most distinguished group of individuals in France and America. We were particularly pleased that the First Lady of the United States, Mrs. Laura Bush, so graciously agreed to serve as the Chair of the Honorary Committee. We were equally honored that the governors of most of the states that were carved from the Louisiana Purchase territory generously agreed to join the Committee as well.

Finally this exhibition would not have achieved its final form without the extraordinary generosity of over one hundred public institutions and private collectors who agreed to our requests to borrow their treasures and bring them to New Orleans. Hopefully the new insights that the exhibition and catalogue will generate about the Louisiana Purchase will justify these extraordinary loans and the immense efforts of everyone involved in this Bicentennial Celebration.

E. John Bullard
The Montine McDaniel Freeman Director
New Orleans Museum of Art

ACKNOWLEDGEMENTS

Exhibitions are, inevitably, collaborations, and this one more than most. The intellectual, historical and artistic territory surveyed herein is vast, and we needed a great deal of conceptual and practical help. For the latter I want to thank first The Honorable Corinne Claiborne Boggs, former United States Ambassador to the Vatican, not only for a wonderful lunch in Rome but also for working a small miracle in Washington on behalf of the exhibition. For conceptual help I want to thank another friend of this exhibition, Peter Onuf, Thomas Jefferson Memorial Foundation Professor of History at the University of Virginia, whose clear vision and advice helped me to come to terms with a Thomas Jefferson who, it seemed, was becoming a more complicated character by the day. William Tronzo, Professor at Tulane University, offered ideas and inspiration. Teresa Toulouse of Tulane University tutored me in American Studies over many a Sunday dinner. Susan Stein, Curator of Monticello, who must know more than anyone else alive about the material world of Thomas Jefferson, shared her knowledge unstintingly. Amy Meyers, Director of the Paul Mellon Center for British Art, and Therese O'Malley, Associate Dean of the Center for Advanced Study in the Visual Arts at the National Gallery of Art, were expert guides to the Franco-American exchanges in natural science.

In France the contribution of Bernard Chevallier, Director of the Musée National du Château de Malmaison, was crucial to the success of this venture. Thierry Lentz, the far-sighted Director of the Fondation Napoléon who appreciated the historical perspective offered in this exhibition, provided generous support. We owe special thanks to Princesse de La Tour d'Auvergne, President, French Heritage Society, and to Eugenie Anglès, President of American Friends of Blérancourt, for working so effectively behind the scenes for us. I must also mention my gratitude to Jean-Pierre Samoyault, Administrateur général du Mobilier National de France; Pierre Rosenberg emeritus director of Louvre; Henri Loyrette, present director of the Louvre; and Jacques Perot, Director of the Musées Nationaux des Châteaux de Compiègne et de Blérancourt. A number of colleagues at French museums have been extraordinarily kind and offered excellent advice, and I would single out for special mention Amaury Lefébure, Director of the Musée Nationale du Château de Fontainebleau; Pierre Arizzoli-Clémentel, Directeur Général du Musée National de Versailles et de Trianon; Alain Pougetoux, formerly of Versailles and now Malmaison; Antoinette Hallé, Director of the Musée National de Céramique, Sèvres; and Madame Christine Lahaussois, also of Sèvres; Karine Hugenaud of the Fondation Napoléon; Daniel Alcouffe, Sylvain Laveissière, and Catherine Loisel of the Musée du Louvre; Guy Blazy, Director of the Musée des Tissus in Lyon; Luc Thevenon, Curator of the Musée d'Art et d'Histoire, Palais Masséna in Nice; Ann Dopffer, Curator of the Musée National de la Coopération Franco-Américaine at Blérancourt; Odile Nouvel and Veronique de la Hougue of the Musée des Arts Décoratifs, Paris; Lea Perez and Katja Grasse of the Embassy of the United States of America in Paris; David Verhulst of the Musée de l'Histoire Naturelle in Lille; Isabelle Richefort of the Ministère des Affaires

Etrangères; Stéphane Martin, Le Président-Directeur général, Musée du Quai Branly. Carole Thibault Pomerantz and Alain Chastagnol were also tremendously kind.

My American colleagues were unfailingly generous with their help, and I would like to thank especially the following: James Abbott of the Baltimore Museum of Art; Peter Kenny and Wolfram Koeppe of The Metropolitan Museum of Art; Scott Schaeffer and Lee Hendrix of the J. Paul Getty Museum; Michelle Majer, Maurie McInnis, Ann Poulet, Nancy Davis of the Maryland Historical Society; Gail Serfaty of the Department of State; Anne Cassidy of the New York State Parks; Phyllis Magidson and Deborah Waters of the Museum of the City of New York; Kevin Stayton of the Brooklyn Museum of Art; Nancy Anderson of the National Gallery of Art; and the late Ted Carter II, American Philosophical Society.

I have happily come to expect nothing less than overwhelming good will from my colleagues in New Orleans, which is precisely what we received from Priscilla Lawrence, John Lawrence, and Alfred Lemmon of the Historic New Orleans Collection; Sharon Litwin, Executive Director of the Louisiana Philharmonic Orchestra; and Courtney Ann Sarpy of the Consulate of France; and Gary Manina, Headmaster of St. Andrews Episcopal School. A special thanks is owed to Debbie de la Houssaye at the Consulate of France in New Orleans who deserves enormous credit for all she has done to make this exhibition a reality.

The spirit behind this exhibition was Thomas C. Keller, longtime trustee of the New Orleans Museum of Art and patron of the American Friends of Blérancourt. With his untimely death last year the Museum lost one of its truest friends.

In addition to the members of our historical committee who offered excellent advice along the way, and whose names are listed in their proper place at the beginning of this book, I want to mention some of my amazing collaborators, especially Paul Staiti, David O'Brien and Jessie Poesch who did not even wait to be asked to go far beyond the call of duty. When a strike made it impossible for us to have our original selection of Native American materials from the Musée du Quai Branly, Bill Mercer and Paul Tarver rushed valiantly into the breach, launching an extensive, and remarkably successful, search for an equivalent group of rare and important objects in French and American collections. My thanks to my NOMA colleagues Marilyn Dittmann for being so smart, optimistic, tactful and effective, and to Jackie Sullivan who was whole-hearted in her support. I owe a special debt of gratitude to Susan Taylor-Leduc and to Victoria Cooke who have been the best of all possible collaborators. I left my curatorship at the New Orleans Museum of Art a little more than a year before the opening of this exhibition, to become Associate Director of the Getty Research Institute. It has been an adventure, and a pleasure to continue to work with my colleagues at long distance to realize this exhibition and catalogue. Finally, I want to thank my husband, Bill Tronzo, and our daughter Phoebe for their wonderful company during this pursuit of Jefferson and Napoleon.

Gail Feigenbaum

LAC SUPÉRIEUR

HAUT CANADA

BAS CANADA

Pays des CHIPPEWA HUSTING

CHIPPAWAYS

MONOMONIS

CHIPPAWAYS

LAC HURON

LAC MICHIGAN

OOTAWAS

LAC ONTARIO

MAHA

PADOUCAS

OOTAGAMIS

SAUQUES

WINNBAGOS

NEW YORN

POOTEWATOMIS

LAC ERIE

O P A N I S

MASCOOTENS

ME AMES

PENSILVANIE

L O U I S I A N E

PANIMAHA

ILLINOIS

PANIS

WEAUTENAUS

PADOUCAS

MISSOURIS

Grand espace de Pays

CANECIS

KENTUCKY

VIRGINIE

qui n'est point connu

A K A N S A S

CHICASAWS

TENNASSEE

NORTH CAROLINE

CHEROKEES

CANOATINOS

T E C A S

GEORGIE

SOUTH CAROLINE

M É X I Q U E

OUACHITA

CHECTAWS

CONTREE des Georgie

Pays inconnu dans le détail

Creeks de MUSKOGULGEES

BAS CREEKS ou SIMONOLES

TALASEE

APELOUSSAS

FLORIDE OCCIDENTALE

FLORIDE ORIENTALE

G O L F E D U M É X I Q U E

COURS DU MISSISSIPI
Comprenant
LA LOUISIANE, LES 2 FLORIDES,
UNE PARTIE DES ETATS-UNIS,
et Pays Adjacents.

Par J. B. POIRSON, Ingénieur Géographe,
Nivose An XI. (1803)

"We Dreamed of Your Times" Looking back at the Louisiana Purchase

Gail Feigenbaum

Arts and Sciences will change the Face of Nature in their Tour from Hence over the Appalachian Mountains to the Western Ocean; Shall not then those vast Quarries, that teem with Mechnic Stone,—those for Structure be piled into Great Cities,—and those for Sculpture into Statues to perpetuate the Honor of renowed [sic] Heroes; even those who shall NOW save their Country!—O! Ye unborn Inhabitants of America! . . . when your Eyes behold the Sun after he has rolled the Seasons round for two or three Centuries more, you will know that in Anno Domini 1758, we dream'd of Your Times.

Nathanial Ames, *Almanack,* 1758

On the occasion of the bicentennial of the Louisiana Purchase, the almanac of Nathanial Ames seems to offer an astonishingly accurate prophecy.[1] In 1803, forty-five years after he wrote these words on westward expansion, without a shot fired, with just a few strokes of a pen, the Louisiana Purchase more than doubled the size of the United States. Other parts of Ames's vision had just begun to be realized as the stones of the western quarries began to be used as the building blocks of American cities, such as the new capital, Washington D.C. Sculptors had yet to carve stone on these shores, though, so Jefferson had to import sculpted busts of American heroes from France in order to create his pantheon of great men at Monticello. While the exact borders of the Louisiana Territory have never been entirely certain, approximately 827,987 square miles changed hands when France sold the land to the United States for the sum of fifteen million dollars. It worked out to about four cents an acre, which seems a bargain price in today's dollars, but put quite a strain on the young country's small treasury. The money to finance the Purchase had to be borrowed from banks in London and Amsterdam. The Purchase encompassed roughly the land stretching west from the Mississippi River to the Rockies. New Orleans was included, but not the land that became Texas, and not the Floridas to the east, still controlled by Spain.[2]

The men who were responsible for this outsized land deal, Thomas Jefferson and Napoleon Bonaparte, were themselves larger-than-life personalities. Indeed there is something of the epic in the Louisiana Purchase stories, as befits a sale so vast in size and in repercussions. In this exhibition, commemorating the two-hundredth anniversary of the Purchase, we have tried to avoid reducing matters to the simple, manageable tale of the preordained destiny of the United States taught to schoolchildren, an account that has tended to flatten one of the most complicated episodes of international relations into a cliché, and a false one at that. For every vision of westward expansion of the United States there was a (nearly) equal and opposite reaction, internally from the Federalists with their vision of a country of governable size, and externally from foreign colonial powers, not to mention a number of seditious adventurers who saw the opportunity to take matters into their own hands in the sparsely populated territories. We have tried to capture the suspense and fascination of a story whose outcome is known, yet was

not foreordained, and to tell it through a rich variety of objects, embracing the complexity and scope warranted by the subject.

The year of the Louisiana Purchase was 1803. France and the United States, sister republics, had survived the agony and triumph of revolution. The United States was still in the process of calibrating its precarious balance of democracy, a successful experiment in government by the people, though not all of them. Across the Atlantic, France was lurching from tragedy and chaos toward a military dictatorship clothed as a reversion to monarchy, or rather empire.

Louisiana and the Atlantic World

It is customary to begin an account of the Louisiana Purchase with the incident in 1802 of the Spanish governor of the Louisiana Territory suddenly revoking the Americans' right of free deposit. This right, long enjoyed by the Americans, meant the riverboatmen could, without paying duty, deposit the cargo from their barges in warehouses in New Orleans where it would await loading onto ocean-going vessels. The economy of the territory west of the Appalachians depended almost entirely on the route of the Mississippi River and the outlet of the port of New Orleans to transport their furs and other products to the rest of the Atlantic world. No viable roads connected the land east of the Appalachians to New Orleans. When their privilege of free deposit was revoked, the American frontiersmen were incensed at losing what they regarded as their right to treat New Orleans as their own port. Their economic livelihood endangered, they threatened to take New Orleans by force. Rumblings of this would have been unsettling not only to Jefferson but also to Napoleon, who had in the meantime secretly negotiated the retrocession of Louisiana from Spain to France in the Treaty of San Ildefonso (**cat. no. 236**). For the United States it was one thing to have as a neighbor a territory ruled by the comparatively unthreatening Spanish regime, and quite another to have the aggressive Bonaparte at one's back. With the twin threats of Bonaparte ready to garrison the Mississippi River up to St. Louis, and thousands of angry frontiersmen ready to lead their own expedition down the Mississippi to seize New Orleans, Jefferson was under pressure to act. In early 1803 he gave Robert Livingston in Paris instructions to negotiate a remedy, and sent James Monroe after him to help, hoping to buy New Orleans and also the Floridas. (East and West Florida, which Spain had retained even after the secret Treaty of San Ildefonso had ceded the Louisiana Territory to France, would have gained more useful rivers and gulf ports.) As nearly every schoolchild knows, Bonaparte surprised the Americans by offering to sell the whole Louisiana Territory instead.

Looking back at this moment, as most American historians have tended to do, through the lens of Manifest Destiny (the quest to expand the United States west to the Pacific that had already been a gleam in Nathanial Ames's eye in 1758, but began to seize the popular imagination only in the 1820s), the Louisiana Purchase has come to seem inevitable. It even came to conjure a faintly comical scenario: the American diplomats being Robert Livingston, slightly deaf and with an imperfect knowledge of French,[3] and James Monroe who took sick upon arrival in Paris and was home in bed until the very last of the negotiations; their astonishment at Bonaparte's offer; their nervousness at being forced to act immediately and without authority, unable to consult the president back in Washington; not to mention the chuckle at besting the French who had given up the land at such a cheap price. There are farcical aspects of Bonaparte's reactions to the machinations around the deal as well.[4] For all this, on the occasion of the bicentennial of the Louisiana Purchase, we have chosen a more searching perspective that puts New Orleans and negotiations over the Louisiana Territory in the center of the international, rather than national, theater of history. Readers will find more on the remarkable cultures of New Orleans and its environs in Jessie Poesch's essay, a portrait of the region in 1803. Ranging more widely, the exhibition explores an exciting, complicated nexus of far less well-known relationships between the United States and France as these two post-revolutionary nations reinvented themselves at home and in the greater Atlantic world. If the persistence of an American dream of westward expansion made an eventual arrival at the Pacific inevitable, the Louisiana Purchase was by no means the inevitable way for that dream to be realized. Rather, it was a particular solution that unfolded against a background of personalities, politics, and prejudices, historical contingencies that deserve to be better understood. Other scenarios—now the stuff of counterfactual exercises—were at least as probable at the time as the events that actually transpired. Had the Federalist John Adams, and not Jefferson, won the contested election for president in 1800, for example, the acquisition of Louisiana would have been doubtful. Had Bonaparte been killed in battle, or been willing to accept the governance of Saint Domingue without slavery, the fate of the Louisiana might have been something else entirely. As historian Patrice Higonnet argues in his provocative essay, giving due consideration to issues of slavery and to Napoleon's side of the story, things might have been different.

A broader historical perspective on the Louisiana Purchase must include the hideous, failed expedition of Bonaparte's army, commanded by his brother-in-law General Leclerc (**cat. no. 251**), to retake the island of Saint Domingue (Haiti), which was under the leadership of Toussaint Louverture (**cat. nos. 252a–252c**), hero of the slave rebellion of the 1790s. Saint Domingue may

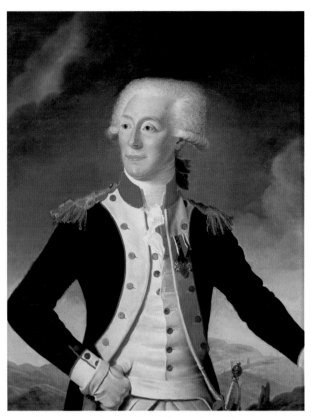

Figure 1: Joseph Boze (French, 1745–1826), *Marquis de Lafayette*, 1790, Oil on canvas, 36-1/4 x 28 inches (92.1 x 72.4 cm), Massachusetts Historical Society, Boston, Massachusetts. Catalogue number 5

have been small, but its economic importance was large: Britain's entire colonial trade was five million pounds in 1789; France's trade with Saint Domingue alone was eleven million pounds. For Bonaparte it was the sugar-producing Saint Domingue, not Louisiana, that was the glittering colonial prize. Louisiana was useful as a breadbasket for the Caribbean, and the French garrisons that Bonaparte had ready to deploy up the Mississippi River would keep the hated British away from the silver mines of Mexico. But once he failed to reconquer Saint Domingue, Bonaparte regarded the entire colony of Louisiana as lost, declaring "to attempt to retain it would be folly." He let go of his ambition for an empire in the west. If the Americans wanted New Orleans, let them have all of Louisiana for a price. Bonaparte had other wars to finance. And he had turned his gaze to the east, backwards in history, following the footsteps of Alexander the Great.

By contrast, Jefferson understood that America's future was an empire of the west. "It was impossible," he wrote, "not to look forward to distant times when our nation will cover the whole northern, if not southern continent . . ."[5] The idea was certainly thicker in the air than it had been in Nathanial Ames's pre-revolutionary days. In 1801 Gouverneur Morris (who had succeeded Jefferson as min-ister to France in the 1790s) echoed Ames's prediction as he stood on the shores of Lake Erie gazing westward and declared, "The proudest empire in Europe is but a bauble compared to what America will be, *must* be, in the course of two centuries, perhaps one . . ."[6]

Storied Objects, Storied Personalities

The objects in this exhibition may be beautiful or fascinating in themselves, but they have been chosen because they are eloquent bearers of stories and pulse with historical resonance. Consider one of the less obviously prepossessing items, a French translation of the *Constitutions of the Thirteen Colonies*, published in 1783 (**cat. no. 8**), in which the United States seal with its eagle is depicted for the first time. It is emblazoned with the arms of Marie Antoinette. What might she have made of it if she read it? As we learn in Susan Taylor-Leduc's essay on Jefferson's French sojourn, Benjamin Franklin, while minister to France, supervised this translation by the Duke de la Rochefoucauld, a sympathizer of the American Revolution who had fought alongside the Marquis de Lafayette. Lafayette was a close, lifelong friend of Thomas

Jefferson who commissioned his portrait (*fig. 1*), and it is Lafayette's ship set to sail to the aid of the American revolutionaries that we see in Hubert Robert's harborscape (**cat. no. 7**). Jefferson was minister to France from 1785 to 1789, long enough to witness the storming of the Bastille (**cat. no. 9**). On the eve of his departure, he dined with his aristocratic friends Lafayette and la Rochefoucauld (who did not survive the Revolution) at his home, the Hôtel de Langeac (**cat. no. 11a**) on the Champs-Elysées. Jefferson reports that they discussed the scarcity of bread and the threat of a march on Versailles. Perhaps they also sampled some of the wine Jefferson had shipped from Virginia, thought to be the first American wine drunk in France. It was September, so Jefferson might have taken his friends to see the ripening corn in the garden he had planted with American specimens (**cat. no. 11b**). Jefferson counted heavily on his friendship with Lafayette, and after the Purchase he even tried to persuade him to become governor of Louisiana, declaring him to be the only man whom both the French-speaking populace of New Orleans and its new American owners could trust.[7] This is typical of the sometimes unpredictable, sometimes seemingly inevitable way that objects, events and personalities interweave in the Franco-American nexus that surrounds the Louisiana Purchase.

We have sampled the crucial subplots and themes that comprise this epic, and to bring out the vital interconnections between France, America, and the greater Atlantic world, we have anchored the installation with some key comparisons. These pairings can be surprising. We are not accustomed to looking at a portrait of an American woman by an American painter beside a contemporary French example (**cat. nos. 143, 142**), and yet such a comparison drives home more vividly than words the contrasting ideals of womanhood. The French ideal of seductive charm is unmistakable in Lefèvre's portrait of Napoleon's sister Pauline Bonaparte, or Gérard's of Madame Récamier, and one detects the gravitational allure of the French model of femininity on the American ideal of the virtuous, self–reliant republican matron in Gilbert Stuart's portrait of Eleanor Parke Custis Lewis. Lewis is clad in the latest Parisian fashion that has been adapted for modesty. Beautiful, she is by no means stolid, yet there seems to be more substance and seriousness in Lewis's character, as befits a participant in the project of building a new republic. Americans, and Thomas Jefferson was typical in this aspect, were buffeted by their own ambivalence toward European culture, manners, art and luxury objects as they tried to create lives befitting a new kind of state.[8] The Republic did not need fashion plates, it needed citizens of strong mind. Females should be ruled by civic virtue, not passion; Roman, not romantic.[9] If the ideal American woman resisted the vagaries of fashion, many of the real life versions, if they were in a position to afford it, avidly followed and copied the latest in Parisian style. Eleanor

Parke Custis Lewis had this in common with Dolley Madison, for example, who, from a Quaker background, was a famous convert to the gorgeous fashions from France that she wore as Jefferson's unofficial hostess at parties in the President's House. Contemporary correspondence betrays a burning curiosity on the part of the American women for up-to-the-minute news on Paris fashions, on colors, the shapes of hats, cut of sleeves, setting of a waist, undergarments and lack thereof, footwear, hair styles. A year or so before the Louisiana Purchase one such correspondent declared of New York, "the revolution here is complete, all the women here have cut their hair."[10] Evidently they had adopted the cropped, curly *coiffure à l'antique* that had swept post-revolutionary Paris, and seen in Josephine's portraits (**cat. no. 79**) as well as Lewis's, a style that went so nicely with the sheer, white, unstiffened, vaguely classical dresses with raised waists, the *robes de simplicité* that had become the signature style during the Directory in France.

In America those sheer French dresses (**cat. no. 145**) caused a stir, as witness the reaction to Elizabeth Patterson (**cat. no. 144**), daughter of a Baltimore merchant, who fell in love with the dashing French officer Joseph Bonaparte, Napoleon's youngest brother. They were married the year of the Louisiana Purchase, against the wishes of both families, and Betsy Bonaparte appeared at Washington social events in the latest Paris fashions. Keeping warm was not her priority. As chronicled by the highly respectable Washington insider Margaret Bayard Smith, Betsy's low-cut, gauzy dresses worn in the French manner with little underneath, scandalized the ladies in the American capital, and even attracted crowds to peer at the spectacle through the windows. Bonaparte himself disapproved of the revealing styles worn by the fashionable Josephine when they met, and when he prevailed upon her to moderate the sheerness and décolleté of her gowns, her image was so influential that all Europe and America followed suit. Americans were consistently prudish about exposing their bodies, and even squeamish about the nude body in art. In the rare instances that a classical statue of Apollo or Diana (**cat. no. 181**) was imported into the country even the body in marble had to be outfitted with a fig leaf or an extra piece of drapery so as not to offend the sensibilities of female viewers. When the American painter John Vanderlyn (**cat. no. 135**), who had studied in France, painted a copy of a famous renaissance painting of the nude *Antiope* by Correggio, he was characteristically ambivalent. He worried, "it might not be chaste enough for the more modest Americans . . . but on that account it might attract a greater crowd if exhibited publicly."[11]

The engagement with French style went beyond clothing, and beyond the decoration of the interior environment to deportment. A gossipy letter to a Charleston woman recounts the peculiar behavior of an acquaintance

in the New York area, who was receiving visitors while lying in her bed. This practice, which struck the writer of the letter as bizarre, should probably be understood as imitating the custom of Juliette Récamier, the celebrated muse of French style who sometimes received visitors to her house in Paris while lying in bed. Récamier was regarded as unusually chaste, and her bedroom was a site of conversation. Rarely seen elements from Madame Récamier's own bedroom and guest bedroom—her interiors were made famous in Percier's engravings—are in this exhibition (**cat. nos. 114–118**).

"You see I am an enthusiast on the subject of the arts"[13]

Recently widowed, Jefferson accepted the post as minister plenipotentiary to France where he would stay from 1784 to 1789. He moved into an expensive *hôtel particulier*, the Hôtel de Langeac adjacent to what is now the Champs-Elysées.[14] Rented or not Jefferson set about extensive renovation of the Hôtel de Langeac, and redesigned the garden. The story of his sojourn is told in Susan Taylor-Leduc's essay. Suffice to say here that Jefferson spent a great deal of time and money shopping for all the luxury goods that constituted the necessities of life for the diplomatic posting to Paris of a Virginia squire. It is worth noting that his tastes were not so dissimilar to those of Marie Antoinette: both were partial to Paris porcelain flecked with dainty cornflowers (**cat. no. 167**), not to mention the kind of elegant chairs made by the great craftsman Georges Jacob (**cat. no. 170**). As Susan Stein's essay on Monticello recounts, much of this found its way back to the United States in the eighty-six crates that Jefferson had shipped to America when he returned, and a good percentage was at Monticello (**cat. no. 161**).

To understand Jefferson's experience, we must realize that in the young United States the visual arts were by no means a national priority. There were no collections of old master paintings or sculptures to train the eye and taste of an aspiring artist or collector. The most gifted painters of the Revolutionary period, West (**cat. no. 125**) and Copley (**cat. no. 133**), settled in England and the subsequent generation felt compelled to study either in England or on the continent, as did Trumbull and Vanderlyn. Paul Staiti's catalogue essay provides insight into the situation of the nascent American arts. Bronze and marble sculpture were not yet practiced in the United States.[15] Nathanial Ames's dream of the stone from American quarries transformed into statues was far from being fulfilled. The best sculptors here made crude, if powerful, wooden figureheads for ships.

One can only imagine how a man so alive to aesthetics would have felt upon arriving in Paris. Jefferson visited the biennial Salon at the Louvre crammed with paintings and sculptures by France's finest contemporary artists,

and attended by just about everyone in the city (**cat. no. 17**). He was thrilled by the neoclassical compositions of painters David and Drouais (**cat. nos. 18** and **19**) and reveled in the skill of Houdon's chisel enough to commission and acquire his portraits (**cat. nos. 159, 180**). But this story is better told in the essays to come. Here we linger only over Hubert Robert's drawing of the Maison Carrée (**cat. no. 14**); according to Jefferson "the best morsel of ancient architecture now remaining," and the depiction of the Virginia State Capitol (**cat. no. 15**). So captivated was Jefferson by the Maison Carrée, an exceptionally well-preserved ancient Roman temple, that he traveled to see it in Southern France and even commissioned measured drawings. Thus it transpired that an Albemarle County squire in Paris recreated this temple as the Virginia State Capitol on the banks of the James River.[16] Today we take it for granted that our public architecture should have spoken with the classical vocabulary of columns and triangular pediments, but Jefferson's capitol was the first public building in the temple form in the Western Hemisphere.[17]

Jefferson was delighted to host American visitors in Paris, including the young and gifted artist John Trumbull who had come to further his ambitious project to paint "the great events of our country's revolution." While a guest in Jefferson's house Trumbull sketched the likenesses of the French officers who had helped the American cause, Lafayette, Rochambeau, Chastellux and others. Later, remembering Jefferson's hospitality in Paris, Trumbull gave Jefferson a sketch, similar to the one in this exhibition, for his *Surrender of Lord Cornwallis at Yorktown* (**cat. no. 129**). With Jefferson's encouragement Trumbull planned his monumental *The Signing of the Declaration of Independence* (**cat. no. 1**) during this visit, and Jefferson even provided him with a little rough sketch—the sort of thing one jots on the back of an envelope—of the Assembly room at Independence Hall, noting who stood where on the momentous occasion of the signing.

In Paris Jefferson entered the world of the Enlightenment salon, introduced into this extraordinary social and intellectual realm by aristocratic friends like the Marquis de Lafayette and by his own predecessor as minister to France, Benjamin Franklin. Jefferson thus became part of a larger conversation, an active, intense interchange of ideas about natural philosophy and literature. It was in the salons held in private houses that a public intellectual sphere came into being, that the ideas of the *philosophes*, D'Alembert, Voltaire and Rousseau were introduced and debated. Art, politics, mathematics, and new approaches to understanding the natural world were discussed. Circulating in this "Republic of Letters," as it later came to be known, was heady and stimulating for Jefferson. Like Franklin, he was instrumental in forging links between the important French thinkers and their colleagues in the United States. The American Philosophical Society

in Philadelphia was a headquarters for the leading lights in American natural science, and a number of Frenchmen became members.[18] Jefferson's passion for horticulture was nourished in this circle as well, for among its members flourished a constant exchange of botanical specimens, disseminating the flora of the newly explored Americas and the South Sea islands.[19] An orrery (**cat. no. 176**), similar to the one Jefferson owned, a device modeling the motions of the solar system and Peale's *Exhumation of a Mastodon* (**cat. no. 178**), attest to Jefferson's enthusiastic participation in the Republic of Letters.

Even before revolution was in the air America had fascinated the French mind. Never sure whether America was a new Eden or an inferior continent that could not support civilization, French visitors, explorers, settlers, and even those who never set foot on these shores, published their notions of America. Jefferson wrote his book *Notes on the State of Virginia* (**cat. no. 21**), which was a comprehensive exposition of natural history, political history, and the inhabitants of the state, partly to refute such influential European writers as the Comte de Buffon (**cat. no. 20**). Their view held America to be an inferior continent that could support only degenerated forms of animal and human life, not to mention civilization. This notion prompted Jefferson to procure the largest specimen of a stuffed American elk he could find, with a set of the most impressive antlers, to send to Paris to prove the point that the animals here were not inferior to their European counterparts. Jefferson also offered up the wonders of nature, like the Natural Bridge in Virginia (which he owned) and Niagara Falls, as America's answer to Europe's monuments of bronze and marble.

For a long time the inevitable image of America was of the Indian as we see it personified in allegories (**cat. no. 22**), and in Suau's *Allegory of France Liberating America*, 1784, where an Indian in feathered headdress represents the young nation (**cat. no. 4**). Suau was depicting the theme assigned by the Academy of Fine Arts in Toulouse the year Jefferson arrived in France, pointing to the pride the French took in their role in the American Revolution. French royalty and visitors to America avidly collected souvenirs of the Indians preserving these treasures in royal and aristocratic collections (**cat. nos. 199, 200**). Bill Mercer and Paul Tarver's contribution in this catalogue addresses the Indians and the interest in their artifacts, considering some of the remarkable examples to survive that we are so fortunate to have in the exhibition. These include painted buffalo robes (**cat. nos. 190–192**) very like the famous ones Jefferson displayed in the entrance hall of Monticello.[20] Jefferson's proto-anthropological interest, typical of the Enlightenment, and of the imperial cast of mind of the period, coexisted with a highly romanticized vision that is conjured brilliantly in Girodet's painting, *The Funeral of Atala* (**cat. no. 24**). Girodet was inspired by the best-selling novel *Atala*, a Christianized

love story published in 1801 by Chateaubriand, an aristocrat who spent his post-revolutionary exile traveling in America. *Atala* is set on the banks of the Mississippi and in the forests of Louisiana, and Girodet, one of David's most gifted pupils, sought out American specimen plants to copy at the *Jardin des Plantes* in order to create an "authentic" Louisiana setting.

Jefferson and Napoleon, Vision and Image

The agreement to sell and buy the Louisiana Territory was, in the last analysis, between two leaders, Napoleon Bonaparte and Thomas Jefferson. Their diplomats Barbé-Marbois, Livingston, and Monroe, may have negotiated its terms—and for the Americans this required a brave leap of faith when an effort to gain New Orleans became an all-or-nothing offer to purchase the whole Louisiana Territory—but the vision and decision belonged to their leaders. How each of these men came to assume and inhabit their roles as men of revolution and leaders of sister republics can be summed up in a pair of their portraits done just after the Louisiana Purchase (**cat nos. 27, 28**), and by a pair of their chairs (*figs. 2 and 3*).

In 1798, General Bonaparte returned to Paris a military hero and victorious general, though after the Egyptian campaign, "victorious" was more a term of propaganda than reality.[21] The tragedy and chaotic aftermath of the Terror had left France without a credible government, and in the strangely desultory military *coup de Brumaire*, so-called after the revolutionary name for the month when it occurred, Bonaparte emerged as First Consul of France, the other two consuls quickly receding into supporting roles. Historically, this moment seems a little off-beat, inglorious, and David O'Brien's analysis of Napoleon's self-transformations in this catalogue offers a rare consideration of the problem. Bolstering Napoleon's glory required a good deal of retrospective revision on the part of the painter. Unpleasant interstices, and ignoble incidents were normally, and quite naturally, left uncommemorated, or improved beyond recognition. A perfect example of such improvement is Bonaparte's glorious appearance on a rearing stallion in David's portrait of him crossing the Alps (**cat. no. 34**), when in fact he had ridden on a mule. Sablet's painting of the *Meeting Room of the Council of Five Hundred, on the Night of the 19 Brumaire, Year 8* (**cat. no. 30**) stands apart from this trend, registering the confusion and instability of a couple of days when France was effectively without a leader or a government. It is a fateful yet ignominious scene: Bonaparte is not even in the room.

It was as First Consul that Bonaparte signed the Louisiana Purchase documents, but a few months later he had determined to declare himself Emperor Napoleon, in effect creating a new monarchy to replace the one the Revolution had destroyed. For this Corsican general who

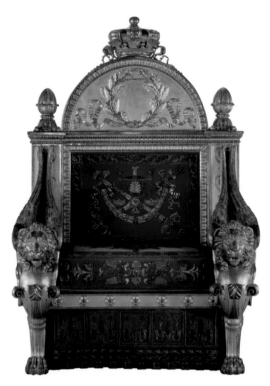

Figure 2: François-Honoré-Georges Jacob-Desmalter (French, 1770–1841), *Throne from the Legislative Assembly*, 1804, Gilt wood, velvet, gold embroidery, 63 x 43-1/4 x 32-1/4 inches (160 x 110 x 82 cm), Musée des Arts Décoratifs, Paris. Catalogue number 48

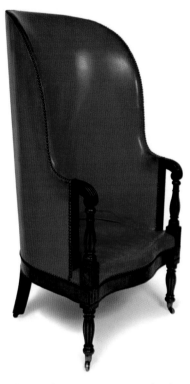

Figure 3: Unidentified Artist, American School, Mid-Atlantic Manufacture, *Easy Chair*, 1800-10, Mahogany, maple and poplar, red leather, 58 x 28-3/4 x 23-1/2 inches (147.3 x 73 x 59.7 cm), University of Virginia, on loan since 1926 to Monticello/Thomas Jefferson Foundation, Inc., Charlottesville, Virginia. Catalogue number 160

had seized dictatorial power as Consul to then assume the role of emperor, proclaiming his future sons heirs to his imperial throne, was an utterly illegitimate act. And so Bonaparte, who henceforth would be called Napoleon, marshaled all the symbolic and propagandistic power of ritual tradition to legitimize his audacious usurpation. In the regalia of the medieval emperor Charlemagne, he crowned himself and Josephine in a ceremony of unparalleled pomp and magnificence. He installed his siblings as the rulers of kingdoms across Europe. And Napoleon held court, though it was constituted as the Legislative Assembly, upon a magnificent red upholstered throne (**cat. no. 48**) embellished with gilded lions, emblems of monarchy since antiquity.

The leader of the first modern democratic republic did not sit upon a throne. We do not know if this tradition is true, but as vice-president, Jefferson is thought to have presided over the Senate in the handsome, plain, red-leather armchair (**cat. no. 160**) that survives at Monticello. He tolerated no gilded lions, no ritual trappings of monarchy for his presidency. He sold the fine coach that Adams had kept as president, preferring to ride his own horse. His antagonism toward the Federalists was in part in response to the ceremonial glamour, the pomp that he felt tainted the Adams presidency. A hint of this regality

is presaged in Copley's earlier grand and monumental portrait of Adams of 1783 (**cat. no. 133**). Jefferson was duly elected president in a close, vexed election that was all the more remarkable for it could have torn apart the still young and fragile democracy.[22] No wonder he was concerned about what his manner of self-presentation and living would say about his political principles.[23] For Jefferson, there was no military coup, and no love for the spit and polish of the military. He detested the rigid court protocol of the old monarchies and was at pains to present himself as a plain, dignified citizen. David's Napoleon confronts his spectator with the cold, hieratic stare of an emperor (**cat. no. 27**). Rembrandt Peale's Jefferson (**cat. no. 28**) turns his head slightly betraying no hauteur, but rather the thoughtful gravity, simplicity, and dignity of a citizen who serves as president. Napoleon's robes are trimmed in the royal ermine familiar from centuries of portraits of King Louis of France. The fur on Jefferson's collar probably came from an animal trapped in the western territory beyond the Appalachians. It appears to trim a dressing gown, a typically informal garment he liked to wear—he wore it even to receive foreign diplomats, much to their

horror—and surely was meant to keep him warm in the notoriously drafty President's House. Napoleon's ceremony, swords, glaives of office, proud uniforms, and costumes were anathema to Jefferson's iconography of presidency.

Jefferson and Napoleon were little alike in their fundamental characters, but they did share many of the Enlightenment ideas of their time. It is fascinating, for example, to see in both leaders the unquestioned cultural imperialism that rode the tide of territorial conquest. From Bonaparte's Egyptian campaign, analyzed more fully in Victoria Cooke's essay, we exhibit war trophies: a splendid Mameluk sword (cat. no. 72), taken from a fallen soldier and carried by the general at the Battle of the Pyramids, and an impressive *toug* (cat. no. 73), the staff of office of a Mameluk commander captured in battle and taken to Paris as a souvenir. Jefferson was no proponent of violent conquest. Nevertheless, he took it for granted that the Indians in the western territories, including Louisiana, would accept domination and appropriation of their land by the United States settlers. A scientific curiosity about the "natives" on the part of both the French and the Americans was enthusiastically expressed in the collecting of objects they made, and in the careful recording of details about their language, religion, architecture, history and social relations. Vivant Denon's publications on Egypt were monumental visual records of the systematic study conducted at Bonaparte's behest by scholars, draftsmen, cartographers, botanists and other experts who accompanied the army to Egypt.[24] Perhaps it is not stretching things too far to compare this with Jefferson's personal interest in the Indians of the western and Louisiana territories that extended to the compilation of a vocabulary, and to his avid collecting of Indian artifacts. Perhaps there is even a parallel to be drawn between Bonaparte's sending the French savants to study Egypt and Jefferson's instructions to Meriwether Lewis emphasizing that their expedition to the American West also entailed learning as much as possible about the qualities of the land, and its inhabitants, its flora and fauna. To see the records of the Lewis and Clark expedition (cat. no. 183) beside Denon's publications on Egypt (cat. no. 63) is to recognize a deep link between the ambitious gazes turned toward both the western and eastern frontiers.

For all of his beliefs in the "Rights of Man," Jefferson could not escape the terrible consequences of slave ownership. The author of the Bill of Rights and the Declaration of Independence was deeply conflicted on the subject of slavery. Jefferson's late wife, Martha Skelton, to whom he was devoted, was the model mate for a Virginia planter, a virtuous wife and mother, responsible for running a complicated household with numerous slaves, one of which was Sally Hemings. Jefferson's relations with Sally Hemings, a slave who was his late wife's half-sister, have been the focus of much discussion, both at the time of Jefferson's presidency, and in recent years.[25] The historical

record is complicated. There is substantial, though not conclusive, evidence to support the nineteenth-century reports that Jefferson was the father of children by Sally Hemings. One fact underlined by the research on Jefferson and Hemings and on slavery in general, is that sexual relations between masters and slaves were not uncommon. Relations between free people of color and whites were likewise frequent and such liaisons could be lasting and lived out in the open socially, even in Virginia. As a consequence of centuries of mixing of races in the colonies, in the United States and in the Caribbean, not to mention the Louisiana Territory, the social construction of race had grown ever more complicated, and skin color became a problematic marker, raising even higher the tensions inherent in the system of slavery. This was the social context of Jefferson's Virginia and Monticello, which was built by slaves and operated by their efforts. It was the context of Martha Skelton, it was the context of Sally Hemings, and it was the context of Josephine Bonaparte, reared on a sugar plantation in Martinique.

Many writers have undertaken to assess the characters of Jefferson and Napoleon. The exhibition cannot take on such a task, and the interested reader is urged to consult the excellent historical studies that go deeper than the journalistic debates over whether Jefferson and Napoleon were men or devils, or simply, "men of their times."[26] Historian Annette Gordon Reed remarks how Jefferson has come to stand for America, to "carry the moral character of the country on his back . . . the crucial point on which he faltered, for modern observers, was on the question of slavery and race." He served as governor of Virginia, secretary of state, vice-president, president, drafter of the Declaration of Independence, and founder of the University of Virginia. Gordon Reed observes that we cannot expect a person who is extraordinary on so many fronts to be extraordinary on all fronts.[27] Character is perhaps an even more vexed issue with Napoleon, who could be brilliant on the battlefield, who brought civil order out of anarchy, and who was among the greatest civil administrators France has ever known. Patrice Higonnet judges him harshly in his essay on the Louisiana Purchase; other historians have found much to admire in his achievements on other fronts.

To return to the story of the families of Jefferson and Bonaparte, we find that contrasts in values come again to the fore. For Jefferson's wife, Martha, we have her terse account book testifying to a life dedicated to managing the possessions, furnishings, and labor of the Monticello household. We have Jefferson's record of tenderness and devotion. Was Martha elegant and stylish? Did she present herself with soignée charm and sophistication? Was her conversation supple and witty? These qualities, highly sought after in French women—and perfectly embodied in Napoleon's wife Josephine (*fig. 4*)—were not the ones prized in the wives and mothers of American patriots who

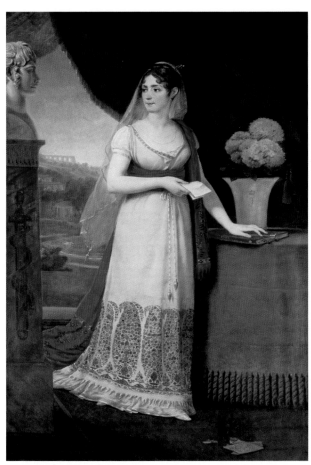

Figure 4: Antoine-Jean Gros (French, 1771–1835), *Portrait of the Empress Josephine*, 1808, Oil on canvas, 84 x 55 inches (215 x 140 cm), Musée d'Art et d'Histoire, Palais Masséna, Nice, France. Catalogue number 79

were expected to build the economy of a new country. Josephine was from Martinique, aristocratic but just barely, poor and possessed of a talent for bettering her position. As we learn from Susan Taylor-Leduc's essay, she was sent to Paris to marry well in the person of the Comte de Beauharnais. The guillotine claimed her husband, and Josephine herself had a narrow escape, but she was smart and famously charming. She was a *merveilleuse*, one of the trendsetters of the Directory who wore the daringly transparent gauze dresses *à l'antique*. She conquered General Bonaparte, and though their marriage was peppered with infidelities on both sides, their love seems to have been genuine. Josephine was extravagant and had a brilliant sense of style. It was she who assembled the teams of architects and decorators, among them Percier and Fontaine, who created the Consular and Empire styles. Their laboratory and showcase was Malmaison, Josephine's house just outside Paris. There they devised a new vocabulary of forms, and the means by which this taste became ubiquitous in ambitious houses from St. Petersburg to Washington was the print, especially the collections of

line engravings published in the *Recueil de décorations intérieures comprenant tout ce qui a rapport à l'ameublement* by Percier and Fontaine and *Plans, coupes et élévations des plus belles maisons et des hôtels construits à Paris et dans les environs* by Krafft and Ransonette.

The American Reception of French Style

The Directory, Consulate, and Empire styles in France tended to segue into one another without clear demarcation, and the objects in the exhibition exemplify the apex of design and craftsmanship that marked the decorative arts in this arc of years around the Louisiana Purchase. The American response was enthusiastic and took a variety of forms.[28] From his sojourn in Paris Jefferson had firsthand experience with the styles of Louis XVI. The scores of chairs, sets of porcelain, and the like that he shipped back to America reflected French taste of the old regime. By the time of his presidency though, French furniture transformed into a neoclassical, or better neoantique mode.[29] In the United States the new French furniture was being acquired piece by piece. Buying furniture in France and trans-Atlantic shipping were expensive, of course, and with on-and-off blockades and the volatile political and military situations, sometimes impossible. American cabinetmakers had for some time been copying the French styles to make more affordable versions. Years might pass between the appearance of a new form in Paris and an American-made response. Such American pieces were often made of native woods and painted in imitation of imported models. Quite a few years separate the appearance in France in the 1790s of the klismos chair, a type inspired by an ancient Greek model, and the first American versions. A handful of splendid examples were imported from France (**cat. no. 153**). Henry Latrobe's design from 1809 for a klismos chair may be the first such model from these shores (**cat. no. 156**).[30] Latrobe interpreted with relish the splayed legs, curving back rails and concave backrests typical of the klismos, and his drawing was a prototype for the set of thirty-six such chairs ordered by James and Dolley Madison for the President's House.

After the Revolution, French craftsmen found their way to the United States joined by craftsmen fleeing Saint Domingue. Their old clientele had disappeared. The most important émigré cabinetmaker was Charles-Honoré Lannuier whose work is represented in the exhibition by two exquisite examples. Lannuier arrived in New York the year of the Louisiana Purchase. It was only in the teens that he created the extraordinary French bedstead (**cat. no. 150**) for the Albany town house of Stephen Van Rensselaer IV and his bride, Harriet Bayard.[31] His clients turned to him because they had a taste for French style, and the Van Rensselaer bedstead, which has been

described as "simply the richest and most beautiful ever made in America," is Lannuier's interpretation of a Parisian type popular in the years just after 1800, and disseminated throughout the Atlantic world through the line engravings of Percier and Fontaine and the *Collection de Meubles et Objets du Goût* of Pierre de La Mesangere.

Capital Cities

The Louisiana Purchase documents (**cat. nos. 233–235**) conjure a picture of the two capitals, Washington and Paris, in 1803. Jefferson signed the American Exchange Copy in a drafty, unfinished President's House that he considered a palace far too grand in scale, too aristocratic, incommensurate with the political principles of a republic. There he kept a French steward, served French food, and drank French wine. He hosted Meriwether Lewis, preparing him for the expedition that would cross the Louisiana Territory, and Lewis brought home for supper game that he hunted in the muddy avenues laid out in the original city plans of Washington drawn by French architect Pierre L'Enfant. Congress ratified the Purchase in unfinished quarters on a hill so rural that wild turkeys were shot on the grounds. To execute the ambitious neoclassical designs for the building such as the American column capitals adorned with corncobs and tobacco leaves instead of the Greek acanthus, required craftsmen from Europe as there were no Americans skilled in carving marble. A drawing of an American bald eagle by Charles Willson Peale had to be provided to the Italian sculptor who was to carve the colossal eagle in order that the western constituency not be offended by any inaccuracy in rendering the bird.

In Paris, Bonaparte signed his exchange copy in a capital city that was becoming more—literally—monumental by the day. He signed in his office in the Tuileries, which like the American President's House, was under construction, but this was to make an already immense palace even grander, commensurate with Bonaparte's enormous imperial ambitions. Soon the colossal Vendôme Column (**cat. no. 37**) would be erected of bronze melted down from captured enemy canons, and celebrating Napoleon's military deeds, just as Trajan's Column had done for that ancient conquering emperor. Huge triumphal arches were erected to the glory of the French army, dwarfing those of ancient Rome.

In Washington, Jefferson and his friend, the architect Henry Latrobe, experimented with building a small triumphal arch serving as a gate on the grounds of the President's House. They were so impatient to see their arch that they removed the scaffold that framed it up before the mortar had time to set fully in the damp autumn weather. The triumphal arch collapsed.[33] It seems the grandiose forms of emperors, conquerors and despots were not suited for the American climate.

Notes:

1. I am indebted to Susan Allen for bringing to my attention this remarkable passage in Ames's *Almanack*.
2. No comprehensive study on the Louisiana Purchase in English or French has been published in recent years, a curious lack that may be filled if this bicentennial sparks new research on the subject.
3. Edward A. Parsons, *The Original Letters of Robert R. Livingston 1801–1803* (New Orleans: Louisiana Historical Society, n.d.)
4. One of these moments will be familiar to visitors to the Musée Conti Wax Museum in New Orleans's French Quarter, where they encounter the unforgettable tableau of Bonaparte jumping up from his bath in a rage at his brother's treacherous actions regarding the cession of Louisiana.
5. Peter Onuf in *Jefferson's Empire: the Language of American Nationhood* (Charlottesville: University Press of Virginia, 2000), provides a compelling exploration of Jefferson's attitudes toward the West. I want to thank Peter Onuf and Tom Crow for helping me to understand the Louisiana Purchase in international perspective.
6. Jared Sparks, *The Life of Gouverneur Morris* (Boston: Gray and Bowen, 1832), 3:143-44.
7. Jefferson wrote a remarkable letter to Lafayette on this subject, trying to persuade him to accept valuable land in New Orleans and to settle there as governor, a measure that would calm the French-speaking population, and quell the volatile political situation that had developed after the United States took possession and placed the territory under Claiborne's governorship. Following on his mention of discussing the "uneasiness" in New Orleans with a member of the Senate, Jefferson writes to Lafayette, "if they [the Senate] would permit your lands to be located in the territory of Orleans, they would be so valuable that they might induce you to come over with your family and establish yourself there; and that I had rather have your single person there than an army of ten thousand men for the purpose of securing the tranquility and preservation of the country; that you would immediately attach all the antient [sic] French inhabitants to yourself and the U.S. and would reduce to nullity the disorganising [sic] foreign adventurers who were flocking thither." Jefferson's letter 30 March 1804, Lafayette Collection at Cornell University (accessible on their website).
8. Richard Bushmen in *The Refinement of America: Persons, Houses, Cities* (New York: Knopf, 1992), identifies a consistent strain of ambivalence toward European culture, even as it is continuously assimilated into the fabric of American life in the seventeenth and eighteenth centuries. In America, as Benjamin Franklin declared, the invention of a machine or improvement of an implement was of more importance than a masterpiece by Raphael, and maybe in a future time the arts could flourish in America. Jefferson himself won a medal in a French industrial fair for his design of a mould board plow.
9. Linda Kerber, *Women of the Republic. Intellect and Ideology in Revolutionary America* (North Carolina: University of North Carolina Press for the Institute of Early American History and Culture, 1980), 203, 229.
10. Katell le Bourhis, ed., *The Age of Napoleon: Costume from Revolution to Empire* (New York: Metropolitan Museum of Art, 1989), which is an excellent source for all issues of dress. See especially Michele Majer's lively and informative, "American Women and French Fashion," and the important correspondence published in Betty-Bright Low, "Of Muslins and Merveilleuses: Excerpts from the Letters of Josephine du Pont and Margaret Manigault," *Winterthur Portfolio* 9 (1974).
11. Lillian B. Miller, *Patrons and Patriotism. The Encouragement of the Fine Arts in the United States 1790-1850* (Chicago: University of Chicago Press, 1966).
12. Low, *Winterthur Portfolio*, op. cit.
13. Jefferson letter to Madison, 20 September 1785.
14. In addition to the essays in this catalogue by Susan Stein and Susan Taylor-Leduc on Jefferson in Paris, there are numerous publications on the subject; outstanding are Howard C. Rice, *Thomas Jefferson's Paris* (Princeton: Princeton University Press, 1976) and the seminal *The Eye of Thomas Jefferson* (Washington, D.C.: National Gallery of Art, 1976)
15. William Rush was just beginning his career as a sculptor in Philadelphia.

16. Roger G. Kennedy, *Orders from France: the Americans and the French in a Revolutionary World, 1780-1820* (New York: Alfred A. Knopf, 1989).

17. The temple type had been employed only once before in America, in Prince William's Chapel in South Carolina.

18. It is worth noting that the American Philosophical Society had sponsored the mission by French botanist Andre Michaux to explore the West and find a way to the Pacific, and that Jefferson had instructed Michaux to take notes on the plans and animals he encountered. Unfortunately, Michaux became entangled in a scheme to overthrow the Spanish government of Louisiana, and his expedition did not get very far west.

19. Joseph Kastner, *A Species of Eternity* (New York: Knopf, 1977) provides an excellent overview of this phenomenon.

20. Susan Stein, *The Worlds of Thomas Jefferson At Monticello* (New York: Harry N. Abrams in association with Thomas Jefferson Museums Foundation, 1993). Susan Stein advises us that questions have since been raised about the Monticello provenance of some of the Indian objects in that exhibition.

21. Darcy Grimaldo Grigsby, "Rumor, contagion, and colonization in Gros's Plague-stricken of Jaffa, 1804," *Representations* 51 (Summer, 1995): 1-46.

22. At the time Jefferson's victory was called the "revolution of 1800." The Federalists were called aristocrats and monarchists, especially the Duke of Braintree, John Adams. In turn the Republicans were called Jacobins.

23. William Seale, *The President's House: A History* (Washington D.C.: White House Historical Association with the cooperation of the National Geographic Society, 1986).

24. See Victoria Cooke's essay in this catalogue.

25. Peter Onuf and Jan Lewis, eds., *Sally Hemings and Thomas Jefferson. History Memory and Civic Culture* (Charlottesville: University Press of Virginia, 1999), is a recent, thoughtful exploration of a subject that has become something of a news story in the last few years.

26. Peter Onuf, ed., *Jeffersonian Legacies* (Charlottesville: University Press of Virginia, 1993) and *Thomas Jefferson Genius of Liberty* (New York: Viking Studies in association with the Library of Congress, 2000), are good places to start with Jefferson. Thierry Lentz, *Le Grand Consulat: 1799-1804* (Paris: Fayard, 1999), Jean Tulard's many publications, or the classic biographies in English of Napoleon will provide rich sources on Bonaparte.

27. Annette Gordon Reed in *Thomas Jefferson: Genius of Liberty*, cited above.

28. I am indebted to Peter Kenny for his generous advice on the subject of American reception of French design in this period. My thanks as well to Maurie McInnis.

29. Wendy A. Cooper, *Classical Taste in America 1800-1840* (New York: Abbeville Press, 1993), provides an excellent survey of this period in the American decorative arts. The subject of this exhibition necessitates a focus on France as the source of the new styles in decorative arts, but it is important to bear in mind that British designers, particularly Thomas Hope, also played a major role in the shaping of American taste.

30. Maryland Historical Society.

31. Peter Kenny et al., *Honoré Lannuier Cabinet Maker from Paris* (New York: Abrams, 1998), cat. no. 5, and p. 87.

32. Kenny, as above.

33. Seale, *President's House*, cited above.

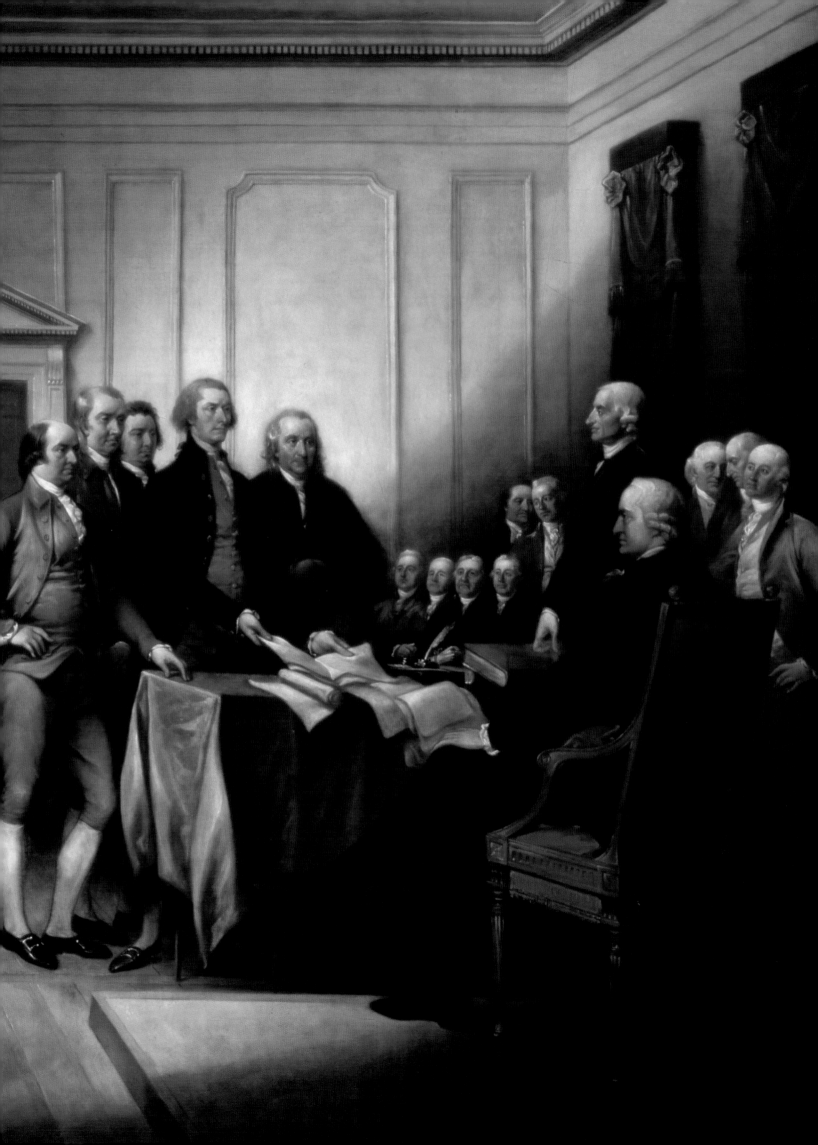

Thomas Jefferson's Paris Years: A Franco-American Affair

Susan Taylor-Leduc

A more benevolent people I have never known, nor greater warmth and devotedness in their select friendships. Their kindness and accommodation to strangers is unparalleled, and the hospitality of Paris is beyond anything I had conceived to be practicable in a large city. Their eminence, too, in science, the communicative dispositions of scientific men, the politeness of the general manners, the ease and vivacity of their conversations give a character to their society, to be found nowhere else.[1]

Thomas Jefferson

When Thomas Jefferson arrived in Paris in August 1784, Louis XVI and Marie Antoinette were amongst the most powerful reigning monarchs of Europe. When Jefferson left Paris five years later in September 1789, he had witnessed the destruction of the Bastille and the first revolutionary assemblies. To be a diplomat in Paris from 1784 to 1789 meant negotiating within the hierarchical structure of court society while at the same time mediating with the emerging groups of French opinion-makers outside the court. Jefferson, like his predecessor Benjamin Franklin, paid homage to the *Philosophes* and became an active participant in the Republic of Letters.[2]

Jefferson—as philosopher, diplomat, collector and patron—represented America for the French. Many members of the French nobility had firsthand experience of America as a result of their military service during the American Revolution. Louis XVI's alliance with the Americans allowed both the court and members of the high aristocracy to fashion themselves as benefactors of the American Revolution. In this exhibition, Jefferson is presented as an American in Paris, but the French perception of America is evoked as well. This Franco-American dialogue is a critical prelude to the Louisiana Purchase. Jefferson remained a Francophile throughout his life, serving lavish meals following the French fashion with fine French wines in the president's house in Washington, D.C. and at Monticello, where French furnishings and luxury objects surrounded him. Despite his Francophile leanings,

Jefferson was forced to adjust to the radically changed political and social realities of Napoleon Bonaparte's consulate and empire that prevailed during his presidency.

The image of America constructed by the French nobility at first evoked an ideal society that promoted innocence, rugged directness, and freedom from Old World etiquette. French émigrés forced to leave France after the French Revolution arriving in America were often disillusioned when they had to adjust to the harsh physical realities of a country whose topography, climate and culture they had only imagined. The exchanges between the two nations from 1784 to 1803 were not only established through diplomatic missions or the written word, but were imbedded in the rich trade in material culture and fashions presented in the exhibition.[3]

Jefferson's Paris

When Jefferson arrived in Paris at the age of forty-one, he had never lived in a major metropolis: the "vaunted scene" unfolded before him and the perspicacious ambassador took advantage of all its wonders.[4] Shopping at the Palais Royal, buying books on the Left Bank, attending theater performances on the Grands Boulevards, and visiting art exhibitions at the Louvre, Jefferson paid keen attention not only to its architectural marvels, but also to urban planning with an eye toward the future development of an American capital city.[5]

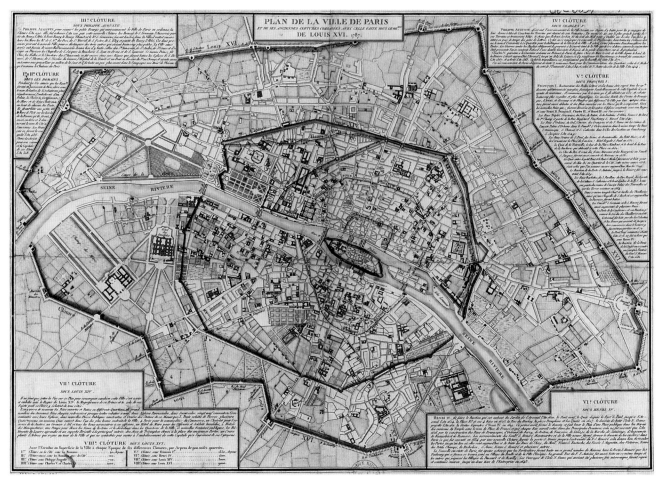

Figure 1: Pierre-François Tardieu (French, active late 18th century), *Plan de la ville de Paris de Louis XVI*, Engraving, 1787, Bibliothèque nationale de France, Paris

DeMachy's *L'Hôtel de la Monnaie and the Louvre seen from the Pont Neuf*, circa 1800 (**cat. no. 13**), depicts a contemporary perspective of the city. DeMachy's painting shows the view of the Seine from the Pont Neuf as Jefferson could have seen it. On the left is the Mint (Hôtel des Monnaies) on the quay de Conti, built in 1775 by the architect Jacques Denis Antoine (1733-1801). Across the Seine, we see the Cour Carrée of the Louvre, with Perrault's monumental colonnaded façade. We also see the extent of the Louvre complex, which at that time was still linked to the Tuileries Palace whose domed roof is shown in the background plane. Comparing DeMachy's painting to a contemporary map, *Plan de la ville de Paris de Louis XVI*, 1787, engraved by Tardieu (*fig. 1*), we can see how the city spread from the Seine to its eighteenth-century limits. The Wall of the Farmer's General was not a fortification wall *per se*, but forty-seven tollhouses designed by the architect Claude-Nicolas Ledoux (1756-1806) that marked the judicial and topographical boundaries of the capital. Ledoux envisioned his tollhouses as an opportunity to create a series of linked propylea that provided dignified entrances to the city.

In Paris Jefferson first lived on the rue Taitbout. Jefferson lived at his second residence, the Hôtel de Langeac, located near one of the Ledoux's tollhouses, from 1785 to 1789.[6] The town house was built for the Marquise de Langeac, by the celebrated neoclassical architect Jean Françoise-Thérèse Chalgrin (1739-1811). Shortly after his moving in in 1785, Jefferson started to modify the building and the garden. The site was characterized by sharp angles as the urban lot was at the intersection of the Champs-Elysée and Rue Berri. The elevation of the garden façade shows the symmetric detailing typical of the neo-classical period (**cat. no. 11a**). The site plan (**cat. no. 11b**) shows the importance Jefferson attached to gardening. Curved paths fit into the angular site reflecting the "English style" that was popular in Paris at this time. The garden also included hothouses and a kitchen garden. Jefferson was passionately interested in the transplantation of species and he grew American plants, including sweet corn, in his garden that he often distributed as diplomatic gifts.[7]

To entertain courtiers, bankers, and philosophers, Jefferson had to establish a Parisian lifestyle that would allow him to receive guests and execute official business.

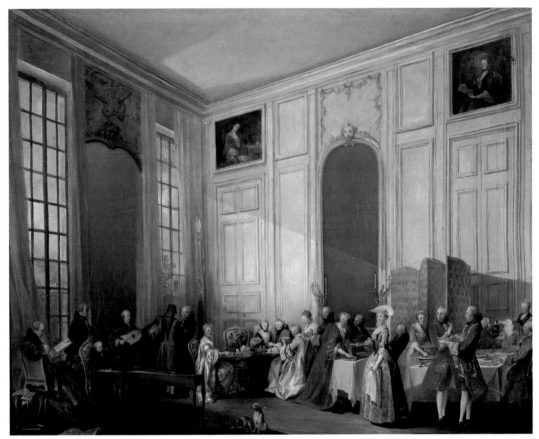

Figure 2: Michel-Barthélémy Ollivier (French, 1712–1784), *English Tea Served in the Salon des Quatre-Glaces at the Palais du Temple in Paris in 1764 (Mozart at the Clavichord)*, 1777, Oil on canvas, 21 x 26-3/4 inches (53 x 68 cm), Musée National du Château, Versailles, France
©Réunion des Musées Nationaux / Art Resources, NY

Jefferson, at his own cost, decorated his home with the luxury goods—furniture, wallpapers, silver, sculpture and paintings—that were considered appropriate to his position as minister to France, but also reflected his personal taste.[8] *English Tea Served in the Salon des Quatre-Glaces at the Palais du Temple in Paris in 1764 (Mozart at the Cavichord)*, 1777, a contemporary painting by Michel-Barthélémy Ollivier, evokes an elegant Louis XVI style interior similar in style to Jefferson's salons (fig. 2). He grew so fond of his French acquisitions that not only did he send eighty-six crates back to America, he later sent orders to the same boutiques when furnishing Monticello. The Hôtel de Langeac was a meeting place for Americans traveling to Paris, and Jefferson hosted numerous evenings where he introduced Americans to French friends sympathetic to America. At the end of his Paris sojourn, the Hôtel de Langeac was also a hotbed of political activity.

From the Hôtel de Langeac, Jefferson explored the city. Not far from Jefferson's home on the Right Bank was the Place Louis XV (the present-day Place de la Concorde, begun in 1757 and completed in 1774), the new square that rejuvenated urban planning by connecting the Faubourg Saint Germain and the Faubourg Saint Honoré

thus providing a breathtaking view of the Seine.[9] An engineering marvel was the Halle aux Bleds, or grain market, whose light-filled dome especially impressed foreign travelers to the city. Perhaps the most symbolic and controversial edifice, the Church of Sainte Genviève (the Pantheon), dedicated to the patron saint of the city, was completed in circa 1780 following the plans of Jacques-German Soufflot (1713-1780). Jefferson shopped at the Palais Royal, the Duc d'Orléans' enclave in the center of the Right Bank with its lined arcades and gardens. Opened to the public in 1784, the Palais Royal included a circus, concert halls, boutiques and cafés (fig. 3).[10] Jefferson recorded his reactions to all these monuments and desperately tried to convince his fellow citizens to imitate them on American soil.

Private entrepreneurs spurred the Paris real estate boom of the 1780s by buying large tracts of land to develop lavish *hôtel particulier* or town houses. One of the most spectacular was the Hôtel de Salm (**cat. no. 12**), built by Pierre Rousseau for the German Prince Frederick III de Salm-Kybourg from 1782 to 1787. The neoclassical façade and central dome captivated Jefferson and certainly inspired his plans for Monticello. The unsigned painting probably

Figure 3: Philibert Louis Debucourt (French, 1755–1832), after Jean François Bosio (French, active 18th–19th century), *The Gallery of the Palais Royal*, 1798, Aquatint, Musée Marmottan, Paris ©Musée Marmottan, Paris, France / Bridgeman Art Library

dates from 1784 and shows the edifice under construction thus capturing the frantic pace of the building trades in the 1780s. The building entranced Jefferson:

> *While at Paris I was violently smitten with the Hôtel de Salm, and used to go to the Thuileries [sic] almost daily to look at it. The Louseuse des chaises, inattentive to my passion never had the complaisance to place a chair there; so that, sitting on the parapet and twisting my neck round to see the object of my admiration, I generally left it with torticolis.*[11]

Jefferson's admiration for neoclassical architecture in Paris grew after his trip to the south of France where he saw the Maison Carrée, a first-century Roman temple, in Nîmes. The painter Hubert Robert, whom Jefferson admired, depicted the Maison Carrée in his drawing *Assembly of the Most Famous Monuments of France* (**cat. no. 14**), a fanciful recreation of Roman buildings located in southern France. He wrote to Madame Tessé: "I am immersed in antiquities from morning to night; Here I sit, gazing whole hours at the Maison Carrée, like a lover at his mistress." This architectural infatuation directly inspired Jefferson's plans for the Virginia State Capitol (**cat. no. 15**). Jefferson received a request from Virginia's legislative committee for the construction of a new building in Richmond, and

after having seen the Maison Carrée, Jefferson hired the French architect Charles Louis Clérisseau to submit a series of drawings of the temple as a model for the Virginia State Capitol.[13] It was a remarkable translation of the antique temple building type to American shores, and it inspired the neoclassical vocabulary of public architecture in the United States.

Jefferson as Diplomat

The first American diplomats—John Adams, Benjamin Franklin and Jefferson—were desperate for international recognition. The envoys worked together to present America as a good financial risk to encourage foreign governments to develop international trade networks. Jefferson described his diplomatic responsibilities:

> *My duties, at Paris were confined to a few objects; the receipt of our whale oils, salted fish, and salted meats, on favorable terms; the admission of our rice on equal terms with that of Piedmont, Egypt and the Levant; a mitigation of the monopolies of our tobacco by the Farmers-general, and a free admission of our productions into their islands were the principal commercial objects which required attention.*[14]

A young American, Thomas Shippen, followed Jefferson to Versailles and witnessed Jefferson's presentation at court. He described the event:

I observed that although Mr. Jefferson was the plainest man in the room, and the most destitute of ribbands, crosses and other insignia of rank, that he was the most courted and most attended to (even by the Courtiers themselves) of the whole Diplomatic corps.[15]

Jefferson modestly stated that no one could "replace" his predecessor, Dr. Franklin, and thanks to Franklin's network of friends and sympathizers, Jefferson was able to integrate himself smoothly into the French aristocracy.[16] During his years as the American in Paris (1779-85), Franklin invited such luminaries as de la Rochefoucauld, Condorcet, Buffon and Lavoisier into the American Philosophical Society. Franklin effectively used the society to cement Franco-American relations among scientists and intellectuals. Several weeks before the Treaty of Versailles was signed in Paris on September 3, 1783, marking the end of the American Revolution, Benjamin Franklin commissioned a French translation of the American constitutions. Franklin considered the translation useful for recognition of the new country by European courts so he turned to the Duke Alexandre de la Rochefoucauld d'Einville, who had served with Lafayette in America, for the translation. Franklin oversaw the printing of the *Constitutions des Treize Etats Unis de L'Amerique* (Constitutions of the Thirteen United States of America; **cat. no. 8**). He probably provided the model for the seal of the United States, which appears for the first time on the title page.

More than any other figure Marie Gilbert Motier, Marquis de Lafayette (1757-1834), facilitated Franco-American relations from the 1780s onwards.[17] Jefferson commissioned a portrait of Lafayette after his return to America (**cat. no. 5**). Jefferson wrote "I was powerfully aided by all the influence and the energies of the Marquis de Lafayette, who proved himself equally zealous for the friendship and welfare of both nations . . ."[18] Lafayette, like many young nobles of his generation, enlisted for military service in the American Revolution where he found himself fighting under General Washington.[19] Hubert Robert's commemorative painting *The Departure of Lafayette for America in 1777* (**cat. no. 7**) portrays Lafayette's early enthusiasm for the American War of Independence. Having inherited a fortune from his maternal grandfather (both his father and mother died before he was fifteen), Lafayette financed the ship *Victory* (*La Victoire*) to help the American "insurgents." Robert evokes the craggy shoreline of Spain since the ship sailed from a foreign port as France did not officially enter the war until 1778.[20] During his military service in America, Lafayette forged a number of friendships that in turn became

essential to Americans in France, where the Marquis generously welcomed those he considered his compatriots.

When Lafayette learned of Jefferson's ministerial appointment to Paris he wrote: "My house dear Sir, my family and anything that is mine are entirely at your disposal and I beg you will come and see Madame de Lafayette [Adrienne de Noailles] . . . her knowledge of the country may be of some use to Miss Jefferson. Indeed, my dear Sir, I would be very angry with you, if either you or she did not consider my house as a second home . . ."[21] In fact, Martha, better known as Patsy, had accompanied her father from the outset of his Parisian sojourn. Jefferson did avail himself of Lafayette's hospitality and frequented those artistic, literary and intellectual gatherings directed by *Salonnieres*, those remarkable eighteenth-century women who held weekly gatherings in their homes (salons) to encourage debates in science, art, and politics.[22] The Marquise de Lafayette introduced Jefferson to her aunt Madame de Tessé (1741-1814, born Adrienne Catherine de Noailles). Their correspondence reveals the many-shared interests between them: politics, fine arts, and gardening. Jefferson also established lasting friendships with the Duchesse d'Einville, mother of the Duc de la Rochefoucauld. The Comtesse d'Houdetot (1780-1813) was also sympathetic to the American cause. Perhaps best known today as the object of Jean-Jacques Rousseau's unrequited passion, Sophie de Houdetot was a close friend of Franklin, Jefferson and Saint John de Crévecoeur.

Jefferson's participation at these Parisian salons required that he engage in conversations on a wide variety of subjects that naturally included politics. In his *Autobiography* he details the unfolding of the French Revolution where he admits that he was "privy" to inside information:

Possessing the confidence and intimacy of the leading Patriots, and more than all of the Marquis de Lafayette, their head and Atlas, who had no secrets from me, I learned with correctness the views and proceedings of that party; while my intercourse with the diplomatic missionaries of Europe at Paris, all of them with the court, and in eager prying into its councils and proceedings, gave me a knowledge of these also.[23]

Jefferson firmly believed that the American Revolution awakened the spirit of the French Revolution. His account of Franco-American relationships prior to the outbreaks of 1789 reveals just how deeply he had integrated into French society:

Celebrated writers of France and England had already sketched good principles on the subject of government; yet the American Revolution seems first to have awakened the thinking part of the French nation in general, from the sleep of despotism in which they were sunk. The officers too, who had been to America, were mostly young men. They came

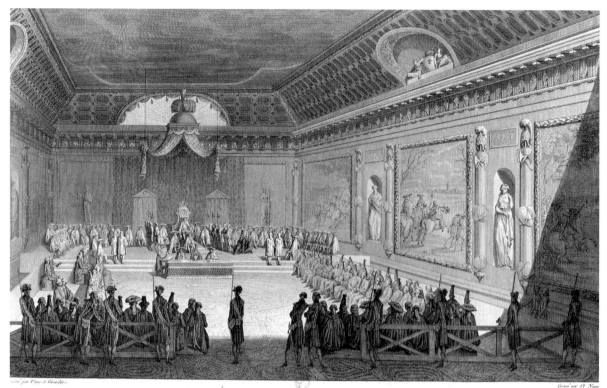

ASSEMBLÉE DES NOTABLES, TENUE A VERSAILLES,
Le 22 Fevrier 1787.

Figure 4: Niquet (French, 18th century), *Assembly of Notables, meeting at Versailles*, February 22, 1787, Engraving after Veux and Giradet, 12 x 16-3/4 inches (32 x 42.4 cm), Bibliothèque Nationale de France, Paris

back . . . [to France] with new ideas and impressions. The press notwithstanding its shackles, began to disseminate them, conversation assumed new freedoms; Politics became the theme of all societies, male and female, and a very extensive and zealous party was formed, . . . the Patriotic Party, who, sensible of the abusive government under which they lived, sighed for occasions of reforming it.[24]

Through his friendships with members of the Patriot party and his official contacts at court, Jefferson monitored the tides of public opinion, such as the speeches that occurred at the Assembly of Notables held at Versailles in 1787 (fig. 4).[25] The night of the storming of the Bastille, Jefferson found himself at the home of Ethis de Corny, who had served in the American Revolution and since then had become *Procurer du Roi et de la Ville*.[26] Houel's watercolor *Demolition of the Bastille* (**cat. no. 9**) shows the prison from the Rue de la Contre-Escarpe and the towers loom above the spectators in the foreground. Upon close inspection we see the beginning of the demolition of the crenellated towers, the spectacle that "Tout-Paris" had come to watch. As Corny was directly implicated in the events, Jefferson was able to have a firsthand account

of the early signs of public unrest. This event inspired Jefferson's support of limited violence to change the exisiting French political situation: "Surely under such a mass of misrule and oppression, a people might justly press for a thorough reformation, and might even dismount their rough-shod riders, and leave them to walk on their own legs."[27]

Jefferson's most profound—albeit behind the scenes—diplomatic mission occurred in the summer of 1789 at the Hôtel de Langeac. In July 1789 members of the committee of the Assembly of Notables, given the charge to create a constitution, asked Jefferson "to attend and assist" at their deliberations. As minister to the French court, Jefferson refused, but he continued to nurture the Patriots. It was not by chance that the Marquis de Lafayette, the hero of the American cause, proposed the *Declaration des Droits des Hommes* (**cat. no. 10**) to the National Assembly. It was composed with the advice and scrutiny of Jefferson who felt obliged to explain his activities himself to the French royal authorities: "But duties of exculpation were now incumbent on me; I waited on Count Montmorin . . . [the next morning], and explained to him, with truth and candor, how it had happened that my house had been

made the scene of conferences of such character."[28] In this way, Jefferson actively assured that "The appeal to the rights of man, which has been made in the United States, was taken up by France, first of the European nations."

In retrospect, Jefferson saw the events of the Revolution as a series of missed opportunities that inexorably led to bloody conflicts. His condemnation of Queen Marie Antoinette (*fig. 5*) reveals a contemporary prejudice against women in the public sphere, but he equally condemned a situation that allowed the future Napoleon Bonaparte to emerge:

I should have shut up the Queen in a Convent, putting harm out of her powers, and placed the King in his station, investing him with limited powers, which I verily believe, he would have honestly exercised, according to the measure of his understanding. In this way, no void would have been created courting the usurpation of a military adventurer, nor occasion given for those enormities which demoralized the nations of the world and destroyed, and is yet to destroy, millions and millions of its inhabitants.[29]

Perhaps Jefferson's greatest diplomatic regret was his inability to publicly persevere in the negotiations underway in the Assembly of Notables. Thirty years later he wrote of that particular historic moment (June 1789) with both sadness and anger at Napoleon Bonaparte:

For, after thirty years of war foreign and domestic, the loss of millions of livres, the prostration of private happiness, and the foreign subjugation of their own country for a time, they [The French] have obtained no more, [The Declaration of the Rights of Man] nor even that securely. They were unconscious of (for who could foresee?) the melancholy sequel of their well-meant perseverance: that their physical force would be usurped by a first tyrant to trample on independence, and even the existence, of other nations.[30]

In light of these reminisces, we can only begin to imagine Jefferson's trepidation when the occasion arose to negotiate the Louisiana Purchase.

Jefferson and the Republic of Letters

Jefferson's quick mind and natural curiosity were soon embroiled in the challenging intellectual debates of Salon society, well-known as the "Republic of Letters" where, under the auspices of such women as Sophie Houdetot and the Duchesse d'Einville, aristocrats and intellectuals discussed art, politics and natural philosophy. Although Jefferson circulated in a number of aristocratic salons, his entry into the Republic of Letters was marked by his engagement with the world renowned naturalist Georges

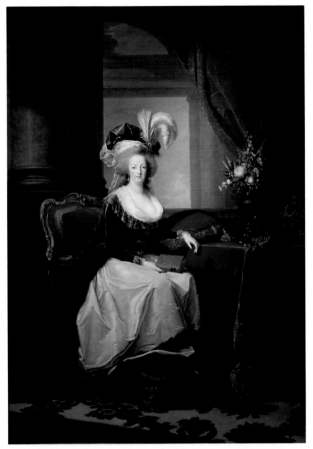

Figure 5: Elisabeth Louise Vigée-Lebrun (French, 1755–1842), *Portrait of Marie Antoinette, Queen of France*, circa 1788, Oil on canvas, 109 x 75 inches (278.1 x 191.8 cm), New Orleans Museum of Art, New Orleans, Louisiana. Women's Volunteer Committee and Carrie Heiderich Fund (85.90)

Louis Leclerc, Comte de Buffon (1707-1788). Jean Antoine Houdon's (1741-1828) portrait bust captures the scientist's vivacious personality and intellectual prowess (**cat. no. 20**). Jefferson's *Notes on the State of Virginia* (Paris 1782, 1784) was conceived as a rebuttal to Buffon, who, in his *Époques de l'Histoire Naturelle*, presented theories of America as a "degenerate place." *Notes on the State of Virginia* was perhaps his most important intellectual accomplishment during his Parisian sojourn (**cat. no. 21**).

In the fall of 1780, when Jefferson was the governor of Virginia, the French delegate to Philadelphia, Marquis François Barbé-Marbois, was sent to assess future commercial prospects and exchanges. Barbé-Marbois, who later became Bonaparte's treasurer and one of the signatories of the Louisiana Purchase, presented Jefferson with a series of questions. Jefferson's responses constituted the beginnings of the manuscript that would become *Notes on the State of Virginia*; however, his expert commentaries eulogized not only Virginia, but also displayed the benefits of life in America. Jefferson reworked the manuscript

from 1782 to 1783 in America, but he prepared it for publication in France.[31] Abbé Morellet undertook its translation into French in 1786 giving Jefferson the diplomat an opportunity to become an active member of the Republic of Letters.

Jefferson intended that his book would challenge the traditional view of America propagated by European natural scientists such as DePauw, Raynal, and Buffon, who argued that the climate in America caused all forms of life, animals or men, indigenous or transplanted, to degenerate.[32] Jefferson dedicated his book to setting the record straight—revising the image of America through scientific means. Jefferson, as America's representative in France, clearly believed that it was one of his duties to prove Buffon's theories wrong:

So far the Count de Buffon has carried his theory of the tendency of nature to belittle her productions on this side of the Atlantic. Its application to the race of whites transplanted from Europe remained for the Abbé Raynal: 'One must be astonished [he says] that America has not yet produced a good poet, an able mathematician, a man of genius in a single art or a single science.' When we shall have existed as a people as long as the Greeks did before they produced a Homer, the Romans a Virgil, the French a Racine and Voltaire, the English a Shakespeare and Milton, should this reproach be still true, we will inquire from what unfriendly causes it has proceeded, that the other countries of Europe and quarters of the earth shall not have inscribed any name in the roll of poets . . . We therefore suppose that this reproach is as unjust as it is unkind: and that, of the geniuses which adorn the present age, American contributes its fair share.[33]

To emphasize his point, after the publication of *Notes*, he presented a skeleton of an American moose or palmate elk, which stood one-third taller than the European elk, as a gift to the Jardin des Plantes (Royal Botanical Garden).[34] Jefferson's exchange exemplifies the clash of two world views: French scholars' perceptions of America were often based on supposition rather than fact while Americans in France believed they should supply a credible, factual vision of the New World. Consequently, *Notes on the State of Virginia* was not only important for American diplomacy but also for the advancement of knowledge.

Jefferson: Collector and Patron

The most important artistic event in eighteenth-century Paris was the Salon, where members of the Royal Academy of Painting and Sculpture exhibited their paintings, drawings, sculptures, and engravings to the public in the Salon Carrée of the Louvre.[35] During Jefferson's sojourn in Paris there were three Salons, in 1785, in 1787,

Figure 6: Thomas Jefferson, *Letter of introduction on behalf of sculptor Jean-Antoine Houdon, in regards to a portrait of George Washington*, July 12, 1785, Page one, recto, Musée de la Coopération Franco-Américaine, Chateâu de Blérancourt, France
©Réunion des Musées Nationaux / Art Resources, NY

and the last in 1789, where upwards of 350 works were packed from ceiling to floor (**cat. no. 17**). Jefferson might have seen all three, but we only have proof of his visit to the Salon of 1787 as he wrote to the American painter John Trumbull, then in London, on August 30, 1787, "The Salon has been open four or five days . . . upon the whole it is well worth your coming to see . . . the whole will be an affair of 12 or 14 days . . . and it happens but once in two years, you should not miss it." Jefferson commented on the paintings by Jacques-Louis David, the extraordinary young painter who was carving a name for himself as leader of the neoclassical movement (**cat. no. 18**). His attraction for "the pencil of David" reflects his appreciation of the great painter's ability to merge the roles of citizen and patriot. At the same Salon, Jean Germain Drouais's *Marius at the Minturnae* (for a study see **cat. no. 19**) impressed him where he described the painting: "All Paris is running to see it, and really it appears to me to have extraordinary merit; It fixed me like a statue a quarter of an hour, or half an hour, I do not know which, for I lost all ideas of time, even the consciousness of my existence."[36] Jefferson's aesthetic transport that he experienced in front of both paintings and architecture—the Hôtel de Salm, the Maison Carrée and works by David and his followers—suggests that he had developed a highly tuned aesthetic spirit during his Paris years.

Two persons mentored Jefferson's artistic education in the summer of 1786: the painters John Trumbull and Maria Cosway. Trumbull (1756-1843) had been studying

under the expatriot American painter Benjamin West
(1738-1820) in London when Jefferson convinced him
to come to Paris and offered him lodgings at the Hôtel
de Langeac. During Trumbull's visit, Jefferson encouraged
him to enlarge his series of paintings commemorating
the battles of the American Revolution to include the
creation of contemporary history paintings. This resulted
in Trumbull's masterpiece *The Signing of the Declaration of
Independence* (**cat. no. 1**) where Jefferson clearly supplied
the painter with important eyewitness details.

Trumbull introduced Jefferson to Maria Cecilia
Hadfield Cosway (English, 1759-1838), and the twenty-
seven-year-old Maria Cosway enchanted Jefferson (**cat.
no. 16**). From that moment on, until her departure two
months later, Trumbull, Jefferson and Cosway discovered
the artistic sites in Paris and the suburbs. It was while
visiting the garden called the Dessert de Retz with Mrs.
Cosway that Jefferson dislocated his wrist, prompting one
of history's most celebrated love letters, Jefferson's battle
between his "head and heart."[37]

Jefferson's apprenticeship in the visual arts under
Trumbull and Cosway seems to have enhanced his inter-
est in the public patronage of the arts. As early as Novem-
ber 1784 Jefferson received a letter from Governor
Benjamin Harrison regarding the Virginia Legislature's
desire to create a statue of General Washington. On July
12, 1785, he replied that he had engaged Monsieur
Houdon, the foremost portrait sculptor in Europe, and
underwrote his trip to America so he could meet
Washington (*fig. 6*), thus Houdon was the first European
artist of intenational sature to visit the new American
Republic. Partially as a result of Jefferson's patronage,
Houdon, who executed portrait busts of Franklin (1778),
Washington (1785), and later Jefferson (1789) (**cat. no.
159**), became the French artist to create the effigies of
three of America's founding fathers, which are now
ensconced as American icons.[38]

French Visions
of America

Historian Robert Darnton has demonstrated that from
1780 to 1789 America appeared almost daily as a subject
in the popular culture of Paris.[39] Plays, such as *Le Héro
americaine*, were performed at vaudeville theaters on the
Grands Boulevards. Engravings of famous personalities
such as Washington and Franklin or prints of American
types, such as the Virginia planter, the Pennsylvania
Quaker, or the Nantucket whaler could be purchased on
the rue Saint Jacques. Books about America were equally
popular and reviewed in *Le Journal de Paris*, including
Jefferson's *Remarques sur la Virginie* (*Notes on the State of
Virginia*) and Hector Saint Jean de Crèvecoeur's *Lettres
d'un cultivateur américaine*, French edition, 1784 (*Letters

from an American Farmer, London edition 1782). Crévecoeur
left to seek his fortune in America at the age of nineteen,
built two farms in the woods, married an American
woman, returning eventually to France, where he became
the favorite in the salon of Madame de Houdetot, and
Louis XVI's official counsel to America in 1783.

More polemical issues were debated in the press, such
as Thomas Paine's rebuttal to the Abbé Raynal's best sell-
er *Histoire philosophique et politique des établissements et du
commerce des Européens dans les deux Indes* (*Philosophical
and Political history of the European trade with the Two
Indias*), which echoed Jefferson's desire to debunk the
myth of degeneracy. Jefferson, like Franklin before him
realized that America was a screen onto which French
authors could project their own agendas for political
reform in France.

Allegories of the continents were depicted as female
figures. America was often shown as a woman crowned
with feathers, adorned with pearls, and carrying a bow
and arrow, standing on or next to an alligator, the animal
considered the emblem of the continent.[40] The anonymous
early nineteenth-century painting *Allegory of America*
(**cat. no. 22**) conflated this allegorical tradition with that
of the classical goddess Diana, sacred to the hunt. Converg-
ing classical and exotic, this allegory typifies pre-eighteenth-
century visions of America as the exotic "other" whose
riches could be appropriated by France.

In 1784 the Royal Academy at Toulouse, a regional
academy modeled on the Royal Academy of Painting
and Sculpture in Paris, proposed as a subject for young
painters the theme of France liberating America. Jean Suau
(1758-1856) won the first prize with his painting entitled
Allegory of France Liberating America, 1784 (**cat. no. 4**).
Suau depicts an allegory of France surrounded by Victory,
Peace, Commerce and Abundance. France extends her
hand to present Liberty to America, who moves forward
to receive her. America is identified by an Indian feathered
headress. By placing France in the center Suau has effec-
tively negated the earlier iconographic tradition so that
the monarchy, and the entire notion of "civilization"
imposes herself not only on the insurgent colonists but
also on the Native Americans.

Perhaps the most significant image of America for
Europeans in the second half of the eighteenth century
was that of the Noble Savage. Lafayette had in fact
brought two Indians back to France to serve as houseboys,
providing curious Parisians with an opportunity to see
what they called "savages" in the flesh. Since 1750 Jean-
Jacques Rousseau's published tracts popularized the fasci-
nation for the primitive and the noble savage. Americans
were thought of as "primitive," taking to the woods to
escape civilization and live close to nature, often with
the Indians. Inspired by Crèvecoeur in his *Letters from
an American Farmer* are two scenes by Antoine Borel
(*figs. 7 and 8*) that show the ideal Noble Savage: a wise

L'ENFANT PERDU.

Figure 7: Antoine Borel (French, active late 18th century), after J. Hector St. John de Crèvacoeur, *The Lost Child*, 1784, Ink, graphite and pen on paper, 14-1/4 x 11 inches (36.3 x 28.3 cm), Musée de la Coopération Franco-Américaine, Château de Blérancourt, France
©Réunion des Musées Nationaux / Art Resources, NY

L'ENFANT RETROUVÉ.

Figure 8: Antoine Borel (French, active late 18th century), after J. Hector St. John de Crèvacoeur, *The Found Child*, 1784, Ink, graphite and pen on paper, 14-1/4 x 11 inches (36.3 x 28.3 cm), Musée de la Coopération Franco-Américaine, Château de Blérancourt, France
©Réunion des Musées Nationaux / Art Resources, NY

and generous Indian who helps a family of European settlers find their lost child. Some of these idealized images collapsed when Europeans who actually traveled to America following the revolutionary decade encountered a different reality.

As Jefferson recounted, young Frenchmen traveling to America who served in the War of Independence mingled with American society and brought what they had learned back to France. After the ebullience of the American revolutionary period, however, the next waves of French aristocratic visitors were forced to leave France as émigrés fleeing from the aftermath of the French Revolution. Felix Marie Ferdinand Storelli's meticulous, topographical *Souvenir of Tokouo*, after the original drawing by Antoine-Philippe d'Orléans, Duc de Montpensier (1775-1807) shows a more reflective and almost quasi-ethnographic attitude towards Native Americans (**cat. no. 23**).[41] Antoine-Philippe d'Orléans, son of Louis Philippe-Joseph, Duc d'Orléans better known as Philippe d'Egalité, fled with his older brothers, including the future King Louis-Philippe, on a voluntary exile to the United States in 1796. The next year the Orléans brothers visited George Washington at Mount Vernon and embarked on an extensive tour of America during which he sketched this Cherokee village in southeastern Tennessee named Toqua (in French, *Tokouo*). His image of the village with its horizontal dwellings and hothouses (windowless tents in the middle ground) is one of the earliest representations known of Native American villages.

François René de Chateaubriand (1768–1848), novelist and politician, inspired by his five-month voyage to America in 1791, described another America for the post-revolutionary French audience. Chateaubriand confirmed Rousseau's ideals of a Noble Savage, but his descriptions of the American wilderness, based on firsthand experience, sparked the emerging romantic sensibility that sought inspiration in "natural" land-scapes. Chateaubriand's *Atala*, published in 1801, went through five editions in one year and was the best seller of the period.

Atala has a complex plot. Subtitled "the loves of two savages in the wilderness," Chateaubriand's novel recounts the story of Chactas, a Natchez Indian who has been educated by a Spanish settler named Lopez. He returns to his tribe only to be captured by the Muscogulges where he is condemned to be burned alive, but Atala, a half-Indian girl, the daughter of Lopez, rescues him at the last minute. They escape together into the wilds of Florida—a topos rather than a specific place—where she falls in love with Chactas. Arriving at a mission,

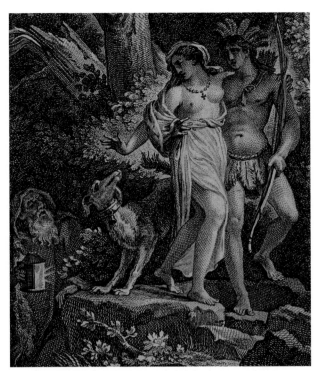

Figure 9: Etienne Garnier (French, active 18th–19th century), *"I have looked for you for a very long time,"* Engraving for Chateaubriand's *Atala*, page 104, Musée de la Coopération Franco-Américaine, Château de Blérancourt, France
©Réunion des Musées Nationaux / Art Resources, NY

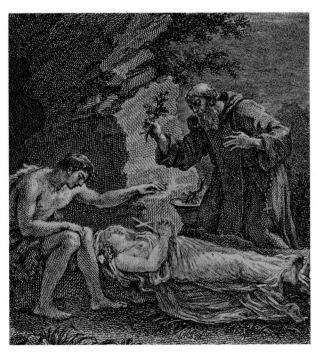

Figure 10: Etienne Garnier (French, active 18th–19th century), *"The pale flame of the moon illuminated this night vigil,"* Engraving for Chateaubriand's *Atala*, page 193, Musée de la Coopération Franco-Américaine, Château de Blérancourt, France
©Réunion des Musées Nationaux / Art Resources, NY

Atala reveals that she has sworn an oath of virginity to her dying mother and to remain true to her oath, rather than submit to her passion for Chactas, she commits suicide (*fig. 9*).

This Christian novel, set in America, appealed to the post-revolutionary audience who longed to be reconciled with the church. Following the Concordat proclaimed by Napoleon on April 15, 1802, that allowed for a restoration of the Catholic church, a Catholic revival flourished in France. *Atala* provided painters with a rejuvenated Catholic theme that was both Americanized and exotic appealing to the romantics throughout the nineteenth century. In this context, perhaps it is not surprising that the most celebrated visual representation of the novel, Anne-Louis Girdodet-Trioson's *The Funeral of Atala* (**cat. no. 24**) captures the Christian rite of burial. Following Girodet's model, Chactas, the Native American, becomes the prototype of the romantic hero whose passion can never be consummated.

The historiography of Thomas Jefferson's Paris years is complex and many issues that erupted during this period—slavery, piracy, freedom of the press—to mention but a few, are beyond the scope of our essay. The international events following his return to America in 1789 until the signing of the Louisiana Purchase encompass another phase of both American and French history, yet, it is fascinating to return again to Jefferson's *Autobiography* where his assessment of historical events reveal the power of his enlightenment vision:

> *There are three epochs in history, signalized by the total extinction of national morality. The first was of the successors of Alexander, not omitting himself. The next; successors of the first Caesar: The third, our own age; this was begun by the partition of Poland, followed by the treaty of Pilnitz; next the conflagration of Copenhagen; then the enormities of Bonaparte, partitioning the earth at his will, and devastating with it fire and sword . . .*[42]

Notes:

1. *The Autobiography of Thomas Jefferson* in *The Life and Selected Writings of Thomas Jefferson*, ed. A. Koch and W. Peden (New York: The Modern Library, 1998), 101. Hereafter cited as *Autobiography*.
2. Dena Goodman, *The Republic of Letters: A Cultural History of the French Enlightenment* (Ithaca: Cornell Univeristy Press, 1994).
3. Durand Echeverria, *Mirage in the West: A History of the French Image of American Society to 1815* (Princeton, N.J.: Princeton University Press, 1957) still provides the most comprehensive and insightful overview of the subject.
4. Susan R. Stein, *The Worlds of Thomas Jefferson at Monticello* (New York: Harry N. Abrams, Inc., 1993), 19-38.
5. In his directions to Benjamin Latrobe for the capital building in Washington, Jefferson specifically recalled the Dome of the Halle aux Bleds. When plans were under discussion for the president's house, Jefferson wrote to Washington that he preferred the models of "the celebrated fronts of modern buildings which have already received the approbation of all good judges. Such are the Galerie du Louvre, the Gardes Meubles, and two fronts of the Hôtel de

Salm." Also see William Howard Adams, ed., *The Eye of Thomas Jefferson* (Washington, D.C.: National Gallery of Art, 1976), 118.

6. His first residence was the on the rue Taitbout from October 1784 until October 1785; see Howard C. Rice, *Thomas Jefferson's Paris* (Princeton, N.J.: Princeton University Press, 1976), 37-43. On the Hôtel de Langeac, see Howard C. Rice, *L'Hotel de Langeac: Jefferson's Paris Residence 1785-1789* (Paris; Monticello: Thomas Jefferson Memorial Foundation, 1947); and *idem*, 1976, 51-54. The Hôtel de Langeac was destroyed in 1842.

7. Thomas Jefferson, *Letter to Nicholas Lewis*, Paris, September 17, 1787, "I cultivate in my own garden here Indian corn for use at my own table, to eat green in our manner; But the species I am able to get here for seed, is hard, with a thick skin and dry; I had at Monticello a species of small white rare ripe corn which we called homony-corn. . . . Great George will know well what kind I mean; I wish it were possible for me to receive an ear of this in time for the next year." *The Papers of Thomas Jefferson*, ed. Julian P. Boyd (Princeton, N.J.: Princeton University Press, 1971), 1950-present. Although the topic of Jefferson's interest in gardens is vast, an idea of his passion for plants and the plant trade while in France can be found in Thomas Jefferson's *Garden Book*, ed. Edwin Morris Betts (Philadelphia: The American Philosophical Soceity, 1947), for the years 1786-1790.

8. Jefferson's memorandum books meticulously record his expenses— in his first year in Paris he had spent one-quarter of his salary on household linens, curtains, and upholstery alone. William Howard Adams, *The Paris Years of Thomas Jefferson* (New Haven, Conn.: Yale University Press, 1997), 48.

9. On Jefferson's visits to the Place Louis XV, see Rice, 1976, 25-27.

10. On Jefferson's visits to the Palais Royal, see Rice, 1976, 13-18.

11. Adams, *Eye of Jefferson*, 125

12. George Green Shackleford, *Thomas Jefferson's Travels in Europe, 1784-1789* (Baltimore and London: John Hopkins University Press, 1995), 103-08.

13. Adams, *Paris Years*, 12-13, 89, Shackleford, ibid. and Thomas J. McCormick, *Charles-Louis Clérisseau and the Genesis of Neo-Classicism* (New York and Cambridge, Mass.: Architectural History Foundation and MIT Press, 1990), 191-200.

14. *Autobiography*, 63

15. Thomas Shippen, Letter to his Father, quoted from Boyd, vol. 12, 504. I would like to thank Susan Stein and Elizabeth Chew for bringing this quotation to my attention.

16. See Rice, 1976, 51. Jefferson wrote some biographical "anecdotes" about Franklin on the bequest of Robert Walsh a letter dated December 4, 1818. "When Doctor Franklin went to France, on his revolutionary mission, his eminence as a philosopher, his venerable appearance, and the cause on which he was sent, rendered him extremely popular. For all ranks and conditions of men there, entered warmly into the American interest." *Autobiography*, 167.

17. On Lafayette see Patrice Geuniffey, "Lafayette" in François Furet and Mona Ozouf, eds. *A Critical Dictionary of the French Revolution* (Cambridge: Harvard University Press, 1989), 224-33, and Simon Schama, *Citizens* (New York: Knopf, 1989).

18. *Autobiography*, 63.

19. Schama, 26; Adams, *The Paris Years*, 12-13.

20. Lafayette's defiance of the king was pardoned upon his return to France where he was able to cultivate his reputation as a patriotic citizen hero, Schama, 28-29.

21. Quoted from Rice, 1976, 62.

22. On the importance of the Salon in eighteenth-century Paris, see Dena Goodman, *The Republic of Letters*, cited in note 2.

23. *Autobiography*, 100.

24. Ibid., 67.

25. Ibid., 87, "The objects for which this body was convened being of the first order of importance, I felt it very interesting to understand the views of the parties of which it was composed, and especially the ideas prevalent as to the organization contemplated for their government. I went therefore daily from Paris to Versailles, and attended their debates generally until the hour of adjournment."

26. *Autobiography*, 93-95.

27. Ibid., 82.

28. Ibid., 99.

29. Ibid., 96.

30. Ibid., 89.

31. Rice, 1976, 79-80.

32. Echeverria, op. cit.

33. *Notes on the State of Virginia*, republished in Koch and Peden, *Selected Writings*, 200-01.

34. Stein, 64.

35. On history of the Salon see Thomas Crow, *Painters and Public Life in Eighteenth Century Paris* (New Haven, Conn.: Yale University Press, 1985).

36. Quoted from Stein, 31.

37. Thomas Jefferson, Letter to Maria Cosway, Paris, October 12, 1786, reprinted in Koch and Peden, *Selected Writings*, 367-77.

38. On Houdon, see H. H. Arnason, *The Sculptures of Houdon* (New York: Oxford University Press, 1975). Jefferson brought plasters of Houdon's portraits of Benjamin Franklin, John Paul Jones, the Marquis de Lafayette, George Washington, Turgot, Voltaire and several of himself for Monticello. See Stein, 215-31; Rice, 1976, 55-59.

39. Robert Darnton, "Condorcet and the Craze for America in France" in Franklin and Condorcet, *American Philosophical Society* (Philadelphia: American Philosophical Soceity, 1997), 27-39. For the following paragraphs I am following Darnton's essay.

40. See H. Honour, *L'Amerique vue par l'Europe* (Paris: Grand Palais, Washington, D.C.: National Gallery of Art, 1976).

41. Robert Wilson Torchia, "Storelli" in *American Paintings* (Philadelphia: Schwarz Gallery, 2001), 8-11.

42. *Autobiography*, p. 96.

I would like to thank Victoria Cooke, Gail Feigenbaum, Catherine Healey, Peter Onuf and Susan Stein for their generous comments on this essay.

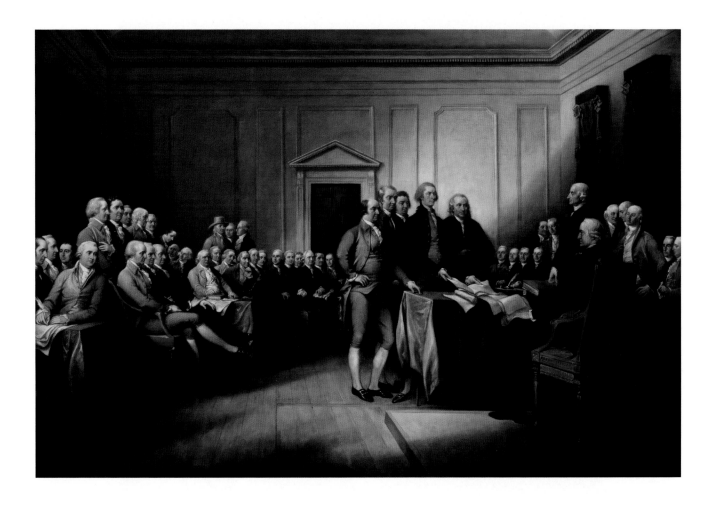

1.

John Trumbull (American, 1756–1843)
The Signing of the Declaration of Independence

Oil on canvas
72 x 108-3/4 inches (184.2 x 175.8 cm)
The Wadsworth Atheneum Museum of Art,
Hartford, Connecticut. Purchaed by Daniel
Wadsworth and Members of the Atheneum
Committee (1844.3)

This is Trumbull's third and final version of a renowned historic subject that
occupied him—and the nation—for five decades. Painted in New York City, it
was part of a grand ensemble of American Revolutionary subjects that included
The Capture of the Hessians at Trenton (1831), *The Death of General Mercer at the
Battle of Princeton* (1831), *The Death of General Warren at the Battle of Bunker's
Hill* (1834), and *The Death of General Montgomery in the Attack on Quebec* (1834).
The set was exhibited at the American Academy in New York in 1835. Trumbull
first painted the subject in London in 1787 (now in the Yale University Art
Gallery) and again in New York City in 1818 (now in the Rotunda of the
United States Capitol). The original idea for painting the subject arose in 1786
during conversations in Paris with Jefferson.

The picture shows the events of June 28, 1776, when Jefferson submitted his
draft of the Declaration of Independence to John Hancock, president of the
Continental Congress, for consideration by the whole legislative body. Standing
next to Jefferson are the other members of the drafting committee, from left to
right: John Adams, Roger Sherman, Robert Livingston, and Benjamin Franklin.
Behind them are other congressmen sitting and standing in Independence Hall.
Unlike the battle pictures that dominate Trumbull's three revolutionary series,
the *Declaration* celebrates the philosophical and moral courage of the Founding
Fathers and emphasizes the power of the pen to effect revolutionary change. **P.S.**

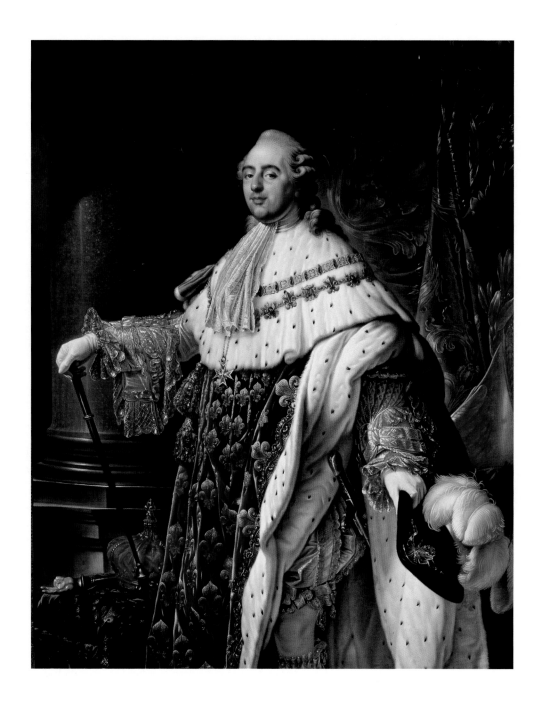

2.

Antoine François Callet (French, 1741–1823)
Portrait of Louis XVI, King of France, circa 1782–83

Oil on canvas
64 x 51 inches (162.56 x 130.81 cm)
New Orleans Museum of Art, New Orleans, Louisiana.
Museum Purchase: Women's Volunteer Committee Fund
in honor of the 75th Anniversary (86.90)

As minister to France, Jefferson was the American emissary to the court of Louis XVI (1754-1793) during the last years of his reign. In this official portrait, the king is surrounded by the symbols of royalty. He wears coronation robes decorated with the fleur-de-lis and on the stool beside him are the crown and scepter. Note the ermine trim, a luxurious material favored by royalty, which Napoleon would emulate in his own coronation robes. Beneath his robes, at his side, is the sword of state. Callet, an influential member of the Royal Academy and the official portrait painter to Louis XVI, celebrates the opulence and self-indulgence of court life that fueled the fires of revolutionary discontent in France. **V.C.**

3.

Nicolas Gatteaux (French, 1751–1832)
Profile Portrait of Marie Antoinette, 1779
Signed and dated lower right: *GATTEAUX 1779*

Plaster with blue-tinted background
Diameter: 11-1/2 inches (29.21 cm)
New Orleans Museum of Art, New Orleans, Louisiana.
Museum Purchase: George S. Frierson, Jr. Fund (2002.295)

Nicolas Gatteaux, the medallist to the King who developed a machine for copying and reducing works of art, produced many portraits of Louis XVI (1754-1793) and Marie Antoinette (1755-1793). Here, in simple plaster on a dramatic blue ground à la Wedgwood, Gatteaux captured the queen in profile, a popular, informal mode of portraiture popular in the mid to late eighteenth century. **V.C.**

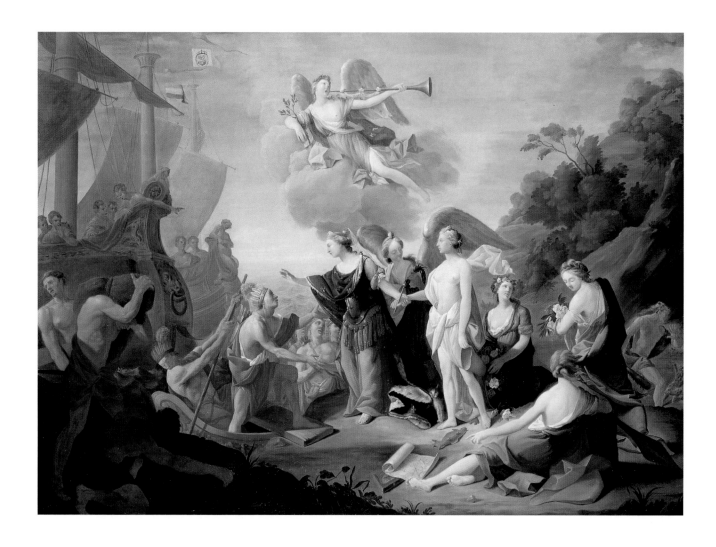

4.

Jean Suau (French, 1758–1856)
Allegory of France Liberating America, 1784

Oil on canvas
53 x 73 inches (135 x 186 cm)
Musée de la Coopération Franco-Américaine,
Château de Blérancourt, France (MNB 93.8)
©Réunion des Musées Nationaux / Art
Resources, NY

In 1784 the Toulouse Academy of Fine Arts assigned this theme to the academicians, and Suau's painting earned first place. Here, an allegorical figure of France presents Liberty who extends her right hand towards the figure of America, who wears an Indian headdress. France is surrounded at the right by Victory, Peace, Commerce and Abundance. Fame rises above the scene. By placing France in the center, Suau suggests that the monarchy, and the entire notion of "civilization," imposes herself not only on the insurgent colonists but also on the Native Americans. **S.T-L.**

5.

Joseph Boze (French, 1745–1826)
Marquis de Lafayette, 1790

Oil on canvas
36-1/4 x 28 inches (92.1 x 72.4 cm)
Massachusetts Historical Society, Boston, Massachusetts

6.

Unidentified Artist, French School
Sabre of Lafayette with Scabbard

Steel and gilded steel
40 inches with Scabbard (101.6 cm)
Musée de l'Armée, Paris (cc286 (2))

Joseph Boze depicted Lafayette in the military uniform of the Parisian National Guard wearing the medals of the Society of Cincinnati, the *Vainquers* of the Bastille and the Cross of Saint Nicolas. Jefferson commissioned this portrait in 1790 and it hung in the top tier of the parlor at Monticello. **S.T-L.**

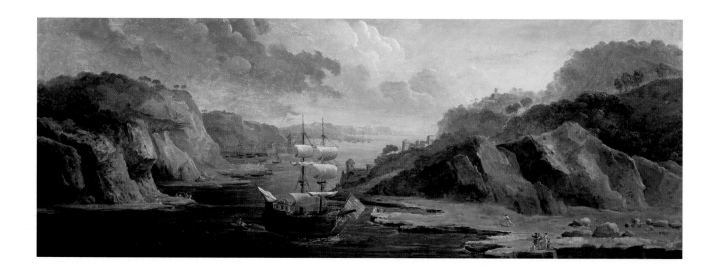

7.

Hubert Robert (French, 1733–1808)
The Departure of Lafayette for America in 1777, 1800

Oil on canvas
25 x 68 inches (63 x 173 cm)
Musée de la Coopération Franco-Américaine,
Château de Blérancourt, France (MNB 91-1)
©Réunion des Musées Nationaux / Art Resources, NY

Originally intended as an overdoor for Lafayette's Parisian town house, Hubert Robert's commemorative painting portrays the departure of the *Victory* (*La Victoire*), the ship that Lafayette had outfitted at his own expense since France did not officially enter into the war until 1778. The ship sailed from Spain, as the French officers did not have permission to leave France, arriving in South Carolina in June 1777. Robert's painting imaginatively evokes the rugged Spanish coast. **S.T-L.**

8.

Constitutions des Treize États-Unis de l'Amérique
(*Constitutions of the Thirteen Colonies of the United States of America*), 1873

Red morocco gilt binding with the arms of Queen Marie Antoinette
10-1/4 x 8 inches (26 x 20.5 x 5 cm)
Bibliothèque Nationale de France, Paris (res. 4 (to) Pb746 1783)

Several weeks before the Treaty of Versailles was signed in Paris on September 3, 1783, marking the end of the American Revolution, Benjamin Franklin commissioned a French translation of the various constitutions of the thirteen colonies. Franklin turned to the duc Alexandre de la Rochefoucauld d'Einville, a member of the Marquis de Lafayette's circle who was sympathetic to the American cause, for the translation. Franklin probably oversaw the printing as he provided the model for the eagle seal of the United States depicted for the first time on the title page Franklin considered the translation useful for recognition of the new country by European courts. Surprisingly, this copy belonged to the Queen of France, whose coat of arms appears on the binding. **S.T-L.**

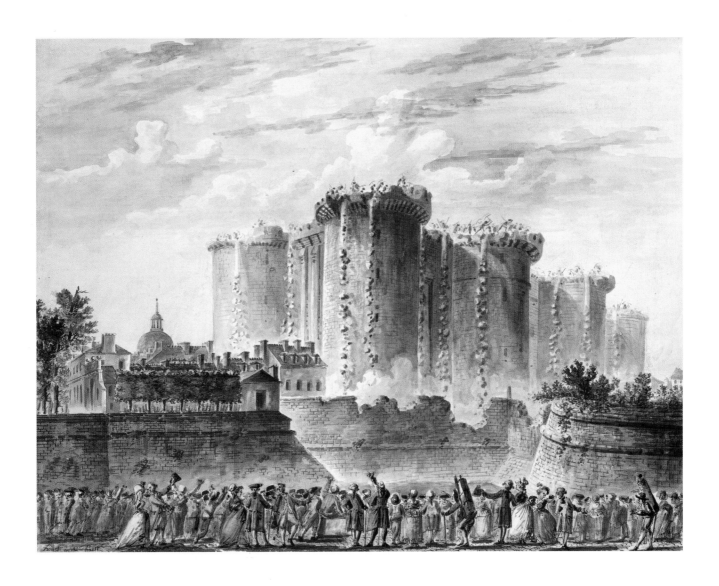

9.

Jean-Pierre Houel (French, 1735–1813)
The Demolition of the Bastille, circa 1789
Signed in lower left: *Houel archi: pixxit*

Watercolor on paper
14-3/4 x 19 inches (37.8 x 49.5 cm)
Musée Carnavalet – Histoire de Paris, Paris (D6009)
©PMVP / Toumazet / Ladet

Houel was an eyewitness to the demolition of the Bastille, which occurred shortly after the storming of the prison on July 14, 1789. His on-the-spot watercolor captures the excitement of the crowd in the foreground as the citizens destroy the crenelated towers that dated from 1328. This act of public violence occurred just before Jefferson's return to America, and portended the bloody Revolution to follow. **S.T-L.**

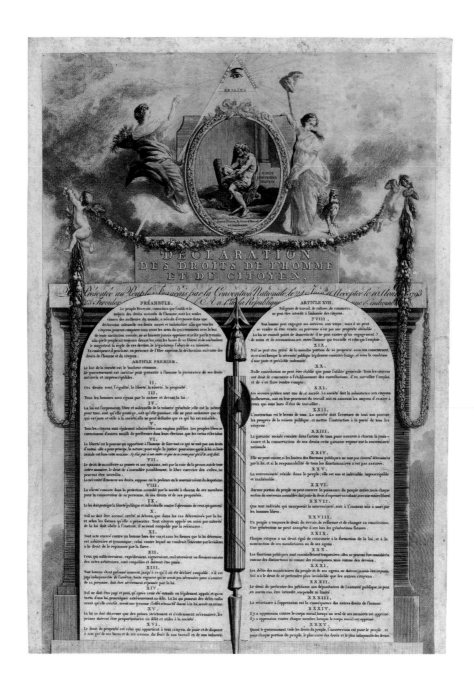

10.

Marie Gilbert Motier, Marquis de Lafayette (French, 1757–1834)
Declaration des Droits des Hommes (Declaration of the Rights of Man), 1793

Color engraving by Queverdo
17 x 12 inches (42.5 x 30.8 cm)
Musée de la Coopération Franco-Américaine,
Château de Blérancourt, France (66 B 2)
©Réunion des Musées Nationaux / Art Resources, NY

The Marquis de Lafayette, the French hero of the American Revolution, proposed the *Declaration des Droits des Hommes* to the National Assembly in Paris. Lafayette's text was composed with the advice of Jefferson and inspired by the American Bill of Rights. **S.T-L.**

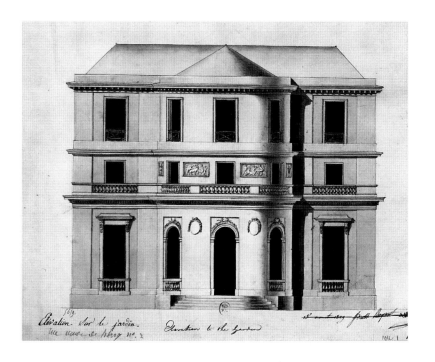

11a.

Unidentified Artist, French School
Hôtel de Langeac, elevation toward the Champs-Elysée, 1780

Ink on paper
13-1/4 x 10-7/8 inches (33.7 x 27.5 cm)
Bibliothèque Nationale de France, Paris
(Va280 folio, t.2 H63 288)

11b.

Unidentified Artist, French School
Hôtel de Langeac, plan in 1817 with gardens, 1780 with later additions

Ink on paper
27-1/2 x 21-3/4 inches (70 x 55 cm)
Bibliothèque Nationale de France, Paris (Va280 folio, t.2 H63 286)

The Hôtel de Langeac, Jefferson's rented residence in Paris, was a town house built for the Marquise de Langeac by the celebrated neoclassical architect Jean Françoise-Thérèse Chalgrin (1739–1811). The two-story building had a neoclassical façade so it appeared like a suburban villa. Jefferson took on extensive renovations to the property. The site was characterized by sharp angles as the urban lot was at the intersection of the Champs-Elysée and Rue Berri. The site plan shows the importance Jefferson attached to his garden. The paths cut through the space in a circular manner. This emphasis on a circuit walk was popular in gardens in the last two decades of the eighteenth century. Jefferson imported American plant specimens to grow in his Paris garden, including native corn. **S.T-L.**

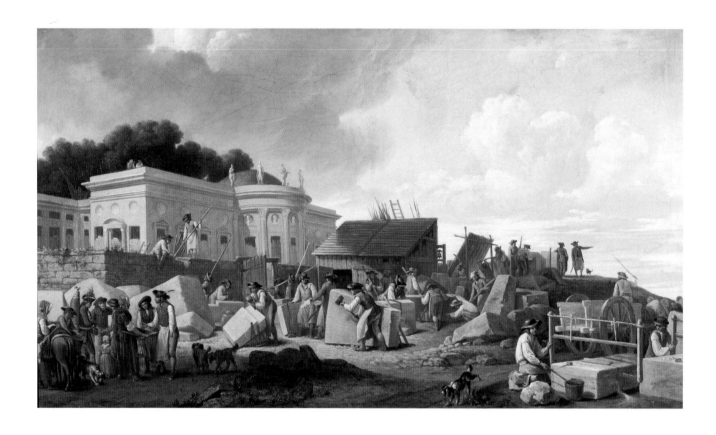

12.

Unidentified Artist, French School
Construction of the Hôtel de Salm, circa 1786
Signed at the bottom right on a rock: *Faldot* or *Jaldot*

Oil on canvas
22-1/4 x 39-3/4 inches (56.5 x 101 cm)
Musée Carnavalet – Histoire de Paris, Paris (P692)
©PMVP / Toumazet

Pierre Rousseau built this mansion for the German Prince Frederick III de Salm-Kybourg from 1782 to 1787. Jefferson wrote memorably of sitting in the Tuileries gardens on the opposite bank of the Seine and craning his neck to watch the construction of this exceptionally fine and sumptuous example of private architecture. Its neoclassical façade and central dome captivated Jefferson and certainly inspired his plans for Monticello. The unsigned painting probably dates from 1786 and shows the edifice under construction thus capturing the frantic pace of the building trades in the 1780s. **S.T-L.**

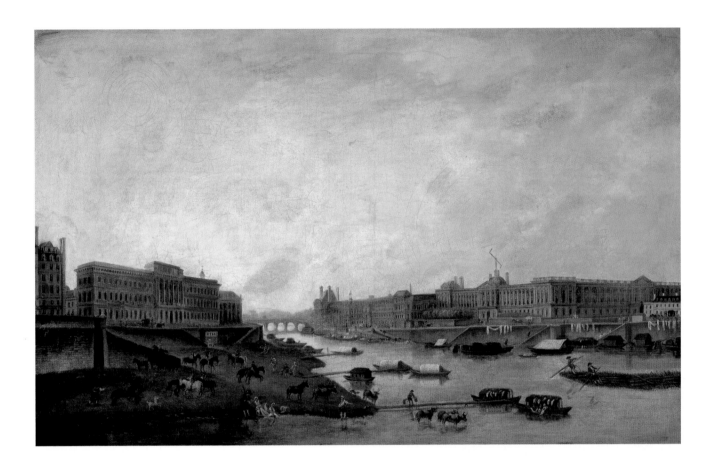

13.

Pierre-Antoine DeMachy (French, 1723–1807)
Hôtel des Monnaies and the Louvre seen from the Pont Neuf, circa 1800
Signed in lower left: *Machy*

Oil on canvas
24 x 37 inches (60.5 x 95 cm.)
Musée Carnavalet – Histoire de Paris, Paris (P94)
©PMVP / Berthier

DeMachy's painting shows the view down the Seine from the Pont Neuf around 1800. Clearly visible on the left is the Mint (Hôtel des Monnaies) on the quay de Conti built by the architect Jacques Denis Antoine (French, 1733–1801) and completed in 1775. Across the Seine is Cour Carrée of the Louvre, with Perrault's monumental colonnaded façade. The extent of the Louvre complex is apparent, which at that time was still linked to the Tuileries Palace whose domed roof is shown in the center background. Jefferson recommended both these façades as examples of modern architecture appropriate for public buildings that should be emulated in America. **S.T-L.**

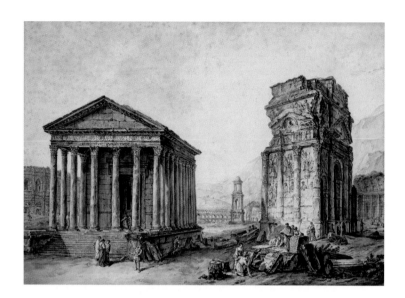

14.

Hubert Robert (French, 1733–1808)
Maison Carrée (Assembly of the Most Famous Monuments), 1783–1808

Pen and ink with wash heightened
with white on paper
15 x 21-1/3 inches (38.1 x 54.2 cm)
Phoenix Art Museum, Phoenix, Arizona.
Gift of an anonymous New York Foundation
(1962.10)

This drawing by Hubert Robert is a fanciful assembly in an imaginary setting of real ruined Roman monuments located in southern France. His rendering of the Maison Carrée, a first-century Roman temple, accurately captures the scale of the building that Jefferson so admired. This drawing is probably related to a royal commission for a series of monumental paintings Robert exhibited at the Salon in 1787. Jefferson singled out Robert's works as amongst the best of the Salon. **S.T-L.**

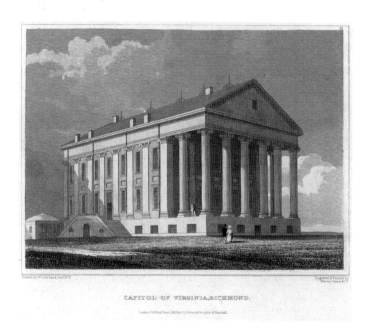

CAPITOL OF VIRGINIA, RICHMOND.

15.

William Goodacre, Jr. (American, active 1829–35)
Virginia State Capitol, circa 1830

Engraving
7-3/4 x 9-3/4 inches (19.7 x 24.8 cm)
The Library of Virginia, Richmond, Virginia (16604)

When Jefferson was asked to help with the design of the new Virginia State Capitol, he commissioned the architectural draftsman Charles-Louis Clérisseau (French, 1721-1820) to assist with the project. Clérisseau had previously created detailed drawings of the Maison Carrée published in 1778 in *Antiquitiés de la France*. Their design for the Capitol was adapted from the antique temple, as this engraving shows. Today Americans take it for granted that public buildings should have the columns and triangular pediments of ancient architecture, but, in fact, Jefferson's Virginia State Capitol was the first government building in the new Republic to be designed as a classical temple. **S.T-L.**

16.

Richard Cosway (English, 1742–1821)
Portrait of Maria Cosway, 1781-83
Inscribed on mount (partially cut): *Maria*

Pencil with watercolor on paper
11-1/4 x 9 inches (28.6 x 24.2 cm)
Collection of Beryl Kendall, London

In the summer of 1786 Jefferson became infatuated with Maria Cosway, a young painter of portrait miniatures visiting Paris with her husband, the English artist Richard Cosway. Richard's portrait of Maria captures her beauty and charm. **S.T-L.**

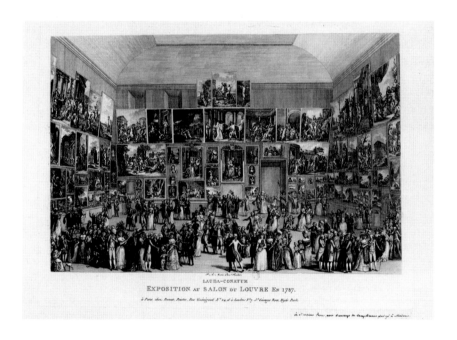

LAUDA-CONATUM
EXPOSITION au SALON du LOUVRE En 1787.

17.

P. A. Martini (French, 18/19th century)
Salon of the Louvre in 1787, August 1787

Engraving on paper
16 x 21 inches (41 x 54.4 cm)
Bibliothèque Nationale de France, Paris (Qb1 Août 1787 M98 191)

Just about everyone in Paris attended the biennial Salon to see the latest works of artists in the Royal Academy of Painting and Sculpture. The walls were covered with pictures and the room filled with spectators. Martini's print of the Salon of 1787 illustrates the manner in which paintings were hung in the room: large history paintings high on the wall, above smaller history paintings and large portraits. Smaller portraits, genre paintings, landscapes, and still lifes normally occupied the lower wall. At the Salon of 1787, Jefferson admired in particular David's *Death of Socrates*, visible at the bottom of the wall, just to the left of center in Martini's print. **D.O.**

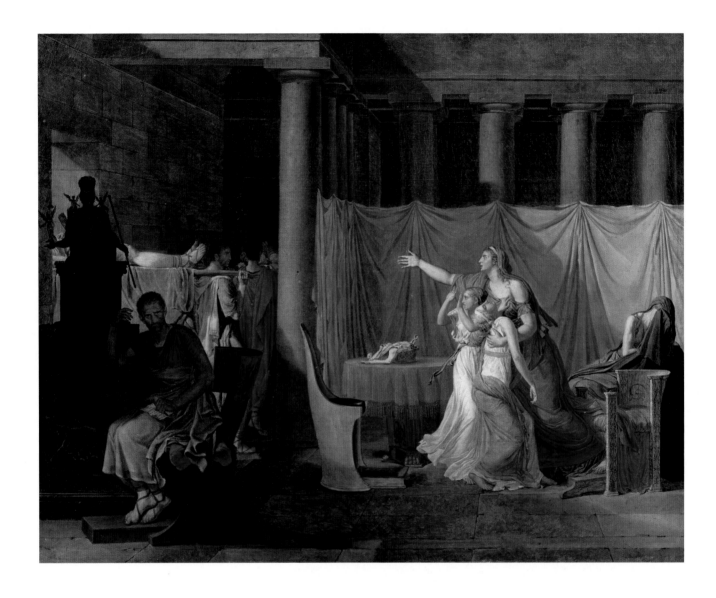

18.

Studio of Jacques-Louis David (French, 1748–1825)
Lictors Bringing to Brutus the Bodies of his Dead Sons, circa 1789

Oil on canvas
27 x 36 inches (70 x 91 cm)
The Wadsworth Atheneum Museum of Art, Hartford,
Connecticut. The Ella Gallup Sumner and Mary Catlin
Sumner Collection Fund (1934.34)

This painting is a reduced version produced in David's studio in 1789, the same year as the original. It is one in a series of paintings depicting classical narratives about virtue, sacrifice, and civic duty, the very ideals that many thought were missing in the government of pre-revolutionary France. Junius Brutus, the founder of the Roman Republic, was obliged by a law that he himself had enacted to have his own sons executed for conspiring against the new Roman Republic and attempting to restore the tyrannical Tarquin monarchy. In the left background of David's canvas, the decapitated bodies of Brutus's sons are returned to his home. Brutus sits in shade in the left foreground, while his wife, daughters, and maid mourn on the right. To illustrate Brutus's divided allegiances to the state and to his family, David broke with accepted compositional practices and left a huge gap in the center of his picture. This device encourages the viewer to engage critically with the painting's story by exploring the dual consequences of Brutus's difficult decision: on the one hand we recognize his devotion to the Republic, symbolized by the cult statue behind him and the decapitated bodies of his sons; on the other hand we see the extreme costs of that devotion embodied in the grieving forms of the women. This profound meditation on the potential conflict between private devotion and public duty appeared at the Salon on the eve of the Revolution. **D.O.**

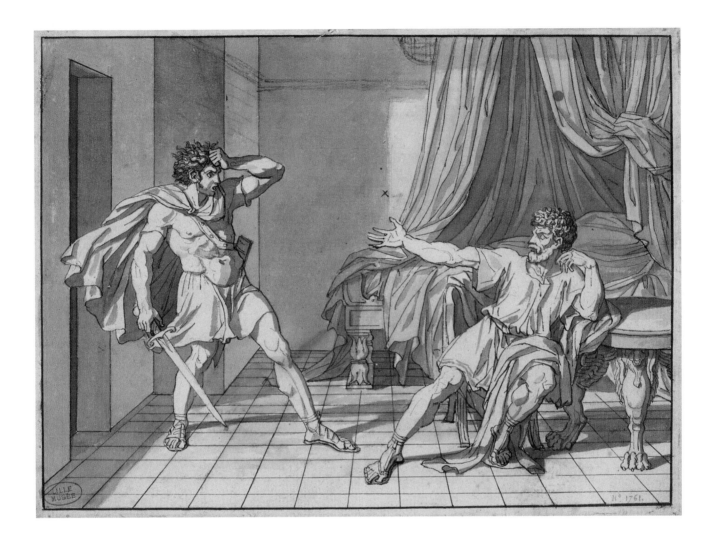

19.

Jean-Germain Drouais (French, 1763–1788)
Study for Marius at Minturnae, circa 1787

Pen and ink on paper
8 x 10 inches (19.5 x 26.5 cm)
Musée des Beaux-Arts, Lille, France (1322)
©Réunion des Musées Nationaux / Art
Resources, NY

This is a study for Jean-Germain Drouais's *Marius at Minturnae*, exhibited in the home of the artist's mother in 1787. Drouais's painting related an episode from the life of Gaius Marius, a distinguished but corrupt general and consul who fled Rome after being sentenced to death by the Senate. He was caught near Minturnae, but no one there dared to kill him. In the picture we see him staring down a would-be assassin, who will shortly drop his sword and flee in the face of Marius's overwhelming presence. Drouais's stern neoclassical work was much admired by Jefferson. **D.O.**

20.

Jean-Antoine Houdon (French, 1741–1828)
Bust of Georges-Louis Buffon, circa 1783
Signed on the right shoulder: *houdon f.*

Marble
25 x 11 x 11 inches (64.5 x 28.9 x 29.1 cm)
Musée du Louvre, Department of Sculpture, Paris (RF 379)
©Réunion des Musées Nationaux / Art Resources, NY

Jean-Antoine Houdon's bust of the world-renowned naturalist
and director of the Jardin des Plantes (Royal Botanical Garden)
Georges Louis Leclerc, Comte de Buffon (1707–1788), captures
the scientist's vivacious personality and intellectual prowess. It
was, in part, to refute Buffon's assertion of the American conti-
nent's deficiencies that Jefferson wrote his *Notes on the State of
Virginia.* **S.T-L.**

21.

Thomas Jefferson (American, 1743–1826)
Notes on the State of Virginia, 1787
Bound volume, printed for John Stockdale, London
8 x 5 x 1-1/4 inches (21.6 x 14 x 3.2 cm)
Howard-Tilton Memorial Library, Tulane University,
New Orleans, Louisiana

Jefferson's *Notes on the State of Virginia*, his only original full-
length book, was begun in 1780–81 and he revised it in
1782–83. The *Notes* were first published anonymously in
Paris in 1784, although dated 1782, in an edition of two
hundred copies at Jefferson's expense. Following the French
text, popular editions appeared in England, Germany and
America. Jefferson framed his comprehensive account of the
natural and political history of Virginia, its ways and its
inhabitants, as a reply to questions posed by Marquis Barbé-
Marbois. **S.T-L.**

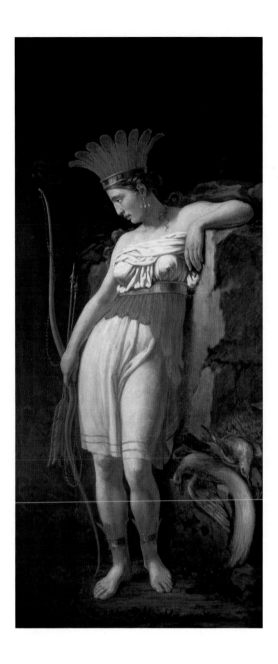

22.

Unidentified Artist, French School
Allegory of America, early 19th century

Oil on canvas
73 x 32 inches (187 x 83 cm)
Musée du Nouveau Monde, La Rochelle, France (81.3.2)

This painting shows the merging of the allegorical tradition of
America personified as an Indian maiden with the more aca-
demic figure of Diana, classical goddess of the hunt. The exotic
and the classical converge in this allegory, which typifies pre-
eighteenth-century visions of America as the exotic "other"
whose riches could be assimilated to France. **S.T-L.**

23.

Félix Marie Ferdinand Storelli (Italian, 1778–1854),
after Antoine-Philippe d'Orléans, Duc de Montpensier (French, 1775–1807)
Souvenir of Tokouo, 1819
Inscribed in ink on lining verso, probably copied from inscription on
original canvas: *"Souvenir du Tokouo, ville/des Cherakis dans l'Amérique/
Septentrionale,/par Storelli en 1819, d'apres le tableau fait en 1805 par/
Mgr. Le Duc de Montpensier"*

Oil on canvas
21-3/4 x 29-3/4 inches (55.25 x 75.56 cm)
Collection of Ridley Wills II, Franklin, Tennessee

Antoine-Philippe d'Orléans, son of the Duc
d'Orléans, better known as Philippe d'Egalité,
fled to the United States with his older brothers
(including the future King Louis-Philippe) in
voluntary exile from the revolutionary chaos of
France in 1796. Antoine-Philippe sketched this
Cherokee village in southeastern Tennessee named
Toqua (in French, *Tokouo*). Fourteen years after
the original gouache was made the Italian artist
Storelli reproduced it in oil paint. This image is a
rare depiction of a southeastern Indian village
during this period. The log structures reflect
Western influence while the conical building in
the background is a traditional lodge. On the right
is an overgrown prehistoric temple mound built by
the ancestors of the historic southeastern tribes.
S.T-L.

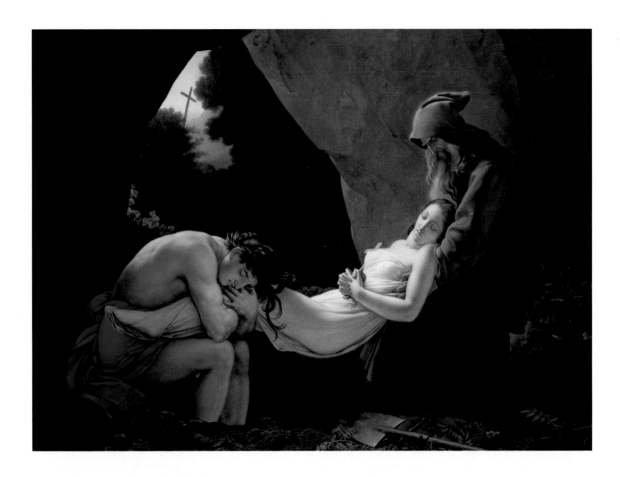

24.

Anne-Louis Girodet de Roussy Trioson (French, 1767–1824)
The Funeral of Atala, circa 1811

Oil on canvas
35 x 46-3/8 inches (88.9 x 117.8 cm)
High Museum of Art, Atlanta, Georgia.
Purchased with funds from the Forward Arts Foundation (1990.1)

25.

Attributed to Anne-Louis Girodet de Roussy Trioson (French, 1767–1824)
Study for the head of Atala, circa 1811

Pencil and chalk on buff paper
25 x 21 inches (63.5 x 53.3 cm)
Collection of Dr. and Mrs. Alfredo Lopez, New Orleans, Louisiana

This painting is a reduction of the canvas shown at the Salon of 1808 now in the Louvre. Girodet's composition combines two episodes from the story—the passage describing the night Chactas and Père Aubry spend in a cave watching over Atala's body and her funeral the next morning. Chateaubriand's romanticized descriptions of the untamed wilderness of the Floridas and the banks of the Mississippi, as well as his descriptions of Native American culture, were a significant influence on the vision of North America in the French imagination. Atala, the daughter of a Spanish settler and a Native American woman, took a vow of chastity to honor her mother's dying wish. Her love for Chactas proving to be a too great a temptation, she poisons herself. Atala embodies the romantic notion of chaste Christian piety, clutching a crucifix even in death. In Girodet's painting, the pious message of the story is reinforced by the cross seen through the cave opening, atop the rock that will overlook her grave. Chactas, mourning the promise of love that cannot be fulfilled, is shown as Jean-Jacques Rousseau's ideal Noble Savage, although his features are distinctly European. **V.C.**

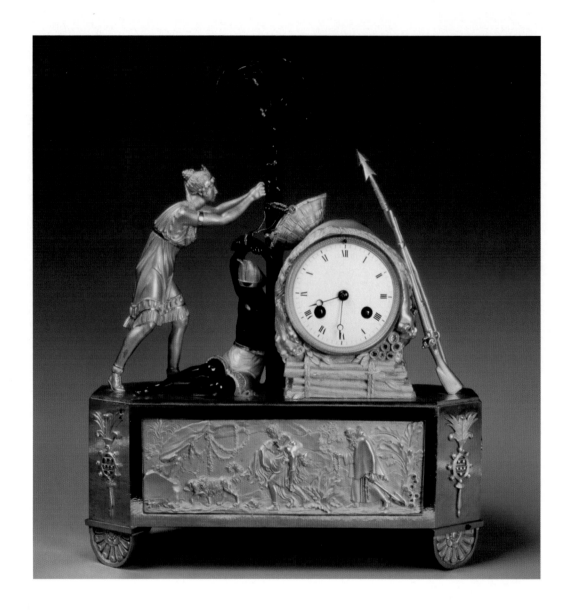

26.

Unidentified Artist, French School
Mantle Clock depicting: Atala Delivering Chactas, circa 1805–15

Bronze, partly gilt
15-3/4 x 4-1/3 x 12 inches (40 x 11 x 32 cm)
Maison de Chateaubriand/La Valée aux Loups,
Château Malabray, France (0 590-1)

Decorated clocks, part timepieces and part sculpture, were popular during the Empire, often reproducing scenes from literature. This clock is decorated with two scenes taken from Chateaubriand's novel, *Atala*. The statuettes show Atala untying Chactas while his guard sleeps. The logs supporting the clock dial indicate that she has saved him from being burned at the stake. In the relief on the base of the clock, Atala is carried to her grave by a grieving Chactas, followed by Père Aubry. **V.C.**

EXECUTIVE AUTHORITY: IMAGES OF LEADERSHIP IN POST-REVOLUTIONARY FRANCE AND AMERICA

David O'Brien

In the wake of the French and American Revolutions, portraitists in both nations grappled with a similar problem: What should the leaders of the new regimes look like? Older portraits of aristocrats and monarchs carried with them the aura of legitimacy that time alone can create. These images, however, could serve only in a limited way as models for painters working in a post-revolutionary society because so much of their symbolism referred to now-outmoded forms of government, discredited forms of deference, or rival claimants to power. Post-revolutionary leaders needed to establish their difference, just as much as their continuity, with the past. How were portraitists to transform government officials into revered leaders without relying on well-understood signs? Those who painted Jefferson and Bonaparte in the years around 1803 struggled with this question.

In some respects it is remarkable that portraits of Jefferson and Bonaparte share anything at all. Bonaparte came to power through a coup d'état, dismantled many of the democratic reforms of the Revolution, and eventually established himself as a dictator. In 1803 he was completing his astounding transformation from the Corsican Napoleon *Buonaparte* to Emperor Napoleon. On August 2, 1802, the Senate had proclaimed him First Consul for Life; on May 18, 1804, he was declared Emperor of the French; and on December 2, 1804, he was formally crowned. Jefferson, in contrast, assumed power as the third president of the United States only after an orderly transition of power through regular, democratic elections. He presided over a functioning republic. His prestige within the fledgling nation was based not on military achievements, but on his intellectual role in the independence movement and as a diplomat, secretary of state, and vice-president. After two terms in office, he chose not to run for president again.

Painters also occupied very different positions in France

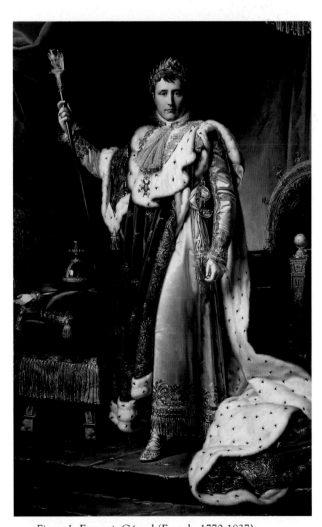

Figure 1: François Gérard (French, 1770-1837), *Napoleon I in Coronation Robes*, 1806, Oil on canvas, 87-3/4 x 56-1/4 inches (222.9 x 142.9 cm), Musée National du Châteaux, Versailles, France
©Réunion des Musées Nationaux / Art Resources, NY

45

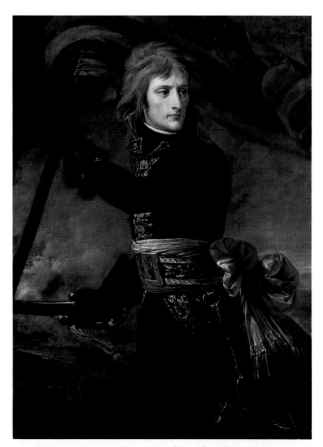

Figure 2: Antoine-Jean Gros (French, 1771-1835), *Bonaparte at the Bridge of Arcole*, 1796, Oil on canvas, 51-1/8 x 37 inches (130 x 94 cm), Musée National du Châteaux, Versailles, France
©Réunion des Musées Nationaux / Art Resources, NY

and America. France could boast of a long and glorious artistic tradition, regular public exhibitions, a rigorous educational system for artists, a large class of wealthy individuals who patronized the arts, and unparalleled state resources devoted to painting (though these last three features had been interrupted or attenuated during the Revolution). American painters struggled to find training and patronage. They habitually deferred to their English and French colleagues on artistic matters, and many ambitious students crossed the Atlantic at their first opportunity in order to hone their skills. The state devoted almost no resources to them, and they had almost no regular venues in which to exhibit their work publicly.

The Napoleonic regime created a small industry for painters and sculptors by commissioning literally hundreds of different images of the Emperor, many of them enormous in scale. In contrast, the federal government never commissioned a monumental painting or sculpture of Jefferson during his lifetime, and most of the artists who portrayed him did so on their own initiative. The imposing emperor in the portraits of Jacques-Louis David (**cat. no. 27**) and François Gérard (*fig. 1*) seems wholly different from the

dignified but unassuming president in a contemporaneous painting by Rembrandt Peale (**cat. no. 28**). Napoleon wears the elaborate costume of his coronation and, in Gérard's painting, is surrounded by elaborate ceremonial objects, whereas Jefferson appears informally in a dressing gown with a fur collar and against a plain background.[1] Napoleon seems intimidating, aloof, and impersonal, whereas Jefferson's slightly flexed brow, focused gaze, and hint of a smile suggest an intimate, personal encounter.

In the exhibition, visitors can examine many elaborate objects that linked Bonaparte to rulers of the past. For example, Nicolas Boutet fashioned a ceremonial glaive for Bonaparte ornamented with a variety of finely carved motifs and wrought in expensive materials such as gold, silver, ivory, enamel, and mother-of-pearl (**cat. no. 43**). The antique form of the sword referred to the Roman origins of the office of the First Consul. Similarly, the massive Vendôme column (for a scale model, see **cat. no. 37**), covered with scenes from the Austrian campaign of 1805 and crowned by an image of Napoleon as a Roman emperor, connected the French ruler to the Emperor Trajan, who had commissioned a similar monument in imperial Rome. No comparable objects exist for Jefferson. While Napoleon sat on a throne in front of his Legislative Assembly (**cat. no. 48**), legend has it, appropriately, that Jefferson sat in a simple arm chair (**cat. no. 160**) as vice-president.

Such differences might suggest that a comparison of portraits of Bonaparte and Jefferson would be uniquely one of contrasts. Yet, because artists in both countries shared the basic task of embodying political authority in the wake of radical revolutions, their varying solutions illuminate one another. Moreover, the changing significance of their portraits bears comparison, particularly in light of the demise of Napoleon's Empire and the rise of Jefferson's Republic into the world's most powerful nation. If, in their own day, Napoleon's portraits most obviously took on the traditional trappings of majesty, today it is, ironically, Jefferson's portraits that more commonly inspire attitudes of reverence and deference.

The Emperor's New Clothes

Napoleon Bonaparte's image steadily evolved in relation to his growing powers, and most portraits of him served an overtly political purpose.[2] The earliest monumental portraits of Napoleon Bonaparte date from his First Italian Campaign (1796-97), when the twenty-six-year-old general took over a demoralized French army and conquered most of the Italian peninsula. The most famous of these, by Antoine-Jean Gros, shows Bonaparte leading a charge across a bridge in the town of Arcole (*fig. 2*). The charge had in fact ended in failure. Bonaparte lost many men and had to be extracted from a deep ditch into which he had stumbled. He seized on the episode nonetheless

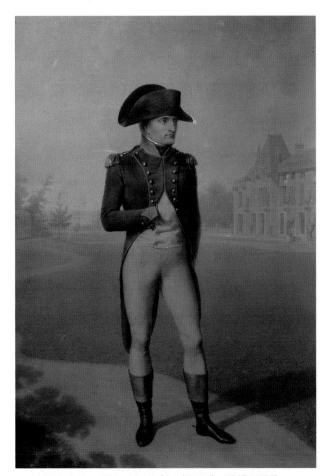

Figure 3: Jean-Baptiste Isabey (French, 1767-1855), *Bonaparte at Malmaison,* circa 1800, Watercolor, Musée National du Château de Malmaison, Rueil-Malmaison, France
©Réunion des Musées Nationaux / Art Resources, NY

critics maintained that government and military uniforms were "attributes of the offices and not of the individuals who temporarily fill them."[4] Accordingly, politicians and generals were often portrayed as private citizens or simple soldiers and did not appear in their most formal regalia. Such an image reinforced the idea that under the new political settlement power did not belong inherently or innately to any individual. On the other hand, Bonaparte wished to become an absolute ruler almost from the start and immediately began to assume many of the trappings of royal authority. As early as the autumn of 1800, his brother Lucien anonymously published a pamphlet, *The Parallel between Caesar, Cromwell, Monk, and Bonaparte,*

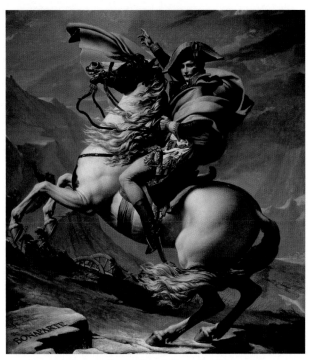

Figure 4: Jacques-Louis David (French, 1748-1825), *Bonaparte Crossing the Alps,* 1800, Oil on canvas, 87 x 102-3/8 inches (260 x 221 cm), Musée National du Château de Malmaison, Rueil-Malmaison, France
©Réunion des Musées Nationaux / Art Resources, NY

because, as a revolutionary general, he wanted to demonstrate that he would risk his own life just like the rank and file, and that he led by example. His exploits at Arcole were the best material he had for creating such a message, and they quickly became legendary. In contrast to the portraits of aristocratic military leaders of the past, the picture shows Bonaparte dashing to the center of a raging battle. His tightly coiled body, along with the paintings bold colors and forceful strokes, suggest passionate, irrepressible energy. Like another important early portrait of Bonaparte by Charles-Louis Corbet (**cat. no. 29**), Gros insisted on the general's youth and, by including his long, unkempt hair, his disdain for conventional fashions.[3]

Bonaparte's image changed dramatically after his return from Egypt and successful coup d'état in late 1799. The office of First Consul was created to recall the chief executive office of the Roman Republic and thus allay fears that the democratic reforms of the Revolution were in peril. But such a position was unprecedented in France and, consequently, there was much uncertainty about how to represent Bonaparte. During the Revolution, some art

arguing that he should be placed permanently at the head of state. The idea turned out to be premature, and Lucien was forced to resign from his post as minister of the interior.

Consular portraits of Bonaparte depicted him sometimes as a modest, private citizen and sometimes as a great public leader, though they gradually migrated toward an aggrandizing, monarchical vision. In one much-copied drawing, Jean-Baptiste Isabey represented Bonaparte as a simple citizen-soldier, standing in front of his chateau in Malmaison (*fig. 3*). This image was probably intended to dispel worries about a return to monarchy and connect Bonaparte to other modest representations of post-revolutionary heroes.[5] In the same year, however, Jacques-Louis David represented Bonaparte atop a rearing charger, leading

Figure 5: Étienne-Maurice Falconet (French, 1716-1791), *Peter the Great*, 1782,
Bronze, Saint-Petersburg, Russia
©Réunion des Musées Nationaux / Art Resources, NY

the French army across the Alps en route to victory in his
Second Italian Campaign of 1800 (*fig. 4*). This large paint-
ing drew overtly on equestrian portraits of monarchs by
Valázquez, Bernini, and Falconet (*fig. 5*), and the inscrip-
tion on the rock in the lower left likened the conqueror's
feats to those of Charlemagne and Hannibal. Bonaparte
appeared not simply regal, but also as a man of destiny,
calmly leading his soldiers through an awe-inspiring, windswept
landscape. With his horizontal features and erect torso,
Bonaparte provides a stable center to a composition filled
with soaring diagonals and jagged forms. His confident
features are juxtaposed with those of the horse, whose
fury he keeps in check. David offered a hero for the ages,
comparable to great monarchs of the past. His talents as
a painter established this image as one of the most frequent-
ly reproduced images of Bonaparte (**cat. no. 34**).[6]

In 1802 and 1803 Bonaparte asked Gros for four full-
length portraits of himself dressed in the uniform of the
First Consul, and ordered variations on them from seven
other painters.[7] These paintings offered a compromise

between Isabey's plain image and David's awe-inspiring
one. They substituted Bonaparte's civic achievements for
his military exploits and portrayed him simply in his offi-
cial Consular uniform. In the first version of the Consular
portraits (*fig. 6*), Bonaparte stands with his hand resting
on a stack of papers. The topmost document lists the
treaties signed by Bonaparte and cites three of his greatest
non-military achievements: the coup d'état of 18 Brumaire,
the Comices de Lyon, and the Concordat. Thus he appears
simultaneously as a peacemaker, statesman, diplomat,
and restorer of the Catholic church in France.

This painting conformed to a basic type used for states-
men: full-length portraits in which the sitter stands with
one arm extended toward or resting on a table, and the
other resting on a hip or in a vest, or at a similar angle.
Ornate furniture and grand architecture (often a soaring
column) typically set the scene, objects on the table refer
to the past achievements or learning of the sitter, and
the background sometimes recalls his greatest feats. Gros's
first version eliminated the more imposing of these motifs,

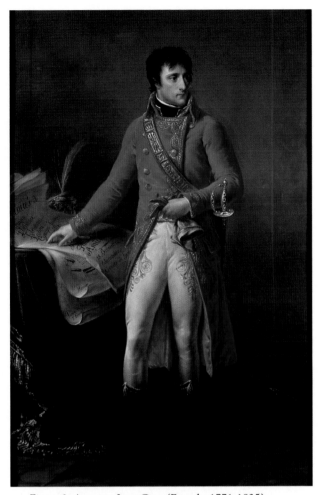

Figure 6: Antoine-Jean Gros (French, 1771-1835), *Bonaparte, First Consul*, 1802, Oil on canvas, 80-3/4 x 42 inches (205 x 127 cm), Musée de la Légion d'Honneur, Paris
©Réunion des Musées Nationaux / Art Resources, NY

Figure 7: Antonio Canova (Italian, 1757-1822), *Napoleon as Mars the Peacemaker*, 1806, 132 inches high (335.3 cm), Marble, Apsley House, Wellington Museum, London
©Réunion des Musées Nationaux / Art Resources, NY

perhaps in order to render Bonaparte a more approachable citizen-leader, but subsequent versions recalled the imperious grandeur of state portraits of French court officials of the early eighteenth century. Many of these, such as that by Vien, fils after Lefèvre (**cat. no. 31**), use the more inflated conventions of the portrait type, such as the hand placed assertively on the hip and the throne-like chair.

From early 1802 to early 1803 France was enjoying its only period of peace in over a decade, but war was to return shortly, as was the military image of Bonaparte. In history paintings Napoleon appeared as a general, but now he was celebrated primarily as a healer, peacemaker, or orator.[8] In official portraits executed during the Empire, such as those by David and Gérard, Napoleon adopted all the trappings of absolute monarchy. Officials fabricated a set of clothes and paraphernalia that drew heavily on what was known of the Carolingian tradition in order to create a lineage for Napoleon even as they separated him from the Bourbons. Yet the use of rich materials, such as

ermine and gold brocade, and the elaborate symbols obviously emulated the practices of the preceding French monarchy, just as Gérard's portrait emulated the work of the Old Regime portraitist Hyacinthe Rigaud (French, 1659-1743). The enormous number of signs of authority and rulership in these imperial portraits suggests that Bonaparte and his propagandists were overcompensating for his lack of any legitimate claim to a throne. Yet the transformation of the revolutionary general into a monarch was now complete. For many on the Left this was a betrayal, while for those on the Right it was a travesty.

The most imposing likeness of Napoleon came from the hand of the presiding genius of European art, the Italian Antonio Canova. The sculptor had been summoned to Paris in 1802, where he reluctantly took up a commission for a number of portraits. A series of busts, based on a clay model taken from life, soon emerged from his workshop. These were almost twice life-size, represented the French ruler undraped, *à l'antique*, and endowed him with a mus-

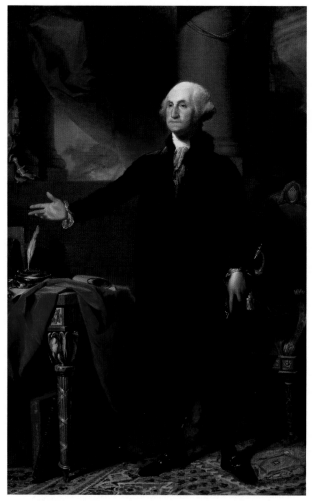

Figure 8: Gilbert Stuart (American, 1755-1828), *George Washington (The "Lansdowne" Portrait)*, 1796, Oil on canvas, 96 x 60 inches (244 x 152.4 cm), Pennsylvania Academy of the Arts, Philadelphia, Pennsylvania

cular brow, lean cheeks, and unruly hair (**cat. no. 35**).[9] Canova's main charge, however, was to execute a full-length sculpture of Napoleon and an equestrian portrait. The latter was never begun, while disagreement plagued the former. Napoleon wanted to appear in modern dress, but Canova, who was far more interested in the aesthetic aspects of the commission, wanted to graft a portrait head onto an idealized, nude body, feeling that the noblest art should distance itself as much as possible from the markers of class, nationality, and partisan politics.[10] Eventually Napoleon's artistic advisors, Vivant Denon and Ennio Quirini Visconti, prevailed upon him to accept the idea of himself as "Mars the Peacemaker." When Napoleon saw the statue in 1811, he ordered it into storage, apparently fearing that it would expose him to ridicule if exhibited to the public.

Napoleon as Mars the Peacemaker (*fig. 7*) points to one of the central artistic problems of the period. Aesthetic theory held that the noblest forms of art should emulate

the antique, with its idealized, superhuman cast of characters, but when this was applied to contemporary subjects, they risked appearing absurd. The hyperbole and nudity used for rulers of the past no longer seemed appropriate in the modern period. People now expected their leaders to live in essentially the same world as themselves, and thus they expected to see some of the imperfections, happenstance, and contingency of their own lives. Even Napoleon's megalomanical vision of himself did not stop him from appreciating this more modern notion to some extent.

The Inconspicuous President

The first question that needs to be answered when we turn to Jefferson is not how he was represented, but why he sat for so few portraits. Most of the life portraits of him are modest in scale and show only his face or bust. They were created for family or friends, or by artists who had their own reasons for taking Jefferson's likeness.[11] It is not enough to point to the small number of accomplished portraitists and limited support of the visual arts in America to explain this. Portraits of George Washington demonstrate that, under the right conditions, artists could produce accomplished and varied images of the chief executive. Rather, Jefferson's own brand of politics and a rapidly evolving concept of the new office of the presidency account for much of what is peculiar to his iconography.

The various depictions of Washington help us to understand the uniqueness of portraits of both Jefferson and Bonaparte. He could appear as a military leader in the grand manner of Van Dyck, as a family man in conversation pieces, as the Roman Consul and reluctant dictator Cincinnatus giving up the sword for the plow, or as a statesman in the same tradition as Gros's *Portrait of Bonaparte as First Consul*.[12] Like Bonaparte, Washington had to fashion an unprecedented identity, but he and his portraitists made significantly different choices.[13] Gilbert Stuart's famous "Lansdowne" portrait (*fig. 8*) utilizes the same grandiose setting as the Consular portrait by Vien, fils. The sword and throne-like chair are still there, but Washington wears the modest clothing of a private citizen and his gesture appears less imperious and affected. The unpretentious nature of the Lansdowne picture is especially evident if we compare it to Gérard's portrait of the Emperor Napoleon. Washington never gravitated toward the divine and monarchical imagery that Bonaparte increasingly cultivated.

Washington's life was easily converted into myth.[14] His career was marked by astounding achievements, but also dramatic relinquishments of power. Most notably, he resigned as general-in-chief of the revolutionary army at the soonest possible moment after victory and stepped down as president after two terms in office. Trumbull, who painted the first resignation, described it as "a Conduct so novel, so inconceivable to People, who far from giving up powers they possess, are willing to convulse the Empire

to acquire more."[15] Washington sought to allay fears that he would parlay his military success into a dictatorship, and he established the precedent of smooth transitions in the presidency through democratic elections. Thus the importance of images like Savage's and Peale's of him as a father surrounded by his family and as former soldier who had turned his sword into plow shares. Bonaparte, as we have seen, proceeded in an entirely different manner.

The image of Washington as pacific and retiring is found in one of the most memorable portraits of him, Houdon's sculpture of 1786 to 1795 (*fig. 9*). This statue resulted from an exceptional act of official patronage for commemorative sculpture by the Assembly of the state of Virginia, which voted to commission it in 1784. The lack of formally trained sculptors in America forced officials to look abroad, and it was Jefferson who recommended Houdon for the job. Both Houdon and Jefferson hoped that this commission might lead to an equestrian portrait along the lines of Falconet's *Peter the Great*. Jefferson went so far as to take this idea to the United States Congress, but nothing ever came of it.[16] When it was decided that Washington would appear standing in a life-size statue, Houdon and Jefferson still entertained the possibility of representing him in Roman dress, but Washington suggested that "a servile adherence to the garb of antiquity might not be so expedient, as some little deviation in favor of the modern costume. . . . This taste which has been introduced in painting by [Benjamin] West I understand is received with applause, and prevails extensively."[17] He was referring to the immense influence of West's *Death of General Wolfe* (1770), which had introduced contemporary subject matter and dress into history painting. Jefferson came to endorse this idea. Unlike Napoleon in regard to Canova's *Napoleon as Mars the Peacemaker*, Washington could not countenance the pretension of the antique conceit. In the final statue he is a strong, towering man dressed in his regimental uniform, but his marked stoutness, relaxed attitude, and the casual way he wears his clothes render him human. Houdon portrayed him leaning on a fasces (a Roman symbol of authority) with a plow beside him (referring to Cincinnatus). Washington has abandoned his sword and military cape in favor of a walking stick, the attribute of a gentleman farmer, as he returns to private life. His person is not identified with divinity or the permanent endowments of a hereditary rank; rather, he is a private individual who has served to great effect in public office and has now retired.

A more aggrandizing vision of Washington was offered by Giuseppe Ceracchi, an Italian admirer of the American Revolution. Discussions of an official monument to Washington lured Ceracchi to the United States in 1791, where he mounted an unsuccessful campaign to have his own design supported by Congress. His plan called for multiple sculptural groups with an equestrian portrait of Washington at the center rising sixty feet in the air. As part of his campaign, he executed a bust of

Figure 9: Jean-Antoine Houdon (French, 1741-1828), *George Washington*, 1786–95, Marble, 72 inches high (182.9 cm), State Capitol, Richmond, Virginia

Washington from life, which was copied in numerous variants, including the fine example in a New Orleans collection (**cat. no. 132**). Ceracchi likened his subject to a Roman general or statesman, endowing him with a muscular neck, idealized, massive features, and thick locks of hair. In some versions he wears a cuirass and in others a chlamys. The hair and eyes are abstracted and deeply incised in the classical manner. Ceracchi's bust found plenty of admirers in America, but Congress was unwilling to fund his monument, and Washington declined to purchase a marble version of the bust, prompting Ceracchi to leave the country in a fury.[18] In retrospect, his grand classical vision of Washington ran counter to the dominant concepts of presidentiality in the United States.

The most reproduced likeness of Washington, based on Gilbert Stuart's "Atheneum" type portrait (**cat. no. 131**), was far more prosaic, consisting of a bust-length view of the president in plain formal attire. Its simplicity, as well as the reserved, thoughtful attitude of the sitter, became the image of presidentiality in the United States and was

Figure 10: Charles Willson Peale (American, 1741-1827), *Thomas Jefferson*, 1791, Oil on canvas, 25 x 20-3/16 inches (64.8 x 51.3 cm), Independence National Historic Park, Philadelphia, Pennsylvania

emulated by many succeeding presidents. There are obvious reasons why subsequent presidents did not enjoy the same elaborate iconography that grew up around Washington. No other American could have aspired to the heroic status enjoyed by Washington. He had played the most prominent and central roles in the Revolution and first years of the Republic. Throughout, he remained largely above partisan disputes. Jefferson, in contrast, established the rudiments of the Republican party and, as its de facto leader, was locked in bitter feuding with the Federalists for much of his political life. His presidential contests with John Adams in 1796 and 1800 introduced a level of invective and character assassination from which neither man ever fully recovered in his lifetime.

In any case, Jefferson never would have promoted his own image through the production of overtly propagandistic portraits for a number of reasons. First, presidential politics had not developed to the point where candidates actively campaigned before the public. This was especially true of Jefferson, who held to "a lingering aristocratic code" according to which it "was still considered unbecoming for a statesman to prostitute his integrity by a direct appeal to voters."[19] To a remarkable extent he left the propagation of his own image to enterprising individuals who chose to paint him for their own purposes. Second, Jefferson eschewed pomp and cultivated a form of republican aus-

terity in his personal presentation that, for him, stood over and against the decadence of monarchy and federalism. In his view, the president should be above all inconspicuous and, accordingly, he delivered only two public speeches (his inaugural addresses) during his eight years as president. Finally, he could never have envisioned the massive government art patronage program that existed in France, and certainly not one that functioned as a propaganda machine to promote the politics of the federal government and its leader. Jefferson's vision of the federal government was minimalist: its powers strictly limited and subordinated to those of the States, its budget austere, its authority based on consensus and voluntary support. He was not about to expand its power and expenditures to include a permanent bureaucracy devoted to painting and sculpture.

Jefferson saw sculpture and painting in various and contradictory ways: as edifying, learned pursuits; as tempting luxuries capable of distracting viewers from serious social questions; and as important ways of commemorating events and individuals.[20] He was a great admirer of French visual culture, as he was of all things French, but at the same time he could dismiss painting and statuary as "too expensive for the state of wealth among [Americans]. They are worth seeing, but not studying."[21] On occasion he was a strong advocate for government support of artistic projects, such as the Houdon portrait of Washington and Trumbull's series of paintings commemorating the events of the Revolution, but such instances were rare. His most sustained engagement with pictorial art was in the form of a gallery of portraits of great men, particularly those who established the American colonies and the United States, that he assembled for Monticello. This was very much an Enlightenment idea. Jefferson was no doubt aware that one of the major patronage programs of the French state before the Revolution was for a series of paintings and sculptures of *grands hommes* who had performed exemplary service to the nation.[22] Such projects appealed widely to viewers in the late eighteenth century partly because they believed that a man's character was perceptible in his physiognomy, a belief that greatly enhanced the moral function and worth of portraiture.[23]

Thus it is appropriate that the portraits taken from life of Jefferson are limited in number, privately commissioned, relatively modest, and focus on his physiognomy. An early bust by Houdon (for plaster cast, see **cat. no. 159**) showed him in contemporary dress and played up his unique features with remarkably fine modeling: dramatically deep eye sockets; prominent chin; lean cheeks; a sharp, straight nose above horizontal, contracted lips; and a square, protruding chin. The slightly tensed brow and focused eyes establish him as a man of thought. The first public image of Jefferson in the United States was executed in 1791 by Charles Willson Peale for his gallery of "the great founders of the republic" in Philadelphia (*fig. 10*).[24] Just like its predecessor in pre-revolutionary France, this

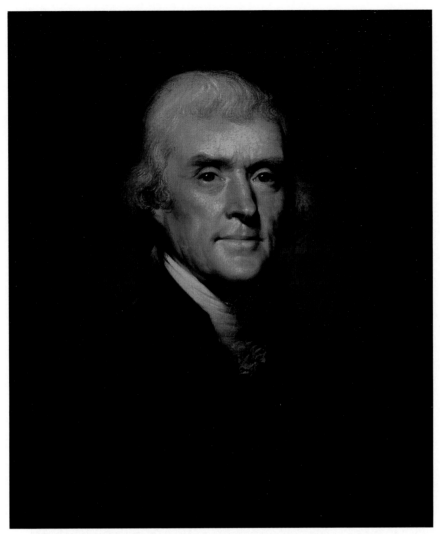

Figure 11: Rembrandt Peale (American, 1778-1860), *Thomas Jefferson*, 1800, Oil on canvas, 23-1/8 x 19-1/4 inches (58.7 x 48.9 cm), The White House Historial Association, Washington, D.C.

gallery was intended to provide citizens with edifying examples of public service to the nation, only now with republican virtues emphasized. Jefferson appeared in a simple, bust-length portrait that again focused on his physiognomy. He wears plain attire and no wig. His character is defined simply through his body, not through the usual signs of social station or rank or allusions to the past.[25] Again he looks like a man of thought, perhaps even a visionary, with his eyes looking into the distance and his slightly unkempt, distinctive reddish-white hair brushed back, almost as if by a wind.

In 1800, during his second run for president, Jefferson sat for three painted portraits, perhaps recognizing, in a limited way, the value of propagating his likeness. One of these, by Charles Willson Peale's son Rembrandt (*fig. 11*), was reproduced in dozens of different engravings and became the commonest image of Jefferson during his presidency. It adopted the standard bust-length format and

simple dress, but offered a more frontal and formal view of Jefferson emerging dramatically from a dark background. Rather than the visionary thinker found in his father's portrait, Rembrandt's Jefferson confronts the viewer directly with a focused, alert gaze. As with so many portraits of Jefferson, no props reinforce the authority of the man. These early likenesses lack even the most basic elements of the European statesman portrait type. Likenesses of Jefferson rarely alluded to republican Rome through an overtly antique iconography, but instead emulated such classical ideals as simplicity and directness through their style and the sitter's personal appearance.

John Adams, the second president of the United States, had himself portrayed by John Singleton Copley in the statesman-like fashion when he was a diplomat in England (**cat. no. 133**): he appears full-length in a regal pose, next to a table holding documents referring to his work and learning, and with grand draperies pulled back

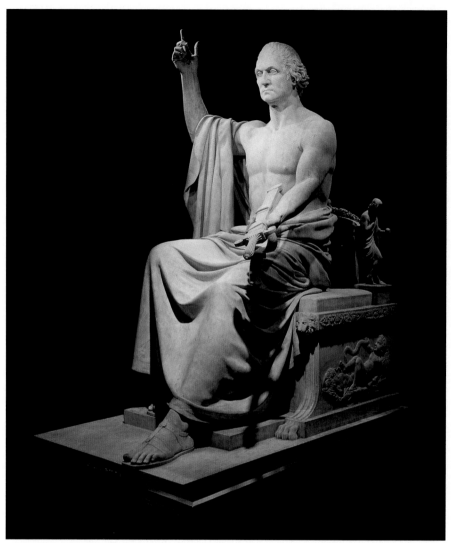

Figure 12: Horatio Greenough (American, 1805-1852), *George Washington,* 1832–41, Marble, 126 inches high (320 cm), National Museum of American History, Smithsonian Institution, Washington, D.C.

to reveal palatial architecture and a classical statue. There are details here that Jefferson and his portraitists may have been conspicuously omitting from his own image: the aristocratic sword, luxurious rug, wig, and courtly dress. In the years when Jefferson ran for president against Adams, Jeffersonian Republicans might well have associated these bits of pomp with the corrupt ways of the Old World, elitism, and an affinity for wealth, all characteristic, they said, of Adams and the Federalists. Subsequent portraits of Adams were not nearly so lavish, and when in 1793 a London bookseller asked to reproduce the Copley portrait as the frontispiece of a new edition of Adams' *Defence of the Constitutions of Government of the United States of America,* Adams confessed, "I should be much mortified to see such a Bijou affixed to those Republican Volumes."[26]

The numerous engravings after Rembrandt Peale's portrait of Jefferson from 1800 reveal that it answered a demand for images of the president better than any other. The appearance in 1801, however, of two different engravings portraying Jefferson in full-length suggests that many admirers desired a grander image. Both engravings grafted the head from Rembrandt Peale's portrait onto the very type of body and setting found in the Consular portraits of Bonaparte and the Lansdowne portrait of Washington.[27] Such an elaborate painting did not exist of Jefferson until 1805, when Gilbert Stuart completed a seated portrait in which the president appears before a monumental column and billowing draperies (**cat. no. 134**). The picture's background and suave handling, as well as the sitter's erect posture and wig-like coiffure, introduced a new level of grandeur. Yet even this stately portrait is a far cry from the imperial imagery then appearing in France. The portrait soon replaced that of Rembrandt Peale as the best known likeness of the third president of the United

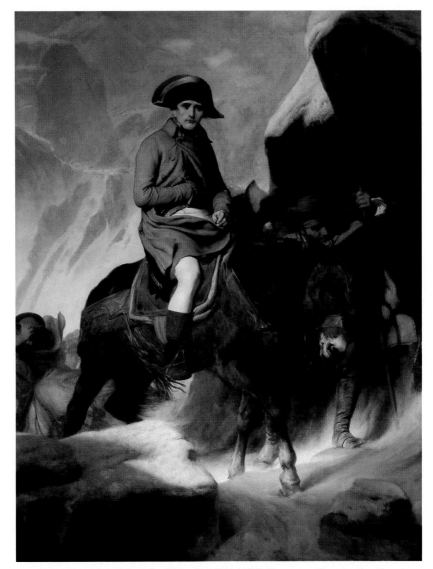

Figure 13: Paul Delaroche (French, 1797-1856), *Bonaparte Crossing the Alps*, 1848, Oil on canvas, 113-3/4 x 87-1/2 inches (289 x 222 cm), Musée du Louvre, Paris
©Réunion des Musées Nationaux / Art Resources, NY

States. Stuart used a similar arrangement for subsequent presidents, as, for example, in his portrait of James Monroe (**cat. no. 247**), thus establishing the standard presidential iconography in the early republican period.

Evolving Perceptions

If human, approachable images of Washington and Jefferson dominated their portraiture during their own lifetimes and contrasted starkly with the god-like monarch in official portraits of Napoleon, an odd inversion of this situation occurred as the nineteenth century progressed. When Horatio Greenough carved his Washington for the Capitol rotunda in 1841—this was the first federal government commission to an American sculptor—he trans-

formed the man into an enthroned, eleven-foot-high Jupiter, the king of the classical pantheon (*fig. 12*). The work's grandiose rhetoric was controversial in its own day (if far less so today), but the likeness of Washington would only become more inflated, eventually appearing with Jefferson's on the side of Mount Rushmore.[28] Seven years later, Paul Delaroche completed a large canvas of Napoleon crossing the Alps that emphasized the First Consul's human qualities: his weariness, puny mount, and personal discomfort (*fig. 13*). Such deflated images of Napoleon proliferated in the middle of the nineteenth century, even as his admirers continued to eulogize him. Whereas, after the fall of the Empire, Napoleon appeared in all manner of representations and became a controversial historical figure in France, the regime of Jefferson and

Washington has never fallen and their likenesses, often derived from the original life portraits, seem only to grow more superhuman, elusive, and auratic. Important discoveries about Jefferson's relationship with Sally Hemings and gratuitous invocations of his name in partisan politics do little to dampen such reverent attitudes. Historians continually remind us of the human qualities of the Founding Fathers, but our desire to celebrate the origins of our nation continually pushes their images higher up into a mist-filled pantheon. The early portraits of Jefferson, so notably secular and republican in their own day, begin to appear, for better or worse, like images of a god.

Notes:

1. Admittedly, the French paintings are state portraits while Peale executed his image on his own initiative for display in his father's museum, but the differences between these portraits are borne out generally by other images of the leaders. For a more complete analysis of Peale's portrait, see Carol Eaton Hevner, "The Paintings of Rembrandt Peale: Character and Convention," in Lillian Miller, *In Pursuit of Fame: Rembrandt Peale, 1778-1860* (Washington, D.C.: Smithsonian Institution, 1992), 256. For David's portrait and its relation to other Napoleonic portraits, see Philippe Bordes and Alain Pougetoux, "Les Portraits de Napoléon en habits impériaux par Jacques-Louis David," *Gazette des Beaux-Arts*, 6ᵉ période, 102 (juillet-août 1983): 21-34.

2. For extended discussions of portraits of Napoleon, see Werner Telesko, *Napoleon Bonaparte: Der "moderne Held" und die bildende Kunst, 1799-1815* (Wien: Böhlau, 1997); and Gérard Hubert and Guy Ledoux-Lebard, *Napoleon. Portraits contemporains. Bustes et statues* (Paris: ARTHENA, 1999), 88-93.

3. For more on the painting, see my "Antoine-Jean Gros in Italy," *Burlington Magazine* 137 (October 1995): 651-660.

4. Tony Halliday, *Facing the Public: Portraiture in the Aftermath of the French Revolution* (Manchester: Manchester University Press, 1999), 179.

5. For an examination of Isabey's drawing, see the discussion in Halliday, 182-84.

6. For an excellent account of the painting that sorts out the provenance of its many versions and summarizes earlier accounts, see Antoine Schnapper, *Jacques-Louis David 1748-1825*, (Paris: Réunion des musées nationaux, 1989), 381-85. Many scholars have argued that Bonaparte's imperial ambitions are evident in David's painting, but Dorothy Johnson has argued that David may have included the monarchical allusions in order to legitimize Bonaparte's rule in the eyes of the King of Spain, the patron of the first version. See Dorothy Johnson, *Jacques-Louis David: Art in Metamorphosis* (Princeton: Princeton University Press, 1993), 180.

7. On these commissions, see Edward Lilley, "Consular Portraits of Napoleon Bonaparte," *Gazette des beaux-arts* 6ᵉ période, 106 (November 1985): 143-56; and Nicole Hubert, "A propos des portraits consulaires de Napoléon Bonaparte. Remarques complémentaires," *Gazette des beaux-arts* 6ᵉ période, 108 (July-August 1986): 23-30.

8. See my *After the Revolution: Antoine-Jean Gros, Painting and Propaganda Under Napoleon Bonaparte* (University Park, Pa.: Penn State Press: Forthcoming 2003); Derin Tanyol, *Napoleonic History Painting from Gros to Delaroche: A Study in History Minor* (Ann Arbor, Mich.: University Microfilms International, 2000); and Christopher Prendergast, *Napoleon and History Painting: Antoine-Jean Gros's La Bataille d'Eylau* (Oxford: Clarendon Press, 1997).

9. On the busts, see Hubert and Ledoux-Lebard, 88-93; Christopher Johns, *Antonio Canova and the Politics of Patronage in Revolutionary and Napoleonic Europe* (Berkeley: University of California Press, 1998), 88-106.

10. I follow here the account in Johns, 88-106.

11. For thorough discussions of the life portraits of Jefferson and the problems of identifying their provenance, see Alfred L. Bush, "The Life Portraits of Thomas Jefferson," in *Jefferson and the Arts: An Extended View*, ed. William Howard Adams (Washington, D.C.: National Gallery of Art, 1976), 11-100; Noble E. Cunningham, *The Image of Thomas Jefferson in the Public Eye: Portraits of the People* (Charlottesville: University of Virginia Press, 1981); Dorinda Evans, *The Genius of Gilbert Stuart* (Princeton: Princeton University Press, 1999), 92, 104-04, 150-51; David Meschutt, "Gilbert Stuart's Portraits of Thomas Jefferson," *American Art Journal* 13 (1981): 2-16; and idem., "The Adams-Jefferson Portrait Exchange," *American Art Journal* 14 (1982): 47-54.

12. For extended analyses of visual representations of Washington during the early republican period, see Gustavus Eisen, *Portraits of Washington*, 3 vols. (New York: Robert Hamilton and Associates, 1932); Wendy C. Wick, *George Washington, An American Icon: The Eighteenth-Century Graphic Portraits* (Washington, D. C.: Smithsonian Institution Traveling Exhibition Service and the National Portrait Gallery, 1982); Garry Wills, *Cincinnatus: George Washington and the Enlightenment* (Garden City, N. Y.: Doubleday, 1984); Barbara J. Mitnick, *The Changing Image of George Washington* (New York: Fraunces Tavern Museum, 1989); Ellen G. Miles, *George and Martha Washington: Portraits from the Presidential Years*, (Washington, D.C.: Smithsonian Institution, National Portrait Gallery, 1999); and Barbara J. Mitnick, ed., *George Washington: American Symbol* (New York: Hudson Hills Press, 1999).

13. Despite Washington's oft-expressed impatience with sitting for portraits, there is still much debate on the extent to which Washington took a role in fashioning his own public image. A full exploration of this extends beyond the space available here. On this question, see Wills; and Paul K. Longmore, *The Invention of George Washington* (Berkeley: University of California Press, 1988).

14. On Washington's transformation into a historical and legendary personage, see Wills; and Barry Schwartz, *George Washington: The Making of an American Symbol* (New York: Free Press, 1987).

15. Cited from Wills, 13.

16. Jefferson proposed the commission to Congress on July 8, 1786. Arnason speculated that the cost of the sculpture killed the project. H. H. Arnason, *The Sculptures of Houdon* (New York: Oxford University Press, 1975), 72-77.

17. Letter of August 1, 1786. Quoted from *The Papers of George Washington*, ed. Dorothy Twohig, *Confederation Series*, vol. 4, April 1786-January 1787, ed. W. W. Abott (Charlottesville: University Press of Virginia, 1995), 183-84.

18. On Ceracchi's busts of Washington, see Ulysse Desportes, "Giuseppe Ceracchi in America and his Busts of George Washington," *Art Quarterly* 26 (Summer, 1963), 141-178.

19. Joseph Ellis, *American Sphinx: The Character of Thomas Jefferson* (New York: Vintage Books, 1998), 194.

20. For Jefferson's attitude toward painting and sculpture, see the William Howard Adams, ed., *Eye of Thomas Jefferson* (Washington, D.C.: National Gallery of Art, 1976); Harold Dickson, "Jefferson as Art Collector," in *Jefferson and the Arts*, 101-32; and George Green Shackelford, "A Peep into Elysium," in *Jefferson and the Arts*, 233-70.

21. "Travel Notes for Mr. Rutledge and Mr. Shippen, June 3, 1788," in *The Life and Selected Writings of Thomas Jefferson*, ed. A. Koch and W. Peden (New York: The Modern Library, 1998), 138-39.

22. On the French project, see Francis H. Dowley, "D'Angiviller's Grands Hommes and the Significant Moment," *Art Bulletin* 39 (December, 1957): 259-277.

23. For a discussion of this belief in relation to Stuart's portraits of Washington, see Evans, 66-67.

24. Charles Willson Peale, *The Selected Papers of Charles Willson Peale and his Family*, vol. 5, *The Autobiography of Charles Willson Peale*, ed. Sidney Hart (New Haven: Yale University Press, 2000), 396.

25. On this aspect of early republican presidential portraiture, see Elizabeth Johns, "Science, Art, and Literature: Their Prospects in the Republic," in *Everyday Life in the Early Republic*, ed. Catherine E. Hutchins (Winterthur, DE: Winterthur Museum, 1994), 355-63.

26. Quoted in Andrew Oliver, *Portraits of John and Abigail Adams* (Cambridge, MA: Harvard University Press, 1967), 25.

27. On the engravings, see Cunningham, 55-69.

28. For a study of George Washington's image across the nineteenth century, see Mark Thistlethwaite, *The Image of George Washington: Studies in Mid-Nineteenth-Century American History Painting* (New York: Garland, 1979).

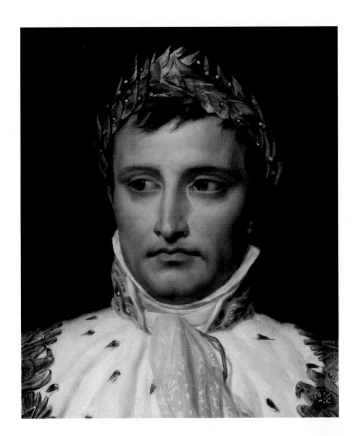

27.

Jacques-Louis David (French, 1748–1825)
Head of Napoleon as Emperor

Oil on wood
17 x 14 inches (42.4 x 34.8 cm)
Fondation Dosne-Thiers, Institut de France, Collection Frédéric Masson, Paris (MP033 (1346))

This painting is either a study for or replica after the head of Napoleon in a lost portrait that David painted for Napoleon's brother, King Jérôme of Westphalia (Jérôme Bonaparte) in 1808. From related works, we know that it resembled those of eighteenth-century Bourbon kings in pose and iconography unlike David's earlier portraits of Napoleon. David surrounded the emperor with ceremonial objects and clothed him in ermine robes. On his head he wears the gold laurel wreath from his coronation. Recent scholarship has emphasized how David, who had been a prominent Jacobin revolutionary, approached such imperial portraits with ambivalence. **D.O.**

28.

Rembrandt Peale (American, 1778–1860)
Portrait of Thomas Jefferson, 1805

Oil on canvas
28 x 23 inches (71.1 x 59.7 cm)
The New-York Historical Society, New York. Gift of Thomas J. Bryan

Rembrandt Peale completed his second life portrait of Jefferson shortly after the president's reelection. He displayed it in Charles Willson Peale's museum in Baltimore, where it was given special illumination on the night of Jefferson's second inaugural. The president's casual dress, slightly unkempt hair, and focused gaze make this an exceptionally personal and engaging portrait. **D.O.**

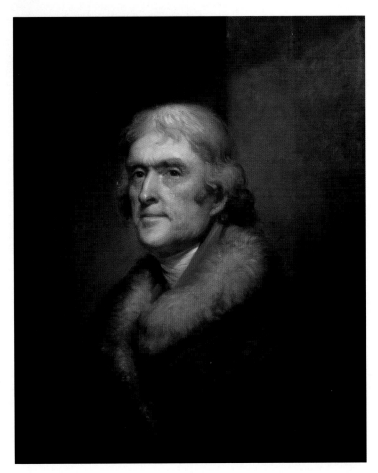

29.

Charles Louis Corbet (French, 1758–1808)
Bust of General Bonaparte, circa 1798–1800

Bronze
32-3/4 x 24 inches (83 x 62 cm)
Fondation Napoléon, Paris, Collection
Martial Lapeyre (43)

Corbet exhibited a plaster version of this bust in the Salon of 1798 and claimed that it was executed from life. It was certainly one of the earliest sculpted portraits of Bonaparte, who had already departed for Egypt when it went on display. Corbet captured many of the characteristics that became typical of the early likenesses of Bonaparte: he appears slightly gaunt, has long hair and a pronounced chin and nose, and wears an ardent expression. **D.O.**

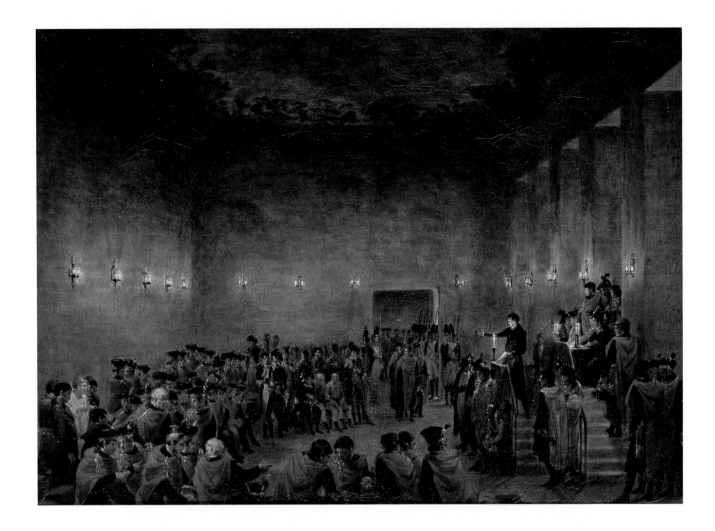

30.

Jacques Sablet (French, 1749–1803)
*Meeting Room of the Council of Five Hundred,
on the Night of the 19 Brumaire, year 8,* 1799

Oil on canvas
18 x 26 inches (46 x 66 cm)
Musée des Beaux-Arts, Nantes, France (694)
©Réunion des Musées Nationaux / Art
Resources, NY

On November 9, 1799, as part of the coup d'état that established the Consulate, France's two legislative assemblies, the Council of the Ancients and the Council of the Five Hundred, were moved out of Paris to the Chateau of Saint-Cloud, where the conspirators hoped to persuade them to support the new regime. On November 10, the Council of Five Hundred refused to acquiesce. Shouted down by the angry deputies, Bonaparte became faint and was helped from the hall. Once outside, he and his fellow conspirators claimed that an attempt had been made on his life and dispersed the Five Hundred with soldiers. Sablet's painting depicts a scene that took place later that evening. In order to give the new regime a veneer of legality, Lucien Bonaparte assembled a group of deputies from the Five Hundred and successfully convinced them to invest the power of government in three "Consuls": Napoleon Bonaparte, Emmanuel Joseph Sieyès, and Roger Ducos. **D.O.**

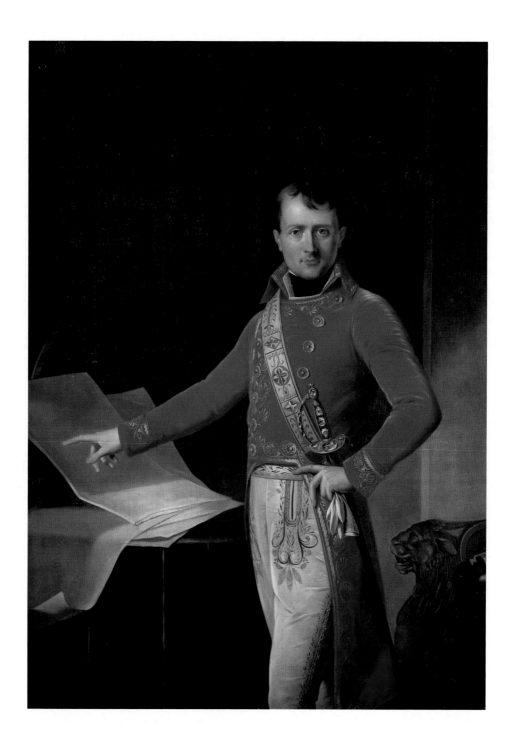

31.

Joseph-Marie Vien, fils (French, 1761-1848)
after Robert Lefèvre (French, 1755–1830)
Portrait of Bonaparte as First Consul, 1803

Oil on canvas
95-1/4 x 69-3/4 inches (241.93 x 177.16 cm)
Musée National du Château de Versailles,
France (MV 4633)
©Réunion des Musées Nationaux /
Art Resources, NY

In 1802 and 1803 Bonaparte asked Gros for four full-length portraits of himself dressed in the uniform of the First Consul. These served as prototypes for seven other pictures sent to provincial cities and carried out by Mme Marie-Guillèmine Benoît, Jean-Baptiste Greuze, Jean-Auguste-Dominique Ingres, Robert Lefèvre, Charles Meynier, Fortuné Dufau, and Joseph-Marie Vien, fils. The portrait by Vien, fils was intended for Bruges, which Bonaparte had incorporated into France. The documents on the table refer to the First Consul's efforts to stimulate commerce in the city and an offer made by the city to contribute to the war against England. **D.O.**

32.

Joseph Chinard (French, 1756–1813)
Portrait of Napoleon as First Consul

Terra cotta
14 inches (35.5 cm) with base
Private Collection

In this consular portrait bust of Bonaparte, Joseph Chinard carefully represented the uniform worn by the consuls, which was a combination of military and civilian design. The youthful face, however, more closely resembles portraits of Bonaparte as a rising military officer, particularly the portrait by Jean-Baptiste Greuze (French, 1725-1805) *Captain Bonaparte at age 22*, now in the collection at Malmaison. **V.C.**

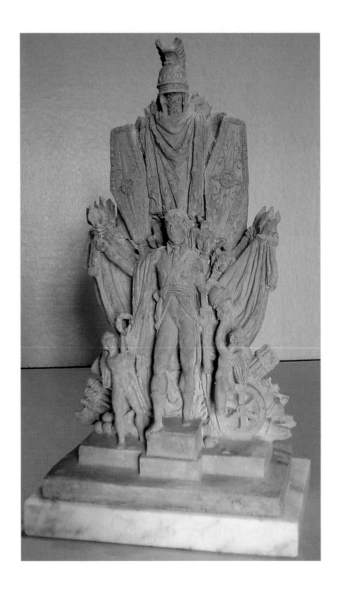
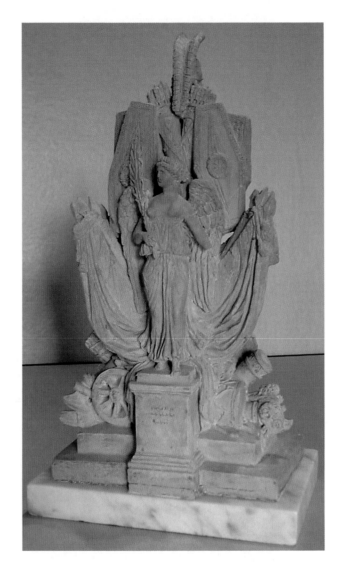

33.
Joseph Chinard (French, 1756–1813)
Project for Allegorical Monument of Napoleon as First Consul, circa 1801
Terra cotta
14 x 7 x 5-1/3 inches with base (35 x 18 x 10 cm)
Musée National du Château de Malmaison, Rueil-Malmaison, France
(N.31)

In 1801 Lyon held a contest to select a monument for the newly named Place Bonaparte. Contestants were instructed to show a "hero" with "the emblems of Victory, Peace, the Arts, and Commerce." Chinard's sculpture seems to relate to this competition. Standing before a trophy of flags, armor, and weapons, Bonaparte receives a crown and a helmet from two small putti. On the back, Victory holds a palm. **D.O.**

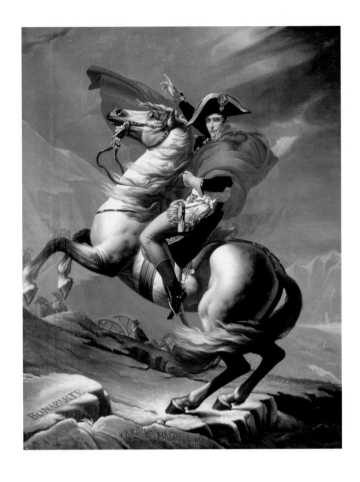

34.

After Jacques-Louis David (French, 1748–1825)
Napoleon Crossing the Alps by the Great Saint Bernard Pass,
19th century

Oil on canvas
64 x 50 inches (162.5 x 128.3 cm)
Louisiana State Museum, New Orleans, Louisiana

Jacques-Louis David, with the help of his studio, painted
five versions of this famous equestrian portrait of Napoleon
on a rearing horse. The romantic, charismatic leader calling
his men to follow him through the Saint Bernard Pass
became an iconic image of the First Consul. In reality,
Bonaparte had ridden a mule across the Pass. David's
large-scale originals are now too fragile to travel. Copies
were made throughout the nineteenth century, including
this one, by an unidentified French artist. **V.C.**

35.

Antonio Canova (Italian, 1757–1822)
Head of Napoleon

Marble
29 x 24 inches (73.7 x 61 cm)
Collection Roger Prigent, Malmaison Antiques, New York

In 1802 Bonaparte summoned Canova to Paris from Rome to execute
his portrait. The reluctant sculptor modeled a clay bust of the First
Consul, which subsequently served as the model for numerous marble
busts of Napoleon as well as the famous statue now in Apsley House.
Many examples of the bust in marble, mostly fashioned in Carrara, still
exist; at least forty-two were imported into France between 1804 and
1814. This is a particularly fine example of the monumental busts
which were intended to capture the idealized image of a ruler rather
than an exact portrait likeness of Napoleon. **D.O.**

36.

Anne-Louis Girodet de Roussy Trioson (French, 1767–1824)
Nude study of Napoleon, circa 1812

Black chalk
22 x 16-1/4 inches (56.9 x 41.3 cm)
Musée du Louvre, Département des Art Graphiques, Paris (RF34527)
©Réunion des Musées Nationaux / Art Resources, NY

In 1812 Napoleon commissioned thirty-six portraits of himself
from Girodet. This drawing reveals how the artist built the portrait
up from studies of an idealized nude figure in the pose of a Roman
emperor. Even though Napoleon would appear clothed in the final
portrait, Girodet believed, like his teacher David, that a proper
understanding of the human figure could only be achieved by
beginning with the nude body. **D.O.**

37.

Nicolas-Guy-Antoine Brenet (French, 1770–1846)
Model of the Vendôme column, circa 1832

Bronze
72 x 9-7/8 inches (184 x 25 cm)
Musée de la Monnaie, Paris (230)

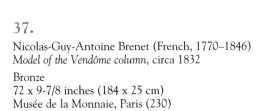

The medal-maker Brenet produced this scale model of the Vendôme column in 1832.
Originally known as the Column of the Grande Armée, or the Austerlitz Column, the
Vendôme column was made from the bronze of canons captured in the 1805 Austrian cam-
paign. Jean-Baptiste Lepère and Jacques Gondouin designed the structure, and a sculpture of
Napoleon as a Roman emperor holding a winged Victory by Antoine-Denis Chaudet crowned it.
The monument explicitly refers to Trajan's Column in Rome. By the time Brenet produced his
model, the statue of the Emperor by Chaudet had been replaced by one by Charles-Emile
Seurre. In Chaudet's version, Napoleon appeared muscular and idealized in antique dress, with
one hand resting on a glaive and the other supporting a winged Victory. When he saw the statue,
the emperor said he did not like such "idols," but he left it in place. **D.O.**

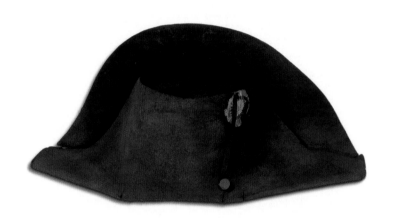

38.

Poupard (French, 18th-19th century)
Hat worn by Napoleon at the Battle of Eylau, circa 1807

Felt with silk
8 x 19 x 7 inches (21 x 49 x 18.5 cm)
Musée de l'Armée, Paris (Ca 02)
©Musée de l'Armée, Paris

Napoleon wore this hat at the Battle of Eylau, one of the bloodiest and most futile episodes of the Napoleonic wars. The simple design of this bicorne, which lacks both a plume and trim, accorded well with the modest appearance he cultivated on the battlefield. This hat was given to Antoine-Jean Gros when he was at work on his famous painting of the aftermath of the battle, *Napoleon Visiting the Battlefield of Eylau the Morning after the Battle* (1808, Louvre). Eventually it was placed atop Napoleon's coffin in the Invalides, but in 1966 it was removed for reasons of security. **D.O.**

39.

Unidentified Artist, French School
Travel Briefcase of Bonaparte, circa 1799-1804

Leather, embossed in gold
10-3/4 x 20-3/4 inches (27.5 x 53 cm)
Musée de l'Armée, Paris (Ca 31)
©Musée de l'Armée, Paris

Embossed in gold, *Premier Consul*, this leather briefcase was used by Bonaparte to transport important documents on his military campaigns. **V.C.**

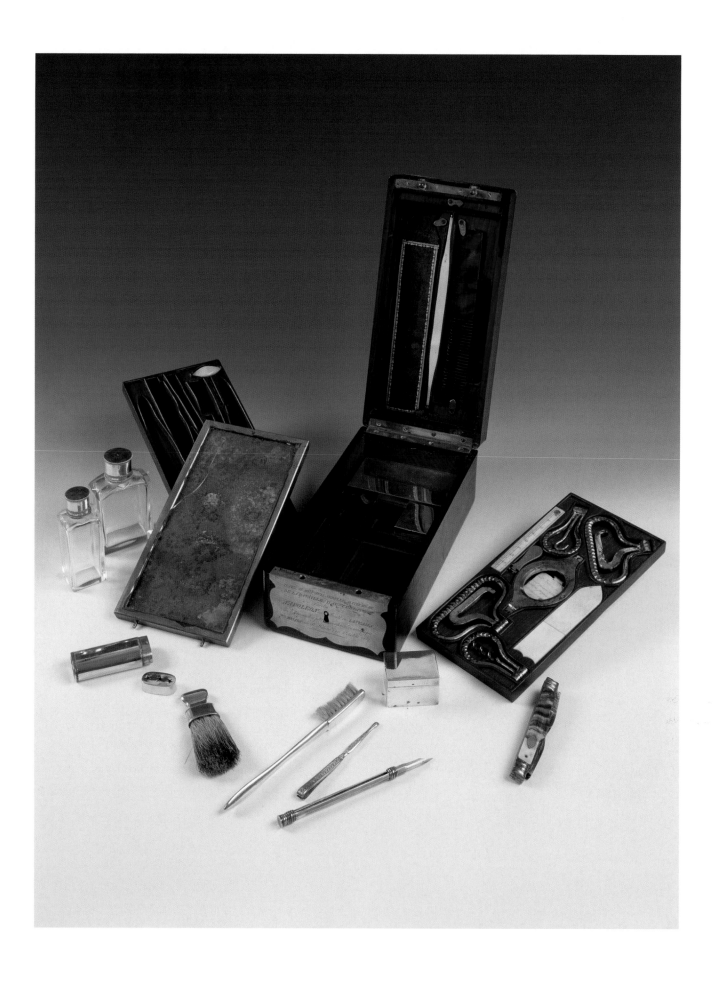

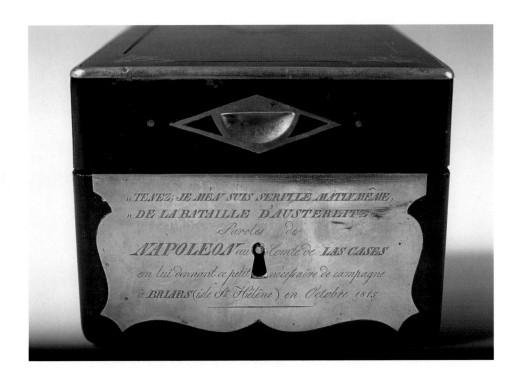

40.

Martin-Guillaume Biennais (French, 1764–1843)
Napoleon's Necessaire from Battle of Austerlitz

Silver, steel, copper, ivory and mahogany
4-3/8 x 32-1/2 x 8-1/4 inches (11 x 83 x 21 cm)
Fondation Napoléon, Paris, Collection Martial
Lapeyre (1160)

Biennais provided Napoleon and Josephine with several *necessaires*, traveling cases containing "necessary" objects for the toilette and writing in portable sizes. These cases vary in complexity. This *necessaire* was used by Napoleon at the battle of Austerlitz and contained twenty-two objects including boot hooks and shaving instruments. **V.C.**

41.

Napoleon Bonaparte (French, 1769–1821)
Code Napoléon, 1804

On vellum, bound in blue Moroccan leather
10-2/3 x 8 x 3-1/3 inches (27 x 21.5 x 8.5 cm)
Bibliothèque Nationale de France, Paris (4-Z-Adler-53)

On March 21, 1804, Napoleon promulgated a new legal code to replace several different codes inherited from the Old Regime. After 1807 it became known as the Code Napoléon. Its clarity and organization made the Code a model for numerous other nations, and its influence is still evident in Louisiana civil law. Despite many changes, the Code remains in effect in France. Napoleon's influence on the Code is evident in the power given to husbands over their wives and children, the guarantees of freedom of religion, and equality before the law. This copy of the Napoleonic Code belonged to Jean-Jacques-Régis Cambacérès, whose initials appear on the cover. Cambacérès replaced Emmanual Joseph Sieyès as Second Consul shortly after the coup de état that placed Bonaparte in power. He played a major role in the creation of the Code. **D.O.**

42.

François-Louis Couche (French, 18th-19th century)
Napoleon I Reestablishing the Cult of the Israelites, 1810

Lithograph
12-5/8 x 5-5/8 inches (32.1 x 14.3 cm)
The Library of the Jewish Theological Seminary of America, New York

On May 30, 1806, Napoleon reestablished the Grand Sanhedrin and gave the Jews of France civil rights. His motive seems to have been to gain influence and control over the Jewish population and, moreover, the conscription of Jewish men into the military. In this print reproducing the Imperial Proclamation, he is shown in his coronation robes receiving the gratitude of his Jewish subjects. **V.C.**

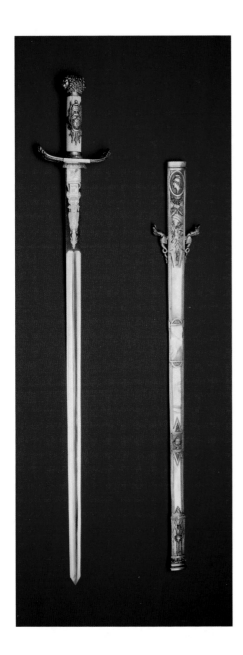

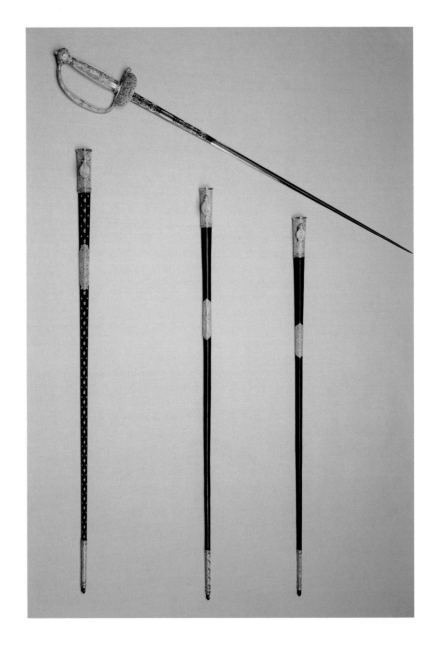

43.

Nicolas-Noël Boutet (French, 1761–1833)
Glaive of the First Consul, circa 1800
inscribed: *Boutet Directeur Artiste Manufre à Versailles*

Gold, silver gilt, steel, ivory, mother of pearl, enamel
36 inches (92 cm)
Musée National du Château de Malmaison,
Rueil-Malmaison, France (N202)
©Réunion des Musées Nationaux / Art Resources, NY

The antique form of this glaive was no doubt intended
to reinforce the Roman associations of Bonaparte's
office of First Consul. The sword is superbly fashioned
from dazzling precious materials. Such military objects
were never associated with the office of the chief
executive in the United States, and Jefferson eschewed
items of such lavishness. **D.O.**

44.

Martin-Guillaume Biennais (French, 1764–1843)
Epée of the Emperor with its case and three scabbards, circa 1806
Signed on the quillon: *Biennais Orfèvre de LL MM Impériales et Royales/
et de Sa Majesté le Roi de Holland à Paris / an 1806*

Gold, enamel, steel, and leather
37 inches (93 cm)
Musée Nationale du Château de Fontainebleau, France (207)
©Réunion des Musées Nationaux / Art Resources, NY

Napoleon had several epées in this style, known as an *epée de service*. This
piece was made by Biennais, who held the position of goldsmith to the
emperor. The ornamental design incorporates Napoleonic symbols such as
the bee and the eagle, as well as sixteen stars representing the original
sixteen cohorts of the Legion of Honor. Other symbols refer to fame and
military strength, including the heads of Minerva and Hercules and the laurel
wreath. Napoleon presented this epée to the Grand Duke Constantine,
brother to Czar Alexander I of Russia, during negotiations in Erfurt in 1808.
V.C.

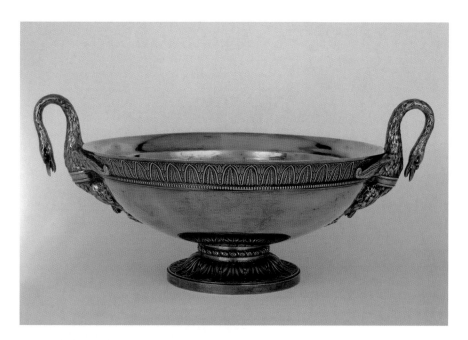

45.

Henri Auguste (French, 1769–1816)
Basin, 1804

Vermeil
8-2/3 x 20 inches (22 x 51 cm)
Musée National du Château
de Fontainebleau, France (8438)
©Réunion des Musées Nationaux /
Art Resources, NY

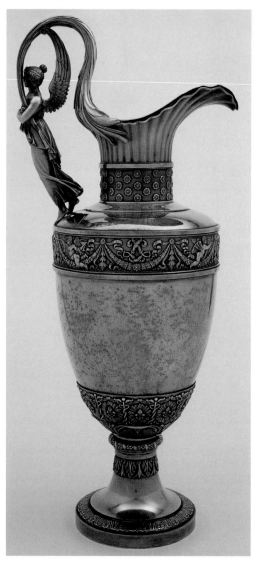

46.

Henri Auguste (French, 1769–1816)
Ewer, 1804

Vermeil
18-3/4 x 8-1/2 inches (47.5 x 21.5 cm)
Musée National du Château de Fontainebleau, France (MM 40.47.8437)
©Réunion des Musées Nationaux / Art Resources, NY

This basin and ewer belong to a silver gilt service, the Grand Vermeil, given to
Napoleon and Josephine by the city of Paris in 1806. These richly designed
objects were used, according to French etiquette, by the Emperor and Josephine
to wash their hands at the beginning or end of each meal. During the Empire,
the aristocracy returned to the extravagant dining rituals of court society, which
stand in contrast to Jefferson's efforts to abolish ceremony and formal protocol
in the American presidency. **V.C.**

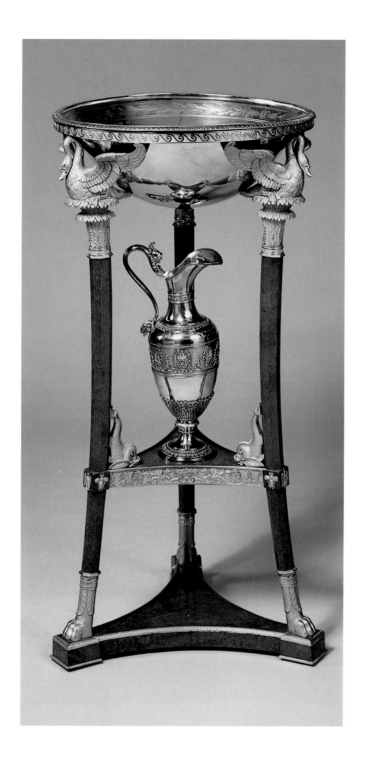

47.

Martin-Guillaume Biennais (French, 1764–1843)
Napoleon's Personal Washstand, circa 1800–04

Yew, gilt, bronze, silver
35-3/8 x 18 inches (90 x 47 cm)
Musée du Louvre, Département des Objets d'Art,
Paris (OA 10424)
©Réunion des Musées Nationaux /
Art Resources, NY

The design of this washstand derives directly from a Roman tripod discovered in Paris. Napoleon kept this washstand in his bedroom in the Tuileries Palace and took it with him to Saint Helena after his final defeat at Waterloo. He commissioned it in 1800. The swans are part of the original designs and allude to Apollo, while the eagles were added later and belong to the imperial imagery introduced when Napoleon became emperor in 1804. Biennais's magnificent design and exquisite execution exemplify Napoleon's revival of the opulent lifestyle cultivated by the kings of pre-revolutionary France. **D.O.**

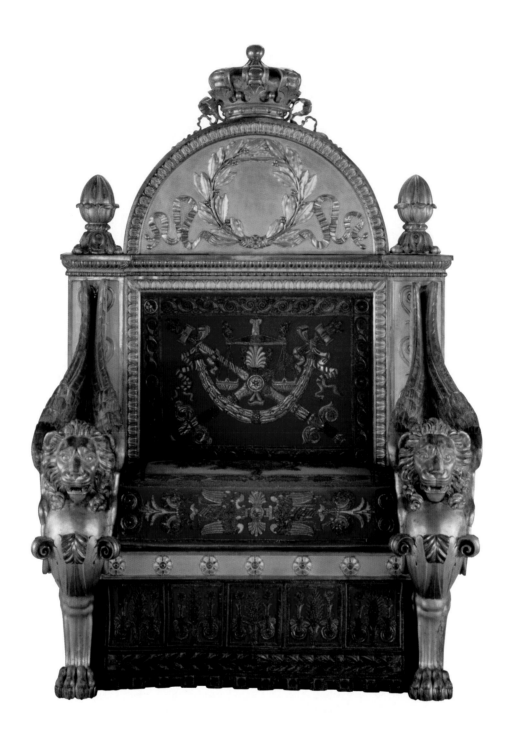

48.

François-Honoré-Georges Jacob-Desmalter (French, 1770–1841)
Throne from the Legislative Assembly, 1804

Gilt wood, velvet, gold embroidery
63 x 43-1/4 x 32-1/4 inches (160 x 110 x 82 cm)
Musée des Arts Décoratifs, Paris (14421)

Explaining his abandonment of the republican ideals promoted
by the French Revolution, Napoleon declared, "The French
love monarchy and all its trappings." Upon crowning himself
emperor, he adopted the symbolism of monarchical rule and
had several thrones designed and built for his use. This one,
built by Jacob-Desmalter, *ébéniste de l'Empereur*, after a drawing
by Bernard Poyet, was used in the Legislative Assembly. Its gilded
wood frame and rich upholstery stand in marked contrast to the
austere, simple design of the red leather, easy chair Jefferson is
thought to have used when presiding over the Senate as vice-
president during the Adams administration (**cat no. 160**). **V.C.**

49.

Pierre-Joseph-Simon Tiolier (French, 1763–1819)
20-franc piece, 1803–04
Gold
13/16 inch (21 mm)
The Metropolitan Museum of Art, New York. Gift of C. Ruxton
Love, Jr., 1967 (67.265.2)
©2002 The Metropolitan Museum of Art

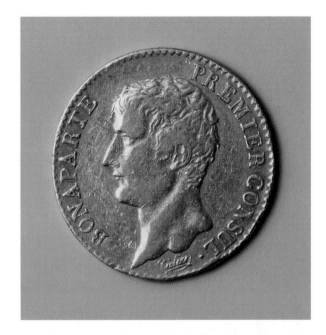

50.

Jean-Pierre Droz (French, 1763–1819)
20-franc piece, 1811
Gold
13/16 inch (21 mm)
The Metropolitan Museum of Art, New York. Gift of John W.
Auchincloss, 1912 (12.170)
©2002 The Metropolitan Museum of Art

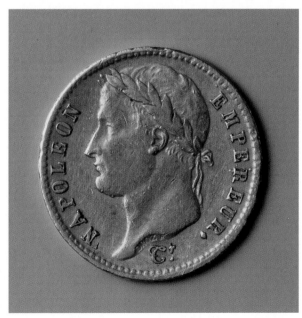

Following the ancient tradition, Napoleon ordered his image placed
on newly minted coins. Tiolier, the engraver-general of the French
mint, designed the consular gold 20-franc piece that shows Bonaparte
in profile, surrounded by the words "Bonaparte Premier Consul." The
imperial coin, designed by engraver-machinist Jean-Pierre Droz, shows
a similar profile crowned with a laurel wreath and identified as
"Napoleon Empereur." Ironically, the reverse continued to refer to
France as a Republic until 1809. Jefferson was instrumental in early
discussions of United States currency; however, his now familiar pro-
file did not appear on the American nickel until 1938. **V.C.**

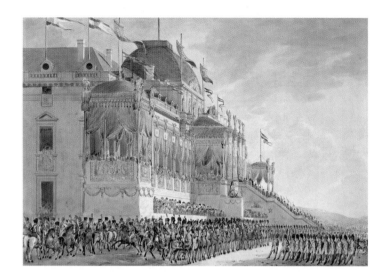

51.

Charles Percier (French, 1764–1838)
and Pierre-François-Léonard Fontaine (French, 1762–1853)
Livre de Sacre: Distribution of the Eagles on the Champs Mars, 1804

Watercolor image in a bound volume
14-1/4 x 20 inches (36.2 x 52 cm)
Fondation Napoléon, Paris, Collection of Martial Lapayre (1150)

As part of the ceremonies surrounding his coronation, Napoleon distributed standards adorned with gilt bronze eagles to delegations from the Army and National Guard, who swore an oath to defend them to the death. For the event, the architects Percier and Fontaine attached three enormous pavilions, connected by galleries, to the façade of the Ecole Militaire. The central pavilion, which housed the thrones of the emperor, featured four monumental columns surmounted by gilt Victories. An enormous staircase ran down from it to two statues of France, at peace and at war. The various members of the imperial court, the government, and the Legion of Honor found their place in this structure, while the military delegations swore their oath on the stairs. **D.O.**

52.

Pierre-Philippe Thomire (French, 1751–1843),
after Antoine-Denis Chaudet (French, 1763–1810)
Eagle from the Flag of the 26th Infantry of the Line, 1804

Gilt bronze, length with staff
95 inches (241 cm)
Musée de l'Armée, Musée de l'Empérie, Paris (6167)
©Musée de l'Armée, Paris

Inspired by imperial Rome, Napoleon chose the eagle as the emblem of the Empire. Eagles crafted by bronze caster Pierre-Philippe Thomire, after a design by Antoine-Denis Chaudet, adorned the standards of his troops. **D.O.**

Napoleon, Egypt and the Birth of Orientalism

Victoria Cooke

To associate the glory of your name with the splendor of the monuments of Egypt is to combine the grandeur of our century with the mythical eras of history . . . I have spared no effort in making it worthy of the hero to whom I wish to dedicate it.
Vivant Denon, *Travels in Upper and Lower Egypt . . .*[1]

During the revolutionary decade and under the auspices of the government known as the Directory, the young general Napoleon Bonaparte forged his image as a dashing war hero, first in Italy, but most importantly, in Egypt, then a semiautonomous state within the Turkish Ottoman Empire. Preparing for the Egyptian campaign of 1798 to 1799, General Bonaparte amassed an experienced military force, as well as an impressive entourage of savants—experts, including artists, scholars, architects, and engineers—who measured and recorded Egypt in every conceivable way. They gathered knowledge about the people, their history and antiquities, and their culture. While Napoleon's military objective was to conquer Egypt thereby cutting off Britain's most direct route to India, its most valuable colony, he also desired the acquisition of knowledge; and, he established the Institute of Egypt in August 1798 to promote the scholarly research of the savants. The institute, which thrived until the French withdrawal from Egypt in 1801, was conceived as a great cultural and intellectual achievement for France, an ambition influenced by the ideals both of the Enlightenment and the Revolution. Combining the desire to conquer with the desire to explore and document an exotic culture, the Egyptian campaign was the opening salvo of modern Orientalism, the fascination with—and representation of—the peoples of the Middle East, North Africa and Asia.[2]

Leading the savants was the artist Dominique Vivant Denon (1747–1825) who became Napoleon's chief artistic advisor and the director of the Louvre, renamed the Musée Napoléon (*fig. 1*). The publication in 1802 of Denon's *Travels in Upper and Lower Egypt, during the cam-*

Figure 1: Pierre-Paul Prud'hon (French, 1758-1823), *Baron Vivant Denon*, Oil on canvas, 24 x 20 inches (61 x 51 cm), Musée du Louvre, Paris
©Réunion des Musées Nationaux / Art Resources, NY

paigns of General Bonaparte in that country (**cat. no. 63**) provided the public with an eyewitness account of the military campaign, descriptions of the peoples of Egypt, and a record of the excavations and detailed study of ruins conducted by the savants. Quickly translated into other languages, including English in 1803, it became an authoritative source book for artists who wanted to portray the appearance and manner of dress of the people, details of the ancient monuments, and the hieroglyphics. Denon's *Travels*, and the encyclopedic, multivolume *Description de l'Egypte, ou, Recueil des observations et des recherches qui ont été faites en Egypte pendant l'expédition de l'armée française*, published between 1809 and 1828, remain invaluable sources for the study of Egyptian society at the end of the eighteenth century, the early years of Egyptology, and contemporary French attitudes toward the country.

General Bonaparte returned from Egypt in October 1799, hailed as the victorious commander. Seizing upon his notoriety, he became First Consul in the bloodless coup of 18 Brumaire (9 November 1799). During the Consulate and the Empire, the legends of the Egyptian campaign generated an explosion of interest in the Near East. As the backdrop for biblical stories, the ancient Muslim land was both familiar and exotic, and the French public's fascination with Egypt sparked a demand for Egyptian motifs in the arts, from textile patterns representing ancient monuments (**cat. no. 67**) to the grand history paintings destined for the Salon.

This demand was fed, in part, by projects encouraged by Denon. As an artistic advisor for the Sèvres porcelain factory, he supervised the production of two complete dinner services based on the illustrations in *Travels*, one for Napoleon and a second for Josephine.³ The plates are a rich combination of the ancient and the modern. The rims are painted with gold figures and symbols drawn from ancient wall decorations. These form borders for scenes from Denon's book. *The Combat and Death of Duplessis* (**cat. no. 64**) shows not a grand battle between opposing armies but a lone French officer fighting to the death against three Mameluk horsemen. The scene pits the purported ferocity of Muslim warriors against the bravery of the French soldier. The numerous views of archeological sites celebrate the scientific contribution of the savants. In the plate showing *Ruins of the Temple on the Isle of Elephantine* (**cat. no. 66**), an ancient seated figure towers over his modern counterparts evoking the past grandeur of Egyptian civilization.

Denon's images celebrated the benefits of Bonaparte's restoration of organized and peaceful civil authority to Egypt as well. When the British Fleet under the command of Lord Nelson sunk the French Fleet and stranded the army in Egypt, General Bonaparte dedicated his prodigious talent for organization to the civil society of Egypt. He renewed the custom of administrative councils, called *divans*, each comprised of seven local Arab men, which advised the French generals assigned to each province. Each divan sent a representative to the grand divan in Cairo. In Denon's *Military Divan* (**cat. no. 65**), French officers listen to the grand divan, led by Shaykh al-Sharqawi, illustrating the "civilizing effect" of French presence in Egypt.

While Denon's illustrations found on the Egyptian service plates referred to actual events, other instances of Orientalism fed the French taste for fantasy. This was particularly the case with the portrayal of women as European artists had little contact with modern Egyptian women who were restricted by Islamic law to the private quarters of their homes. Artists often represented them in the timeless realm of the past.⁴ In ancient Egyptian wall paintings, women were shown nude to the waist, which inspired designs such as the Sèvres *Ink Well* (**cat. no. 70**) and the *Clock in the Form of an Egyptian Woman* (**cat. no. 69**). In the clock, the *nemes*, or headdress, terminates in two tassels positioned carefully to draw attention to her bare breasts.

Orientalism was most closely associated with the large history paintings of the Salon. Throughout the Consulate and the Empire periods, artists were employed to commemorate the great battles of the Egyptian and Syrian campaigns. The first of these projects was the competition for a monumental picture showing the Battle of Nazareth (**cat. no. 74**). The winner of the competition was Antoine-Jean Gros (1771–1835), whose sketch is part documentation of the event, part pro-colonialist propaganda. Not having traveled to the region, the artist relied on information from Denon's drawings for details of dress and physiognomy, and consulted a map of the battle by the French commander General Andoche Junot (1771–1813; **cat. no. 75**) for the topography of the battlefield. In his own map and schematic drawing for the painting's composition (**cat. no. 76**), Gros altered the landscape so that the French defended Christian holy sites from the forces of Islam, a stock motif in pro-colonial discourse.⁵

The Battle of Nazareth was a significant victory for the French as Junot defeated several thousand Turks and Mameluks with only a few hundred men. Bonaparte, who carried a Mameluk saber into the Battle of the Pyramids on July 21, 1798, (**cat. no. 72**) referred to these warriors as "objects of veneration and terror."⁶ The Mameluks were taken as children from their homes in the regions of Georgia and Caucasus by the Turks, converted to Islam and trained to serve in the Turkish cavalry. These were not slaves in the conventional sense. Over several centuries the Mameluks had become an elite class who nominally paid allegiance to the Ottoman Sultans but, in fact, ruled Egypt as an independent state within the Empire. The defeat of this reputedly invincible force at the hands of the French shocked the Muslim world.

Among the spoils taken from the Battle of the Pyramids was the *toug* (**cat. no. 73**) of the Turkish commander.

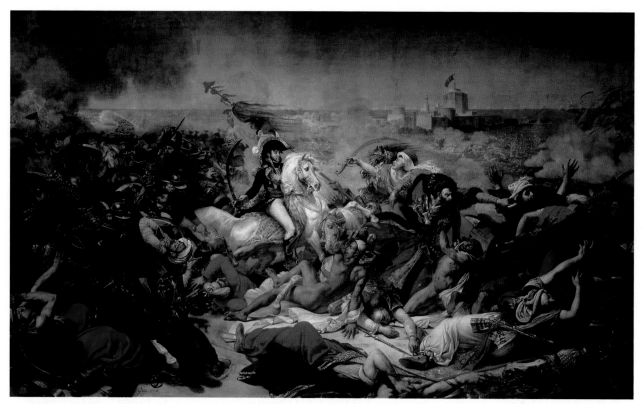

Figure 2: Antoine-Jean Gros (French, 1771-1835), *The Battle of Aboukir, July 25, 1799*, 1806, Oil on canvas, 173 x 381-1/8 inches (578 x 968 cm), Musée National du Châteaux, Versailles, France
©Réunion des Musées Nationaux / Art Resources, NY

Tougs, decorated staffs more than eight feet long, preceded leaders into battle and were often offered as a sign of surrender, as seen in Gros's 1806 painting *The Battle of Aboukir, July 25, 1799*, (fig. 2) commissioned by Bonaparte's brother-in-law, the flamboyant French cavalry hero Joachim Murat (1767–1815; **cat no. 53**). Here Gros deliberately draws a contrast between the figure of Murat, who embodies the honorable principles of French culture, and the paired figures of the Pasha of Rumalia—wild-eyed, passionate and continuing to resist—and his young son who submits, ready to receive the benefits of French rule. The son hands Murat his father's saber, which, like the offering of a commander's *toug*, was a symbolic gesture of capitulation.

Perhaps the most unusual war trophy Bonaparte brought back to France was his own personal Mameluk, Roustam Raza (1780-1845), given to him by the Shiek El-Bekry in 1799. Bonaparte did not keep him as a slave; rather, Roustam served as his personal bodyguard until 1814. In a portrait by Jacques-Nicolas Paillot de Montabert shown at the Salon of 1806, Roustam wears a richly embroidered vest based on Ottoman textile design and a saber, emphasizing his Mameluk heritage (**cat. no. 71**). The vest, however, was made in France, and the Mameluk's round face and his easy smile lack the fierce *otherness* common to depictions of Muslim warriors.[7] Roustam, having pledged

his Mameluk training to the protection of Bonaparte and assimilated into French society, was seen as a living testament to the "civilizing effects" of French culture. Bonaparte himself was so impressed by Mameluk military prowess that he ordered his successor in Egypt, General Jean-Baptiste Kléber (1753–1800), to recruit Mameluk warriors to serve in the French cavalry. They became one of the most celebrated units of the imperial military.

Napoleon's desire to create a positive public image led him to encourage artists to transform defeats into positive propaganda. Gros faced this challenge in his *General Bonaparte Visiting the Plague-Stricken Soldiers in the Hospital at Jaffa*, 1804 (**cat. no. 77**). During the Syrian campaign of 1799 many French soldiers contracted the plague. Bonaparte is believed to have ordered the plague victims poisoned with opium to hasten their death. When the British arrived in Jaffa, a few soldiers had survived and the story became a scandal in the British press, sparking rumors in Paris. Gros's painting would recast the episode by showing the general on his visit to the victims in a temporary hospital. He carefully depicted Bonaparte as the fearless and benevolent leader of men, "a healer, harmonizer, and savior to the Frenchmen."[8] He reaches out a bare hand to touch the open sore of a sick soldier, a gesture reminiscent of images of Christ healing the sick and of the ancient tradition of the healing powers of

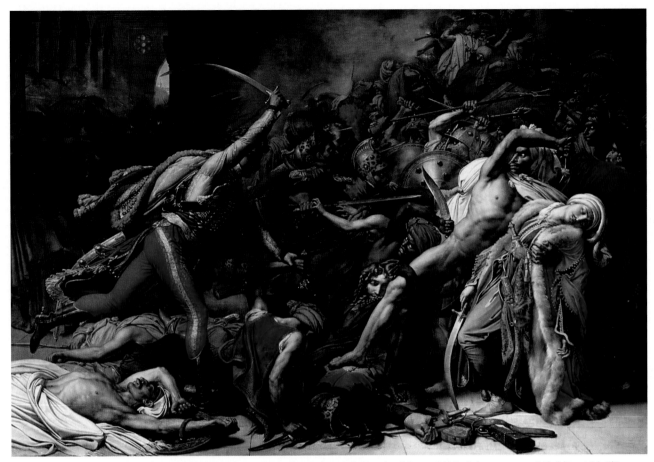

Figure 3: Anne-Louis Girodet de Roussy-Trioson (French, 1767-1824), *Revolt of Cairo*, 1810, Oil on canvas, 143-3/4 x 196-7/8 inches (365 x 500 cm), Musée National du Châteaux, Versailles, France
©Réunion des Musées Nationaux / Art Resources, NY

French kings. This was significant symbolism in 1804, the year of Napoleon's coronation as emperor, implying that he could repair the lingering wounds inflicted on France by the divisive government of the Directory.[9]

Artists evoked the Egyptian campaign in a variety of ways, as the paintings at the Salon of 1810 show. Girodet's dramatic *Revolt of Cairo* highlighted the direct confrontation between the French and the Muslims (*fig. 3*), while Gros's *Bonaparte Haranguing the Army before the Battle of the Pyramids* celebrated the charismatic General Bonaparte addressing his troops before leading them to victory (*fig. 4*). In Jean-Pierre Franque's *Allegory of the Condition of France before the Return from Egypt* (**cat. no. 78**), the general answers the call home to restore order to France. With the great pyramids of Giza as a backdrop, Bonaparte lays his sword aside, heeding the pleas of a female personification of France. She is besieged by allegorical figures representing the corruption of the Directory. The inscription reads, "France, suffering under an unhappy government, summons from the bosom of Egypt the hero on whom her destiny depends."[10] In his allegory, Franque retroactively legitimizes the coup de Brumaire and presents Bonaparte's decision to

leave his struggling army behind in Egypt as an altruistic one; thus, he renders Bonaparte's military coup the only solution to the dangerous chaos the Directory had wrought upon France.[11] The message was one of great propagandistic import: the seemingly reluctant general abandoned his mission to rescue the ancient land of Egypt from the forces of Ottoman "barbarism" not for personal, political ambition but to rescue his beloved France from her own forces of discord.

The taste for Egyptian motifs in the arts, often described as Egyptomania, was in some respects an extension of the glorification of military themes at the imperial court.[12] Under Napoleon the new aristocracy was comprised largely of the generals who made their reputations in Egypt; therefore, military motifs abounded in the decorative arts (**cat. nos. 59, 60**). For the imperial court and the French public, Egyptian motifs evoked a sense of nostalgia for glorious battles in an exotic land and a distraction from the current battles in their own backyard. These images are romantic interpretations of the cult of war that had gripped—and would eventually undo—France under Napoleon's rule. The enduring popularity of these works

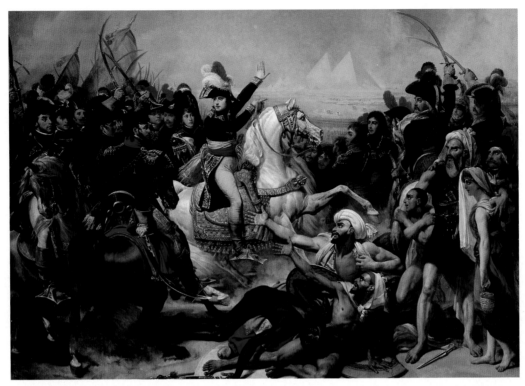

Figure 4: Antoine-Jean Gros (French, 1771-1835), *Bonaparte Haranguing the Army before the Battle of the Pyramids*, 1810, Oil on canvas, 153-1/8 x 201-1/8 inches (389 x 511 cm), Musée National du Châteaux, Versailles, France
©Réunion des Musées Nationaux / Art Resources, NY

has fulfilled the prophesy of Denon's dedication for his *Travels*: the name Napoleon has become forever associated with the great artistic legacy of ancient Egypt.

Notes:

1. Vivant Denon, *Travels in Upper and Lower Egypt, during the campaigns of General Bonaparte in that country*, vol. 1, Dedication to Bonaparte, 5.
2. Orientalism is defined by literature scholar Edward Said as a "Western style for dominating, restructuring, and having authority over the Orient." *Orientalism*: 3.
3. Empress Josephine rejected the second Egyptian service. It remained in storage at the Sèvres factory until Louis XVIII presented it as a gift to the Duke of Wellington in 1818.
4. For a pathway into the vast bibliography on this subject see Reina Lewis, *Gendering Orientalism: Race, Femininity and Representation* (London and New York: Routledge, 1996) and Anne McClintock, *Imperial Leather: Race, Gender and Sexuality in the Colonial Contest* (London and New York: Routledge, 1995).
5. Todd Porterfield, *Allure of Empire: Art in the Service of French Imperialism 1798–1836* (Princeton: Princeton University Press, 1998), 47. On Gros's painting see David O'Brien, *After the Revolution: Antoine-Jean Gros, Painting and Propaganda under Napoleon Bonaparte* (University Park, PA: Penn State Press, forthcoming 2003).
6. Eugène Fieffé, *Napoleon Ier et la garde impériale* (Paris: Furne, 1859), 57.
7. He took great care with his wardrobe, spending lavishly on outfits, particularly for the Sacre. Charles Otto Zieseniss, "Considérations su l'iconographie du mamelouk Roustam," *Bulletin de la Société de l'Histoire de l'Art Français* (1988): 169.
8. O'Brien, 5. For a recent study of the painting, see Darcy Grimaldo Grigsby, *Extremities: Painting Empire in Post-Revolutionary France* (New Haven and London: Yale University Press, 2002), 65-103.
9. Walter Friedlaender, "Napoleon as Roi Thaumaturge," *Journal of the Warburg and Courtauld Institutes* 4 (1941–42): 140.
10. Jacques Foucart, *French Painting 1774–1830: The Age of Revolution* (Detroit: Detroit Institute of Arts, 1975), 421.
11. Boime, 69.
12. For instance see the exhibition catalogue *Egyptomania: Egypt in Western Art 1730–1930* (Ottawa: National Gallery of Canada, 1994).

I would like to thank Gail Feigenbaum, David O'Brien and Susan Taylor-Leduc for their comments on this essay.

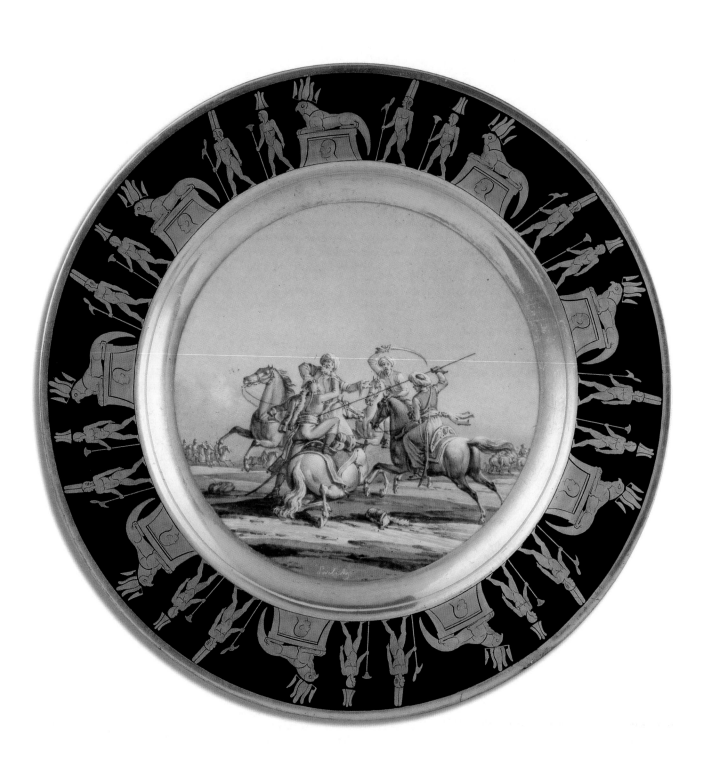

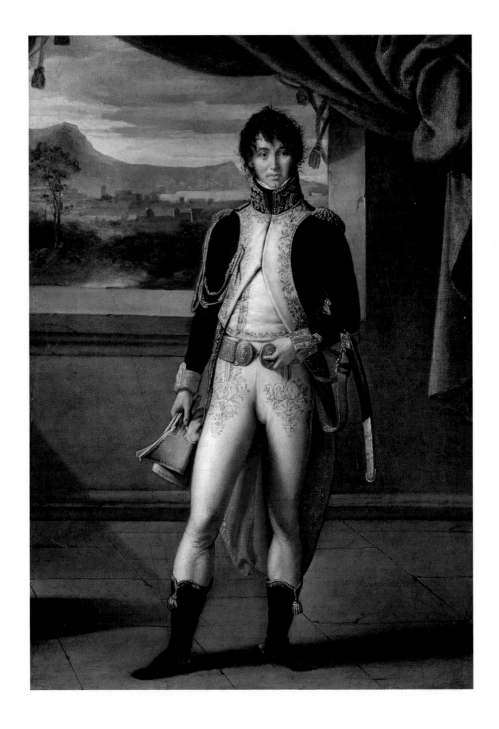

53.

Jean-Baptiste Joseph Wicar (French, 1762–1834)
Portrait of Joachim Murat, marshal of the Empire

Oil on canvas
22 x 15 inches (55.7 x 39.5 cm)
Musée des Beaux-Arts, Lille, France (P.434)
©Réunion des Musées Nationaux / Art
Resources, NY

Known for his flamboyant style, Joachim Murat (1767-1815) was one of the
Napoleonic era's most revered cavalry commanders. During the Egyptian Campaign,
Murat earned a battlefield promotion to general of the brigade following his victory
at the Battle of Aboukir, July 25, 1799. He married Napoleon's sister, Caroline
Bonaparte (1782-1839) in 1800, became a marshal of the empire in 1804 and the
king of Naples in 1808. Shown here as a young and dashing military hero, his
reputation as a dandy was exceeded only by his reputation for bravery. **V.C.**

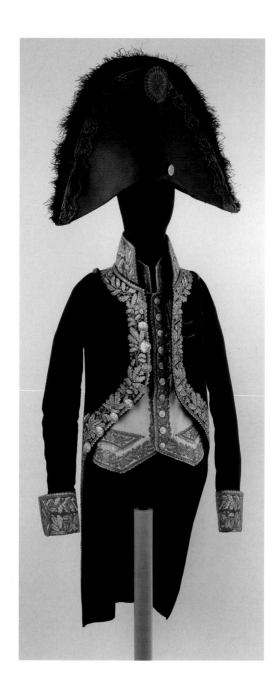

54.

Unidentified Maker, French School
Uniform of a Division General of the Infantry, 1807

Embroidered wool
Musée de l'Armée, Paris (Gb 37 133)
©Musée de l'Armée, Paris

Napoleon considered uniforms important to the morale of the military, observing, "The soldier has to like his condition, he has to give to it his taste and his honor; this is why fine uniforms are so useful." During his reign the military designed distinctive uniforms for each unit as a way to instill esprit de corps and national pride. This sort of military pomp was anathema to Jefferson who believed an army was an unfortunate necessity, not a glory. **V.C.**

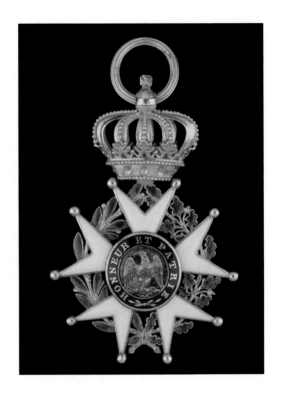

55.

Attributed to Martin-Guillaume Biennais
(French, 1764–1843)
*Insignia of the Chevalier of the Legion of Honor taken
by Napoleon to Saint Helena* (first model)

Silver, enamel and silk
Musée Nationale de la Légion d'Honneur et des
Ordres de Chevalerie, Paris (05733)

56.

Attributed to Martin-Guillaume Biennais (French, 1764–1843)
Legion of Honor, with Imperial Crown, 1808

Enamel gold
3 inches (9 cm)
Musée de l'Armée, Paris (Ka997-185)
©Musée de l'Armée, Paris

In 1802, Bonaparte established the Legion of Honor to reward civil and military service to France. He made clear his intention to create a new aristocracy based on merit, rather than birth, declaring, "Distinctions used to be awarded in France and still are in neighboring countries, only to the well-born man; I shall give them to the man who has served best in the Army or in the State or who has produced the finest creations. It will be an aristocracy, if you will, but an aristocracy always open to new merit, where there would be men who have rendered great services and where there would also be room for other men who are capable of new services."

Thought to have been designed by the painter Jacques-Louis David, the Legion of Honor medal is a star with five double rays. Oak and laurel branches frame a bust of Bonaparte on the obverse while an eagle with the legend "Honneur et Patrie" appears on the reverse. During the Empire, Napoleon added an imperial crown to the top of the medal. One of five awards established by Bonaparte, the Legion of Honor remains one of France's most prestigious awards. **V.C.**

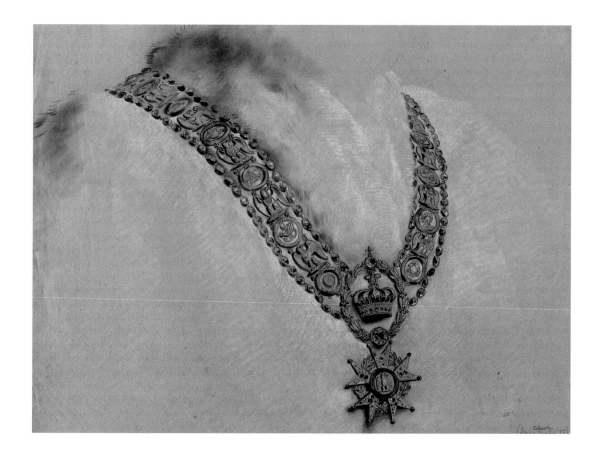

57.

Anne-Louis Girodet de Roussy-Trioson
(French, 1767–1824)
Drawing of the Grand Collier of the Legion of Honor

Black chalk with white on buff paper
15 x 21 inches (39.2 x 52.7 cm)
Musée du Louvre, Départment des Arts
Graphiques, Paris (RF 34530)
©Réunion des Musées Nationaux / Art
Resources, NY

The most prestigious Legion of Honor medals were attached to collars composed of sixteen enamel medallions showing actions, both civil and military, one could perform to merit the award. These medallions alternate with sixteen eagles symbolizing the sixteen cohorts, the regional administrative centers of the Legion of Honor in France. As Girodet's magnificent drawing illustrates, the finest painters in France were called upon to design for the state under Napoleon. **V.C.**

58.

Martin-Guillaume Biennais (French, 1764–1843)
Clef de Chambellan, First Empire

Vermeil
8 inches (20 cm)
Fondation Napoléon, Paris (1125)

Napoleon gave this "key," fashioned by Biennais, to the chamberlains of the empire upon their appointment. Like the Legion of Honor, the design incorporates the eagle, clutching a lightening bolt, surrounded by a laurel wreath, topped with an imperial crown. The creation of the rank of chamberlain, like that of the marshals and the Legion of Honor, illustrates Napoleon's desire to create a new aristocracy in France where rank was earned through merit rather than birth. **V.C.**

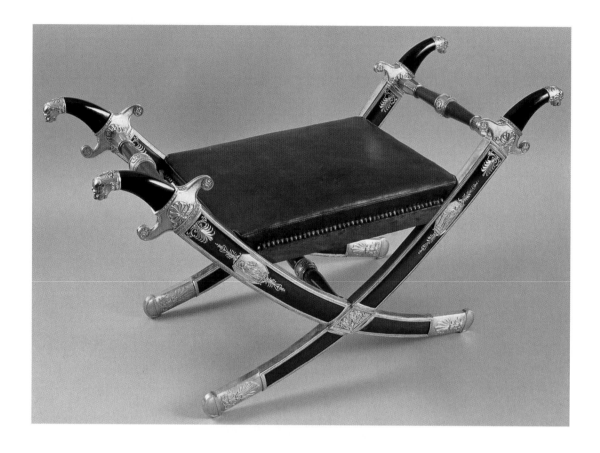

59.

Attributed to Martin-Guillaume Biennais
(French, 1764–1843)
Stool with Sabre Legs

Mahogany, gilded with bronze
25 x 45 x 21 inches (64 x 115 x 53 cm)
Musée National du Château de Malmaison
Rueil-Malmaison, France (MM 65-3-15)
©Réunion des Musées Nationaux / Art
Resources, NY

Although furniture may not automatically be thought of as a political statement, as seen in this exhibition, it often was. The desire for military glory and the cult of war was so pervasive under Napoleon that it was expressed forcefully even in the decorative arts. This was particularly true of furniture designed for the marshals, such as this stool made by Biennais, who modeled the legs after crossed sabers. **V.C.**

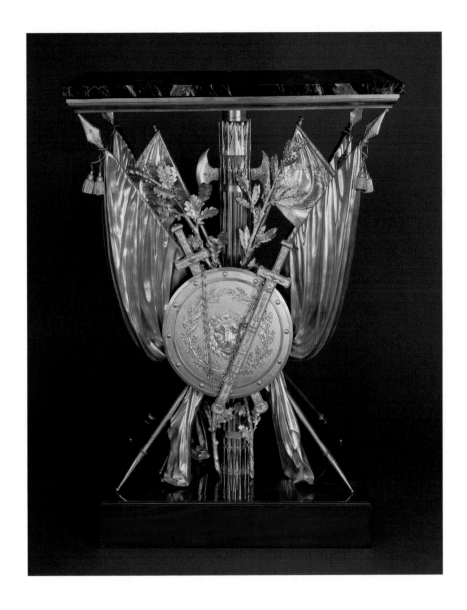

60.

Claude Galle (French, 1759–1815)
Pier Table with Trophies and Fasces, circa 1804

Gilded bronze, mahogany, marble
40 x 28 x 18 inches (102 x 72 x 47 cm)
Private Collection, Montreal

A spectacular example of the expression of the cult of war in the design of furniture, this pier table was given by Napoleon to General Jean-Léonor-François Le Marois (1783-1836) as a wedding present. Le Marois had served under Napoleon in Egypt and by 1804 was one of the emperor's aides de camp. A mass of gilded bronze war trophies including military standards, swords, and fasces, forms a dramatic support for the marble top. **V.C.**

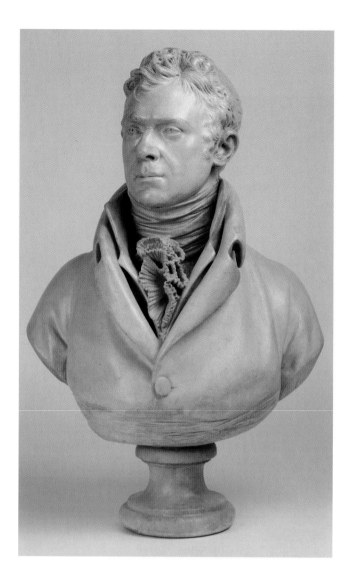

62a.

Robert Fulton (American, 1765–1815)
Plunging Boat, Transverse Section, 1806
Signed and dated: *Robert Fulton 1806*

Watercolor, graphite and ink
28 x 40 inches (71.1 x 101.6 cm)
Library of Congress, Prints and Photographs Division,
Washington, D.C. (ADE-UNIT 2804, no. 2)

61.

Jean-Antoine Houdon (French, 1741–1828)
Robert Fulton, circa 1803
Inscribed under right shoulder: *houdon/anx XII*
Plaster
28-3/4 x 19 x 11 inches (73 x 48.3 x 27.9 cm)
National Academy of Design, New York

In 1803, the year of the Louisiana Purchase, American inventor
Robert Fulton (1765-1815) posed for the French sculptor Houdon
in Paris. The bust portrait was shown at the Salon of 1804 with that
of Fulton's countryman and collaborator, Joel Barlow (1754-1812).
Fulton is best known for his innovative design for a steamboat, the
Clermont, which revolutionized travel on the rivers of the United
States, not least the Mississippi. **V.C.**

62b.

Robert Fulton (American, 1765–1815)
Plunging Boat, Sighting Mechanism,1806

Watercolor, graphite and ink
28 x 40 inches (71.1 x 101.6 cm)
Library of Congress, Prints and Photographs Division,
Washington, D.C. (ADE-UNIT 2804, no. 5)

In hopes of improving France's naval strength and envision-
ing a sneak attack on England, Bonaparte offered financial
backing to the American inventor Fulton, who built an
experimental submarine at the Perrier workshop on the
Seine. Called the *Nautilus*, the contraption made several
successful dives in 1801, managing a depth of twenty-five
feet and staying submerged for two hours. Napoleon felt the
craft had too many technical problems, however, and aban-
doned the project. **V.C.**

63.

Dominique Vivant Denon (French, 1747–1825)
Travels in Upper and Lower Egypt, during the campaigns of General Bonaparte in that country, 1803

Bound volume, printed for T. N. Longman and O. Rees, London
8-1/4 inches (21 cm)
Massachusetts Historical Society, Boston, Massachusetts

Dedicated to Bonaparte and originally published in French in 1802, Vivant Denon's *Travels in Upper and Lower Egypt* provided the public with an eyewitness account of Napoleon's Egyptian campaign—both the military exploits and the scientific expedition. The popular book was translated into several languages, including English in 1803. Engravings reproducing Denon's drawings accompanied the text and helped to usher in the nineteenth-century craze for Orientalism. Denon, who was called the "Eye of Napoleon," became Bonaparte's chief artistic advisor and the director of the Louvre, renamed the Musée Napoléon. **V.C.**

64.

Manufacture Nationale de Sèvres (France, active 1756-present)
After Dominique Vivant Denon (French, 1747–1825)
Plate illustrated with *Combat and Death of Duplessis, Commander of the Brigade*, 1811

Porcelain
Diameter: 9 inches (24 cm)
Musée National de Céramique, Sèvres, France (1800 and 21630)
©Réunion des Musées Nationaux / Art Resources, NY

65.

Manufacture Nationale de Sèvres (France, active 1756-present)
After Dominique Vivant Denon (French, 1747–1825)
Plate illustrated with *Military Divan*, 1811

Porcelain
Diameter: 9 inches (24 cm)
Musée National de Céramique, Sèvres (MNC 26308)
©Réunion des Musées Nationaux / Art Resources, NY

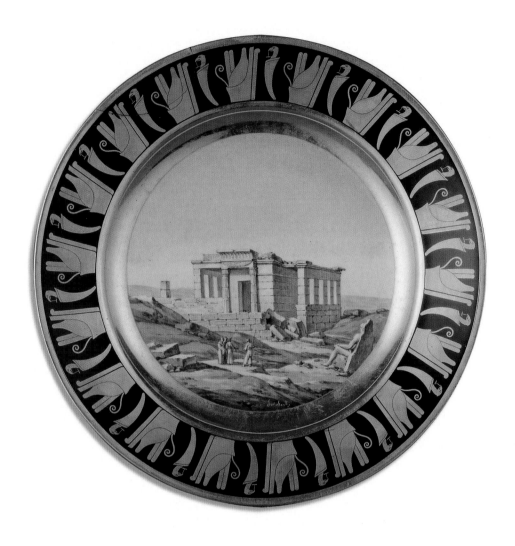

66.

Manufacture Nationale de Sèvres
(France, active 1756-present)
After Dominique Vivant Denon (French, 1747–1825)
Plate illustrated with *Ruins of the Temple on the Isle of Elephantine*, 1811

Porcelain
Diameter: 9 inches (24 cm)
Musée National de Céramique, Sèvres, France
(4047.2992 and 97.29.43)
©Réunion des Musées Nationaux / Art Resources, NY

Denon initiated several projects at the Sèvres porcelain factory including the design for two services based on his *Travels in Upper and Lower Egypt*. Two of the plates exhibited here, *The Combat and Death of Duplessis* and *Military Divan* come from the second Egyptian Service, which was produced for Josephine. The empress refused delivery of the service, which remained at the Sèvres factory until Louis XVIII gave them to the Duke of Wellington in 1818. These two plates, however, were left in the factory collection. The third plate, *Ruins of the Temple on the Isle of Elephantine*, reproduces a scene found in both Egyptian services and appears to have been used as a display model. **V.C.**

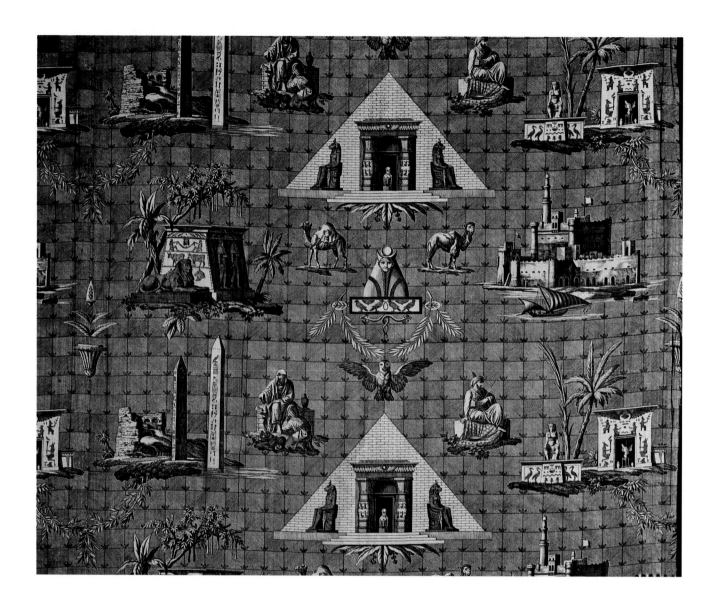

67.

Oberkampf Manufactory, Jouy-en-Josas, France,
designed by Jean-Baptiste Huet
(French, 1745–1811)
Fragment of *Les Monuments de l'Egypte*, 1808

Cotton, printed with a copper roller
57 x 72 inches (132 x 183 cm)
Baltimore Museum of Art, Baltimore, Maryland
(BMA 1984.158)

The toile pattern *Les Monuments de l'Egypte* was produced by Oberkampf's famed textile factory at Jouy. The design was based on illustrations found in *Voyage Pittoresque de la Syrie* by Cassas, one of many travel accounts of Egypt and Syria made popular by Napoleon's Egyptian campaign. Oberkampf's success in competing with British textile production prompted Napoleon to award the manufacturer the Legion of Honor in 1806. **V.C.**

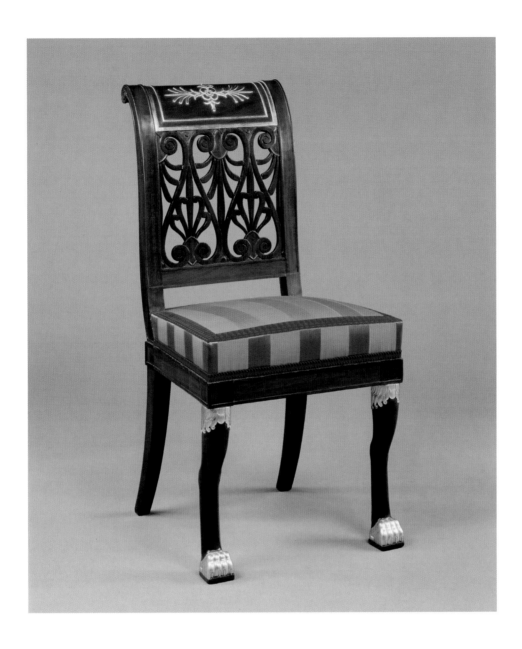

68.

François-Honoré-Georges Jacob-Desmalter (French, 1770–1841)
Chaise, circa 1800–03

Mahogany, partially gilded
36 x 18 x 22-1/2 inches (91 x 45 x 57 cm)
Musée National du Château, Compiègne, France (C81D13)
©Réunion des Musées Nationaux / Art Resources, NY

The craze for Egyptian-inspired decorative arts produced many fanciful motifs in furniture design. Among the most popular were the gilded claw feet seen in this chair by Jacob-Desmalter, one of the most influential designers during the Consulate.
V.C.

69.

Unidentified Artist, French School
Clock in the Form of an Egyptian Women, 1805
Clock face signed: *Galle – rue Vivienne no. 9*

Gilt and antique-green patinated bronze
23-1/4 x 6-3/4 x 6-3/4 inches (59 x 17 x 17 cm)
Mobilier National, Paris (GML 241)

The design of this clock combines the tradition of figurative timepieces with the Empire taste for exoticism. The *nemes*, or headdress, identifies the figure as Egyptian while her pose is reminiscent of many classically inspired female figures as she delicately balances the weight of the clock on her head. **V.C.**

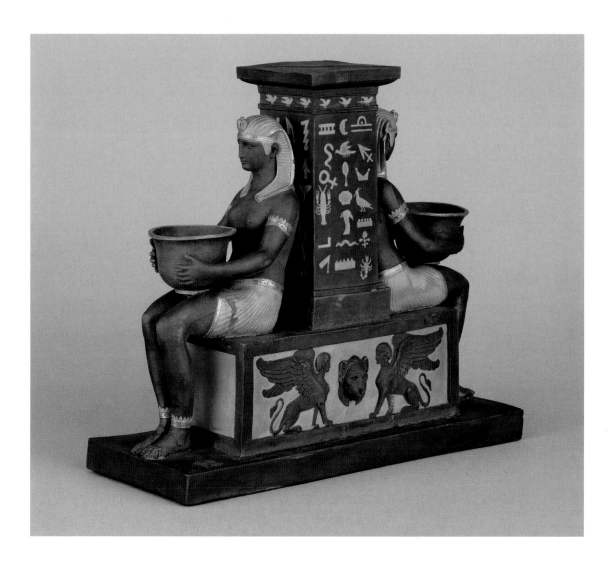

70.

Manufacture Nationale de Sèvres
(France, active 1756-present)
Egyptian-style Ink Well, 1802
Impressed on base: *Sèvres*

Biscuit porcelain colored to imitate bronze
8-3/4 x 10-1/4 in. (22 x 26 cm)
Musée National de Céramique,
Sèvres, France (MNC 2648)
©Réunion des Musées Nationaux / Art Resources, NY

This fanciful inkwell, the first example of an Egyptian-inspired object produced at Sèvres, was originally available in white, blue and black biscuit porcelain. The female figures are dressed in a manner seen in ancient wall decorations, nude to the waist, wearing a loincloth. Each holds a bowl for ink on her lap. The piece was designed before the publication of Denon's book and combines authentic details with fantasy, as demonstrated by the odd array of symbols on the pillar. **V.C.**

71.

Jacques-Nicolas Paillot de Montabert
(French 1771–1849)
Portrait of Roustam, Mameluk, Salon of 1806

Oil on canvas
46 x 35 inches (116 x 88.5 cm)
Musée de l'Armée, Paris (3659, Ea 62)
©Musée de l'Armée, Paris

Roustam Raza (1780-1845) was a Mameluk slave given to
Bonaparte by Sheik el-Bekti in 1799. The Mameluks were taken
as children from their homes in the regions of Georgia and
Caucasus by the Turks, converted to Islam and trained to join the
elite corps of the Turkish cavalry. Roustam, sometimes called "the
Emperor's Mameluk," served Bonaparte as a personal guard until
1814. This portrait by Paillot, a student of David, was shown at
the 1806 Salon and served as the model for Roustam's features in
several Napoleonic history paintings. **V.C.**

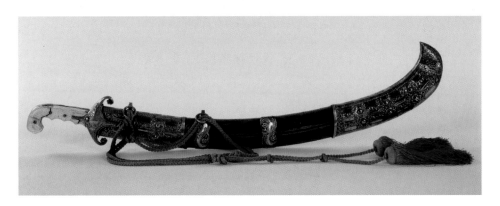

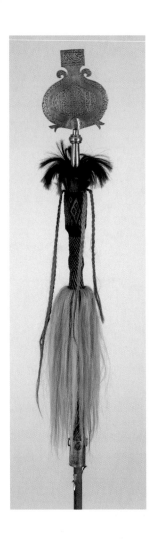

72.

Unidentified Artist, Egyptian
or Turkish School
*Mameluk Sabre Carried by Bonaparte
at the Battle of the Pyramids*

Steel, ivory, copper gilt, wood and velvet
32-1/4 inches (82 cm)
Musée de l'Armée, Paris (142)
©Musée de l'Armée, Paris

This saber was probably taken as a war
trophy from a fallen Mameluk during the
Egyptian campaign. It was carried by
General Bonaparte during the Battle of
the Pyramids on July 21, 1798. **V.C.**

73.

Unidentified Artist, Egyptian or Turkish School
*Toug of the Turkish Commander
at the Battle of the Pyramids*, 1798

Copper, wood and horsehair
96 inches (245 cm)
Musée de l'Armée, Paris (Aa 8)
©Musée de l'Armée, Paris

Similar to a military standard or flag, the *toug*
was a symbol of command that preceded a Turkish
leader into battle. Such long decorated staffs
allowed soldiers to identify their commander's
position. Along with sabers and other military
accouterments, *tougs* were brought back to
France by Napoleon's troops during the Egyptian
campaign as highly prized trophies of war. **V.C.**

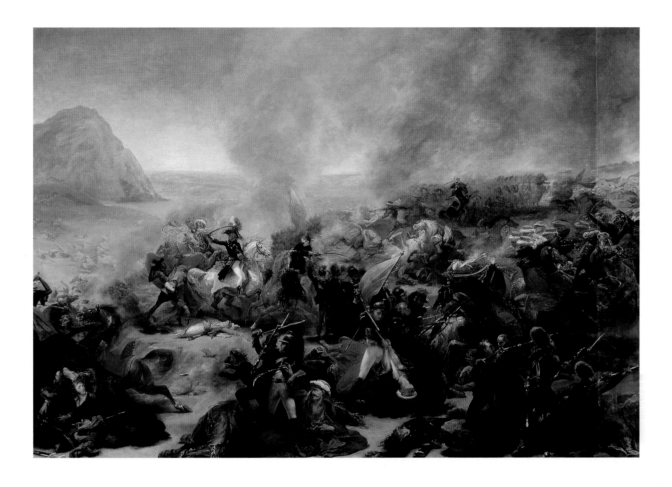

In March of 1801, the Ministry of the Interior organized a competition for a painting of the Battle of Nazareth, fought during Bonaparte's Middle-Eastern campaign. The battle actually took place in Loubia, near Nazareth, where four hundred French soldiers led by General Andoche Junot (1771-1813) defeated a force of three thousand Turks on April 8, 1799. The winner of the competition was to receive a commission for an enormous painting measuring twenty-four feet in width. Nine painters submitted sketches. This sketch by Gros was selected as the winner, though not without considerable controversy. For reasons that remain unclear, the final canvas was never completed.

Taking his lead from the program given to the contestants, Gros included actions that reinforced common Orientalist stereotypes. For example, the groups in the lower left and lower center juxtaposed French humanity with Oriental brutality: While the Frenchman in the center spares the life of a surrendering foe, a Turk in the lower left prepares to cut the head of his defenseless enemy, only to be stopped by a French bullet. In the lower right, above the wounded carabineer, a fanatical Mameluk rushes headlong into French bayonets. Gros carefully arranged the point of view in his canvas so that Cana, site of the biblical Marriage at Cana, occupies the background of his composition and Mount Tabor, site of the Transfiguration, rises prominently on the left, reinforcing the notion of Bonaparte's campaign as a latter-day crusade.

The rapid, vigorous handling, brilliant hues, and swirling composition of Gros's sketch stunned many contemporary viewers (and later inspired Romantic painters such as Géricault and Delacroix). The chaotic, colorful imagery renders Gros's sketch difficult to read, but also communicates the violence of battle. The exotic subject matter and limited time frame of the contest seem to have unleashed Gros's creative energies, enabling him to break with the controlled, linear style then dominating French painting and invent a gestural, heroic manner appropriate to the new demands of Napoleonic propaganda. **D.O.**

74.

Antoine-Jean Gros (French, 1771–1835)
Battle of Nazareth, 1801

Oil on canvas
53-1/8 x 76-3/4 inches (134.9 x 195 cm)
Musée des Beaux-Arts, Nantes, France
(1005)
©Réunion des Musées Nationaux /
Art Resources, NY

75.

General Andoch Junot (French, 1771–1813)
Map of Battle of Nazareth given to Baron Gros, 1801

Ink on paper
13 x 19 inches (33 x 47.8 cm)
Musée des Beaux-Arts, Nantes, France (1529 (1))

76.

Antoine-Jean Gros (French, 1771–1835)
Map and Schematic Drawing of the Battle of Nazareth, 1801

Ink and wash on paper
10 x 32 inches (25.5 x 83 cm)
Musée des Beaux-Arts, Nantes, France (1529 (2))

Gros's plan, based on the one given to him by General
Andoche Junot, showed the location of the participating
units in the area around Loubia and indicated what could
be seen in the sketch by shading in the area that fell out-
side the edges of Gros's canvas. In a second drawing, he
transposed the landmarks and troops represented on the
map into a perspective view. As in the final sketch, a
long line of French soldiers arcs up and back from the
lower right of the drawing, through a point in the middle-
ground marked by the flag of the French Republic, then
curves into the distance toward the upper right of the can-
vas. To the right of this arc is a mass of wounded and flee-
ing Turkish cavalry, and in the distance on the left, before
the historic Mount Tabor, are the rest of the routed Arab
troops. **D.O.**

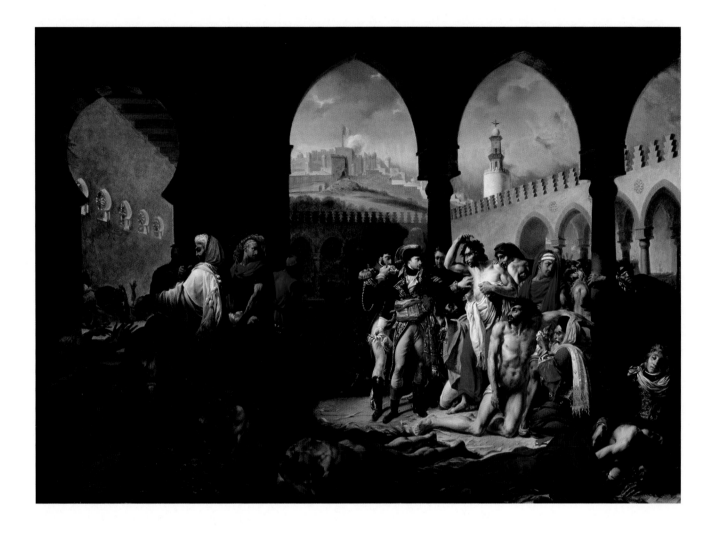

77.

Auguste-Hyacinthe Dabay (French, 18th/19th century)
after Antoine-Jean Gros (French, 1771–1835)
Bonaparte Visiting the Plague-Stricken Soldiers in the
Hospital at Jaffa, circa 1804

Oil on canvas
46 x 65 3/4 inches (118 x 167 cm)
Museum of Fine Arts, Boston, Massachusetts (47.1059)
©2002 Museum of Fine Arts, Boston

A masterful example of painting as propaganda, General Bonaparte is
shown visiting French soldiers stricken with the plague during the Syrian
campaign. He bravely removes his glove and touches the open sore of
the plague victim's side in a gesture reminiscent of Christ healing the
sick. This is a reduced-scale version of the painting by Baron Gros
exhibited in the Salon of 1804 and now in the Louvre. Long considered
the work of Gros himself, it has recently been ascribed to his student
Auguste-Hyacinthe Debay. **V.C.**

78.

Jean-Pierre Franque (French, 1774–1860)
Allegory of the Condition of France before the Return from Egypt, Salon of 1810

Oil on canvas
102-3/4 inches x 128-3/8 inches (261 x 326 cm)
Musée du Louvre, Départment des Peintures,
Paris (4560)
©Réunion des Musées Nationaux /
Art Resources, NY

Franque's picture mixes real and imagined scenes. While in Egypt Bonaparte dreams of a languishing France, who beseeches him to return. France appears in front of personifications of the evils plaguing her (Crime, Fury, Fanaticism, etc.). An overturned cornucopia symbolizes the disappearance of plenty, and a toppled Altar of Law signifies the corruption of the Directory (the government to be replaced by Bonaparte's Consulate). The painting was exhibited in the Salon of 1810 to great acclaim. **D.O.**

Napoleon and Josephine: Public and Private Images

Susan Taylor-Leduc

Josephine's biography resembles an American success story. Born Marie-Joséphe Rose de Tascher de la Pagerie (1763-1814) into a poor, albeit noble, French family on the Caribbean island of Martinique, she climbed to the highest ranks of Parisian society where she was fatefully introduced to Napoleon Bonaparte.[1] From revolutionary widow, to consulesse, then empress, she became the most influential woman at the consular and imperial courts until her divorce from Bonaparte in 1809. Just as Napoleon transformed his public persona as his political career evolved, Josephine, as Madame Bonaparte and later empress, was an active producer of her own image, adapting to her changing status in French society.

Josephine's legendary beauty, coupled with her remarkable taste and patronage, influenced fashion and material culture internationally (*fig. 1*). Her life was at once public and private: we can chart her public role by examining not only the prints and commentaries of the period, but also the clothes and jewelry she wore at ceremonial events. Thanks to the remarkable collections of the châteaux de Malmaison et Bois-Préau, her private residence, we have the unique opportunity to view examples of her taste during both the consular and imperial years.

Josephine's family arrived at Martinique in 1726. Although the Tascher de la Pagerie family were landowners, they suffered considerable financial distress. Born in 1763 (although her marriage certificate to Bonaparte erased five years off her age so she would appear to be closer in age to her younger husband), she entered the Convent of the Dames de la Providence de Fort Royal in 1772. She left the convent with a summary education in 1777. The most important relationships forged during her youth on Martinique were between her family and the Beauharnais family. The Marquis François de Beauharnais was governor of Martinique from 1756 until 1760, and his mistress, Marie-Euphémie-Desiré-de Renaudin, was Josephine's paternal aunt. Madame de Renaudin arranged Josephine's first marriage to the Marquis de Beauharnais's younger son, Alexandre (1760–1794).

At the age of sixteen Josephine left Martinique for

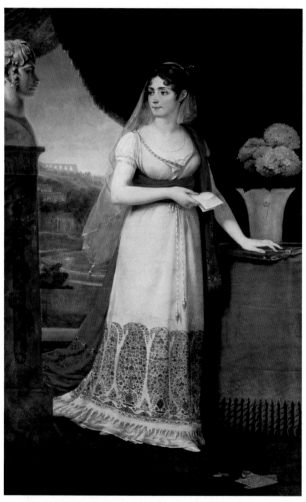

Figure 1: Antoine-Jean Gros (French, 1771–1835), *Portrait of the Empress Josephine*, 1808, Oil on canvas, 84 x 55 inches (215 x 140 cm), Musée d'Art et d'Histoire, Palais Masséna, Nice, France. Catalogue number 79

France, where she was married to Vicomte Alexandre de Beauharnais on December 13, 1779, in Paris. During their five-year marriage Josephine had two children, Eugène

(1781-1824; **cat. no. 111**) and Hortense (1783-1837; **cat. no. 110**). The marriage was not a happy one: Alexandre was often absent on military duty, and Josephine remained in Paris under the care of the Beauharnais family and her aunt, Madame de Renaudin. Josephine obtained a legal separation from Alexandre in 1785; nonetheless, from 1785 until 1788 she lived in Fontainebleau with her father-in-law's family. She returned to Martinique in 1788 where she stayed for two years.[2]

Josephine's entry into the French aristocracy was secured by her noble marriage, but it was amidst the social confusion and turmoil of the revolutionary decade that Josephine gained access to social circles that eventually led to her auspicious meeting with Bonaparte. During the opening years of the French Revolution, Alexandre de Beauharnais became an active political figure and military leader. Elected president of the Constituent Assembly in June 1791 and general of the Army of the Rhine in 1792, he was a visible public personality until his military defeat at Mayence.[3] The rapidly changing political climate in Paris led to his incarceration on March 2, 1794. Throughout this turbulent period, Josephine, as Madame de Beauharnais, found friends and financial support thanks to Alexandre's reputation, until she, too, was imprisoned in April 1794. Alexandre was sent to the guillotine July 23, 1794. Josephine narrowly escaped the same fate. She was liberated from the prison de Carmes on August 6, 1794, saved by the fall of the revolutionary leader Robespierre and the end of the Reign of Terror.

Freed from prison, Josephine publicly fashioned herself as "la veuve Beauharnais" (Alexandre de Beauharnais's widow) an image that she exploited so she could reconstruct her own social and financial security, but also to secure Alexandre's inheritance for Hortense and Eugène. As early as October 1794, she hosted "Republican dinners" where her guests included those prominent political citizens who had felled Robespierre and assumed the reins of power during the new government known as the Directory (1795-99).[4] Amongst Josephine's guests were Vicomte Paul de Barras (1755-1829) and Jean Lambert Tallien (1767-1820). Josephine met Madame Tallien, Thérèse Cabarrus (1773-1835) in the 1780s.[5] Thérèse became one of the most powerful *salonnieres* in Paris after the Terror. They became close friends and it was thanks to Thérèse and her husband that Josephine met Barras.[6] As one of the leading members of the Directory, Barras controlled both military and financial interests of the government. Josephine and Thérèse became part of his intimate social circle and Josephine became his mistress. Once publicly recognized as Barras's mistress, Josephine was liberated from her image as "la veuve." Barras assumed her many debts and underwrote her lavish Parisian lifestyle thus allowing Josephine to ascend to the pinnacles of the social aristocracy of the Directory.

Josephine's first recorded meeting with Bonaparte resulted from her status as widow to one military general and mistress to another. In the autumn of 1795, the government ordered the confiscation of all arms belonging to private individuals. Eugène de Beauharnais, desperate at the thought of giving up his father's sword, appealed to the young General Bonaparte, who served in Paris under Barras's military authority, to let him keep it. Bonaparte granted Eugène's request and Josephine went the next day to thank him. Bonaparte had attracted Barras's attention and admiration following his repression of the royalist troops (14 Vendemaire, October 5, 1795), and he became a local hero.[7] Social obligations and curiosity certainly motivated Josephine's desire to personally meet the popular Bonaparte.[8]

At this pivotal moment of her life, Josephine appeared to be a wealthy woman and well established in the networks of power, while, in fact, her financial situation and popularity were precariously based on her relationship to Barras. She profited from her reputation and introduced Bonaparte to her friends the Talliens, hosted gallant suppers, and initiated Bonaparte into the financial and military society circulating around Barras. Bonaparte fell passionately in love with Josephine; her beauty, her social position, her age and experience, not to mention her noble lineage, attracted the ambitious general. As Prud'hon's intimate drawings of Josephine reveal, her features were captivating and her gaze must have been entrancing (**cat. nos. 80** and **81**). Josephine, probably in consultation with Barras, decided to support Bonaparte, whose Corsican manners, passion and ambition must have fascinated her.[9] On March 9, 1796, they were married in a civil service. For Bonaparte, Josephine offered access to Parisian society while Josephine hoped that the general would provide her with financial security.[10] Their marriage lasted thirteen years until December 1809 when the emperor repudiated Josephine, who was unable to produce an heir to the imperial throne.

While Bonaparte was fashioning his own image as a glorious military leader during the Italian campaign (1796-97) and then the Egyptian campaign (1798-99), Josephine cultivated her own image as a woman of taste in Paris. She was a trendsetter, decorating their Paris residence, the Hôtel de Chantereine, establishing the latest neoclassical tastes that would soon emerge as the Consular style.[11] Josephine ordered new furniture, draperies, wallpapers, and bronzes from the best craftsmen of the period. She spent exorbitant sums on her self-image, both on her home and her clothes, partially to indulge her own unbridled desire for luxuries, but also to firmly establish herself and her husband as the center of a new social elite.

At the same time she was constructing her Paris residence to reflect Bonaparte's rising status, Josephine arranged to buy a house and garden at Malmaison.[12] She visited Malmaison with Bonaparte in 1798 and negotiated its purchase in April 1799.[13] Malmaison became their

Figure 2: Facade and courtyard of the Château de Malmaison, Rueil-Malmaison, France
©Réunion des Musées Nationaux / Art Resources, NY

Figure 3: Auguste Garneray (French, 1785–1824), *View of Josephine's Music Room*, circa 1812, Watercolor on paper, 26 x 36 inches (66.5 x 91 cm), Musée National du Château de Malmaison, Rueil-Malmaison, France
©Réunion des Musées Nationaux / Art Resources, NY

retreat and later Josephine's private residence following the divorce. From Malmaison Josephine reigned as Madame Bonaparte, wife to the First Consul and then as empress. The house and its gardens became a showcase of her patronage and taste. The creation of an international Consular and then Empire styles, even after the divorce, emanated from Malmaison.[14]

Malmaison was more typical of an eighteenth-century garden pavilion rather than a chateau; consequently, the scale of the building can be compared to a country house. A view of Malmaison depicted on a porcelain vase shows the modest residence nestled in the countryside emphasizing the benefits of a country retreat (**cat. no. 104**). Six months after the acquisition of Malmaison, and two days

after the coup de Brumaire (November 9, 1799), Josephine and Bonaparte went to Malmaison in their new roles as First Consul and First Consulesse.[15] Josephine hired the architects Charles Percier (1764-1838) and Pierre Fontaine (1762-1853) in January 1800 not only to modernize the building, but also to set a new standard in neoclassical decoration that legitimized both Napoleon's accomplishments and Josephine's affirmed social status.

During the Consulate, the first campaign of interior decorations symbolically integrated military motifs into the interior design of Malmaison. The main entrance was reconfigured in the form of a tent, a clear reference to Bonaparte's military campaigns (*fig. 2*).[16] Visitors passed through the tent to the entrance hall that was lined with stucco columns to recall an atrium of a Roman villa. In the entrance vestibule, Percier and Fontaine experimented with neoclassical references that would have recalled Bonaparte's Italian campaigns. From 1800 to 1802 Percier and Fontaine completely redecorated the rooms on the entrance floor: to the right of the vestibule were a billiards room, a salon, and a gallery that also served as a music room (*fig. 3*). Under Josephine's supervision, Percier and Fontaine decorated the rooms to the left of the vestibule that included the dining room painted in the Pompeian style, a council chamber decorated in the form of a tent, and a library and office for Napoleon (*fig. 4*).[17] On the upper level, above the salon and the gallery was the apartment of the First Consul and Josephine. Seven smaller bedrooms were located on the second floor, and ten rooms were located on the attic level of the third floor.

Before the coronation ceremony in 1804, court etiquette at Malmaison was rather relaxed and Bonaparte often worked in the library or the council chamber where he received daily reports from his ministers. Consequently, the first-floor reception rooms were luxuriously furnished. The furniture was commissioned directly from the celebrated furniture makers Georges Jacob II (1768-1803) and his brother François-Honoré-Georges Jacob, known as Jacob-Desmalter (1770-1841). Much of the first-floor furniture was constructed in mahogany and decorated with gilded bronze fittings. A stool in the form of an X comes from the council chamber (**cat. no. 94**), which was decorated with striped wallpaper and military trophies on the doors, typifying the masculine style created for rooms where Bonaparte worked (*fig. 5*). The X stool can be compared to a chair in the form of a swan by Jacob-Desmalter created after a drawing by Charles Percier, executed for Josephine at Saint-Cloud but now at Malmaison (**cat. no. 92**). Percier was instrumental in reviving the swan as a neoclassical decorative motif. After 1798 we also find swans on the bedroom furniture designed for Mme Récamir (**cat. nos. 115-117**), Bonaparte's washstand, known as *Athenian* (**cat. no. 47**). Darte Frères even incorporated the swan motif into porcelain sets including teacups (**cat. no. 93**).

Figure 4: Charles Percier (French, 1764–1838); Library of the Emperor at the Château de Malmaison et Bois-Préau, Rueil-Malmaison, France
©Réunion des Musées Nationaux / Art Resources, NY

Figure 5: View of the Consul Chamber at the Château de Malmaison et Bois-Préau, Rueil-Malmaison, France. Catalogue number 94
©Réunion des Musées Nationaux / Art Resources, NY

From 1800 to 1802, Bonaparte and Josephine came regularly to their "country house" often accompanied by Bonaparte's brothers and sisters, Hortense—Josephine's daughter—and young military generals of Napoleon's entourage. Bonaparte divided his day between work, promenades in the park, and the hunt. Josephine negotiated between the members of the Bonaparte clan, the ambitious military generals, and her own guests as she presided over the dinners, theater performances and the gaming tables. She commissioned exceptional objects for her dinner services: porcelain from Sèvres, crystal, (**cat. no. 88**), and silver. Since the seventeenth century, having tea, coffee, or chocolate in the middle or late afternoon had become a small meal prior to a "souper."[18] Taking tea was an aristocratic luxury and Josephine commissioned from Martin-Guillaume Biennais (1764-1843) a silver tea service composed of seven separate pieces displayed on a silver tray that was ingeniously mounted on a tripod, whose sculpted legs in the form of lion paws allowed the tea service to be used anywhere (**cat. no. 89**). This exceptional tea service is engraved with Josephine's imperial arms, and the ornate handles are sculpted into imperial eagles.

Although Josephine was an accomplished hostess, perhaps even more than other aristocratic women, she consecrated an important part of her day to letter writing. Constantly solicited, Josephine was a prodigious correspondent. Not only did she compose intimate letters to her family and friends, she constantly addressed petitions for favors, requested information, or sent orders from her household. As the painting by Henri François Riesener (1767-1828) shows, the art of letter writing was enacted on portable writing tables (*fig. 6*).[19] The collective volumes of Josephine's letters testify that she was a cultivated author and reveal that she knew how to turn a phrase so as to best flatter her correspondent. Josephine composed her letters on elegant letter tables (*écritoires*), including one designed for her in mahogany and polished steel by Biennais. With her insignia *JB* inscribed on the chest, clearly dating the piece to the Consulate period, Biennais created this highly original writing table with hidden compartments so that it also served as a jewelry chest (**cat. no. 90**). Biennais also designed a letter box (*serres lettres*) in mahogany and gilded bronze that was a holding case in the form of two tumblers where each side lifts to access storage space for incoming or outgoing letters (**cat. no. 91**). The *serres lettres* could be moved easily so any room could serve for the art of letter writing.

Josephine's taste can be studied by examining her choices for interior decoration and furniture, but also through her collecting patterns.[20] From the Consulate period onwards, the cities and towns conquered by Bonaparte sent diplomatic gifts to Josephine: antique sculptures, precious stones, fabrics, paintings and ethnographic objects. Josephine did not hesitate to select

but in fact was a guitar modeled to look like an antique lyre.[21] This instrument was fashionable from 1800 to 1820, and similar representations of the guitar-lyre can be found on the door panels to Josephine's boudoir at Malmaison.[22] Hortense, an accomplished musician who enjoyed playing pastoral compositions, probably requested that her portrait include the lyre to allude to her musical talents while at the same time suggesting that she is a muse—both for her mother and her son—the future Napoleon III.

In addition to her painting and sculpture collections, Josephine dedicated the grounds at Malmaison to one of her greatest passions: the creation of a botanical garden (*fig. 7*).[23] Although Josephine's desire to create a botanical garden has often been attributed to her yearnings for her childhood on Martinique, it was a much more serious-minded and deliberate endeavor. Her passion for the natural sciences can be paralleled to Napoleon's imperial ambitions for France. By planting species from around the Empire at Malmaison, Josephine provided an imperial model for the transplantation of species. Moreover, as the letters from her gardeners indicate, Josephine was always searching for plants that could be adapted to the French economy, such as the eucalyptus, whose flowers she hoped would provide nourishment for bees and help the honey industry in the south of France.[24] Josephine went so far as to help finance an expedition to the Cape of Good Hope in search for new plants.[25]

Jean-Marie Morel (1728-1810) designed an English style garden from 1800 to 1802, and the first buildings in the garden recalled the eighteenth-century ideal of an ornamental farm. Morel, the celebrated theorist and designer, built for Josephine a cow shed (**cat. no. 102**), dairy and a sheep-fold (**cat. no. 103**) for merino sheep. These buildings and the activities they promoted were not only picturesque stops on the circuit walk that led from the immediate gardens surrounding Malmaison to her extensive properties at Saint-Cucufa that adjoined the estate, but also suggest Josephine's desire to improve models for domestic agronomics.[26]

Although an Orangerie existed as early as 1800, Josephine, with an eye to extending her collections, commissioned an extensive hothouse that measured more than fifty meters long. It was larger and taller than the existing hothouses at the state-owned botanical gardens.[27] After this, Malmaison attained world-acclaim as a center for botanical study. From 1803 until 1814 more than two hundred new species were planted at Malmaison. Although already well known and respected amongst an international circle of naturalists, Josephine guaranteed the fame of her garden through her patronage of the artist Pierre-Joseph Redouté (1759-1840).

Josephine commissioned from Redouté botanical illustrations of the plants in her collections, such as the *Streptope Amplexifolius* (**cat. nos. 105, 106**) or the *Josephinia Imperatricis* (**cat. no. 107**), which remain a poignant testimony

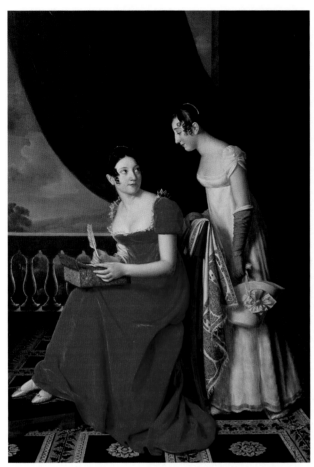

Figure 6: Henri François Riesener (French, 1767–1828), *Madame Riesener and her Sister, Madame Longroy*, 1802, Oil on canvas, Musée des Beaux-Arts, Orléans, France ©Musée des Beaux-Arts, Orléans, France / Lauros-Giraudon-Bridgeman Art Library

objects that had been pillaged from foreign museums thus preempting them from the objects destined for the Musée Napoleon. At the same time she was choosing from the spoils of war, Josephine encouraged contemporary artists and developed a passion for troubadour style paintings. The troubadour style celebrated intimate genre scenes often inspired by medieval or renaissance history or imagined historical anecdotes. Fleury Richard's *François I shows to his sister, the Queen of Navarre, the verses which he has just engraved on a windowpane* (**cat. no. 95**) is a typical troubadour subject. The rich costume and interior are rendered in glistening cool colors that recall miniatures from illustrated Books of Hours. Josephine shared her predilection for troubadour painting with her daughter Hortense who commissioned her portrait from Fleury in an explicitly troubadour pose (**cat. no. 96**). She is seated before a window that overlooks the lake at Bourget in Switzerland. Hortense wears a rich red velour Empire style dress, a matching diadem hairpiece, and two shawls are draped behind her. She holds what appears to be a lyre,

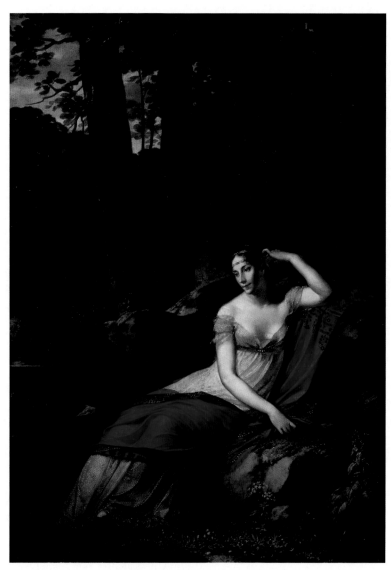

Figure 7: Pierre Paul Prud'hon (French, 1758–1823), *Empress Josephine in the Gardens of Malmaison*, 1805, Oil on canvas, 96 x 70 inches (244 x 179 cm), Musée du Louvre, Paris
©Réunion des Musées Nationaux / Art Resources, NY

to her gardens as none of the rare species exist at Malmaison today. These flower paintings, especially his series of *Les Liliacees* (8 vols., published from 1802-16) and *Les Roses* (1817-24)[28] have been popular since their inception, but they should be considered in the context of Josephine's ambitions for her garden as a showcase for the transplantation of species.

Engravings after Redouté's original vellum drawings were reproduced as a folio edition by Etienne Pierre Ventenant in his *Jardin de la Malmaison* (1803-05), where the plants were lavishly described according to norms of botanical nomenclature and to promote scientific exchange (**cat. no. 107**).[29] Redouté's drawings were also copied onto plates for the creation of a dinner service dedicated to the garden at Malmaison (**cat. no. 108**). After her

divorce in 1809 until her death in 1814, Josephine added a zoo and an aviary to the gardens at Malmaison, where she was the first person to succeed in raising black swans from Australia in captivity (*fig. 8*).

In her very public role as First Consulesse and empress, Josephine's appearance—her hair styles, clothes, jewels, and extensive wardrobe—were considered symbols of French prosperity. Napoleon encouraged her position as an arbiter of contemporary fashion, but even Napoleon could not control Josephine's prodigious spending.[30] Josephine dedicated a considerable part of her day to her "toilette" choosing from the latest modes and creating the most popular fashions. For example, Napoleon required Josephine to wear velvets and silks to encourage domestic industries, but she imported cotton and muslin setting

the trend for the white, light Empire style dresses that allowed her to show her beautiful skin and her latest hair styles to her best advantage.

Josephine had a special fondness for jewelry.[31] Her contribution to the development of Empire style jewelry can be seen in a cameo diadem carved entirely from a single shell and ornamented with gold, pearls and semiprecious stones (**cat. no. 85**). The diadem represents Apollo on his sun chariot. Another stunning example for a display of cameos is a set (*parure*) of carved malachite cameos that were fashioned into a necklace, diadem, brooch, bracelets and six pins (**cat. no. 86**).

At both the *Sacre* of December 1804 and the Coronation at Milan, 1805, Josephine's court costumes were designed to show the best of French fashion. The original fabric sketch and embroidery samples (**cat. nos. 82** and **83**) show these lightweight open sheer fabrics embellished with heavy gold embroidery. In 1805 Napoleon was crowned king of Italy in Milan and although Josephine was not crowned queen, she participated as a guest of honor once again in a sumptuous costume. Josephine's court train (**cat. no. 84**), executed in silk and satin, was embroidered in gold and silver following the fashion established at the *Sacre*. Images of the imperial couple were disseminated through all the arts, yet perhaps the most evocative are the most precious—the porcelain cups and tobacco boxes (**cat. nos. 97–99**). These miniature effigies commemorate Napoleon and Josephine's best public moments, images that Josephine promoted until her death in 1814.

Figure 8: Pierre Dandelot (French, born 1910), after Leon de Wailly (French, active 1803–1824), *Two black swans at the Water's Edge*, 1806, Watercolor on paper, Musée National du Château de Malmaison Rueil-Malmaison, France ©Réunion des Musées Nationaux / Art Resources, NY

Notes:

1. For the historical chronology of this essay, I am following the remarkable biography by Bernard Chevallier and Christophe Pincemaille, *L'Impératrice Joséphine* (Paris: Presses de la Renaissance, 1988), re-edition, "Petite Bibliothèque," Payot, No. 309, 1996, and by the same author, *"Douce et incomparable Joséphine"* (Paris: Payot, 1999). Josephine called Napoleon *Bonaparte* and Napoleon called Rose, *Josephine*.
2. On details of the divorce see Chevallier, 1996, 50-60.
3. Chevallier, 1996, 61-88.
4. Bronislaw Baczko, "Thermidorians" in *A Critical Dictionary of the French Revolution*, ed. François Furet and Mona Ozouf, trans. A. Goldhammer (Cambridge: Harvard University Press, 1989), 400-13.
5. Josephine had met Thérèse when she was still Madame de Fontenay at the Salon of Marie-Anne de Lameth, a friend of the Beauharnais family. Thérèse became known as Notre Dame de Thermidor because Tallien allegedly precipitated the fall of Robespierre to save his mistress from the guillotine. See Chevallier, 1996, 89-91, 105-109. Idem., 1999.
6. Chevallier, 1999, 92, "Sa mere, les dames de la Providence, sa tante Désirée lui ont enseigné les manières du monde; Thérèse l'initie à ses mysteres."
7. On Napoleon's rise during the revolutionary period see François Furet, "Napoleon Bonaparte" in *A Critical Dictionary of the French Revolution*, ed. François Furet and Mona Ozouf, trans. A. Goldhammer (Cambridge: Harvard University Press, 1989), 273-86.
8. Josephine probably met Bonaparte prior to October 1795 at evenings she attended with Barras. The anecdote of the sword recounted by both Napoleon and Eugène in their *Memoirs* marks their first public meeting. Chevallier, 1996, 113-16.
9. In his *Memoirs* Napoleon, returning to the beginnings of his ascension to power, acknowledged the role played by Barras in his marriage to Josephine: "Barras, dirait-il, m'a rendu service en ce qu'il m'a conseillé d'épouser, assurant qu'elle tenait à l'ancien regime et au nouveau; cela me donnerait de la consistence . . . sa maison était la meilleur de Paris et cela m'ôterait mon nom de Corse; enfin, je serais, par cette union tout à fait français." Quoted in Chevallier, 1999, 110.
10. Chevallier, 1996, 122, "Le marriage de Joséphine avec Napoléon ne resulte ni de coup de tête ni d'une manoeuvre machiavélique. Il procède, en vérité, de la conjunction des intérêts des deux conjoints."
11. Denise Ledoux-Lebard, "Joséphine and Interior decoration," *Apollo* 106 (July 1977): 16-24.
12. For a complete history of Malmaison see B. Chevallier, *Malmaison, château et domaine des origines à 1904* (Paris: RMN, 1989).
13. Chevallier, 1996, 184-85; Chevallier, 1989, 35-40. Josephine became the owner of Malmaison in 1809 after the divorce.
14. From 1804 until 1809 Josephine shared two imperial residences with Napoleon, the Tuileries and Saint-Cloud. She also had apartments at Rambouillet and Fontainebleau, but her private residence where she could give free reign to her own taste remained Malmaison.
15. The daily routine at Malmaison changed according to Josephine's status at court. See Chevallier, 1996, 247-51.
16. Chevallier, 1989, 71-77.
17. Chevallier, 1989, 81-96; Also see Denise Ledoux-Lebard, op. cit., 18-22.
18. On meals and dinner services see Bernard Chevallier, *L'Art de Vivre au temps de Joséphine* (Paris: Flammarion, 1998), 112-18.
19. Ibid.

20. Nicole Hubert, "Joséphine and Contemporary Painting," *Apollo* 106 (July 1777): 25-33 and Gerard Hubert, "Joséphine, a Discerning Collector of Sculpture," *Apollo* 106 (July 1777): 34-43. Also see Chevallier, 1989, 117-20.

21. La Reine Hortense, *Une Femme Artiste* (Paris: Musées Nationaux des châteaux de Malmaison et Bois-Préau, 1993), 34-35.

22. Chevallier, 1989, illustration nos. 118 and 119.

23. Christian Jouanin and Jérémie Benoit, *L'Impératrice Joséphine et les Sciences Naturelles* (Paris: Musées Nationaux des châteaux de Malmaison et Bois-Préau, 1997).

24. Ibid., 27

25. Ibid., 81-86; she also benefitted from the expedition by Baudin to Australia.

26. As early as 1801 Josephine enlarged her property to include the lake and the domaine at Saint Cucufa, Chevallier, 1989, 41-50.

27. Chevallier, 1989, 109-10.

28. There were more than 250 species of roses in her collections. The publication of the roses began after Josephine's death; the editions included 486 plates.

29. Ventenant, 2 vols in grand folio, 1803-05, Josephine bought sixteen examples of Ventenant's book, two for her library and the remaining volumes were given as diplomatic gifts

30. Chevallier, 1996, idem, but especially "l'Impératrice ne fait point d'économies," 273-300.

31. Chevallier, 1996, 283-86.

I would like to thank Victoria Cooke, Gail Feigenbaum, Alain Pougetoux and Bernard Chevallier for their kind assistance for the research of this essay.

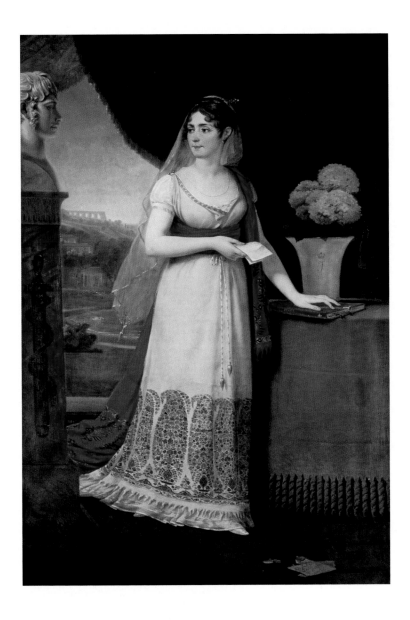

79.

Antoine-Jean Gros (French, 1771–1835)
Portrait of the Empress Josephine, 1808

Oil on canvas
84 x 55 inches (215 x 140 cm)
Musée d'Art et d'Histoire, Palais Masséna,
Nice, France (MAH-2842)

In this impressive full-length portrait commissioned by the emperor in 1808, Josephine (1763-1814) is shown at Malmaison. She is wearing an Empire-style dress constructed from a delicate English shawl draped over white muslin and embroidered with palm motifs. Over her shoulder she wears a shawl and a silken veil. From the 1790s onwards Josephine had followed an innovative style in contemporary dress that was called *à l'antique* or *à la grecque*. Such dresses, perhaps popularized by the painter Madame Elisabeth Vigée-LeBrun (1755-1842), were made of white muslin or light silk, often embroidered with gold and silver threads, that were gathered and draped under the bodice with a scarf or ribbons. Josephine places one hand on a book, *Flore de la Malmaison*, while she is holding a letter in the other hand. She looks towards a portrait bust of her son Eugène, suggesting the letter was written by him. On the table, a vase marked with her imperial coat of arms holds hydrangeas, called *Hortensia* in French, a reference to her daughter Hortense. The curtain behind her is opened to reveal the gardens of Malmaison. A pond contains both black and white swans, reminding the viewer that Josephine was the first person to raise the Austrialian black swans in captivity. The painting contains many references to her fertility—her children and metaphorically her garden. Gros has captured Josephine's poise and beautiful features without suggesting her age—forty-five—and the implicit fact that she was beyond child-bearing years and unable to conceive an heir to the imperial throne. **S.T-L.**

80.

Pierre Paul Prud'hon (French, 1758–1823)
Portrait of Empress Josephine in 3/4 View, circa 1805-09

Black and white chalk, stumped, on blue paper
13 x 9-3/4 inches (33.5 x 24.8 cm)
Musée du Louvre, Département des Art Graphiques, Paris (RF40458)
©Réunion des Musées Nationaux / Art Resources, NY

Prud'hon's drawing, perhaps more than his painted portraits of Josephine, captures what contemporaries consistently referred to as her natural grace and charm. The drawing is executed in charcoal on blue paper and is highlighted with white chalk. Her hair was often tied in a chignon pinned high on the nape of her neck and encircled with narrow bands, so that her forehead was framed by short curls. Although the charcoal on the blue paper does not communicate Josephine's dark blue eyes, long brown hair, or very long eyelashes, Prud'hon nonetheless suggests that Josephine's features became even more beautiful when she focused her gaze so as to captivate her viewers. This drawing was the only sketch Prud'hon made from life for his monumental painting of Josephine in the park at Malmaison now at the Louvre. **S.T-L.**

81.

Pierre Paul Prud'hon (French, 1758–1823)
Portrait of Empress Josephine seated in a Park,
circa 1805-09

Black and white chalk, stumped, on blue paper
9 x 10 inches (24.1 x 25.9 cm)
Musée du Louvre, Département des Art Graphiques,
Paris (RF4105)
©Réunion des Musées Nationaux / Art Resources, NY

This drawing is one of the many studies Prud'hon executed for his large oil portrait of Josephine, which show her at Malmaison in seated profile. He has lightly sketched her wearing a dress popular at the time, where muslin was gathered at the bodice and draped under the bust with a scarf. For the painting Prud'hon rejected this view in favor of a more melancholic pose where Josephine turns towards the left. **S.T-L.**

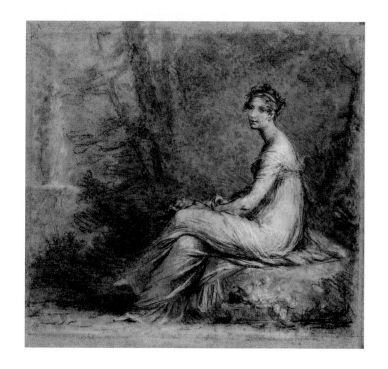

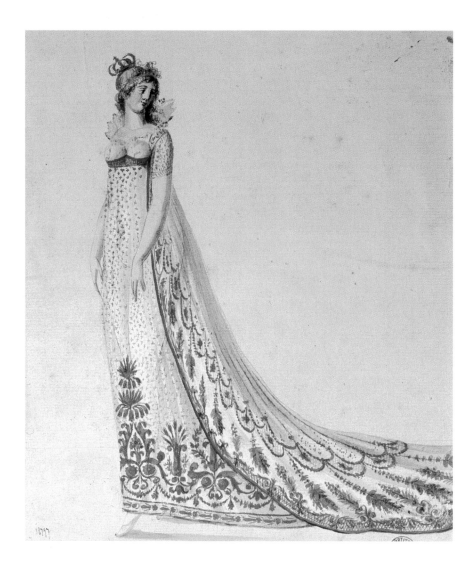

82.

Jean François Bony (French, circa 1760–circa 1825)
Sketch for Josephine's Coronation Dress, 1804

Gouache on paper
11 x 10-1/4 inches (28.8 x 25.9 cm)
Musée des Tissus de Lyon, France (18797)

The preparation for the coronation of Napoleon and Josephine in 1804 prompted the creation of a new type of court dress. The costume worn by Josephine was designed by Jean-Baptiste Isabey (1767-1855). Josephine's coronation gown had short sleeves and a high waist. The dress was embroidered with vertical bands or palmate patterns. The square décolletage was framed by pleated flounces raised like a fan on the shoulders. The court mantle train was embroidered around the hem and had the same motifs and colors as the gown. **S.T-L.**

83.

Jean François Bony (French, circa 1760–circa 1825)
Embroidery sample for Josephine's Coronation Dress, 1804

Metal, silk, paillettes, silk ground
21-1/4 x 15-3/4 inches (54.6 x 40 cm)
Musée des Tissus de Lyon, France (18797 bis)

This embroidery sample shows the detailed needlework dedicated to the coronation dress. The arabesque motifs are highlighted by flower samples perhaps alluding to Josephine's passion for flowers at Malmaison. This type of needlework, exceptional in quality, set the model for future Empire fashions. **S.T-L.**

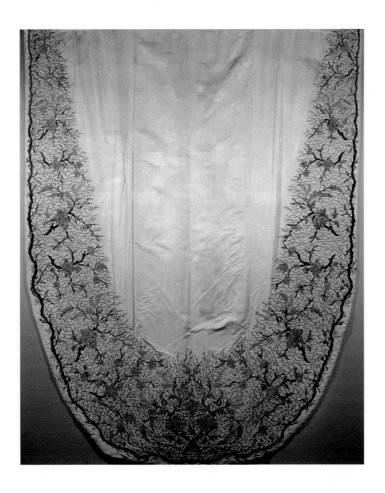

84.

Unidentified Artist, French School
Court train of Empress Josephine for the Milan Coronation, circa 1805

Cream silk, satin, gold thread, embroidered with gold and silver thread
95 x 80 inches (242 x 204 cm)
Musée d'Art et d'Histoire, Palais Masséna, Nice, France (MAH-3927)

In 1805 Napoleon was crowned king of Italy in Milan; and, although Josephine was not crowned queen, she participated as a guest of honor in the tribunes in a sumptuous costume. Josephine's court train, executed in silk and satin, was embroidered in gold and silver following the court fashion established at the *Sacre* of 1804 in Paris. **S.T-L.**

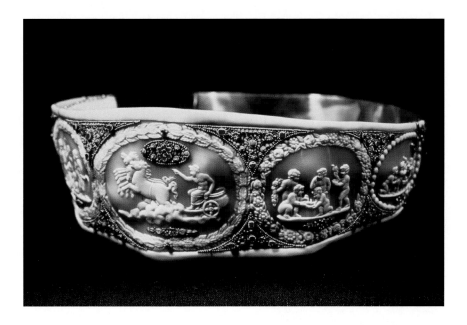

85.
Unidentified Artist, French School
Cameo-Shell Diadem belonging to Josephine, circa 1800

Shell, gold, mother of pearl, cameos, pearls, precious
and semiprecious stones; cut from one shell
2-5/8 x 6-3/4 x 7-3/4 inches (6.7 x 17 x 20 cm)
Musée d'Art et d'Histoire, Palais Masséna, Nice, France
(Chapsal 1360)

86.
Unidentified Artist, French School
Set of Jewelry belonging to Josephine, 1800

Necklace, grand necklace, pair of bracelets, diadem,
brooch, pendant, earrings, and six pins
Cameos of antique figures in malachite, pearls mounted on gold
Fondation Napoléon, Paris. Collection Martial Lapeyre (973)

Josephine's contribution to the development of Empire-style
jewelry can be seen in these exceptional pieces. First is a cameo
diadem carved entirely from a single shell and embellished with
antique cameos, gold, pearls and semiprecious stones. The central
cameo is a representation of Apollo in his sun chariot. The
stunning set of carved malachite cameos was fashioned into a
necklace, diadem, brooch, bracelets and six pins. **S.T-L.**

113

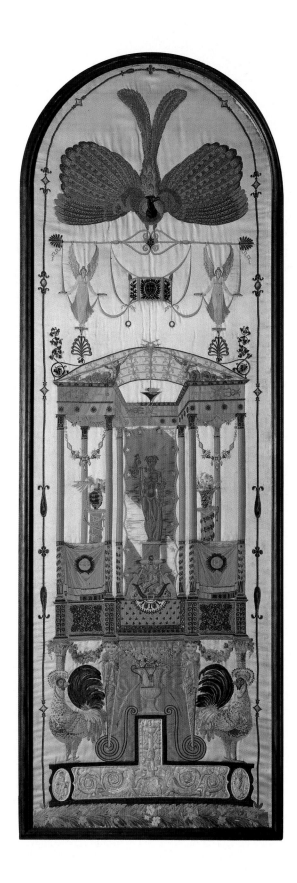

87.

Jean-Demosthène Dugourc (French, 1749–1825)
Embroidered Panel: Mars, 1800-10

Satin stitch, appliqué, tambour work, chenille, painted; silk ground
99 x 35 inches (251.4 x 88.9 cm)
Saint Louis Art Museum, Saint Louis, Missouri. Purchase.
(363: 1923)

When redecorating the palaces at Saint-Cloud and Fontainebleau
in the new Empire style, Napoleon and Josephine promoted
wall hangings and wallpapers that combined neoclassical designs
with Napoleonic symbols, such as bees, laurel wreaths, the
initial *N* and Egyptian motifs. This panel by Dugourc, perhaps
destined for Saint-Cloud, shows how the arabesque framing
devices of the eighteenth century had been updated with neo-
classical references and insets. The figure of Mars, god of war,
was certainly appropriate Napoleonic imagery. **S.T-L.**

88.

Montcenis Crystal Factory (near Paris, active 1796–1832)
Champagne Glass Engraved with the Initial of the Empress Josephine

Crystal
7-7/8 x 2-3/4 inches (20 x 7 cm)
Musée National du Château de Malmaison, Rueil –
Malmaison, France (MM 40-47-196)
©Réunion des Musées Nationaux / Art Resources, NY

The Montcenis factory patronized by Josephine executed the crystal for the imperial service. After 1806 it became the *Manufacture des cristaux de S. M. l'Impératrice*. On this glass we see Josephine's imperial arms—her initial *J* topped with a crown—that she was able to maintain after the divorce. **S.T-L.**

89.

Martin-Guillaume Biennais (French, 1764–1843)
Coffee and Tea Service Belonging to Josephine: cup, sugar bowl, confiture, teapot, coffee pot, creamer on serving tray, circa 1798-1809

Gilded silver (vermeil)
Cup: 3 inches (8.9 cm); confiture: 5 x 5 inches (14 x 13 cm); teapot: 4-1/3 x 8 inches (11 x 22 cm); coffee pot: 7-1/3 x 6 inches (18.7 x 15.5 cm); creamer: 7 x 4 inches (19.2 x 10.5 cm); circular serving tray: 17 inches (44.3 cm)
Fondation Napoléon, Paris.
Collection Martial Lapeyre (966)

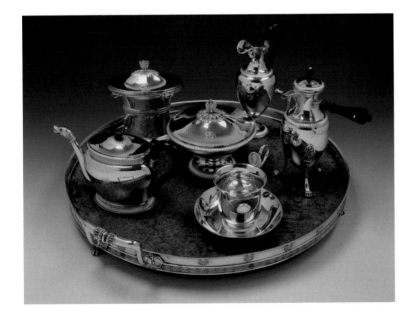

Martin-Guillaume Biennais, a silversmith who specialized in luxury objects, opened his own boutique in 1789. He was named *Orfèvre de S.M. Empereur et Roi* after executing the imperial insignia for Napoleon's coronation in 1804. This exceptional tea service is engraved with Josephine's imperial arms, and the handles on the sugar and marmalade bowls are sculpted into imperial eagles. This gilded silver tea service is composed of seven separate pieces that are displayed on a silver tray. Each piece has an embossed palmated leaf pattern that echoes the same relief on the border of the tray. **S.T-L.**

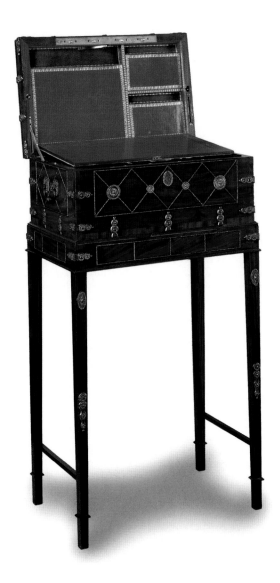

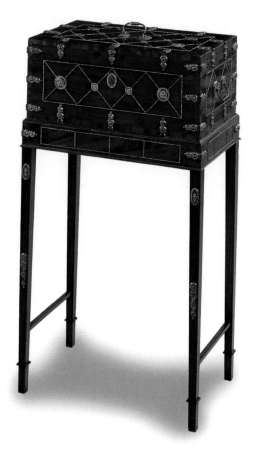

90.

Martin-Guillaume Biennais (French, 1764–1843)
*Jewelry Chest Serving as a Writing Case with the
Monogram of Josephine*, circa 1802-04

Mahogany, steel and silver
35-1/4 x 19-1/3 x 12 inches (89.5 x 49 x 32 cm)
Musée National du Château de Malmaison, Rueil –
Malmaison, France (MM 93-5-1)
©Réunion des Musées Nationaux / Art Resources, NY

This unusual piece was commissioned for Josephine's bedroom at Malmaison
to serve as both jewel box and letter case. Its décor, with faceted steel nails
in lozenge shapes and resembling beaded pearls, is one of the most important
examples of polished steel work in the beginning of the nineteenth century.
Biennais designed the box and table sometime between 1802 and 1804, as
his own signature, as well as Josephine's monogram *JB*, date uniquely from
that period. The mahogany box is attached to the table but can be lifted off
and stand on its own as a jewel chest. When open, the chest has a movable
leather writing pad. When moved, the pad reveals secret compartments for
envelopes, pens and personal stationary. Beneath the writing pad is a jewelry
box lined with silk. Josephine owned several rare pieces of jewelry made from
polished steel. This box was finished by the Schey family who specialized
in making high quality polished steel objects until the 1830s. **S.T-L.**

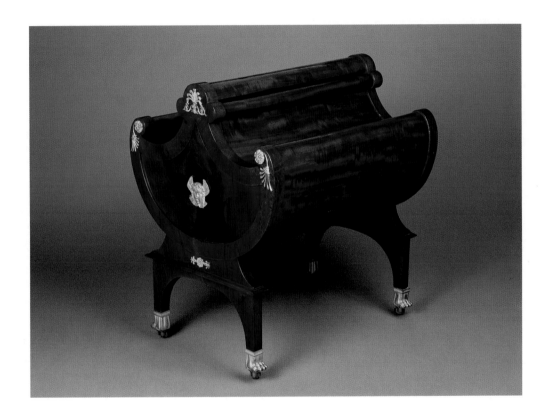

91.

Martin-Guillaume Biennais (French, 1764–1843)
Letter Box

Mahogany and gilded bronze
23-1/4 x 20 x 17-3/4 inches (59 x 52 x 45 cm)
Collection of Alexis and Nicolas Kugel, Paris

Josephine composed her letters on elegant letter tables (*écritoires*). This rare *serres lettres* (two other examples are known, one at Malmaison and another at the Fondation Napoléon) executed in mahogany and gilded bronze resembles a tumbler where each side lifts to a storage space for incoming or outgoing letters. The *serres lettres* could be easily moved from room to room. **S.T-L.**

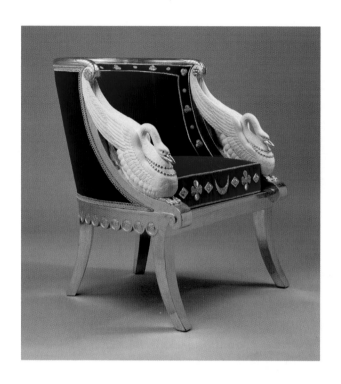

92.

François-Honoré-Georges Jacob-Desmalter
(French, 1770–1841)
Swan Armchair designed for Josephine, circa 1804

Wood, gold, red silk velvet, gold thread
30-1/4 x 26 x 20 inches (77 x 66 x 51 cm)
Musée National du Château de Malmaison,
Rueil – Malmaison, France (MM 40-47-942)
©Réunion des Musées Nationaux / Art
Resources, NY

93.

Darte Frères manufactory (Paris, active 1801–1833)
Swan tea cup and saucer, circa 1810

White and gilded porcelain
Cup: 7 x 5 inches (17 x 14 cm); saucer: 2 x 4 inches (5 x 11.7 cm)
Musée National du Château de Malmaison, Rueil – Malmaison,
France (MM 40-47-6122 and 6123)
©Réunion des Musées Nationaux / Art Resources, NY

This chair was originally part of a set of furniture for Josephine's bedroom at the chateau of Saint-Cloud where she and the First Consul took up official residence in 1802. The swan was one of Josephine's favorite emblems and the arms of the chair were transformed into this bird, evoking feminine grace. The Darte brothers also used the swan motif for porcelain sets as seen in this teacup and saucer. **S.T-L.**

94.

Jacob-Frères (Paris, active 1798–1803)
Stool from the Council Chamber in the Form of an X

Gilt wood, red cloth, gold brocade
28-3/8 x 29 x 18 inches (72 x 75 x 47 cm)
Musée National du Château de Malmaison, Rueil –
Malmaison, France (MM 640-47-6961)
©Réunion des Musées Nationaux / Art Resources, NY

Following the inventory after Josephine's death in 1814, ten stools of this type were placed in the council chamber at Malmaison. In 1802, this room was outfitted to resemble a tent with striped wallpaper and military trophies on the doors and typifies the masculine style created for Bonaparte when he was in residence. **S.T-L.**

95.

Fleury François Richard (French, 1777–1852)
François I Shows to His Sister, the Queen of Navarre, the Verses which He Has Just Engraved on a Window Pane, 1804

Oil on canvas
25 x 30-1/3 inches (65 x 77 cm)
Musée Napoléon, Schloss Arenenberg, Salenstein, Switzerland

This painting was exhibited in the Salon of 1804 and purchased by Josephine. It was given to her daughter Hortense in 1816 then entered the collections of her son Napoleon III. The troubadour style celebrated intimate genre scenes, often inspired by medieval or renaissance history or imagined historical anecdotes. The rich costume and interior are rendered in glistening cool colors that recall miniatures from medieval illustrated Books of Hours. From the salon catalogue we can read the verse written on the window: *Souvent femme varie, Bien fol. Qui s'y fie* (Often a woman is fickle, one would be foolish to follow her.) **S.T-L.**

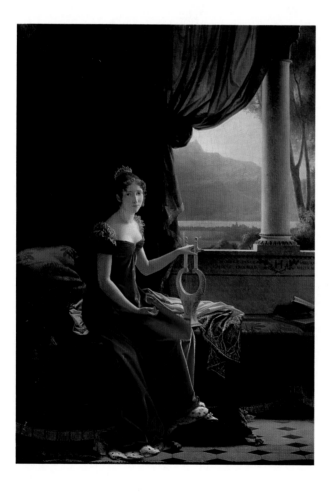

96.

Fleury François Richard (French, 1777–1852)
Portrait of Queen Hortense, 1812

Oil on canvas
28-1/3 x 20 inches (72 x 52 cm)
Fondation Dosne-Thiers, Institut de France, Paris. Collection Frédéric Masson (MP0049)
©Réunion des Musées Nationaux / Art Resources, NY

Hortense (1783-1837) was forced to marry Napoleon's brother Louis Bonaparte (1778-1846) in 1802. As Louis Napoleon he reigned as king of Holland from 1806 to 1810. After his abdication, Hortense continued to reign as queen of Holland until Napoleon's defeat at Waterloo in 1814. She then lived in exile in Switzerland with her son Charles Louis Napoleon (1808-1873), who later became Emperor Napoleon III (1852-1870).

Hortense commissioned her portrait from Richard in an explicitly troubadour pose. She is seated before a window that overlooks the lake at Bourget in Switzerland. Hortense wears a rich, red velour Empire-style dress, a matching diadem hair piece, and two shawls are draped behind her. She holds a guitar modeled to look like an antique lyre. Hortense, an accomplished musician who enjoyed playing pastoral compositions, probably requested that her portrait include the lyre to allude to her musical talents while at the same time suggesting that she is a muse—both for her mother and her son—the future Napoleon III. The inscription under the column reveals her emblem: *"Moins connue, moins troublée. Mieux connue, mieux aimée."* (Less well known, less troubled. Better known, better loved.) **S.T-L.**

97.

Manufacture Nationale de Sèvres
(France, active 1756–present), decorated
by Gérard after Jean-Baptiste Isabey
(French, 1770–1837)
Chocolate cup with portrait of Bonaparte, 1803

Hard porcelain
2 x 3 inches (6.7 x 7.2 cm)
Musée National de Céramique, Sèvres,
France (9370)
©Réunion des Musées Nationaux /
Art Resources, NY

This cup shows Bonaparte in his Consular
uniform after a portrait by Jean-Baptiste
Isabey (1767-1855). Isabey was particularly
celebrated for his miniature paintings on
ivory. The transference from ivory to
porcelain was effortless, and this portrait,
painted by Isabey's student Gérard, conveys
the intimate details of a miniature. The
form of the cup—*calice à volute*—refers to
the extremely delicate curving handle.
The fragility of the form meant that this
service was a very limited series. **S.T-L.**

98.

Manufacture Nationale de Sèvres
(France, active 1756–present), decorated
by Marie-Victoire Jaquotot
(French, 1772–1855)
*Jasmine cup with saucer with portrait of
Empress Josephine*, 1810

Hard porcelain
Cup: 3 x 4 inches (9 x 10.5 cm);
saucer: 6 inches (15.7 cm)
Musée National de Céramique,
Sèvres, France (2008)
©Réunion des Musées Nationaux /
Art Resources, NY

This cup testifies to the extreme luxury
of the porcelain services commissioned by
the imperial family. Josephine is shown in
the costume of the *Sacre*, but the saucer
displays the military trophies that were
the leitmotif of interior decoration under
the Empire. **S.T-L.**

99.

Jacques Félix Viennot and Jean-Baptiste Isabey
(French, 1767–1855)
Box with Portrait of Emperor Napoleon
Signed on right back: *J. Isabey*

Gold and ivory
4/5 x 3-4/5 x 2 inches (2.2 x 9.8 x 6.5 cm)
Fondation Napoléon, Paris. Collection Martial
Lapeyre (44)

This box, probably intended for tobacco, shows
Napoleon in the costume of the *Sacre* after the portrait
by Isabey. Like porcelains and miniatures, the refined
elegance of tobacco boxes shows the preeminence of
the French luxury trades under imperial patronage.
This box also shows how the dissemination of the
imperial image was imposed on even the most inti-
mate objects. **S.T-L.**

100.

Unidentified Artist, French School
Snuff-Box with Cameo Leda and the Swan, circa 1810

Yellow gold and red, matte and polished,
with carven shell cameo and diamonds
3/4 x 3 x 2-1/4 inches (2 x 8 x 5.8 cm)
Fondation Napoléon, Paris. Collection Martial
Lapeyre (1063)

This tobacco box was given by Napoleon to the
Comtesse Louise de Pouel Plater in 1810. A cameo
depicting the story *Leda and the Swan* is placed in the
center of the box surrounded by forty-six diamonds. In
the four corners are roses, also embellished with dia-
monds. **S.T-L.**

101.

Ambroise-Louis Garneray (French, 1783–1857),
after Auguste Garneray (French, 1785–1824)
View of Malmaison: the Park Side Facade,
circa 1815-20

Aquatint on paper
12-3/8 x 15 inches (31.5 x 39.5 cm)
Musée National du Château de Malmaison,
Rueil – Malmaison, France (MM 40-47-4222)
©Réunion des Musées Nationaux / Art
Resources, NY

Auguste Garneray (1785-1824) studied under Jean-Baptiste Isabey and made his reputation as a miniaturist, specializing in portraits and landscapes. He exhibited at the Paris Salons from 1808 to 1824. In 1820 Auguste Garneray gave Prince Eugène de Beauharnais (1781-1824) a series of twelve watercolors of Malmaison that were published after the death of his mother, the empress. Ambroise-Louis Garneray engraved eight of these views. This engraving gives an idea of the scale of Malmaison. An imperial cortege passes by the chateau as a carriage turns to the entranceway. We can see the luxuriant and abundant shrubberies that frame the house and testify to Josephine's horticultural passions. In the background we see dense plantings of trees leading into the park. **S.T-L.**

102.

Ambroise-Louis Garneray (French, 1783–1857),
after Auguste Garneray (French, 1785–1824)
*View of Malmaison: Cow Shed in the Woods of St.
Cucufa,* circa 1815-20

Aquatint on paper
12-3/8 x 15 inches (31.5 x 39.5 cm)
Musée National du Château de Malmaison, Rueil –
Malmaison, France (MM 40-47-4254)
©Réunion des Musées Nationaux / Art Resources, NY

After 1801 Josephine enlarged the estate by purchasing the woods and spring at Saint-Cucufa next to Malmaison. The cow shed, designed by Jean Marie-Morel (1728-1810), included not only a stable for the Swiss cows, but also a dairy and residence for the shepherd. These buildings recall an experimental or "ornamental" farm that promoted new farming techniques. **S.T-L.**

103.

Ambroise-Louis Garneray (French, 1783–1857),
after Auguste Garneray (French, 1785–1824)
*View of Malmaison: Stables and Woods Behind the
Park*, circa 1815-20

Aquatint on paper
12-3/8 x 15 inches (31.5 x 39.5 cm)
Musée National du Château de Malmaison,
Rueil – Malmaison, France (MM 40-47-4237)
©Réunion des Musées Nationaux / Art
Resources, NY

This building, almost ninety meters long, housed
over two thousand merino sheep. It was located
at the edge of the park leading to Saint-Cucufa.
Like the raising of Swiss cows, merino sheep
were considered a species that would improve
domestic production of wool. **S.T-L.**

104.

Schoelcher manufactory (Paris, active 1798–1824)
Vase with View of Malmaison taken from the stone bridge, after an engraving
by Ambroise–Louis Garneray (French, 1783–1857), 1820

Hard paste porcelain
11 x 8-3/4 inches (29 x 22 cm)
Musée national de céramique, Sèvres, France (REC. CXXXXII)
©Réunion des Musées Nationaux / Art Resources, NY

The views of Malmaison presented by Garneray were copied and
disseminated in the decorative arts such as in this monumental blue vase
from the Paris firm of Schoelcher. This view shows the chateau in the
distance through a break in the trees and hedges. A group of fashionably
dressed visitors enjoy the pastoral surroundings. **S.T-L.**

105.

Pierre-Joseph Redouté (French, 1759–1840)
Streptope Amplexifolius from *Les Liliacees*, circa 1810-14

Watercolor on vellum
18 x 13-1/4 inches (47 x 33.7 cm)
New Orleans Museum of Art, New Orleans, Louisiana.
Gift of Mrs. Thomas Mellon Evans in honor of
Thomas C. Keller (95.66)

106.

Pierre-Joseph Redouté (French, 1759–1840)
Streptope Amplexifolius from *Les Liliacees*, circa 1810-14

Stippled engraving ink on paper with watercolor
23 x 17-1/2 inches (58.4 x 44.5 cm)
New Orleans Museum of Art, New Orleans, Louisiana.
Gift of Mrs. Thomas Mellon Evans in honor of
Thomas C. Keller (95.309)

Josephine, through her patronage of the artist Pierre-Joseph Redouté (1759-1840), captured the
ephemeral plants in her garden, commissioned from him botanical illustrations, such as the *Streptope
Amplexifolius*. These illustrations remain a poignant testimony to her gardens as none of the rare
species exist at Malmaison today. These flower paintings, especially his series of *Les Roses* and *Les
Liliacees*, were published after Josephine's death. **S.T-L.**

107.

Etienne Pierre Ventenant (French, 1757–1808) with
color plates by Pierre-Joseph Redouté (French, 1759–1840)
Josephinia Imperatricis from *Jardin de la Malmaison*, 1803

Hand-colored stippled engraving on paper
21-7/8 x 14-1/2 x 3 inches (55.6 x 36.8 x 7.6 cm)
Oak Spring Garden Library, Upperville, Virginia.
Collection of Mrs. Paul Mellon

108.

Royal Manufacture at Berlin, after Pierre-Joseph
Redouté (French, 1759–1840)
Plate with Mesenbryanthenum Carinatum, 1807

Hard paste porcelain
9 inches (24 cm)
Musée National du Château de Malmaison, Rueil – Malmaison,
France (MM 73-5-1)
©Réunion des Musées Nationaux / Art Resources, NY

Engravings after Redouté's original vellum drawings, such as the *Josephinia Imperatricis*,
were reproduced from 1803 to 1805 in Ventenant's *Jardin de la Malmaison*, where the
plants were lavishly described according to norms of scientific nomenclature to promote
scientific exchange. Josephine's garden patronage found another form of expression in
the decorative arts in the creation of a dinner service after Redouté's drawings of the
plants in her garden. The flower on the plate from Berlin service is the *Mesenbryanthenum
Carinatum*, and the border is surrounded by a frieze of fruits from this flower. **S.T-L.**

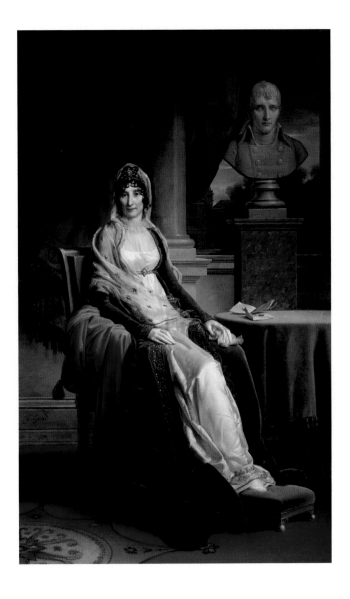

109.

Baron François Pascal Simon Gérard
(French, 1770–1837)
Portrait of Madame Mère, 1800-04
Inscribed, lower left: *Fco Gérard*

Oil on canvas
82-3/4 x 51-1/8 inches (210.8 x 129.8 cm)
National Gallery of Scotland, Edinburgh
(NG 2461)

François Gérard was born in Rome and moved to France at the age of ten, where he apprenticed first with the sculptor Augustin Pajou (1730-1809) then with the painter named Brenet before entering the studio of Jacques-Louis David in 1786. His fame as a portrait painter was established at the biennial exhibition of the Royal Salon of Painting and Sculpture in 1796 with his portrait of his fellow painter Jean-Baptiste Isabey. His portrait of Napoleon's mother, Maria Laetitia Ramolino Bonaparte (1749-1856), probably dates from the Consular period (1800-1804) as Napoleon's bust in the upper right-hand of the composition depicts him in his Consular uniform. In this portrait, Napoleon's mother is depicted in extremely fashionable dress—a muslin and silk gown embroidered in gold, a green embroidered velvet cape and two shawls, one in muslin or cotton embroidered with golden bees, and a red cashmere casually draped over the side of the Directory style armchair. Her jeweled diadem hair piece further emphasizes social status, and Gérard has placed an open letter on the table, although it was well known that Madame Mére was barely literate. Sitting facing the viewer her place in society is clear: she is the matriarch of the Bonaparte clan, and her fame derives from her relationship to her second eldest son—seen in the portrait bust and through the windows to the Tuileries Palace beyond. Her pose recalls not only the tradition of monarchical portraits usually appropriate for queens, but also the fourth-century Roman statue known as the *Seated Agrippina*. **S.T-L.**

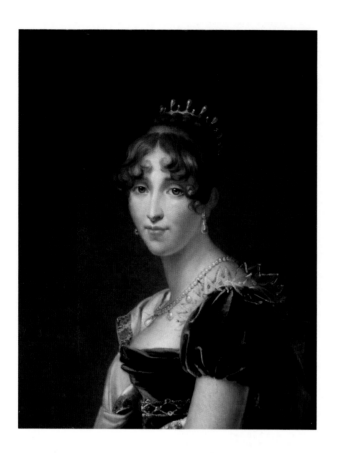

110.

Baron François Pascal Simon Gérard (French, 1770–1837)
Portrait of Hortense de Beauharnais, Queen of Holland, 1820

Oil on canvas
25 x 21-1/4 inches (64.8 x 54 cm)
Collection of Sharon Halton, on extended loan to Ash Lawn-Highland Museum, Charlottesville, Virginia

While in France, James Monroe's daughter became friendly with Hortense de Beauharnais (1783-1837). Upon the birth of her daughter, Hortense sent to her friend these two portraits, which are now in a private collection. In this three-quarter view Hortense is shown in a fashionable blue velvet Empire dress with a silk shawl wrapped around her right shoulder. She wears a pearl diadem, earrings and necklace. Pearls were extremely popular in Empire jewelry, and it is possible she inherited these jewels from her mother's extensive collection. Gérard has painted Hortense with great sensitivity evoking a certain melancholy typical of romantic portraiture. **S.T-L.**

111.

After Joseph Karl Stieler (Bavarian, 1781–1858)
Portrait of Eugène de Beauharnais, circa 1815-16

Oil on canvas
25 x 21-1/4 inches (64.8 x 54 cm)
Collection of Sharon Halton, on extended loan to Ash Lawn-Highland Museum, Charlottesville, Virginia

Prince Eugène de Beauharnais (1781-1824), only son of Josephine by her first husband and brother of Hortense, served as viceroy in Italy from 1805 to 1814. This painting was probably executed circa 1815 to 1816 when Eugène was in exile in Munich. It closely resembles a portrait by Joseph Karl Steifler, who had studied under Baron Gérard in Paris then worked as a portrait painter, first in Frankfort and later in Munich. Here we see Eugène as a mature man wrapped in an ample military cape. This three-quarter view is a typical romantic pose that recalls the glory of the Napoleonic wars and implicitly shows Eugène's loyalty to his step-father Napoleon Bonaparte. **S.T-L.**

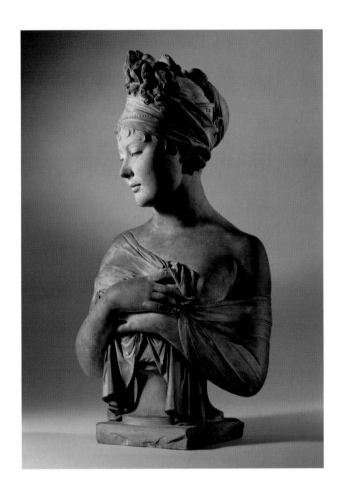

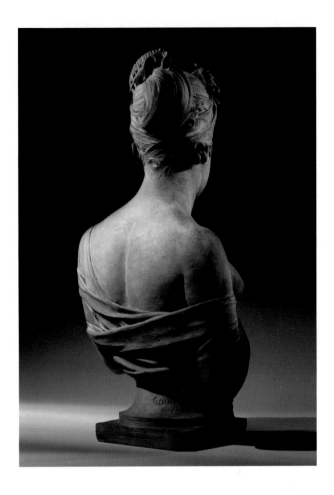

112.

Joseph Chinard (French, 1756–1813)
Madame Juliette Récamier, circa 1801-02
Signed on base: *chinard Lyon*

Terra cotta
24 inches (62.2 cm)
Private Collection, Paris

Jeanne-Françoise-Julie-Adelaide Bernard Récamier (1777-1849) was one of the most celebrated *salonnieres* of the French revolutionary period. Married to the banker Jacques Rose Récamier in 1793, at the age of fifteen, she and her husband survived the turmoil of the Terror and prospered under the Directory. In 1798 the Récamiers purchased from Jacques Necker, former finance minister to Louis XVI, a town house in the fashionable Chausée d'Antin section of the Right Bank. Although Juliette Récamier probably knew Necker's daughter, the future Madame de Staël, before this date, in the following years the two women became friends and orchestrated the meetings of Parisian literary society, including the young Chateaubriand.

Joseph Chinard, who, like the Récamiers, was a native of Lyon, sculpted Juliette Récamier several times. This version, which dates to the Consular period, shows her draping fabric around her shoulders, leaving one breast bare. Her hair is bound with a scarf and pearls and tiny curls frame her face. Chinard captured the very grace and beauty that made Madame Récamier one of the most celebrated women of her time, who was most famously portrayed by Jacques-Louis David (1748-1825), reclining on a chaise longue. **S.T-L./V.C.**

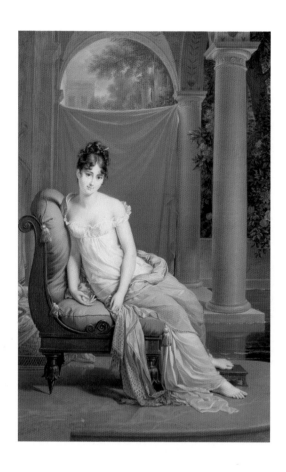

113.

Pierre-Narcisse Guérin (French, 1774–1833),
after Baron François Gérard (French, 1770–1837)
Portrait of Madame Récamier (French, 1777–1849), 1808

Oil on porcelain
14-3/8 x 9-3/4 inches (36.5 x 24.8 cm)
Middleton Place Foundation, Charleston, South Carolina

This is a reduction, on porcelain, of Gérard's portrait of Madame
Récamier in the Musée Carnavalet in Paris. The coquettish pose
captures the informal spirit of her salons and her habit of receiving
visitors in her bedroom. This copy by Guérin was commissioned
by the American John Izard Middleton, who met Récamier in
Paris in 1807, and became one of her many admirers. **V.C.**

114.

Sir Robert Smirke (British, 1781–1845)
Bedroom of Madame Récamier
Watercolor and pencil on paper
11 x 14 inches (28.1 x 35.7 cm)
Royal Institute of British Architects, RIBA Library Drawings
Collection, London

Before Jacques Rose Récamier's bankruptcy in 1806, Juliette
Récamier created one of the most spectacular interior decora-
tion suites of the period, which would have been known, if not
frequented by Josephine de Beauharnais. According to contem-
poraries, Madame Récamier would invite her guests to see her
bedroom, designed by the architect Louis Berthault (1767-1823),
probably under the supervision of Charles Percier (1764-1838)
and Pierre-François-Lèonard Fontaine (1762-1853). The design
of her bedroom gained further influence when reproduced in
Krafft and Ransonnette's *Plans, coupes et élévations des plus
belles maisons et des hôtels construits à Paris et dans les environs,*
published in 1801 to 1802. This publication, along with Percier
and Fontaine's *Recueil de décorations intérieures comprenant tout
ce qui a rapport à l'ameublement,* became a source book for French
craftsmen, many of whom emigrated to the United States.

Although Josephine was certainly inspired by Madame Récamier's
decoration for the Hôtel de Chatereine and to a lesser degree at
Malmaison, Hortense de Beauharnais, in the decoration of the
Hôtel de Beauharnais (present-day German embassy), recreated
a bedroom and bathroom suite that recalls the style and harmony
of Madame de Récamier's boudoir. **S.T-L.**

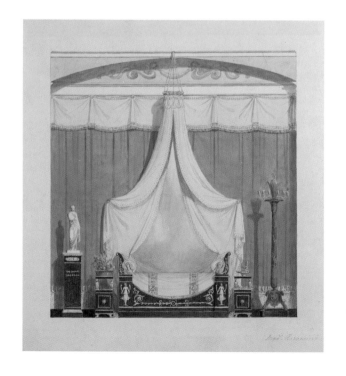

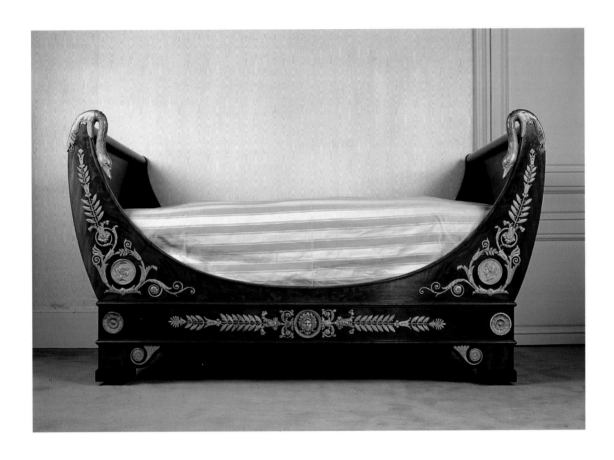

115.

François-Honoré-Georges Jacob-Desmalter
(French, 1770–1841)
Swan Bed from the home of Madame Récamier,
circa 1804

Mahogany, ornamented with gilded bronze
43-1/3 x 78 x 102 inches (110 x 198 x 259 cm)
Private Collection, France

All of the furniture for the house of Madame Récamier was commissioned from Jacob-Desmalter. At a later sale of Récamier's estate, the Count de Montesquiou-Feznac purchased furniture that belonged to the guest bedroom at the Chausée d'Antin that remains in a private collection today. The bed, nightstand, and flower stand were commissioned from Jacob-Desmalter and provide an exceptional example of Consular-style furniture. Madame de Récamier's boat-shaped bed (*lit bateau*) was the interior design success of the 1800s. Comparing the contemporary watercolor by Smirke, we can see the two beds have similar shapes, but the bronze decorations vary. **S.T-L.**

116.

François-Honoré-Georges Jacob-Desmalter (French, 1770–1841)
Nightstand from the home of Madame Récamier, circa 1804

Mahogany, citron-tree, incrusted with motifs in ebony, gilded
wood and bronze
33 x 13-1/3 x 11 inches (85.5 x 34 x 29.5 cm)
Private Collection, France

117.

François-Honoré-Georges Jacob-Desmalter (French, 1770–1841)
Jardinaire from the home of Madame Récamier, circa 1804

Mahogany, citron-tree, incrusted with motifs in ebony, gilded
wood and bronze
37 x 14-1/3 x 13 inches (94 x 36.5 x 33 cm)
Private Collection, France

The nightstand and the flower stand (*jardinaire*) were executed also in the swan
motifs and were meant to coordinate with the bed as pendant pieces. **S.T-L.**

118.

Joseph Chinard (French, 1756–1813)
Silence
Inscribed: *Tutatur somnos et amores conscialecti*

Marble on pedestal with mahogany veneer ornament with bronze ornaments
43 x 10 x 8 inches (108.5 x 25.5 x 21.5 cm)
Private Collection, France

Madame Récamier's bedroom contained a celebrated statue by Joseph Chinard representing *Silence*. This marble sculpture personifies Silence as a woman clad in antique draperies with a forefinger that points to her lips. Its mahogany pedestal was originally ornamented with a bronze relief of cupids at play. The inscription reads *Tutatur somnos et amores conscia lecti* (A party to love's couch, she watches over slumber). The statue was copied after the antique. **S.T-L.**

119.

Unidentified Artist, French School
Pair of Candelabra

Gilded bronze, green marble
53 x 16 inches (135 x 41 cm)
Musée National du Château de Malmaison, Rueil – Malmaison, France
(MM 65-3-24 and 25)

This pair of candelabra is similar to those shown in Smirke's drawing of Madame Récamier's bedroom. They date from the late Directory or early Consular period. Although the designer remains unknown, the candelabra share certain motifs with the work of Pierre Philippe Thomire (1751-1843), where floral patterns were merged with winged victory figures. Thomire was established in the bronze and metal trades prior to the Revolution, and in 1804 he acquired a furniture business that developed into the most important bronze-casting firm of the period. **S.T-L.**

THE STATE OF AMERICAN ART

Paul Staiti

The Federal Plan Most Solid & Secure
Americans Their Freedom Will Ensure
All Arts Shall Flourish in Columbia's Land
And All Her Sons Join as One Social Band.

Painted on a banner carried by the New York Pewterers
Society during a procession in support of the ratification of
the Constitution, July 1788[1]

America is the only nation in the world that is founded on a creed.
G. K. Chesterton[2]

The period between the Constitution's ratification and the end of Jefferson's presidency was an extraordinary time in the history of American art and architecture. It witnessed the first material expressions of the new United States: Jefferson's classical design for the Virginia State Capitol (**cat. no. 15**), a monumental plan for the District of Columbia (*fig. 1*), and the architectural competitions for the Capitol and President's House. It saw the emergence of John Trumbull and Gilbert Stuart as artists who imagined a *national* identity for themselves. It called out for new artistic subjects, such as battle pictures, presidential portraits, ornithological studies, galleries of heroes, commemorative medals (**cat. no. 184-186**) and signs, seals, and personifications of America. It encouraged new artistic institutions and customs, such as museums, academies, and patronage. And it inspired a torrent of passionate words, such as those above, written by the pewter artisans in New York, that forecast the artistic splendor that the Constitution would unleash.

The buoyant optimism of the moment was captured well in 1792 by Samuel Jennings, an expatriate Philadelphian, in his monumental picture *Liberty Displaying the Arts and Sciences* (**cat. no. 148**), painted for the opening of a new building for the Library Company, which served as the nation's Library of Congress when the capital was Philadelphia. Inside the Palladian library, which boasted on its facade a statue of Benjamin Franklin dressed as a Roman orator, Jennings composed a vision of America's future in which Lady Liberty beneficently presides over the abolition of slavery. Under the columns of her classical temple she has already smashed the chains of bondage with her liberty pole and is about to distribute books on agriculture and philosophy to an African-American family that respectfully bows to her. In the distance, more African Americans dance by a liberty pole while ships ply a commercial waterway, both the welcome fruits of liberty. On the far left, a globe has been turned to the Western Hemisphere, which shines in the morning light streaming in from the left. And spilling out from the temple and across the foreground are prominently displayed emblems illuminated by the new dawn's light: music, literature, architecture, sculpture, and astronomy, all ready to be claimed from freedom's warehouse.

All of this was, of course, a triumph of hope over reality. But works of art, like political tracts, were instruments for imagining a future. Charles Willson Peale, friend of George Washington and Thomas Jefferson and the most politically engaged artist of the era, conveyed a similar idea when he designed the title page of *The Universal Asylum and Columbian Magazine* in 1790 (*fig. 2*). It shows young America as a refined woman with an open book on her lap, the shield of the United States supporting her back. She arranges a splendid bouquet of flowers while around her a boy digs in a field, an American flag waves from a three-masted ship, and a globe, paintbrushes and a palette collect at her feet.

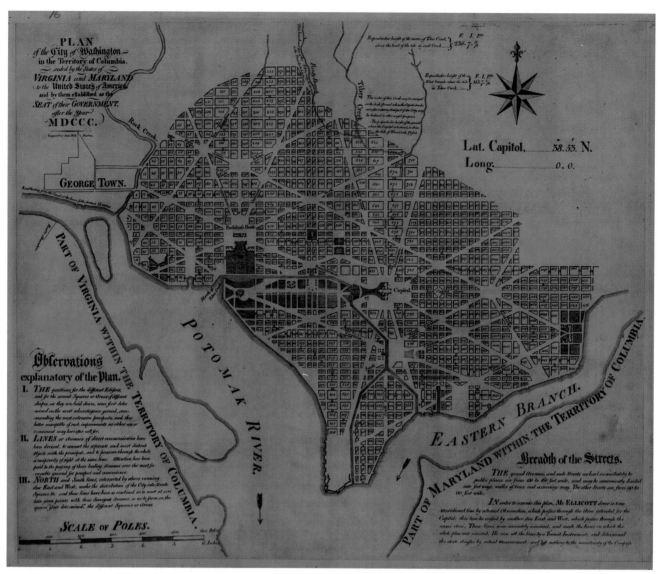

Figure 1: Samuel Hill (American, 1766-1804) after Pierre L'Enfant (American, 1754-1825), *Plan of the City of Washington in the Territory of Columbia*, 1792, Engraving on paper, 42 x 50 inches (106.7 x 127 cm), Library of Congress, Geography and Map Division, Washington, D.C.

Dreamy projections were manifest in architecture, too. Pierre L'Enfant's 1791 plan for a capital city on the Potomac defied the truths of the swampy, uninhabited site that would become the District of Columbia. Benjamin Henry Latrobe's Philadelphia Waterworks (1801) was an engineering project at its heart, but it nonetheless resembled in miniature the massive neoclassical city gates of Paris. Perhaps the boldest, if not the most impudent project was Jefferson's majestic neo-Roman Virginia State Capitol. Looking pointedly un-colonial in Latrobe's sketch of Richmond in 1796 (*fig. 3*), the temple is entirely incongruous with its rustic central Virginia setting sparsely dotted with common timber houses, freshly cleared land, and the lazy James River.

Implicit in all these audaciously grand projects in architecture, planning, printmaking, and painting was the belief that the Constitution had created a mandate or directive for thinking large thoughts. This exhilarating period might in fact be thought of as an experiment of sorts in determining whether a new American visual culture could be manufactured, following the words of the English writer G. K. Chesterton in the epigraph above, from a creed. Or, to reverse the causality, it was a question of whether paintings, sculptures, buildings, and furniture could be sufficiently persuasive to induce a new and still nebulous nation to shape a national identity for itself. Looking back, it must have been a time that was both thrilling and daunting for artists. Certainly, it required deep engagement with what was at stake politically and culturally. And if an artist were apathetic or asleep he would, like Washington Irving's Rip Van Winkle, run the risk of waking up to a land that he no longer understood,

Figure 2: Charles Willson Peale (American, 1741-1827), Title Page, *The Universal Asylum and Columbian Magazine* vol. V. Philadelphia, 1790, Engraving on paper, Library of Congress, Washington, D.C.

Figure 3: Benjamin Henry Latrobe (American, 1764-1820), *View of Richmond from Washington's Island*, Latrobe Sketchbook 1, 24 May 1798, Watercolor, pen and ink on paper, 7 x 10-1/2 inches (17.8 x 26.7 cm). Maryland Historical Society, Baltimore, Maryland

from which he was now estranged because of the swift and fundamental transformations that had occurred in his absence. Irving intended the character of Rip to be cautionary; Rip's misadventure underscored the irreversibility of the juggernaut of destiny and the necessity of being present and accounted for in the national ferment.

But not everyone was euphoric. Artists themselves came to realize that the United States was not actually a new Athens. John Trumbull, though encouraged by Jefferson to pursue a career as a painter, felt compelled in 1800 to advise John Blake White, an aspiring artist from Charleston, to "relinquish . . . painting. It will never repay you for your pains. I would sooner make a Son of mine a Butcher, or a shoemaker, than a Painter."[3] Some leaders, such as John Adams (**cat. no. 133**), feared that art, rather than helping with nation-making was instead a moral threat to it. He had voiced that opinion as early as 1780: "It is not indeed the fine arts which our country requires; the useful, the mechanic arts are those which we have occasion for in a young country . . ."[4] And as late as 1817 he admonished Trumbull to "remember that the Burin and the Pencil, the Chisel and the Trowell, have in all ages and Countries of which we have any information, been enlisted on the side of Despotism and Superstition. Architecture, Sculpture, Painting and poetry have conspir'd [*sic*] against the Rights of Mankind."[5]

Adams the Federalist feared that the arts were fatally associated with Europe—especially France—and every-

thing that that meant: aristocracy, privilege, luxury, and immorality, all values inimical to a republic of virtue. As president in 1798 he waged an undeclared war on France, in which French character was a key issue. One vivid political cartoon of the XYZ affair (**cat. no. 241**), as it was called, shows the United States, again personified as a classically robed maiden, trying to defend her honor against French dandies who tug at her headdress and laugh at her embarrassed face. The French Directorate had been demanding bribes as a prerequisite for peace negotiations (i.e., the sacks of plunder), but the high-minded Adams refused to deal with the French if it meant dishonoring the nation.

The proper relationship with Europe was an entirely vexed issue. Though politically the United States was something completely new under the sun, it was still culturally operating in the long shadow cast by Europe. That put art and artists in a difficult position. Stuart, Trumbull, Washington Allston, and Rembrandt Peale deeply admired and accepted as gospel the legacy of the European masters. But there were political implications to where they studied, what they painted, and in which style. Most American art students went to London, where they knew the language and had living exemplars in the expatriates Benjamin West and John Singleton Copley. There they learned the English taste for colorism and fluid brushwork, evident in Peale's animated portrait of Jefferson from 1805 (**cat. no. 28**).

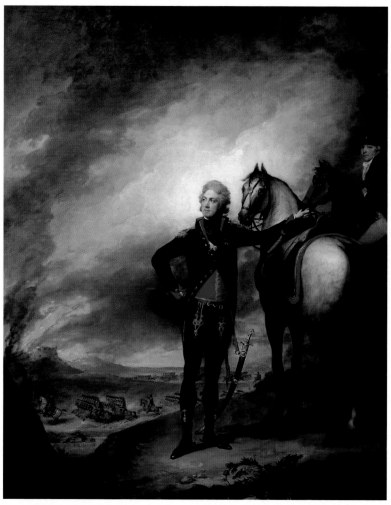

Figure 4: Gilbert Stuart (American, 1755-1828), *Louis-Marie, Vicomte de Noailles*, 1798, Oil on canvas, 50 x 40 inches, (127 x 101.6 cm), Metropolitan Museum of Art, New York
©1983 The Metropolitan Museum of Art

But after the American Revolution, France became an alternative destination for some Americans precisely because it was not England. Rembrandt Peale studied in Paris on his later trips abroad, and in doing so he stylistically moved toward the severe linearism and uninflected color of the neoclassical painters Jacques-Louis David, Anne Louis Girodet, and François Gérard. In 1804 Allston painted his *Rising of a Thunderstorm at Sea* in Paris and studied the old masters in the Louvre, but had no interest in French neoclassicism. John Vanderlyn, however, was an ardent Francophile. He went to Paris in 1796, studied under François-André Vincent, and exhibited his forceful *Portrait of the Artist* of 1800 (**cat. no. 135**) and *Murder of Jane McCrea* of 1804 at the Salon. In 1808 he received the *medaille d'encouragement* from Napoleon for his *Marius Amid the Ruins of Carthage* (**cat. no. 124**), a grand neoclassical history painting that was built along the thematic and stylistic lines of Jean-Germain Drouais's *Marius at Minturnae* (**cat. no. 19**) and Pierre Narcisse Guérin's

Return of Marcus Sextus (**cat. no. 123**), and that alludes directly and sympathetically to the discredited American politician Aaron Burr, who was Vanderlyn's patron.

Of course, it was Jefferson, possessing none of Adams' squeamishness about foreign culture, who was most fully oriented to France. An astute observer of French art, architecture, and design, he once was so provoked by Drouais's *Marius* that he confessed, "It fixed me like a statue a quarter of an hour, or half an hour, I do not know which, for I lost all ideas of time, even the consciousness of my existence."[6] Jefferson worked closely with the avatar of French neoclassical architecture, Charles-Louis Clérisseau, on the design for the Virginia State Capitol (**cat. no. 15**), which was based on the Roman *Maison Carrée* (**cat. no. 14**). When he left Paris in 1789 he shipped French chairs, china, porcelain, furniture, and silver to Virginia, bought statues by Jean-Antoine Houdon (**cat. no. 181**), and copies of pictures by Raphael, Peter Paul Rubens, and Sebastiano Ricci.

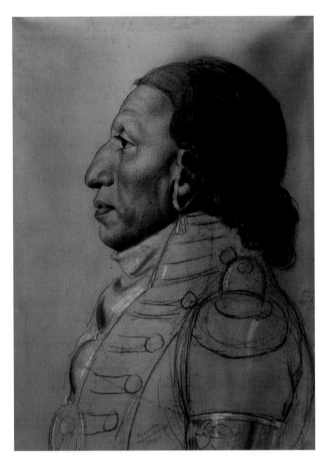

Figure 5: Charles Balthazar-Julien Févret de Saint-Mémin (French, 1770-1852), *Payouska, Chief of the Great Osages*, 1806, Chalk, charcoal, pastel, graphite on paper, 23 x 17 inches (58.4 x 43.2 cm), New York Historical Society, New York

On his return to Virginia he even redesigned his Monticello (**cat. no. 161**) on the architectural theories of Antoine Desgodets and on a contemporary Parisian house, Pierre Rousseau's Hôtel de Salm (**cat. no. 12**), with which he said he was "violently smitten," causing him to visit it "almost daily" while he was minister to France (1785-89).[7]

The dialogue between France and America also traveled in the other direction as French artists and citizens took up residence in the United States after the French Revolution. Charles-Honoré Lannuier, a French cabinet-maker, arrived in New York in 1803 where he introduced the highly ornate and sculptural furniture of the Consulate and Empire styles (**cat. no. 150**). Philadelphia especially was a magnet for French émigrés, among them the silversmith Jean-Simon Chaudron who arrived via Haiti, a French colony until 1804. James Peale of Philadelphia occasionally worked for the French community in that city, and at least once departed spectacularly from his specialty as a miniaturist to paint a monumental family portrait (**cat. no. 137**) in the French neoclassical style for the émigré William Dubocq, who became an American citizen

in 1804. Stuart also adopted a French style when he painted *Louis-Marie, Vicomte de Noailles* (*fig. 4*) in Philadelphia in 1798. A dandy in the French court, Noailles had fought as a colonel during the American Revolution and returned to France where he became a Jacobin during the French Revolution, but during the reign of terror he was forced to escape to America where he asked Stuart to paint him on the battlefield in the regimentals of the national *gendarmerie*. Also in Philadelphia, Bordeaux-born Stephen Girard, an international merchant and financier, hired the sculptor William Rush to carve figureheads of four French philosophers to be attached to his brigantines *Voltaire* (1795), *Rousseau* (1801), *Helveticus* (1804), and *Montesquieu* (1806).

But perhaps the most notable French presences in American visual culture were Pierre-Charles L'Enfant and Charles B. J. F. de Saint-Mémin. L'Enfant, who studied at the Academie Royale in Paris and volunteered to fight against England during the American Revolution, had an American career as an architect designing Federal Hall in New York, building a French Renaissance-style home for Robert Morris in Philadelphia, and developing a daring plan for the District of Columbia. Given the raw landscape and tiny federal budget, there was little chance that L'Enfant's plan could be realized for decades, but what the plan offered was a vision of an American capital city of imperial dimensions on the scale of André Le Nôtre's Versailles and Christopher Wren's London.

Saint-Mémin came to America in 1793 as a refugee from the French Revolution and painted or engraved about nine hundred portraits in Philadelphia, Baltimore, New York, Washington, Richmond, and Charleston between 1796 and 1810. His style is exemplified by *Portrait of Thomas Jefferson from the Physiotrace* (**cat. no. 140**) and *Mrs. David Meade Randolph* (**cat. no. 141**) in the use of a profile bust format that emulates the portraits seen in coinage from the Renaissance and antiquity, an apt look for the citizens of a new republic. Jefferson alone owned forty-eight of Saint-Mémin's engraved portraits of notable Americans. Significantly, Saint-Mémin extended that format—and its connotations—to a series of portraits of Native Americans (*fig. 5*) who had come to Washington between 1804 and 1807 as diplomatic delegates from the Osage and Mandan tribes whose lands were acquired by the United States in the Louisiana Purchase. Because Saint-Mémin treated their images no differently than Jefferson's, there is a resulting impression of republican equality, the felt sense that in their profiled dignity these Native Americans were, too, the Constantines and Leonello d'Estes of the New World.

In addition to being the locus of the Franco-American community, Philadelphia also was the site of United States's first institutions dedicated to the encouragement of the fine arts. In 1784, shortly after the Revolution, Charles Willson Peale founded—and, significantly, opened

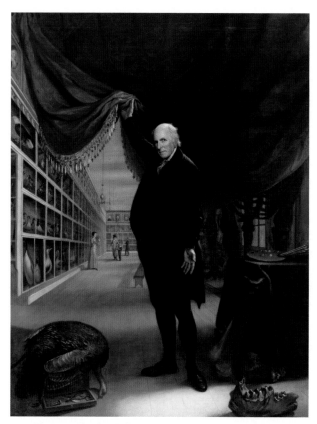

Figure 6: Charles Willson Peale (American, 1741-1827),
The Artist in His Museum, 1822, Oil on canvas,
103-3/4 x 79-7/8 inches (263.5 x 202.9 cm),
The Pennsylvania Academy of the Fine Arts,
Philadelphia, Pennsylvania

to the public—the Philadelphia Museum (*fig.* 6). With its odd combination of native rocks, fossils, stuffed birds and quadrupeds, mastodon bones, and portraits of American heroes, the encyclopedic assemblage, which came to number 100,000 objects, was built along the best Enlightenment principles of classification and naming, and represented Peale's effort to find and display the innate order and harmony of this new world. Its idiosyncratic and mesmerizing blend of natural history and fine arts stood in telling contrast to the high aestheticism evident in European museums. Instead, Peale's museum was self-consciously populist, attracting an astonishing 17,000 visitors in 1805, which was about the size of a large city on the East Coast.

Peale also devised a plan for an art academy in Philadelphia that would have a school, library, and gallery. Founded in 1794 with a mandate to encourage the fine arts, and patriotically named the Columbianum, it held a public exhibition in 1795. But its initial promise quickly faded as a result of ideological disputes among the twenty-nine artists on its board, and within two years the project was abandoned, with little accomplished. But in 1805 Peale organized seventy Philadelphians, now preponderantly lawyers, businessmen, and doctors, to develop the

Pennsylvania Academy of the Fine Arts, which succeeded precisely because its lay supporters had fewer ideological opinions than the artists and because they could provide cash "subscriptions" as stockholders in the institution. Nicholas Biddle, one of the founders, acquired plaster casts of antique statuary at the Louvre, with the idea that they become models for emulation. The artist and inventor Robert Fulton (**cat. no. 61**) lent his collection of European paintings in 1807. And annual exhibitions that included the work of local artists were initiated in 1810. Chancellor Robert Livingston (**cat. no. 245**), minister to France under Jefferson, had formed a similar institution in New York in 1802. First named the Society of Fine Arts in New York City, it was retitled in 1808, with full nationalist intent, the American Academy of the Fine Arts. Vanderlyn was hired to purchase or paint copies of old master pictures in Paris and to supervise the making of plaster casts of the best statuary in the Louvre, which were to be sent on to New York.

Few American artists, however, trained at either of these early academies, mostly because there was little or no instruction offered, and because Europe was, for good reason, a more compelling draw. But as a result of foreign study, Americans returning to the United States were put into the difficult position of having to navigate a fine line between learnt European ideas and local American taste. That course proved disastrous in the case of Allston and Vanderlyn as neither was ever able to duplicate at home the successes they experienced abroad. When Allston, for example, returned to Boston for three years, 1808 to 1811, after the most creative period of his career in Europe where he had painted *Diana and her Nymphs in the Chase* and *Italian Landscape,* he did not publicly exhibit any pictures. Vanderlyn stayed abroad until 1815 and when he returned his historical pictures (**cat. no. 124**) were not well received despite their critical acclaim in Paris.

There were, however, other career routes an artist could take. Stuart, though trained in England, had a spectacular American career because portraiture, his specialty, continued to be the new nation's preferred artistic genre. Other artists, such as Ralph Earl and Charles Willson Peale, simply did not internalize their European training entirely. A much larger number of American artists never studied at any academy, at home or abroad, though they may have taken lessons with an individual artist of note. Reuben Moulthrop (1763-1814), Ezra Ames (1768-1836), William Jennys (d. 1807), Jacob Eichholtz (1776-1842) and many others produced hundreds of pictures without foreign study. The only known African-American professional artist of the period, Joshua Johnson (ca. 1765-1830), once a slave in Maryland, was self-trained. His style (**cat. nos. 138, 139**) came mostly from looking at and trying to emulate the portraiture of the Baltimore artist Charles Peale Polk. Johnston seems to have been very aware of precisely what it meant for an ex-slave to succeed at a

Figure 7: Unidentified Artist (probably a student), *Mrs. Rowson's School, Washington Street near the Roxbury Line*, 1807-09, Watercolor on paper, 8 x 10 inches (20.3 x 25.4 cm), The Bostonian Society, Boston, Massachusetts

white man's profession, for in an advertisement in the *Baltimore Intelligencer* in 1798 he freely described himself: "a self-taught genius, deriving from nature and industry his knowledge of the Art; and having experienced many insuperable obstacles in the pursuit of his studies, it is highly gratifying to him to make assurances of his ability to execute all commands, with an effect, and in a style, which must give satisfaction."[8]

Women were rarely artists in the professional marketplace because of the gender conventions of the era. But there were many women who were accomplished in the domestic sphere, creating samplers, coverlets, bed rugs, quilts, embroidered pictures, and other forms of needlework of subtlety and strength. After the Revolution, some emerged as amateur painters in watercolor and oil. Eunice Pinney (1770-1849) of Simsbury, Connecticut, for example, prolifically painted landscapes, genre, literary, and historical subjects for her own pleasure and for the opportunity of giving pictures as gifts. Though Pinney seems to have begun painting when she was an adult, women often started their study while girls, especially at the boarding academies and seminaries that taught penmanship, drawing, embroidery (**cat. no. 147**), and watercolor as part of the education as young ladies. The academies were an artifact of the new nation, their numbers running into the hundreds. One of most ambitious was run by Susanna Rowson, the accomplished author of the novel *Charlotte Temple* (1791), who opened the Young Ladies Academy in Medford, Massachusetts, in 1797 (*fig. 7*) and by 1805 was holding annual exhibitions of her students' work.

A few women in the new republic took the further step of attending a private drawing school, such as the Columbian Academy that Alexander and Archibald Robertson opened in New York in 1792. And a very few women had the advantage of having painters for fathers and brothers. The Peale family in particular naturalized art for its women and girls. Of those born by 1800, Angelica Kauffman Peale (1775-1853) sketched with her brothers Raphaelle and Rembrandt; Sophonisba Angusciola Peale (1786-1859) drew as a child; Maria Peale (1787-1866) studied with her father James; Anna Claypoole Peale (1791-1878) made a career as a miniaturist; Margaretta Angelica Peale (1795-1882) painted still lifes; and Sarah Miriam Peale (1800-1885) made a career as a portraitist.

Any artist wishing to make a career from painting in a republic that had no aristocracy had to be savvy to art markets, in particular to the kinds of subjects, themes, styles, and formats that were in vogue. Ideally, a professional artist could hope to attract the interest of a patron who believed in his work and who, perhaps, even thought that in buying or commissioning pictures he was encouraging the fine arts and native talent of America. Typically, certain families came back repeatedly to an artist to paint portraits. Stuart, for example, did very well by the Swans and Bowdoins of Boston, and the Manigaults of Charleston. And Stuart's 114 portraits of Washington (**cat. no. 131**) also constituted a de facto annuity for the artist because he knew that collectors and legislatures were always eager to acquire one of his "certified" images of the first president.

Figure 8: Benjamin West (American, 1738-1820), *Death of General Wolfe*, 1776 (retouched 1806), Oil on canvas, 65 x 96-1/4 inches (165 x 244.5 cm), Royal Ontario Museum, Toronto, Canada

But the true patron or collector of American art was much rarer in the new nation. Aaron Burr was unique in that he gave Vanderlyn money to study in Paris, with few strings attached. Most avid art enthusiasts, however, were not willing to support an artist directly, the practice perhaps smacking too much of aristocracy and running counter to the strongly felt value of the American self-made man. Instead, early patrons and collectors of American art— Robert Gilmor Jr. of Baltimore, Thomas Handasynd Perkins of Boston, and Daniel Wadsworth of Hartford— came to their American art collecting by indirect routes. They typically began with a fascination for European artists and old master pictures, and then eventually turned their attentions to Americans, especially to Stuart, Trumbull, Allston, and the young Thomas Sully. Jefferson, perhaps the most avid collector of them all, also began with European art. But already by the late 1780s he was buying or being given portraits of "American worthies," as he described them: a Charles Willson Peale and a Joseph Wright of Washington, a Trumbull of Thomas Paine, a Mather Brown of John Adams, a Joseph Boze of Lafayette (**cat. no. 5**), and numerous portraits of Jefferson himself, by Mather Brown, Saint-Mémin, and Stuart. He owned Trumbull's sketch for the *Surrender of Lord Cornwallis at Yorktown* (**cat. no. 129**), prints after Trumbull's scenes from the Revolution, Edward Savage's *Liberty*, William Birch's twenty-nine prints from *The City of Philadelphia*, prints after Vanderlyn's views of Niagara Falls (**cat. no. 130**), four pictures of the Natural Bridge at Harpers Ferry, and most appropriately after he negotiated the Louisiana Purchase, a print after John L. Boqueta de Woiseri's *A View of New Orleans Taken from the Plantation of Marigny* (**cat. no. 210**), as well as cut silhouettes of the Indian chiefs from the Missouri and Mississippi.

The most popular subjects that were bought after the Revolution, besides family portraits, were, understandably, images of American heroes. Saint-Mémin probably produced the largest number of these, all of them profiles that were sold as prints. But the most compelling and influential images were those of Washington by Stuart. To be sure, other artists—Trumbull, Edward Savage, Charles Willson and Rembrandt Peale, Giuseppe Ceracchi (**cat. no. 132**), Jean-Antoine Houdon—painted and sculpted him either as president or general. But it was Stuart's portraits of Washington in the 1790s (**cat. no. 131**) that carved themselves into the national consciousness as embodiments of

presidentiality, or as visual confirmations of the quality Washington cultivated in himself: "*American* character."[9] In Stuart's hands, the image of Washington calls to mind such words as disciplined, steady, calm, resolved, virtuous, reserved, and thoughtful, all of which were welcome attributes after the politically chaotic period between the Revolution and the Constitution, when the Articles of Confederation were in effect. Moreover, Washington looked the way the leader of a republic should, namely closer to a Roman orator or an American minister than to his French counterpart Napoleon, whose state portraits sometimes bordered on the outrageous, or at the very least drew attention to personality instead of position, and claimed charisma instead of dignity as the central element of his being.

None of Washington's peers—Adams, Jefferson, Franklin, Madison, Monroe (**cat. no. 247**)—were thought to be the *pater patriae*, and as a result were never represented as iconically as the first president. But they continued to be statesmen rather than personalities, imagined to be more about *gravitas* than charm. The era's portraits of women also had a neoclassical dignity. Into the late 1790s Stuart had been the master of rococo brushwork and gay exuberance in his female portraits. But by 1799 he had progressed toward a new restraint that was both stylistic and temperamental. For example, in his magnificent portrait of Eleanor Parke Custis Lewis (**cat. no. 143**), a granddaughter of Martha Washington, he simplified the background, emphasized the body's elegant silhouette, and drew out a tempered sexuality amidst her state of refined contemplation. With her interests in music and poetry, her dignified grace, and her reputation as a hostess to Henry Clay, Zachary Taylor, Andrew Jackson, and Lafayette, Mrs. Lewis was the Madame Récamier of Virginia.

In addition to the fresh faces to be seen in the new nation there were eagles, personifications of liberty, peace medals (**cat. nos. 185, 186**), flags, and emblemata that bespoke the United States. Landscapes, too, often drew attention to distinctive, recognizably American sites: Vanderlyn's drawings, paintings, and prints of Niagara Falls (**cat. no. 130**), John James Barralet's view of the newly engineered Market Street Bridge built in 1800 over the Schuylkill River in Philadelphia, the numerous pictures of the distinctive Rock Bridge at Harper's Ferry, the prospects to be seen from America's country estates, and other *vedute* of special places.

Historical subjects were almost categorically American, since scenes from European history were unsuitable to the new nation. Yet, there was little in the way of American historical subjects besides Trumbull's epic series of paintings from the Revolution (**cat. no. 128**), possibly as a result of the shortage of state patronage. Compared to the French artists who had Napoleonic money lavished on them for their contemporary history subjects, American artists had to be more entrepreneurial, selling to the market or vying for the occasional municipal or state commission, which was likely to be a portrait, not a battle subject. Interestingly, when Trumbull did paint revolutionary battle subjects, it was often about a defeat: for example, *The Death of General Warren at the Battle of Bunker's Hill* (1786) and *The Death of General Montgomery in the Attack on Quebec* (1786). The motive here was to commemorate American bravery and sacrifice. Certainly that was the iconographic path taken by Trumbull's teacher Benjamin West in his six oil versions of *Death of General Wolfe* (fig. 8). In all, such works were far removed from the French habit of depicting heroes in pictures that were centrally about conquest or Napoleon's valor (**cat. nos. 77, 78**). Even in the numerous American pictures of Washington at the battles of Princeton, Trenton, and Dorchester Heights, the scene of the battle was another occasion for the expression of refined character, a concept alien to Napoleon's artists. Historical subjects from literature were rare, but still they often referred obliquely to America. Vanderlyn's *Marius* (**cat. no. 124**), as noted above, related to Aaron Burr and the perils of political fortune. Trumbull's *Priam Returning to His Family, with the Dead Body of Hector* (1785), taken from Homer's *Iliad*, was a rehearsal for his pictures of dying revolutionary heroes. And his *Scene from Ossian's "Fingal": Lamderg and Gelchossa* (**cat. no. 126**), taken from James McPherson's epic poem, which Jefferson admired and the French artists Gérard and Girodet painted (**cat. nos. 127, 128**), shows the dying warrior embrace his rescued wife, as if it could just as easily have been a scene of a revolutionary war soldier returning home.

Trumbull, Stuart, Peale and all the other major artists and architects of the period were committed to the ways in which art could help constitute national identity. They felt that something vital and perhaps indelible was at stake in the first two decades of the United States, that they and their fellow Americans were standing at the threshold of the future, and that whatever artists and architects did, it might be guiding the nation on its cultural and even its political course. Pictures and buildings were their contributions to that emerging national self-consciousness. Though always lurking in the background was the possibility that America's cultural future would never blossom, or, that the arts themselves were antithetical to the good of the Republic, there was nonetheless a sustaining belief in the principle of *translatio studii*, the sense that civilization was moving irrevocably westward. That notion, present in America since the early eighteenth century, welded itself onto the Constitution to produce an intoxicating ideology: that in the new United States there would be an indissoluble linkage between civil liberty and cultural efflorescence. It was that liberal idea, so accurately expressed in Samuel Jennings' *Liberty Displaying Arts and Sciences* (**cat. no. 148**) that steered the aspirations and behavior of many artists of the era: they believed they were approaching the appointed hour for America's ren-

dezvous with destiny, and in short order, painting, sculpture, and architecture would rise to the occasion because of the clear and natural air of a republic. Joel Barlow said it best in the preface to *The Columbiad*, the epic poem that he wrote in the style of John Milton and published in 1807:

> *This is the moment in America to give such a direction to poetry, painting and the other fine arts, that true and useful ideas of glory may be implanted in the minds of men here, to take [the] place of the false and destructive ones that have degraded the species in other countries.*[10]

Notes:

1. Banner is in the New-York Historical Society.
2. G. K. Chesterton, "What is America," in *The Man Who Was Chesterton*, ed. Raymond T. Bond (Garden City: Doubleday, 1960), 125.
3. John Blake White, "Journal of John Blake White," *South Carolina Historical and Genealogical Magazine* 42 (April 1941): 63-64.
4. John Adams to Abigail Adams, 1780, *The Selected Writings of John and John Quincy Adams* (New York: A. A. Knopf, 1946), 65-66.
5. John Adams to John Trumbull, 1 January 1817, in John Trumbull, *Autobiography, Reminiscences and Letters by John Trumbull from 1756 to 1841* (New York: Wiley and Putnam; New Haven: B. L. Hamlen), 1841; an interleaved copy of this book (Yale University Library) contains the Adams letter.
6. Thomas Jefferson to Madame de Tott, 28 February 1787, *The Papers of Thomas Jefferson*, 29 vols. (Princeton: Princeton University Press, 1950), 11, 187.
7. Thomas Jefferson to Madame de Tessé, 20 March 1787, *Papers*, 11, 226.
8. *Baltimore Intelligencer*, 19 December 1798; quoted in John Caldwell and Oswaldo Rodriguez Roque, *American Paintings in the Metropolitan Museum of Art* (New York: Metropolitan Museum, 1994), 231.
9. Quoted in Edmund Morgan, "Preface," *George and Martha Washington: Portraits from the Presidential Years* (Washington, D.C.: National Portrait Gallery, 1999), 13.
10. Joel Barlow, *The Columbiad, A Poem* (London: Richard Phillips, 1809), xiv.

120.

Constance Mayer (French, 1774–1821) and
Pierre-Paul Prud'hon (French, 1758–1823)
The Torch of Venus, 1808
Signed and dated at lower left: *C. Mayer 1808*

Oil on canvas
39-1/8 x 58-1/4 inches (99.5 x 148 cm)
Musée Napoléon, Schloss Arenenberg,
Salenstein, Switzerland

During the Empire, Constance Mayer produced numerous works with her teacher
and lover Pierre-Paul Prud'hon. Normally, Prud'hon produced drawings and
sketches that Mayer worked up into finished canvases with varying degrees of
help from him. In this allegory of Love, Venus shares fire from her torch with her
court of cupids, whose expressions and attitudes reveal the various passions they
inspire. Josephine purchased this painting and hung it in the music room at
Malmaison; it was then inherited by her daughter Hortense, who took it with
her into exile in Switzerland. **D.O.**

121.

Pierre-Paul Prud'hon
(French, 1758–1823)
Sketch for Justice and Divine Vengeance, circa 1805–08

Oil on canvass
12-3/4 x 16 inches (32.4 x 40.6 cm)
The J. Paul Getty Museum, Los Angeles, California
(84.PA.717)

In 1804 Prud'hon received a commission to paint an Allegory of Justice for the Palais de Justice in Paris. He chose to illustrate the idea, found in Horace's *Odes* (3.2: 31-32), that Vengeance, however slow, inevitably catches up to the criminal. Thus, in a barren landscape, a murderer abandons his victim's corpse as Justice and Divine Vengeance take up their pursuit. Like the figure of God in Michelangelo's *Creation of Adam*, the convex forms of Justice and Vengeance seem filled with energy and will surely smite the miserable figure of Crime. This is the earliest known painted sketch for Prud'hon's famous painting, and almost all of the major elements of the final canvas are already in place. **D.O.**

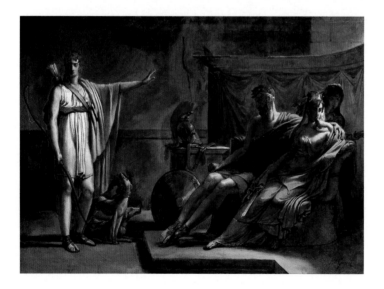

122.

Pierre-Narcisse Guérin
(French, 1774–1833)
Phaedra and Hippolyte

Oil on paper, marouflé
11 x 13 inches (33 x 46 cm)
Musée du Louvre, Département des Peintures, Paris
(RF 1982.13)
©Réunion des Musées Nationaux / Art Resources, NY

In Racine's famous tragedy, Phaedra professes her love to her stepson Hippolytus, only to be spurned. In order to protect her mistress, Oenone tells Theseus, Hippolytus's father, that Hippolytus loves Phaedra. Theseus confronts Hippolytus, who denies the charge but refuses to incriminate Phaedra. In Racine's play, Phaedra and Oenone are not present when Theseus accuses Hippolytus, but Guérin seems to have included them to incorporate more of the play's narrative and a wider range of expressions into his picture. Guérin executed this sketch early on in his exploration of the subject. Technical studies have revealed that he made many changes as he moved from the drawing to the painting of the sketch. Guérin made still other changes in the final canvas: Pheadra's gaze, Oenone's pose, Hippolyte's clothing, and the position of one of the dogs are all significantly different in the definitive work. **D.O.**

123.

Pierre-Narcisse Guérin (French, 1774–1833)
Return of Marcus Sextus, circa 1799

Oil over ink on paper, laid down
14 x 16-3/4 inches (37 x 42 cm)
Richard L. Feigen & Co., New York
©Réunion des Musées Nationaux /
Art Resources, NY

This is a sketch for the most acclaimed painting in the Salon of 1799. Guérin fabricated the story of the picture in order to create an allegory for the fate of émigrés during the French Revolution. Marcus Sextus, a Roman exiled by the dictator Sulla, returned home only to find his wife dead and his daughter emotionally devastated. Robespierre often had been likened by his enemies to Sulla, and Marcus Sextus stood for the moderate émigrés who had begun to return during the Directory. During the Consulate, the government officially adopted the position of reconciliation with émigrés, and consistent with this policy Lucien Bonaparte purchased the Marcus Sextus in 1801 when he was the minister of the interior. **D.O.**

124.

John Vanderlyn (American, 1775–1852)
Marius Amid the Ruins of Carthage, 1832
Signed and dated lower left

Oil on panel
32 x 25-3/8 inches (81.3 x 64.5 cm)
Albany Institute of History and Art,
Albany, New York (1946.81)

The New York-born Vanderlyn received a gold medal at the Paris Salon of 1808 for his *Marius*, and an offer from the Louvre to purchase the painting, which the artist turned down. This picture is Vanderlyn's later reduced-scale version of the 1808 original that is now in San Francisco. Its high neoclassical style is similar to Jean Germain Drouais's *Marius at Minturnae* and Pierre-Narcisse Guérin's *Return of Marcus Sextus*. The theme, about a once high-ranking Roman soldier who is sent into exile in North Africa and is left to contemplate the perils of power in a fractious world, is clearly meant to be read as a reference to the fate of the American Vice-President Aaron Burr, whose career was torn apart by factionalism and his own hubris. It was Burr who financed Vanderlyn's early career in Paris. **P.S.**

125.

Benjamin West (American, 1738–1820)
Death on the Pale Horse, 1783, retouched 1803
Signed bottom right of center: *B. West 1783, retouched 1803*; also signed
to the left of center, below the legs of the pale horse: *B. West/1783*

Pen and brown ink and wash,
heightened with white
22 x 44 inches (57 x 112 cm)
Royal Academy of Arts, London
©Royal Academy of Arts, London

This large drawing, which is on several sheets of
paper that were joined together, is the study for a
painting (1796) of the same title that is in the Detroit
Institute of Arts. West took the Detroit painting of
Death on the Pale Horse to Paris during the Peace of
Amiens in 1802 in order to exhibit it at the annual
Salon du Musée. It attracted the attention of Jacques-
Louis David, and it was said that Napoleon wanted to
purchase it, a request West refused. **P.S.**

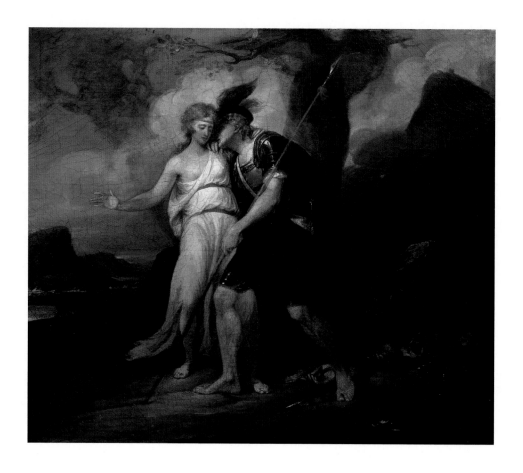

126.

John Trumbull (American, 1756–1843)
Scene from Ossian's "Fingal": Lamderg and Gelchossa, 1792
Inscribed: *You will find the Subject of the picture in / the 5th book of Fingal, the episode of Lamderg and / Gelchossa. "What blood, my Love" She trembling / said "what blood runs down my warrior's side" / "It's Ullin's blood" the chief replies. "Thou fairer / than Snow." Gelchossa let me rest here a while / the mighty Lamderg died. / I hope you will like the picture & am / De Sir / faithfully yours / J^no Trumbull*

Oil on canvas mounted on panel
11-15/16 x 14 inches (30.3 x 35.6 cm)
Toledo Museum of Art, Toledo, Ohio. Purchased with Funds from the Florence Scott Libbey Bequest in memory of her father, Maurice A. Scott (1958.27)

Trumbull, like a number of his French colleagues, was attracted to James McPherson's epic poem *Ossian*, in part through Jefferson's influence when the two men were friends in Paris. This scene is from the fifth *Book of Fingal*, at the point at which Lamderg rescues his wife Gelchossa from the clutches of Ullin, but in the process is mortally wounded and before long dies in her arms: " 'What blood, my love,' she trembling said, 'what blood runs down my warrior's side.' " Overcome by grief, Gelchossa dies shortly after her husband. **P.S.**

127.

Anne-Louis Girodet de Roussy-Trioson
(French, 1767–1824)
The Song of Evirallina at the Celebration at Selma

Pencil, chinese and sepia ink-wash
with white highlights
8-1/16 x 10 inches (20.7 x 25.6 cm)
Musée des Montargis, Musée Girodet, Montargis,
France (71-17)

128.

Anne-Louis Girodet de Roussy-Trioson
(French, 1767–1824)
The Death of Ossian

Pencil, chinese and sepia ink-wash
with white highlights
8-1/3 x 10 inches (21.3 x 26.7 cm)
Musée des Montargis, Musée Girodet, Montargis,
France (71-16)

Like Jefferson, Napoleon had a fondness for the Ossian epic. He was drawn to its heroic military theme. In addition to a grand-scale painting, Girodet designed illustrations for a French translation of McPherson's book and created several drawings showing passages of the story. In these drawings Girodet used diffused light to evoke the dream-like sense of mystery that pervades the epic tale. At a celebration for Fingal held at Selma, the birthplace of his son Ossian, the timid Evirallina, who secretly longs for the saga's hero, plays the harp. Her melancholy is illustrated by her position, with her hair hiding her face from those listening to her performance. In *The Death of Ossian* the aged warrior meets his death and joins his compatriots who fell in battle before him. For Napoleon, a military man, McPherson's stories embodied romantic notions of a warrior society for which he longed. **V.C.**

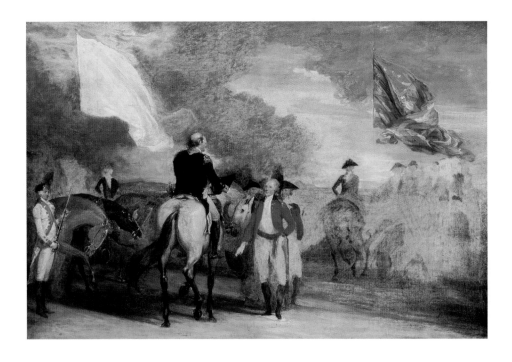

129.

John Trumbull (American, 1756–1843)
Study for the Surrender of Lord Cornwallis, 1787

Oil on canvas
13-7/8 x 21 inches (35.2 x 53.3 cm)
The Detroit Institute of Arts, Detroit, Michigan.
Gift of Dexter M. Ferry, Jr. (48.217)
©1986 The Detroit Institute of Arts

This oil sketch depicts the officers of the British army surrendering to the American Major General Benjamin Lincoln at Yorktown, Virginia, in 1781, an event that ended the Revolutionary War. Rather than depict a battle to conclude his Revolutionary War series, Trumbull emphasized the civility and etiquette of the French, British, and American troops. Trumbull would work on the finished picture in Paris, where he said "I have been in this capital of dissipation and nonsense near six weeks for the purpose of getting the portraits of the French Officers who were at York Town, and have happily been so successful as to find all whom I wished in town." **P.S.**

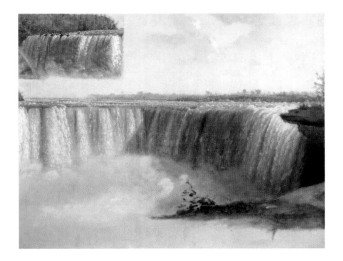

130.

John Vanderlyn (American, 1775–1852)
Double View of the Horseshoe Falls: Niagara Falls, 1826

Oil on canvas
24 x 31 inches (63.2 x 80 cm)
Senate House State Historic Site, New York State Office of Parks, Recreation and Historic Preservation, Kingston, New York (SH.1977.29)

John Vanderlyn's many images of Niagara Falls celebrate the unspoiled landscape of early America. He planned to support himself by selling engravings of his views of the falls and made sketches from various vantage points, including Table Rock, the view seen in this double sketch. By the early nineteenth century, Niagra Falls had already become a popular scenic image of the American landscape. Jefferson believed it to be one of the natural wonders of the world and purchased two of Vanderlyn's prints. **V.C.**

131.

Gilbert Stuart (American, 1755–1828)
Portrait of George Washington, Atheneum type, after 1796

Oil on canvas
29 x 24 inches (74.9 x 62.2 cm)
Pennsylvania Academy of the Fine Arts, Philadelphia,
Pennsylvania. Bequest of Paul Beck, Jr. (1845.3.2)

As the first president of the United States, George
Washington (1732–1799) and his portraitists faced the
challenge of creating an appropriate image for leader-
ship in a republic. The fifty-three-year-old president
first posed for Gilbert Stuart in Philadelphia in March
1795. The artist complained that Washington found
the process tedious; nevertheless, he reproduced the
Atheneum type portrait seventy-two times, making it
one of the most recognizable images of Washington.
V.C.

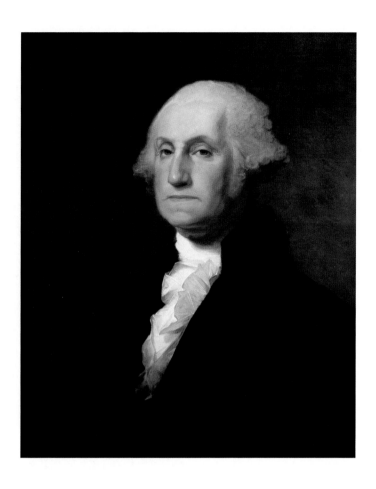

132.

Giuseppe Ceracchi (Italian, 1751–1802)
Bust Portrait of George Washington

Marble
29 x 15 x 12 inches (73.7 x 38.1 x 30.5 cm)
Collection of James Lamantia, on loan to the New Orleans Museum
of Art, New Orleans, Louisiana (EL.2000.115)

The image of George Washington could, at times, take on the classical
grandeur of a Roman statesman, as in this portrait by Ceracchi. This
Italian sculptor wished to create an official monument to the American
president; however, his proposal failed to gain support from Congress.
A terra cotta carved from life in 1791 to 1792, now in Nantes, served
as a model for several marbles, including this one commissioned for the
City of New Orleans. **V.C.**

133.

John Singleton Copley (American, 1738–1815)
Portrait of John Adams, 1783

Oil on canvas
93-3/4 x 57-15/16 inches (238 x 147 cm)
Harvard University Portrait Collection, Cambridge,
Massachusetts. Bequest of Ward Nicholas Boylston
to Harvard College, 1828 (H074)
Photographic Services
©President and Fellows of Harvard College

Boston-born Copley moved in 1774 to London where he secured his British career with a series of remarkable paintings on subjects from English history: *Watson and the Shark* (1778), *The Death of the Earl of Chatham* (1779-81), and *The Death of Major Peirson* (1782-84). After Cornwallis's surrender in 1781, which ended the revolutionary fighting, Copley seems to have felt freer to paint portraits of Americans in London. For example, Copley showed the merchant Elkanah Watson in 1782 standing in front of a ship outfitted with the new American flag and sailing toward an incandescent sun beckoning on the horizon. In the same year he depicted Henry Laurens as a man of affairs, working as a peace commissioner for the United States following his release from wartime incarceration in the Tower of London. Adams was another of the peace commissioners, and Copley painted him full-length in regal splendor. As an iconographic prelude to Stuart's full-length portraits of Washington, Adams is seen as a statesman surrounded with the accoutrements of maps, documents, globe, and statue of peace. But the hilt of a sword at Adams's waist (improbable for Adams, who never fought in the Revolution) is a reminder of the seriousness of America's commitment to independence.

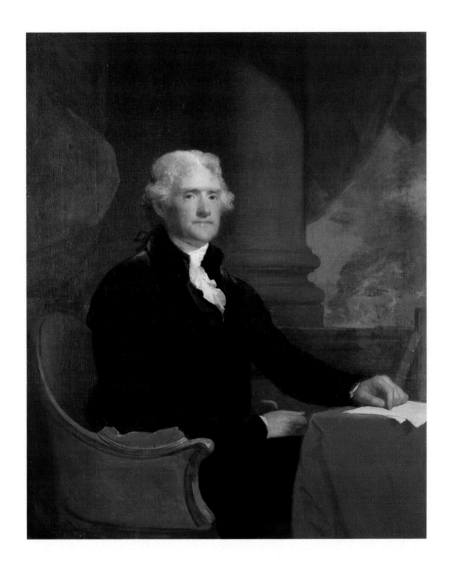

134.

Gilbert Stuart (American, 1755–1828)
Portrait of Thomas Jefferson, 1805-07

Oil on canvas
48-3/8 x 39-3/4 inches (122.9 x 101 cm)
Bowdoin College Museum of Art, Brunswick, Maine.
Bequest of the Honorable James Bowdoin III (1813.055)

In contrast to Copley's portrait of Adams, Stuart's presidential Jefferson, painted two years after the Louisiana Purchase, which was the keynote of his administration, is surprisingly modest. It emphasizes Jefferson as a man of letters and shows few of the trappings of power. The striking difference between Copley's Adams and Stuart's Jefferson encapsulates the division—indeed, the feud—between the Federalists and the Jeffersonians, between a neo-imperial and a republican vision of power. James Bowdoin III, a Bostonian, commissioned the Jefferson portrait on the occasion of his appointment as Jefferson's minister to the court of Spain. He intended to have the picture, and a companion portrait of James Madison by Stuart, hang in the official residence in Madrid, but that never materialized. As an expression of his respect for Jefferson and in appreciation of his ministerial appointment, Bowdoin gave Jefferson a copy of an antique sculpture of Cleopatra, now known to be of Ariadne, to be installed at Monticello. **P.S.**

135.

John Vanderlyn (American, 1775–1852)
Portrait of the Artist, circa 1800

Oil on canvas
25-1/4 x 20-7/8 inches (64.1 x 53 cm)
The Metropolitan Museum of Art, New York.
Bequest of Ann S. Stephens in the name of her
mother, Mrs. Ann S. Stephens, 1918 (18.118)
©1985 The Metropolitan Museum of Art

Painted in 1800, at the apex of his Parisian career, the New York-born
Vanderlyn exhibited his self-portrait at the prestigious Salon of 1800, where it
attracted the praise of Jacques-Louis David and Baron Gros. It is among the
finest neoclassical portraits of the period, showing Vanderlyn's complete mas-
tery of current French art theory. **P.S.**

136.

Rembrandt Peale (American, 1778–1860)
Rubens Peale with a Geranium, 1801
Signed and dated lower right: *Rem. Peale 1801*

Oil on canvas
28-1/4 x 24-inches (71.8 x 61 cm)
National Gallery of Art, Washington,
D.C. Patron's Permanent Fund (1985.59.1)
Photograph ©2002 Board of Trustees,
National Gallery of Art, Washington

The Peale family shared a variety of interests including painting and natural
science. Rembrandt Peale was the son of Charles Willson Peale (1741–1827),
the founder of the Peale Museum and the Pennsylvania Academy of the Fine
Arts, and assisted his father in the exhumation of the mastodon skeleton
(**cat. no. 178**), which had so interested Jefferson. His brother, Rubens Peale
(1784–1865), pictured here, toured England exhibiting the bones and became
a naturalist with a particular interest in botany. In this portrait, Rembrandt
Peale shows his younger brother displaying the first geranium grown in the United
States. He emphasizes the importance of the plant by dedicating nearly half the
canvas to rendering its form in detail. Jefferson and Josephine Bonaparte were
likewise in the thick of this enthusiastic exchange and experimentation with
seeds and plant materials flourishing at the turn of the century. **V.C.**

137.

James Peale (American, 1749–1831)
Portrait of Madame Dubocq and her Children, 1807

Oil on canvas
51 x 41 inches (129.5 x 104.1 cm)
The Speed Art Museum, Louisville, Kentucky.
Gift of Mrs. Aglae Kent Bixby. Conservation funded
in part by a grant from the National Endowment for
the Arts, a Federal agency (1932.29.1)

French-born Madame Dubocq, the daughter of Count Trochon de
Lorriere, was taken as a child to Saint Domingue, the French colony now
known as Haiti. During the Haitian Revolution, she and her husband, the
merchant William Dubocq, fled to Philadelphia where they became
American citizens in 1804. She and her daughters are dressed in empire
gowns and French-style coiffeurs. **P.S.**

138.

Joshua Johnson (American, born circa 1763, active 1796–1824)
Portrait of Charles Herman Stricker Wilmans, circa 1804

Oil on canvas
38-1/4 x 31 inches (97.2 x 78.8 cm)
The Baltimore Museum of Art, Baltimore, Maryland. Bequest of
Susan D. Tilghman Horner (BMA 1844.6)

Joshua Johnson, born a slave, was active as a portrait painter in
Baltimore circa 1795 to 1825. His work shows the influence of—and
he may have trained under—the Peale family of painters. While
over half of his known portraits depict children, the Wilmans por-
trait is an unusually formal depiction. The composition is also dis-
tinctive in its incorporation of both exterior and interior spaces.
Such a dual setting is not found in any other known Johnson por-
trait although it is characteristic of works by Charles Willson Peale
and Charles Peale Polk. **J.S.**

139.

Joshua Johnson (American, born circa 1763, active 1796–1824)
Portrait of a Man, circa 1805-10

Oil on canvas
27-7/8 x 22 inches (79.8 x 55.88 cm)
Bowdoin College Museum of Art, Brunswick, Maine. Museum
Purchase, George Otis Hamlin Fund (1963.490)

While often referred to as *Portrait of a Cleric*, it is not known for cer-
tain that the man in this portrait is a member of the clergy. The
white neck band worn by the sitter could be that of a minister or,
simply, common attire. This portrait, generally assumed to be of a
black man, may be related to the only other known portrait of a
freedman painted by Johnson: a portrait of 1805 to 1810 believed to
be Daniel Coker, a prominent leader of the black community of
Baltimore during the early nineteenth century. **J.S.**

140.

Charles Balthazar Julien Févret de Saint-Mémin
(French, 1770–1852)
Portrait of Thomas Jefferson from the Physiotrace, after 1789

Engraving
6-1/4 x 4 inches (15.9 x 11.7 cm)
Musée de la Coopération Franco-Américaine,
Château de Blérancourt, France (55C 6)
©Réunion des Musées Nationaux / Art Resources, NY

Having immigrated to the United States from France in 1793, Saint-Mémin introduced physiotrace portraiture to America in 1797. The inventor of the process was Gilles-Louis Chretien who used a mechanical device to trace the sitter's profile, then a pantograph to reduce the portrait to a miniature copper plate from which prints could be made. Jefferson sat for Chretien in 1789 at the Palais Royal in Paris and may have been the first American to have his profile taken by the physiotrace. Near the end of his first term as president, Jefferson sat for Saint-Mémin and purchased the original crayon drawing, the copper plate, and forty-eight small engravings. This portrait was widely distributed by both Saint-Mémin and Jefferson in France and America, becoming a highly recognizable and popular image of Jefferson during his lifetime. **J.S.**

141.

Charles Balthazar Julien Févret de Saint-Mémin
(French, 1770–1852)
Mrs. David Meade Randolph, circa 1804

Pastel on pink paper
21 x 15 inches (53.34 x 38.1 cm)
New Orleans Museum of Art, New Orleans,
Louisiana. Gift of Mrs. Emile N. Kuntz and
the Family of Emile N. Kuntz (82.217)

This is an example of the nearly one thousand physiotrace portraits drawn or engraved by Saint-Mémin between 1796 and 1810. Traveling around the United States, Saint-Mémin worked in Philadelphia, Baltimore, New York, Washington, Charleston, and Richmond where Randolph ran a boarding house. Like her cousin, Thomas Jefferson, Randolph is depicted in a profile bust format that Saint-Mémin used for a variety of sitters, including political leaders, Native Americans, and everyday citizens to evoke a sense of equality among individuals in the new Republic. **J.S.**

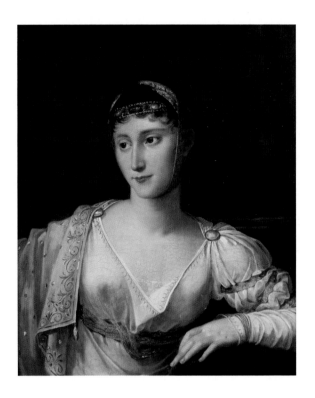

142.

Robert Lefèvre (French, 1755–1830)
Portrait of Pauline Bonaparte, Princesse Borghese, Dutchess of Guastalla, 1806

Oil on canvas
26 x 21 inches (65 x 53 cm)
Musée National du Château de Versailles, France (MV 4711)
©Réunion des Musées Nationaux / Art Resources, NY

Pauline Bonaparte (1780–1825) was Napoleon's favorite sister. Her spirited, often indecorous, behavior made her a common subject of gossip, and she rivaled Josephine Bonaparte and Juliette Récamier as a trendsetter in French society. Lefèvre painted her in the most daring Empire fashion wearing a transparent dress and closely cropped hair. American women, particularly those who traveled to France, often adopted French style; however, while the trend in transparent dresses was accepted in the comparatively libertine Paris, American society had a stricter moral code. Pauline Bonaparte was first the wife of General Charles Victor Emmanuel Leclerc (1772–1802; **cat. no. 251**), who died leading French troops on a failed mission to Saint Domingue in 1802 to regain control of the colony from the slave revolutionaries. After returning to France as a widow, she married Prince Borghese, scion of the great Roman family. **V.C.**

143.

Gilbert Stuart (American, 1755–1828)
Portrait of Eleanor Parke Custis Lewis, 1804

Oil on canvas
29 x 24-1/4 inches (73.7 x 62.2 cm)
National Gallery of Art, Washington, D.C. Gift of H. H. Walker Lewis in memory of his parents, Mr. And Mrs. Edwin A. S. Lewis (1974.108.1) Photograph
©2002 Board of Trustees, National Gallery of Art, Washington

Stuart's portrait of Lewis (1779–1852) represents a move in his art from English colorism and lightness toward the kind of serious and intellectual portrait style preferred by the French. Moreover, the mostly uninflected background that silhouettes her face and body, the simple, high-waisted, empire-style dress, and the Greek-style klismos chair all suggest an interest in French neoclassical art and fashion. Lewis was the granddaughter of Martha Washington and the ward of George Washington. **P.S.**

144.

François Joseph Kinson (French, 1770–1839)
Portrait of Elizabeth Patterson Bonaparte, 1817

Oil on canvas
25 x 21 inches (63.5 x 53.3 cm)
Maryland Historical Society, Baltimore, Maryland

Napoleon's youngest brother, Jérôme (1784–1860), met Elizabeth Patterson (1785–1879) in 1803 at a party in Baltimore. Two months later, the couple, nineteen and eighteen years of age, respectively, married. The new bride imported the latest fashions from Paris, appearing at social functions wearing transparent dresses and causing a scandal among the matrons of Washington society. The romance ended when Napoleon demanded the marriage be annulled on the grounds that his brother was underage. They tried to overcome his opposition; however, Jérôme eventually acquiesced to his brother's wishes. This portrait, painted in France years after her divorce, shows Elizabeth Patterson Bonaparte as an older woman still at the height of fashion in a demure high-waisted dress with gold trim. **V.C.**

145.

Unidentified Artist, American School
Linen Dress, circa 1812

Fine linen trained chemise, tambour-embroidered in staggered tiny hearts and dots; central inserted mechlin panel held by drawnwork and cutwork borders
Museum of the City of New York, New York.
Gift of Mrs. Eliot Norton (29.20.9)

American dressmakers adapted French fashion to suit their patrons. This delicate dress has simple lines and white-on-white embroidery typical of Parisian gowns. The sheer fabric makes the dress transparent and the wearer could choose to line the dress for modesty or wear it in the daring style of the Empress Josephine and Pauline Bonaparte. The style, often satirized as "fashionably nude" caused great concern among America's moralists who felt the purity and chastity of American women were at risk from dangerous influences from abroad. **V.C.**

146.

Unidentified Artist, American School
Liberty, circa 1800-20

Oil on canvas
29-7/8 x 20-1/16 inches (75.9 x 50.8 cm)
National Gallery of Art, Washington, D.C.
Gift of Edgar William and Bernice Chrysler
Garbisch (1955.11.13)
Photograph
©2002 Board of Trustees, National Gallery
of Art, Washington

This painting represents the popular American image of Liberty personified by a woman accompanied by the American flag and an eagle. In the late eighteenth century Edward Savage adapted French revolutionary models for his prints showing Liberty as the Goddess of Freedom. His prints gained popularity among self-taught artists and were copied in various media. The flag was adopted in 1777 and the eagle became the national bird in 1788, although not without competition. Benjamin Franklin had lobbied for the wild turkey. **J.S.**

147.

Relief Pratt (American, 1784–1849)
Allegorical Figure of Liberty, 1804

Silk on silk embroidery
20 x 17-3/4 inches (52 x 45 cm)
Collection of Old Sturbridge Village,
Sturbridge, Massachusetts (20.6.28)

This needlework picture is the work of Relief Pratt perhaps done while she attended school in Shrewsbury, Massachusetts. As in the painting, Liberty is presented as an allegorical female figure holding the American flag and accompanied by an eagle. She leans on a pedestal with an urn while an angel floats above. On the pedestal, printed separately on a ribbon with embroidery over the edges, is the inscription: "Sacred to the memory of/G. WASHINGTON./oBT. dEC. 14, 1799./ AE T. 68 YEARS." **J.S.**

148.

Samuel Jennings (American, active 1789–1834)
Liberty Displaying Arts and Sciences, circa 1792

Oil on canvas
15 x 18 inches (38.1 x 45.7 cm)
The Henry Francis Du Pont Winterthur
Museum, Winterthur, Delaware
(1958.0120.002A)

This is a reduced-scale version of the optimistic vision of America's future painted by Jennings for the Library Company in Philadelphia which, at the time, served as the Library of Congress. He depicts Liberty not as a classical goddess but as an American woman who, having abolished slavery, extends the benefits of Liberty, including education and prosperity, to the freed men and women who gather at her feet. **V.C.**

149.

Unidentified Artist, American School
Providential Detection, 1800

Etching
14-1/3 x 13 inches (36.4 x 33 cm)
American Antiquarian Society, Worcester, Massachusetts
©American Antiquarian Society

This Federalist political cartoon mocks Jefferson's French sympathies by showing him ready to fling the Constitution into a fire fueled by the flames of radical writings. The American eagle stops him, which also causes Jefferson to drop a letter "To Mazzei," a famous note of 1796 in which he complained that the Federalists were "timid men" who were closet monarchists who "prefer the calm of despotism." **P.S.**

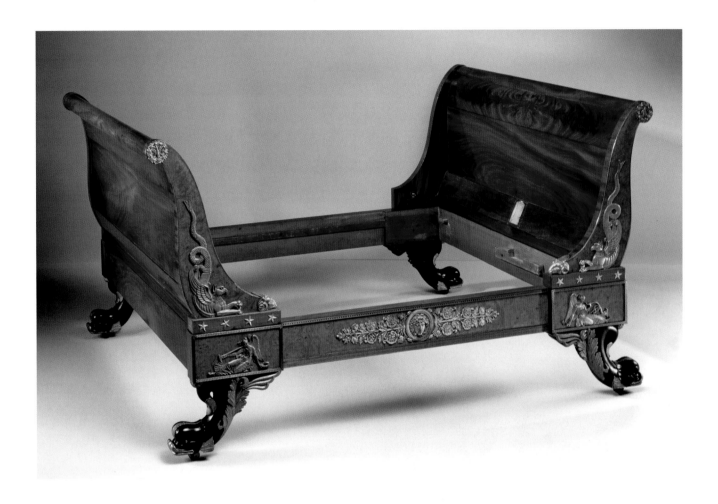

150.

Charles-Honoré Lannuier (French, 1779–1819)
Bedstead, circa 1817-19

Mahogany, burl elm veneer, ash with gilt and vert antique decoration (now black from change of color), eastern white pine, soft maple and hard maple, cherry, rosewood veneers, cut brass inlays, and ormolu mounts
45 x 85 x 60 inches (115.6 x 217.2 x 152.4 cm)
Albany Institute of History & Art, Albany, New York.
Gift of Constance Van Rensselaer Thayer (Mrs. William) Dexter, great-granddaughter of Stephen Van Rensselaer IV (1951.61)

French-born Lannuier was perhaps the most sought-after "cabinet-maker" in the United States. In 1803, having begun his career in Europe, he moved to New York where he would remain until his death in 1819. He introduced the Parisian style to the United States following the trends set by Josephine Bonaparte and Madame Récamier, incorporating many popular French motifs into his designs. Through his influence, American furniture designers adapted European fashion to suit an American taste. This extravagant bedstead, said to be the most elaborate and beautiful bedstead produced by Lannuier, is ornamented with dolphin feet, gilded-brass winged griffins and goddesses, rams heads, and a classical head surrounded by sprays of flowers. It may have been ordered as a wedding present for Harriet and Stephen Van Rensselaer of Albany, New York. **J.S.**

151.

Charles-Honoré Lannuier (French, 1779–1819)
Square Table with Inset Marble Top, circa 1804
Brass plaque screwed to brass edge: *This table was made
in the island of Crete in 1798/ from marble collected by the
wife of/ commodore Richard Valentine Morris/ and brought
home in his ship*; signed in script on underside of top in
chalk: *le 26 Decembre 1804*

Mahogany, brass and marble
29-1/4 x 28-1/2 inches (74.3 x 72.5 cm)
Brooklyn Museum of Art, Brooklyn, New York.
On loan to the Brooklyn Museum of Art from the
Morristown National Historic Park (L82.58.1)

This table is the earliest signed and dated work by Lannuier made just
after his arrival in the United States. The table top is made of 144 squares
of multicolored marble probably collected on the island of Crete by the
wife of Commodore Richard Valentine Morris, the leader of a United
States naval squadron in the Mediterranean and the son of Lewis
Morris, a signer of the Declaration of Independence. **J.S.**

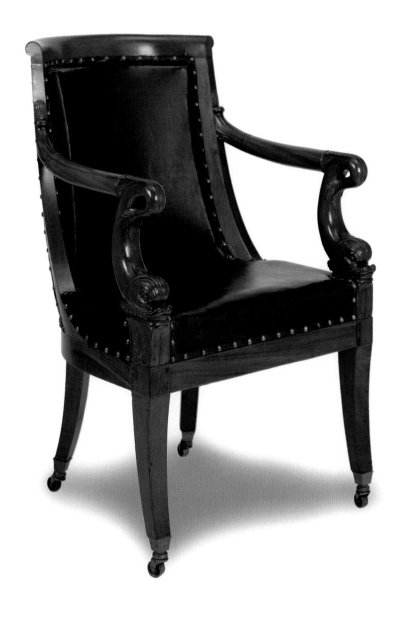

152.

Meynard, Paris, France (active 18th-19th century)
Gondola Armchair with Dolphin Motif, circa 1805

Mahogany, beech, leatherette, casters
36 x 23 x 24 inches (91.4 x 59.7 x 61 cm)
Montgomery Place, Historic Hudson Valley,
Tarrytown, New York

American diplomats serving abroad often bought furniture in the latest European styles. One of four armchairs purchased in France by Robert Livingston and sent to his sister, Janet Livingston Montgomery (1743–1828) in Annadale-on-Hudson, New York, this "gondola"-type chair is decorated with leaf and shell motifs. The dolphin arm supports and the anthemion-shaped carving below the heads are Greco-Roman motifs commonly used in Empire furniture and became hallmarks of American Empire design. **J.S.**

153.

Unidentified Artist, European School
Side Chair, Klismos Shape, circa 1800
Beech
32 x 21 inches (82.6 x 54.6 c.)
Octagon Museum, Washington, D.C.

Wealthy Americans often imported furniture from Europe to decorate their homes. This European-made, tub-shaped side chair with saber legs is believed to have been among the original furnishings of Octagon Hall in Washington, D.C. It may have been a gift to Benjamin Ogle Tayloe (1792–1868) and Julia Marie Dickinson (died 1840) from Henry Clay (1777–1852), senator from Kentucky and eventual author of the Missouri Compromise. **J.S.**

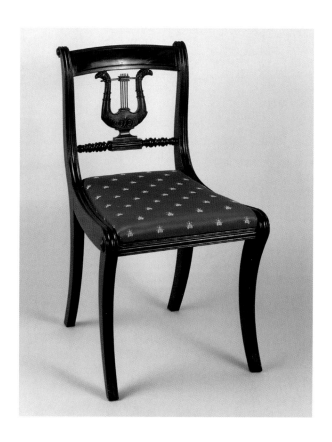

154.

Attributed to Charles-Honoré Lannuier (French, 1779–1819)
Side Chair, Klismos Shape, circa 1815

Mahogany and brass
32 inches (82.6 cm)
New Orleans Museum of Art, New Orleans, Louisiana. Gift of
Mrs. Emile N. Kuntz and the Family of Emile N. Kuntz (82.237)

This mahogany side chair, made in New York circa 1815, has
been attributed to Lannuier. With lyre and eagle-head back
splats and saber legs, this chair exemplifies both Lannuier's per-
sonal style as well as Empire fashion on both sides of the
Atlantic. There are numerous examples of this type of chair by
both émigré and American craftsmen. While the basic shape
remained the same, decorative details were modified according to
the personal taste of the patron. It is believed that this chair was
part of a set purchased for the residence of the Catholic bishop of
New Orleans. **J.S.**

155.

Unidentified American Artist, after Charles-Honoré Lannuier
(French, 1779–1819)
Side Chair, Klismos Shape, circa 1815

Beech, grained to simulate rosewood with gilded decoration
32-3/4 x 17-3/4 inches (83 x 45 cm)
Brooklyn Museum of Art, Brooklyn, New York.
Purchased with funds given by Eric Martin Wunsch
and the H. Lever Fund (73.48.1)

This lyre back chair is strikingly similar to the previous
example and was once attributed to Lannuier. It is now
thought to have been made by an American craftsman
copying Lannuier's style. It is grained to simulate rosewood,
and the artist incorporated eagle-head terminals, gilded wood
strings and carved acanthus leaf decoration into the design.
J.S.

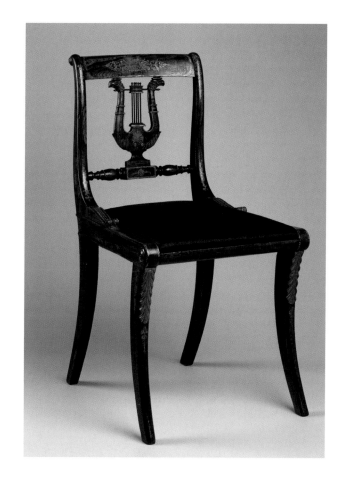

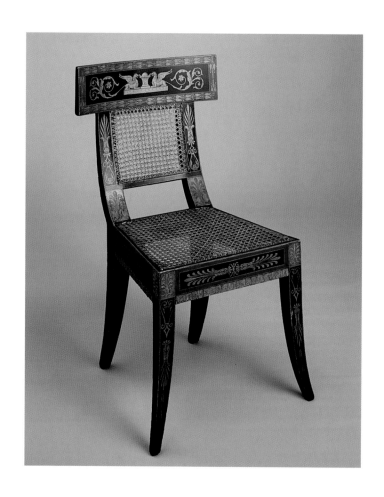

156.

Benjamin Henry Latrobe (American, 1764–1820)
Side Chair, Klismos Shape, circa 1808
Yellow poplar, oak, maple and white pine, gesso
painted and gilded
34-3/8 x 17 x 16 inches (87.3 x 44.5 x 42 cm)
High Museum of Art, Atlanta, Georgia. Purchased
with funds from the Decorative Arts Endowment
(1984.47)

This side chair was originally part of a suite of furniture designed by Latrobe for William Waln of Philadelphia. In this commission, Latrobe introduced elements of French rather than English design that were more appropriate to the American climate and lifestyle. The Waln suite is believed to have been painted by George Bridport. Each piece is painted with a slightly different motif and the side chairs, in particular, show an uncommon spirit of spontaneity in their decoration. **J.S.**

157.

Isidore Grenat (French, active 18th–19th century)
Mantel Clock with Bust of George Washington, circa 1805–10

Patinate bronze and ormolu with original silk suspension works
18 x 7 x 4 inches (45.72 x 19.05 x 11.43 cm)
New Orleans Museum of Art, New Orleans, Louisiana. Gift of
Mrs. Emile N. Kuntz and the Family of Emile N. Kuntz (82.215)

Produced in France specifically for export to the United States,
this clock is a fine example of the many timepieces bearing the
image of George Washington. The clock case, raised on four,
flattened ball ormolu feet, is surmounted by an ormolu plinth
topped by a patinated bronze bust of Washington. The plinth is
inscribed with Patrick Henry's celebrated tribute to Washington:
First in War, First in Peace/ and First in the hearts of his Countrymen.
The lower half of the clock case contains a patinated bronze bas
relief showing the surrender of Cornwallis to Washington at
Yorktown. **J.S.**

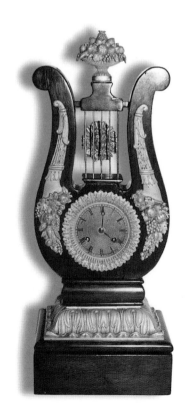

158.

Unidentified Artist, French School
Mantel Clock, circa 1800

Mahogany, gilded brass, glass
20-3/4 inches (52.7 cm.)
The James Monroe Museum and Memorial Library,
Fredericksburg, Virginia. Laurence Gouverneur Hoes Collection
(JM76.395)

This lyre-shaped clock, decorated with fruit and vegetable motifs,
was owned by James Monroe. Fascinated with the science of
"horology," Monroe purchased this and several timepieces while
minister to France, Spain and England during 1794 to 1797
and 1803 to 1807. **J.S.**

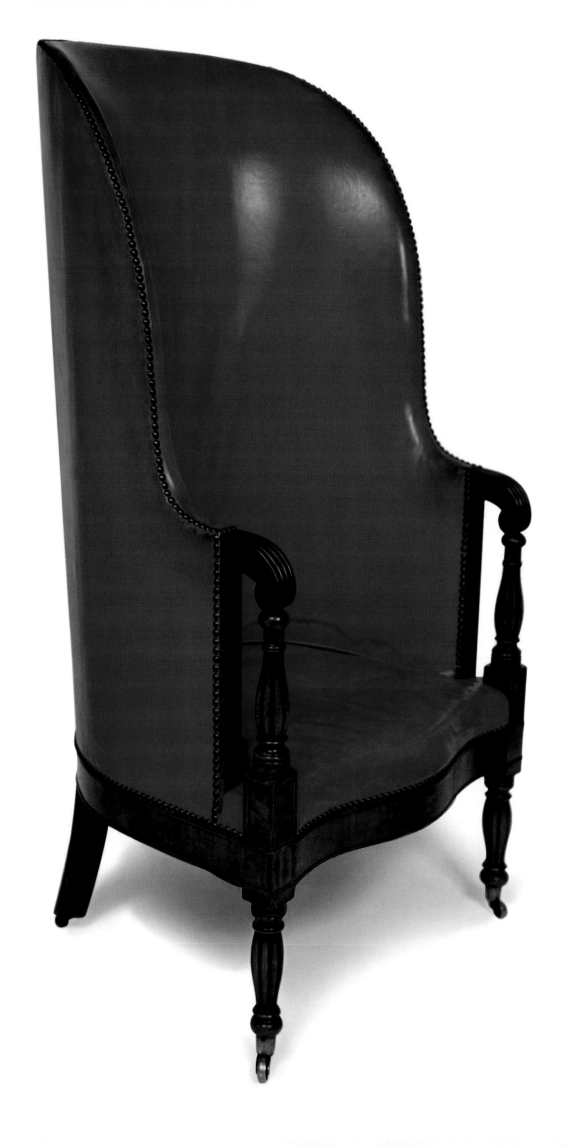

JEFFERSON'S MONTICELLO

Susan R. Stein

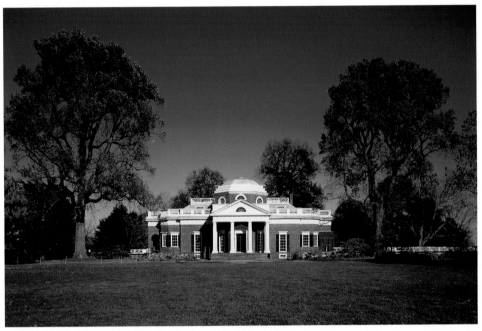

Figure 1: West Front, Monticello, Charlottesville, Virginia

Upon arriving at Monticello (*fig. 1*), Thomas Jefferson's five thousand-acre plantation in Virginia's Piedmont, on April 13, 1782, the Marquis de Chastellux recorded in his diary that "the house of Mr. Jefferson . . . shines alone in this secluded spot."[1] Chastellux was equally impressed with Jefferson's luminous intellect, noting that he was "Musician, Draftsman, Surveyor, Astronomer, Natural Philosopher, Jurist, and Statesman."[2] Although the house was far from complete, Chastellux further observed, "Mr. Jefferson is the first American who has consulted the Fine Arts to know how he should shelter himself from the weather."[3] In Virginia, where the "genius of architecture," according to Jefferson, "seems to have shed its maledictions over this land," Monticello was a conspicuous exception.[4] Jefferson's preference for classical design was apparent to Chastellux, who ascribed it to "the Fine Arts, of which Italy was the cradle and is still the resort."

Had Chastellux returned to Monticello after 1800, he would have found Monticello transformed—inside and out—especially by modern French architecture, decorative

arts, and culture. Monticello's interior became a cosmopolitan mélange emblematic of Jefferson's wide-ranging interests in art, science, and history as well as his access to goods from a wide variety of sources. Jefferson referred to Monticello as his "essay in architecture"; it was a working plantation and home not only to Jefferson and his family but also to many slaves, who tended its farms and helped to construct the house. Jefferson's wealth, created in part by the work of his slaves, allowed him the opportunity to demonstrate the range of his intellect and interests in a setting that became a laboratory for learning. Monticello's furnishings—from decorative arts, natural history specimens, objects made by Native Americans, scientific instruments, and works of art—were a means to educate family, friends, and visitors.

Until Jefferson's diplomatic service at the Court of Louis XVI from 1784 to 1789, his knowledge of architecture came chiefly from books. Monticello was begun in 1768 when Jefferson made arrangements to level part of the mountaintop; the construction of Monticello was to take

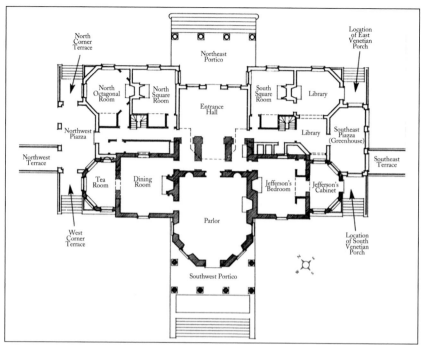

Figure 2: Floor plan of Monticello, Charlottesville, Virginia

more than forty years.[5] Jefferson's first design was greatly influenced by the Italian Renaissance architect Andrea Palladio (Italian, 1508-1580) and his *Four Books of Architecture,* which Jefferson referred to as his "bible." The initial concept with two double-storied porticoes, possibly derived from Palladio's Villa Pisani, called for six rooms but Jefferson soon modified this plan in the 1770s, adding two partly octagonal rooms. At about the same time he conceived the clever idea of concealing extensive dependencies (rooms for work, storage, and sleeping quarters for slaves) in the hillside and linking them to the cellars of the house (fig. 2). When Jefferson departed for Paris in 1784, only the shell of the house, though livable, had been completed.

In Paris, Jefferson marveled at the new architecture, taking note of the Wall of the Farmers-General and the tollhouses of Claude-Nicholas Ledoux, the bridges of the Seine, the Halle aux Bleds (the grain market), the Church of the Madeleine, the new mercantile center of the Palais Royal, and Soufflot's Sainte-Geneviève (today the Panthéon). He "was violently smitten with the hôtel de Salm," and it was likely this building more than any other that influenced Jefferson's striking expansion of Monticello's plan (**cat. no. 161**).[6] Beginning in 1796, the house was enlarged from eight to twenty-one rooms contained in three stories. The most notable feature was a dome, similar to that of the Hôtel de Salm, the first on any American residence (**cat. no. 12**). Jefferson kept the rooms on the main floor of the first house and added new ones, including three bedrooms, a library, and an entrance hall, in addition to two passageways. Rather than a grand stair, Jefferson preferred two small ones in the passageways,

believing that "great staircases . . . are expensive & occupy a space which would make a good room in every story."[7]

With an eye toward comfort and convenience, Jefferson's design for Monticello addressed the landscape through its use of extended L-shaped terraces, porticoes, glass doors, and triple sash windows, which brought the landscape inside the house. The design was meant to embrace the landscape that Jefferson held dear, "where has nature spread so rich a mantle under the eye!"[8] The house also featured two Venetian porches outside his cabinet (study) and book room that provided shade from the constant Virginia sun. Jefferson's notes called for the installation of exterior venetian blinds on the west portico, probably to filter light to the parlor. Ornamental gardens surrounded the house and beyond them the extensive plantation with its four quarter farms.

Just as Monticello's design had been influenced by Jefferson's contact with French architecture and his knowledge of Roman architecture, the furnishings of the house similarly reflected his experiences and access to goods in Williamsburg, Philadelphia, New York, and especially France. Jefferson was well aware of Charlottesville's rural location, distant from the burgeoning urban consumer marketplaces. When he traveled, he took advantage of what cities had to offer from consumer goods to cultural activities.

In Paris, Jefferson found himself on the "vaunted scene" where he immersed himself in the lively entertainments of the theater, musical performances, and art exhibitions that were to have a lasting influence upon him. He wrote a friend in Williamsburg, "Were I to proceed to tell you how much I enjoy their architecture, sculpture, painting, music, I should want words. It is in these arts they shine."[9] Like many Parisians, he attended the Salon of 1787 (**cat. no. 17**) where the latest works of the members or candidates of the Académie de Peinture et Sculpture were crowded on the walls of the Salon Carrée of the Louvre. He summoned the American painter John Trumbull (1756-1843), then living in London, advising him that he "should not miss it," noting that "the best thing is the Death of Socrates by David."[10] Jefferson also mentioned "the five pieces of antiquities by Robert," large canvases depicting Roman ruins. One of these was the *Maison Carrée* (**cat. no. 14**), which he considered the "most beautiful and precious morsel of architecture left us by antiquity" and which served as his model for the Virginia State Capitol (**cat. no. 15**).[11]

As America's minister to France, Jefferson was eager to represent his country in a manner that befitted his rank

within the diplomatic community, and, much to his disappointment, his residences were outfitted entirely at his own expense. His first real residence was a small town house on the cul-de-sac Taitbout in the Chausée d'Antin. When he learned that he would remain in Paris longer than he expected, Jefferson moved to the fine Hôtel de Langeac at the corner of the Champs-Elysée and the Rue de Berri in the fall of 1785 (**cat. no. 10**). He furnished it with what was needed to entertain in an appropriate style his diplomatic colleagues as well as his "circle of literati."[12] As it turned out, his household goods, shipped to America in eighty-six wooden packing crates in 1790, were to last a lifetime at Monticello.

By American standards, a large art collection of sixty-three paintings and ten sculptures was packed in the crates. Although Jefferson wrote that he did not "feel an interest in any

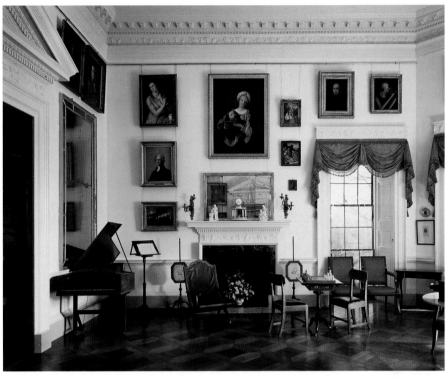

Figure 3: Parlor, Monticello, Charlottesville, Virginia

pencil but that of David," he bought none of his works, probably because of their great cost.[13] In 1788, he wrote that "painting is too expensive for the state of wealth among us" and it would be "preposterous for us to endeavor to make ourselves connoisseurs in those arts."[14] What paintings Jefferson did acquire were mainly copies of Renaissance and Baroque works, and he apparently accepted Jonathan Richardson's argument that "a copy of a very good picture is preferable to an indifferent original."[15]

Jefferson acquired many of his pictures quickly and at relatively low prices, paying an average price of twenty-nine livres. Most of his art was purchased between November 1784 and May 1785. He attended a sale in the *salle de vente* of M. Paillet, and bought at least five pictures from the sale of the collection of the late Dupille de Saint-Séverin. The bulk of his paintings were probably purchased from various *merchands merciers* who specialized in a wide range of luxury merchandise such as silk, porcelain, and furniture. Jefferson rarely identified the subject of the paintings he purchased at the time of the sale, merely noting "pictures" or "Pd. For five paintings (heads)" in his unusually meticulous account book.[16] Of twenty-one documented purchases of paintings, only two artists were identified—Jean Valade (1709-1787), probably for a copy of a portrait of Benjamin Franklin by Joseph-Silfrede Duplessis, and Adélaide Labille-Guiard (1743-1808), a distinguished painter known for portraiture, for an unknown subject (now lost).

In 1789, Jefferson compiled an inventory of the works he owned, identifying each picture by subject and artist. After he retired from the presidency, Jefferson prepared an annotated "Catalogue of Paintings &c. at Monticello," which described the paintings and their literary sources and located them in the public rooms. Renaissance works included copies of works by Raphael (*Transfiguration* and *Holy Family*), Leonardo (*St. John the Baptist*), Pordenone (*Christ Before Pilate*), and Titian (*Danae*). Jefferson's collection clearly favored Baroque painters such as Coypel, van Dyck, Rubens, Solimena, Ribera, Le Sueur, Zampieri, and particularly Guido Reni as Jefferson owned six copies of his works, including *David with the Head of Goliath, Ecce Homo, John the Baptist*, and *Herodias Bearing the Head of Saint John*, which still hangs in Monticello's parlor (*fig. 3*).

Jefferson, who called himself "an enthusiast on the subject of arts," intended to create a museum at Monticello.[18] Isaac Weld, who visited in 1796 just as Monticello was to be enlarged, wrote of Jefferson's plans, "A large apartment is laid out for a library and a museum."[19] In an age when the houses of Virginia planters contained only ancestral portraits, Monticello's art collection and decoration was every bit as exceptional as its architecture. Moreover, the art that Jefferson had obtained to secure his social and diplomatic position in the Court of Louis XVI, took on an added didactic meaning at Monticello. Here art would be exhibited to instruct his family, friends, and visitors about the history of Western civilization, including the history of the United States. Jefferson believed that the future of the country he had helped to found depended

upon educated citizens, and Monticello's collection became a means of educating them.

The entrance hall with its griffin and urn frieze, drawn from the Temple of Antonius and Faustina, was the principal gallery in Jefferson's private collection (*fig. 4*). Eleven paintings, eight or more large wall maps, Native American objects received by Meriwether Lewis and William Clark on their famous expedition of 1804 to 1806, natural history specimens, a sculpture of Ariadne, and a model of the pyramid of Cheops (a gift from Volney) crowded the room, creating an effect that one visitor likened to "the strange furniture of the walls" of the "Man

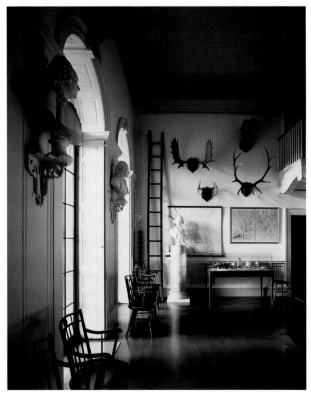

Figure 4: Entrance Hall, Monticello, Charlottesville, Virginia

of the Hill" in Fielding's *Tom Jones*.[20] Eager to dispel the theories of the Comte de Buffon (**cat. no. 20**), who argued that the species of the New World were inferior to those of the old, Jefferson displayed the antlers of moose, elk, and deer.

Beginning with his excavation of Indian burial grounds along the nearby Rivanna River when he was a boy, Jefferson maintained a lifelong interest in Native Americans, including the collection of vocabularies of native languages. On January 18, 1803, Jefferson sent a confidential letter to Congress proposing the Lewis and Clark expedition. Jefferson, who had an avid interest in scientific exploration, encouraged the explorers to document the "languages, traditions, monuments; their ordinary occupations in agriculture, fishing, hunting . . ." of the peoples

they encountered.[21] As they progressed through the West, Lewis and Clark sent three large shipments of Native American objects to Jefferson. In 1806, Jefferson invited the Mandan chief Sheheke to Monticello to see "a kind of Indian Hall" in which he "arranged the tokens of friendship" he had received.[22] These consisted of offensive and defensive weapons, a battle scene painted on a buffalo hide, a map, and more. Together with the European paintings and sculpture, the mastodon bones excavated in Kentucky by William Clark in 1807, the model of Cheops, and the maps, the arrangement of the Indian Hall signified Jefferson's effort to demonstrate the range of his knowledge.

Jefferson's educational aspirations for Monticello also were expressed in the parlor, which contained no fewer than fifty-seven works of art, thus offering another opportunity to instruct visitors and family. Among the works exhibited were thirty-five portraits of the men who had shaped Jefferson's intellectual development as well as influenced world history. The most prized portraits were Jefferson's "trinity of the three greatest men the world has ever produced"—Francis Bacon (1561-1626), Isaac Newton (1642-1723), and John Locke (1632-1704).[23] Because he thought his "country should not be without portraits of its first discoverers," Jefferson displayed pictures of Sir Walter Raleigh, Amerigo Vespucci, Christopher Columbus, Ferdinand Magellan, and Hernando Cortes.[24] In this "large and lofty salon," where family and guests played music and games, read, and wrote letters, were also exhibited pictures of absent friends, the patriots George Washington, John Adams, James Madison, Benjamin Franklin, whom Jefferson considered "the greatest man and ornament of the age and country in which he lived," the Marquis de Lafayette (**cat. no. 5**), and David Rittenhouse, the brilliant Philadelphia scientist.[25]

In addition to the portraits in the parlor, Jefferson owned dozens of small images of family members, political allies, and Indians, many of whom had visited him in Washington while he was president. These smaller images were mainly displayed in the family sitting room, book room, and tea room (*fig. 5*), which he called his "most honorable suite" for its plaster busts of Washington, Lafayette, Franklin, and John Paul Jones by Jean-Antoine Houdon. Jefferson's own portraits by Houdon (*fig. 6*), John Trumbull, Gilbert Stuart, Pietro Cardelli, Giuseppe Ceracchi, and Michal Sokolnicki were apparently shown throughout the house.

Furnishing Monticello

Monticello was the center of Jefferson's life, and he devoted himself to every aspect of its design and function. After the unfortunate early death of his wife, Martha Wayles Skelton Jefferson (1746-1782), Jefferson himself made all of the decisions about furnishings, even specifying how curtains were to be made. Like his art, his possessions

Figure 5: Tea Room, Monticello, Charlottesville, Virginia

tell the story of his life, revealing his taste as much as they do his interests and access to consumer goods. Most of his earliest belongings, including books and furniture, were largely destroyed when Shadwell, the house of his father, Peter Jefferson (1707/8-1757), and mother, Jane Randolph Jefferson (1720-1776), was destroyed by fire in 1770. Thus, virtually all of Jefferson's extant possessions post-date the fire. The household furnishings he owned fall into several general groupings—from Virginia sources, after 1772; from France, between 1784 and 1789; from New York and Philadelphia, between 1790 and 1797; and furniture made at Monticello, largely after 1809.

Jefferson's purchases of furniture before his trip to France in 1784 were mainly in the Baroque, or Chippendale style, certainly the most popular fashion in America in the 1770s. Among this group are a tall desk, made in Williamsburg or Richmond after 1770; a high chest of drawers from Philadelphia; a bureau table from Massachusetts; and several tripod tables. Like other well-known Virginians, he purchased furniture from the Williamsburg shop of Peter Scott, including a square table and several tea tables in 1772 and clothes presses in 1773.[26] If not for Jefferson's travels to distant marketplaces, the furnishings

of Monticello would have borne a stronger regional, if not English, character.

Monticello, however, took on a decidedly French character, because of his years in France and the American government's refusal to underwrite the cost of Jefferson's "outfit"; what he bought was his own. He wrote James Madison that he assumed "an almost womanly attention to the details of the household," which "he found inconsistent with business."[27] Jefferson shopped along the fashionable Rue Saint-Honoré, buying efficient oil lamps

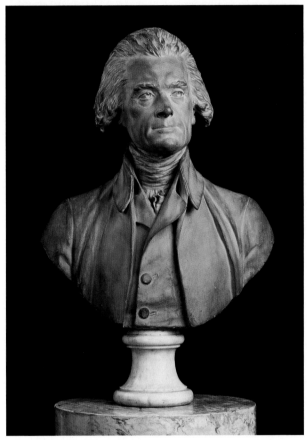

Figure 6: Jean-Antoine Houdon (French, 1741-1828), *Thomas Jefferson*, 1789, Terra cotta patinated plaster, 28-3/4 inches high (73 cm), Monticello/Thomas Jefferson Foundation, Inc.

from Daguerre and silver from the Jean-Baptiste Odiot, who took an order for a celebrated pair of footed neoclassical goblets (**cat. no. 165**) and a tea or coffee urn, both to Jefferson's designs.

Five sofas, forty-eight-chairs (twenty-two arm chairs, twenty-two side chairs, and four easy chairs), bureaus, and many tables were packed among the many crates of goods shipped from Paris to America, eventually finding their way to Monticello. Four to five suites of chairs were upholstered in an unidentified crimson fabric, blue silk, red Morocco (goatskin), *velours d'Utrecht* (silk velvet with a pressed design) in crimson and an unidentified color. Examples of three of the four or five original suites of

chairs survive, and their forms are characteristic of the mid-1780s, featuring either flat or curved oval or trapezoidal backs, patinated but not gilded beech, and incised carving on the legs. The *menusier-ébéniste* Jacques Upton, with a workshop on the rue de Chaillot near the Hôtel de Langeac, is likely to have made many of these chairs.[28] The fourth type of French chair, a *fauteuil à la reine* (an armchair with a straight back; **cat. no. 170**), is attributed to the workshop of Georges Jacob, a cabinetmaker celebrated

Figure 7: Unidentified Artist, French School, *Venus with Cupid* and Jossé-François-Joseph Le Riche (French, 1741-1812), *Hope with Cupid*, circa 1785, Biscuit, 12 x 7-3/4 x 5-1/4 inches (30.5 x 19.7 x 13.3 cm) and 12 x 7 x 5 inches (31.8 x 19.1 x 14 cm), Monticello/Thomas Jefferson Foundation, Inc., Charlottesville, Virginia

for his designs and workmanship. Jefferson might have owned more than twenty of these mahogany chairs with saber legs whose uncommonly sinuous design prefigured the later Directoire and Empire periods.

In addition to the numerous chairs, other French furnishings contributed to the character of the house. These include an assortment of tables for games, writing, and drawing; silk and *toiles de Jouy* curtains; mirrors with gilded frames; lamps; and many tablewares. Not only was the cuisine "served in half Virginian, half French style," but Jefferson's dining tables (no single grand table was used) were ornamented with mirrored *plateaux* for the display of decorative figurines made of biscuit, unglazed high-fired porcelain.[29] Of the seven small sculptures Jefferson acquired, only *Hope with Cupid* and *Venus with Cupid* (fig. 7) survive. Much of the highly prized family silver was French, including silver flatware in the popular fiddle and thread pattern, plates, covered vegetable dishes, and a coffee urn. The silver askos (**cat. no. 168**), though made in Philadelphia, had its origins in a Roman bronze vessel that Jefferson had seen in Nîmes when he went to see the Maison Carrée

Figure 8: Cabinet, Monticello, Charlottesville, Virginia

in 1787. Similarly, the inspiration for the renowned "Jefferson cups" (**cat. no. 164**) was a small French beaker or tumbler with a gilt-washed interior (**cat. no. 163**). Jefferson designed a pair of classically inspired footed goblets (**cat. no. 165**).

Mingled with the French furnishings were at least an equal number of goods from American sources. While serving as the first secretary of state in New York in 1790, Jefferson awaited the arrival of his belongings from France in a rented house on Maiden Lane. He purchased some necessary household goods—a coffee pot, tea kettle, spoons and a ladle from William Grigg, thirty green Windsor chairs (for Monticello), a revolving chair and more furniture from Thomas Burling, mahogany shieldback chairs, two engravings of Washington by Joseph Wright, and more. Jefferson's French belongings finally joined him in Philadelphia after the capital moved there in late 1790. In Philadelphia, Jefferson acquired dumbwaiters (movable sets of shelves to facilitate dining; **cat. no. 173**), more shieldback chairs with foliate ornamentation, and the high-backed chair reputedly used while he was vice-president (**cat. no. 160**). Fewer purchases were made while he served as president (1801-1809) in the young city of Washington.

Jefferson wrote in 1793 that he "longed to be liberated from the hated occupations of politics, and to sink into the bosom of my family, my farm, and my books."[30] With his retirement from the presidency in 1809, he at last was able to live at Monticello year-round but for visits to Poplar Forest, his octagonal house and plantation in Bedford County, Virginia. With Monticello and Poplar Forest largely

completed and his financial resources reduced, Jefferson turned to his enslaved joiners to supply his need for furniture. The principal slave joiner was John Hemings (1775-1830+), a member of the well-known Hemings family. The joiners David Watson and James Dinsmore (ca. 1771-1830), who were hired to help construct the house, trained Hemings. A Monticello overseer wrote that he was "a first-rate workman" who "could make anything that was wanted in wood-work."[31]

Hemings, who could read and write as well as understand architectural drawings, made furniture to Jefferson's designs as well as his own. More than fifty pieces (chairs—**cat. no. 171**, various kinds of tables, and presses) have been attributed to the Monticello joinery, and these straightforward works reflect Jefferson's utilitarian taste and a distinctive plain and neat stylistic vocabulary. Many of the designs were clearly influenced by Jefferson's French furniture, and thus have been recently labeled "Franco-Piedmont." The intermingling of the joinery furniture with more elaborate French pieces led to an eclectic mix in all of Monticello's rooms.

No room at Monticello was more emblematic of Jefferson's intellect and daily activities than his cabinet (*fig. 8*), or study, and book room, located in his private apartment. He famously wrote John Adams, "I cannot live without books." His collection of more than seven thousand volumes was likely then the largest private library in America. After the British army burned the Capitol and destroyed its library, Jefferson offered his entire collection to Congress. He acquired many volumes in Paris where he often prowled "the principal bookstores, turning over every book with my own hand, and putting by everything which related to America and indeed whatever was rare and valuable in every science."[32] Jefferson also had standing orders with booksellers in other European capitals. His collection, for which he devised his own classification system, included the Greek and Roman classics, law, fine arts, architecture, gardening, literature, music, mathematics, politics, trade, religion, ancient and modern history, geography, natural history, natural philosophy, and much more.[33]

After Jefferson's retirement he was free to pursue "the tranquil pursuits of science."[34] He believed that he was "drawn by the history of the times from physical and mathematical sciences, which were my passion, to those of politics and government."[35] In his cabinet Jefferson surrounded himself with an extensive array of "Mathematical Apparatus" for study and experimentation on a variety of subjects. For reading and writing he devised a convenient and comfortable arrangement featuring a revolving chair with candleholders in the arms, a revolving table, a Windsor bench to support his legs, and a revolving bookstand (**cat. no. 172**) that could hold five volumes. His polygraph, a duplicating device with two pens, enabled Jefferson to make copies of thousands of letters. To John Adams in 1817 he lamented, "I am drudging at the writing table," often answering "letters into which neither interest nor inclination on my part enters."[36]

As Jefferson approached the end of his life, he turned his attention to the founding and establishment of the University of Virginia, which he called "the hobby of my old age." At his architectural desk at Monticello, he designed its campus, a remarkable "academical village" with a library modeled after the Pantheon in Rome; ten residential pavilions for professors, each inspired by ancient architectural monuments; and rooms for students. Jefferson even chose the books for the library and hired some of the first professors. His founding of the University of Virginia demonstrated his determination to assure the free exchange of ideas and the improvement of society. Jefferson's commitment to "the illimitable freedom of the human mind to explore and to expose every subject susceptible of its contemplation" was visible throughout Monticello—in its architecture, art collection, Indian Hall, books on every subject, and "mathematical apparatus."

Notes:

1. Marquis de Chastellux, Howard C. Rice, Jr., trans., *Travels in North America in the Years 1780, 1781, and 1782* (Chapel Hill: University of North Carolina Press, 19TK), 2:390.
2. Ibid., 391.
3. Ibid., 391.
4. Thomas Jefferson, *Notes on the State of Virginia*, London, 1787, reprint with notes edited by William Peden, (Chapel Hill: University of North Carolina Press, 1955), 53.
5. For an excellent account of Monticello's architecture, see William L. Beiswanger, "Thomas Jefferson's Essay in Architecture," in *Thomas Jefferson's Monticello* (Charlottesville: Thomas Jefferson Foundation, 2002), 1-40.
6. Thomas Jefferson to Madame de Tessé, 20 March 1787, *The Papers of Thomas Jefferson* (Princeton: Princeton University Press, 1950-), 11:226.
7. Thomas Jefferson to John Brown, 5 April 1797, Library of Congress.
8. Thomas Jefferson to Maria Cosway, 1786, *Papers*,
9. Thomas Jefferson to Charles Bellini. 1785. Washington, ed., 1:445 or 444?
10. Thomas Jefferson to John Trumbull, 30 August 1787, *Papers*, 12:69.
11. Thomas Jefferson to James Madison, 20 September 1785, *Papers*, 8:534.
12. Thomas Jefferson to Abigail Adams, 21 June 1785, *Papers*, 8:241.
13. Thomas Jefferson to Madame de Bréhan, 19 March 1789, *Papers*, 14:656.
14. Thomas Jefferson, "Hints to Americans Travelling in Europe," 19 June 1788, *Papers*, 13:269.
15. Harold E. Dickson, " 'TH.J.' Art Collector," in William Howard Adams, ed., *Thomas Jefferson and the Arts: An Extended View* (Washington, DC: National Gallery of Art, 1976), 109.
16. James A. Bear and Lucia C. Stanton, eds., *Jefferson's Memorandum Books* (Princeton: Princeton University Press, 1997), 1:567.
17. Thomas Jefferson, "Catalogue of Paintings &c. at Monticello," Thomas Jefferson Papers (#2958-b), Special Collections, University of Virginia.
18. Thomas Jefferson to James Madison, 20 September 1785, *Papers*, 8:535.
19. Merrill D. Peterson, *Visitors to Monticello* (Charlottesville: University Press of Virginia, 1989), 19.
20. Ibid., 62.
21. Thomas Jefferson's Instructions to Lewis, 20 June 1803, Donald Jackson, ed., *Letters of the Lewis and Clark Expedition*, 2nd edition, 2 volumes (Chicago: University of Illinois Press, 1978), 1:61.
22. Thomas Jefferson to Meriwether Lewis, 26 October 1806, *Lewis and Clark*, 1:350-1.

23. Thomas Jefferson to Benjamin Rush, 16 January 1811, in Paul Leicester Ford, *The Writings of Thomas Jefferson*, 12 volumes (New York: G.P. Putnam's Sons, 1904-05), 11:168.

24. Thomas Jefferson to Joseph Delaplaine, 3 May 1814, Albert Ellery Bergh, ed., *The Writings of Thomas Jefferson*, 20 volumes (Washington, DC: The Thomas Jefferson Memorial Association, 1907), Andrew A. Lipscomb was editor of the first edition, 1903-04, 14:12.

25. Thomas Jefferson to Samuel Smith, 22 August 1798, Ford, 8:443.

26. Ronald L. Hurst and Jonathan Prown, *Southern Furniture 1680-1830: The Colonial Williamsburg Collection* (Williamsburg: The Colonial Williamsburg Foundation, 1997), 89. *Memorandum Books*, 284, 327.

27. Thomas Jefferson to James Madison, 25 May 1788, *Papers*, 13:203.

28. Upton is mentioned more than a dozen times in the Memorandum Books.

29. "Memorandum of Mr. Jefferson's Conversations," in *Private Correspondence of Daniel Webster*, quoted in Peterson, *Visitors to Monticello*, 99.

30. Thomas Jefferson to Angelica Schuyler Church, 27 November 1793, *The Papers of Thomas Jefferson*, 27:449.

31. Reverend Hamilton Wilcox Pierson, "Jefferson at Monticello: The Private Life of Thomas Jefferson," in James A. Bear, Jr., ed., *Jefferson at Monticello* (Charlottesville: University Press of Virginia, 1967), 101-2.

32. Thomas Jefferson to Samuel H. Smith, 1814, cited in Douglas L. Wilson, "Jefferson's Library," in Merrill D. Peterson, ed., *Thomas Jefferson: A Reference Biography* (New York: Charles Scribner's Sons, 1986), 165.

33. For an excellent succinct account, see Douglas L. Wilson, "Jefferson's Library," in Peterson, *Thomas Jefferson: A Reference Biography*, 157-180.

34. Thomas Jefferson to P. S, Dupont de Nemours, 2 March 1809, Merrill D. Peterson, *Thomas Jefferson: Writings* (New York: Library of America, 1984), 1209.

35. Thomas Jefferson to Caspar Wistar, 10 June 1817, DLC.

36. Thomas Jefferson to John Adams, 11 January 1817, Lester J. Cappon, ed., 2 vols., *The Adams-Jefferson Letters* (Chapel Hill: University of North Carolina Press, 1959), 505.

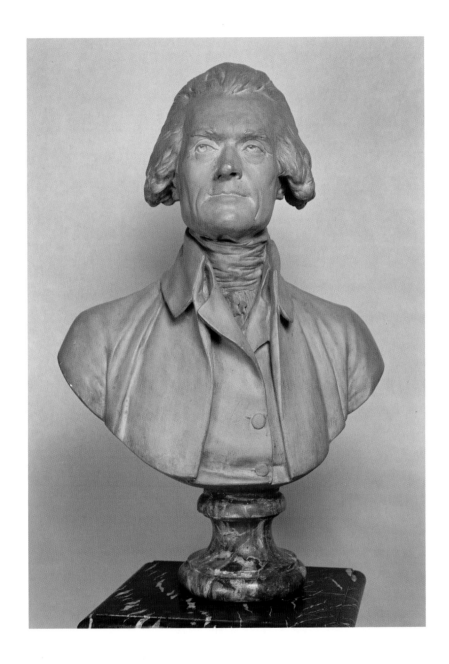

159.

Studio of Jean-Antoine Houdon (French, 1741–1828)
Portrait of Thomas Jefferson, circa 1787

Plaster painted in terra cotta
29 x 22 inches (73 x 55 cm)
Musée de la Coopération Franco-Américaine,
Château de Blérancourt, France (63c10)
©Réunion des Musées Nationaux / Art Resources, NY

Before leaving Paris in 1789, Thomas Jefferson posed for his portrait by France's preeminent sculptor—Jean-Antoine Houdon. This bust became the model for the Jefferson Inaugural Commemorative Medal (**cat. no. 184**), his peace medal (**cat. no. 186**) and, in 1938, the American nickel. Jefferson probably purchased these portraits of himself by Houdon as well as other busts in plaster by Houdon of prominent French and American men for his own "Gallery of Worthies" at Monticello, including Benjamin Franklin, George Washington, Voltaire, and the Marquis de Lafayette. **V.C.**

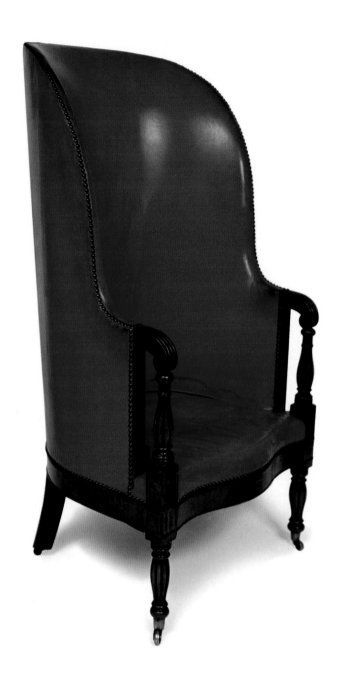

160.

Unidentified Artist, American School, Mid-Atlantic Manufacture
Easy Chair, 1800-10

Mahogany, maple and poplar, red leather
58 x 28-3/4 x 23-1/2 inches (147.3 x 73 x 59.7 cm)
University of Virginia, on loan since 1926 to Monticello/Thomas
Jefferson Foundation, Inc., Charlottesville, Virginia (1926-1)

This unusually tall easy chair with its high, curved barrel
back, no wings, and reeding on the turned arms and front
legs, may have had a ceremonial purpose. Family tradition
says it was used by Jefferson while he served as vice-president
in Philadelphia (1797–1801). In its republican simplicity, it
stands in dramatic contrast to Napoleon's imperial throne
(**cat. no. 48**). **S.S.**

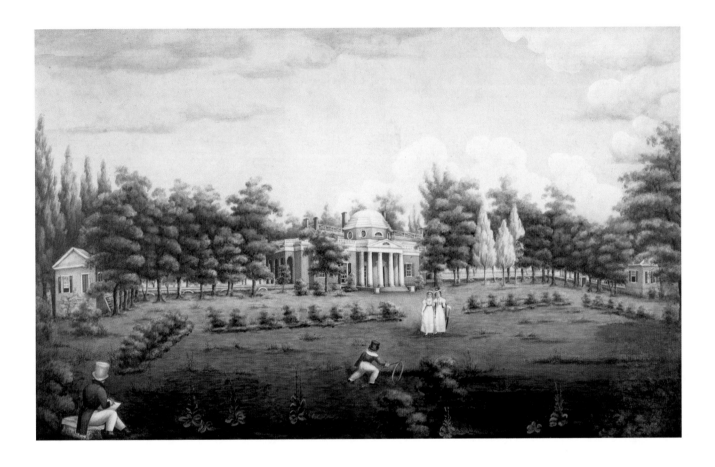

161.

Jane Braddick Peticolas (American, 1791–1852)
West Front of Monticello and Garden, 1825
Signed on back: *To Mrs. Ellen Coolidge,*
from a friend, Washington – 1827

Watercolor on paper
13-5/8 x 18-1/8 inches (34.6 x 46 cm)
Monticello/Thomas Jefferson Foundation, Inc.,
Charlottesville, Virginia (1986-13-30a)

Monticello was seldom depicted during Jefferson's lifetime, and this watercolor has become an important historical document as it records the appearance of the west front of the house and nearby garden toward the end of Jefferson's life. Jane Braddick Peticolas, an artist who ran a school in Richmond, painted it in 1825 for Ellen Randolph Coolidge, a Jefferson granddaughter who had married and moved to Boston. The view shows the west front with three of Ellen's siblings—George Wythe (rolling the hoop), Mary, and Cornelia. The man sketching at the bottom left might be the Richmond painter Edward F. Peticolas, the husband of the artist. **S.S.**

162.

Unidentified Artist, American School
Ivory Notebook

Ivory
2 x 11/16 inches (5.1 x 1.7 cm)
Monticello/Thomas Jefferson Foundation, Inc.,
Charlottesville, Virginia (1927-35)

Jefferson was a fastidious record keeper. He carried
a pocket notebook made of leaves of ivory. Penciled
notes could be erased after they were transferred to his
memorandum books, where he tracked expenditures
to his farm or garden book, or to other papers. **S.S.**

163.

Unidentified Artist, Paris School
Small Tumbler, 1787

Fused silver plate with gilt interior
1-7/8 x 2-5/8 inches (4.8 x 6.7 cm)
Monticello/Thomas Jefferson Foundation, Inc.,
Charlottesville, Virginia (1962-1-55)

164.

John Letelier (also Letellier, Le Tellier)
(American, active circa 1790–1810)
Tumbler, 1810
Inscribed: *GW to TJ*

Silver with gilt interior
2-5/8 x 3-3/16 in. (6.7 x 8.1 cm.)
Monticello/Thomas Jefferson Foundation, Inc., Charlottesville, Virginia
(1938-10)

Thomas Jefferson engaged the silversmith John Letelier, then working
in Richmond, to make eight silver tumblers for him. With its low shape
and heavy bottom for stability, the form was popular throughout the
seventeenth and eighteenth centuries. The model for the tumblers was
a slightly smaller version that Jefferson evidently acquired in Paris and
later sent to Letelier. Jefferson wrote Letelier that he wanted the new
ones to "be about half an inch higher . . . In every other respect I would
wish the model to be exactly imitated." The silver for some of the cups
came from two cups left to Jefferson by his mentor George Wythe. Thus,
four of the eight cups are marked "G.W. to T.J. and the others simply
T.J. in the cipher stile [*sic*]." (27 March 1810, Missouri Historical Society).
The tumblers are popularly known today as the Wythe-Jefferson cups or
simply Jefferson cups; six are known today. (Olson, *Worlds of Thomas
Jefferson*, 333-35). **S.S.**

165.

Claude-Nicolas Delanoy (French, active 1766–circa 1793),
after a drawing by Thomas Jefferson (American, 1743–1826)
Goblet with Pedestal Foot, 1789

Silver with gilt interior
4-5/8 x 2-15/16 inches (11.7 x 7.5 cm); base: 2 inches square (5.1 cm)
Monticello/Thomas Jefferson Foundation, Inc., Charlottesville,
Virginia (1982-33)

This silver goblet is one of a pair made to Jefferson's design in Paris.
The footed form demonstrates Jefferson's interest in neoclassicism,
which was evident not only in his architectural designs but also in his
designs for everyday objects. Jefferson engaged the silversmith Jean-
Baptiste Claude Odiot to make them, but Odiot apparently turned
over their production to Claude-Nicolas Delanoy, whose mark appears
on the bottom of the goblets. (Olson, *The Worlds of Thomas Jefferson*,
327). Unlike most contemporary French silver cups that often were
decorated with gadrooning (decorative motifs consisting of an edge or
border of inverted arcs joined at their edges), these are notable for
their architectural form and plain surface. The interior of the bowls
are gilded. After Jefferson's death the goblets passed to Elizabeth
Martin Randolph, the widow of Jefferson's grandson, Meriwether
Lewis Randolph. **S.S.**

166.

William Jones (American, 1763–1831)
and Samuel Jones (American,
active circa 1807)
Concave Mirror, circa 1807

Glass with walnut frame
12 inches (30.5 cm)
Monticello/Thomas Jefferson Foundation,
Inc., Charlottesville, Virginia (1961-15)

Jefferson owned at least two concave mirrors
that he used with his microscopes, together
with condensing lenses and a scioptric ball,
to enlarge the angle of vision. Related to the
camera obscura, a scioptric ball (typically
attached to a window shutter) projects an
upright image into a darkened room. An
optical phenomenon associated with concave
mirrors might also have amused visitors and
family members. When a viewer stands
outside the focal point of a concave mirror,
the image is reflected upside down. The
mirror might have been moved from
Jefferson's cabinet (study) to the entrance
hall after he abandoned more complex
scientific experiments in his last years.
(Stanton, *The Worlds of Thomas Jefferson*, 359).
S.S.

167.
Manufacture Nationale de Sèvres (France, active 1756–present), decorated by Geneviève Le Roy Taillandier (French, active 1774–1798)
Seau Crénelé, 1787

Hard paste porcelain
5-3/4 x 12 x 8-1/8 inches (14.6 x 31.8 x 20.6 cm)
Monticello/Thomas Jefferson Foundation, Inc., Charlottesville, Virginia (1942-8)

Jefferson acquired at least two pieces from a porcelain dessert service in the *guirlande de barbeaux* (cornflower garland) pattern made at the royal factory at Sèvres. Sprigs of cornflowers were quite popular decorations but the garland form apparently was reserved for the king. This crenelated vessel, part of a larger service, was used for cooling and rinsing wine glasses. The pattern, introduced in 1783 and replenished until the early 1790s, was made for Louis XVI and was used at Versailles. How Jefferson came to own a *seau crénelé* and a *sucrier* is not known; he might have purchased them damaged or they might have been a gift. The decorations were painted by Geneviève Le Roy Taillandier who worked in the factory until her marriage and later by the piece. This *seau* might have been one of four for which she was paid on April 9, 1788. (Personal communication, Rosalind Savill). **S.S.**

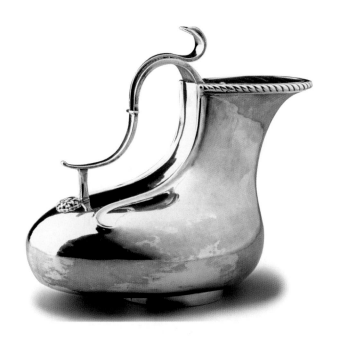

168.

Anthony Simmonds (American, died 1808) and
Samuel Alexander (American, died 1847)
Askos, 1801
Inscribed on lid: *Copied from a model taken in 1787
by Th. Jefferson from a Roman Ewer in the
Cabinet of Antiquities at Nismes*

Silver
8 x 9-1/8 x 4-7/8 inches (20.3 x 23.2 x 12.4 cm)
Monticello/Thomas Jefferson Foundation, Inc.,
Charlottesville, Virginia (1957-29)

169.

Souche (French, active circa 1789)
Askos Model, 1789
Inscribed on base: *Presented by Ex-Pres. Thos. Jefferson
to Thos. Sully*

Mahogany
7 x 9-1/8 x 4-7/8 inches (17.8 x 23.2 x 12.4 cm)
Monticello/Thomas Jefferson Foundation, Inc.,
Charlottesville, Virginia (1974-20)

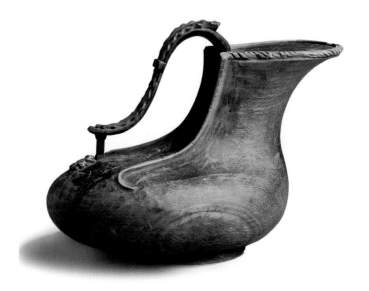

During a trip to Nîmes in 1787 to study the Maison
Carrée in conjunction with his design for the Virginia
State Capitol, Thomas Jefferson saw a Roman, bronze
pouring vessel in the archaeological collection of Jean
François Seguier. Jefferson admired this antique form
for "sa singularité et sa beauté" (*Papers*, 15:172) and
planned to have one made in silver for the architect
Charles-Louis Clérisseau, who had helped Jefferson with
his study of "the best morsel of architecture now
remaining."[1] (*Papers*, 8:462) The model was lost, and
Jefferson was compelled to give Clérisseau a coffee urn.
A second model was commissioned in 1789, and more
than ten years later the Philadelphia silversmiths
Simmons and Alexander made this vessel that Jefferson
used as a chocolate pot. **S.S.**

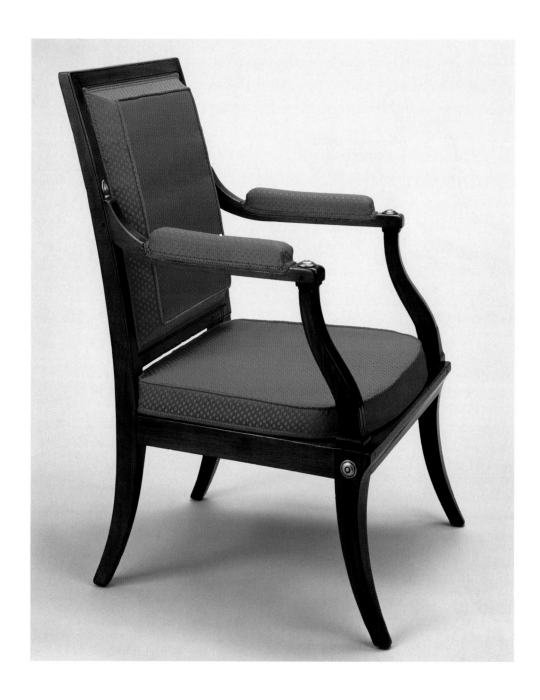

170.
Attributed to Georges Jacob (French, 1739–1814)
Fauteuil à la Reine

Mahogany,
37 x 24-1/4 x 24 inches (95.3 x 61.6 x 61 cm)
Monticello/Thomas Jefferson Foundation, Inc.,
Charlottesville, Virginia (1971-71-3)

Jefferson apparently purchased a suite of at least twelve chairs (eight survive at Monticello) from the renowned Parisian cabinetmaker Georges Jacob, who was celebrated for the versatility, beauty, and craftsmanship of his designs. He is perhaps best known for the gilded, highly carved furniture he made for Queen Marie Antoinette. Jefferson's classically inspired chairs with their saber legs, however, are streamlined, sinuous, and nearly flat. The supports for the arms feature only incised colonettes, a characteristic Jacob treatment. **S.S.**

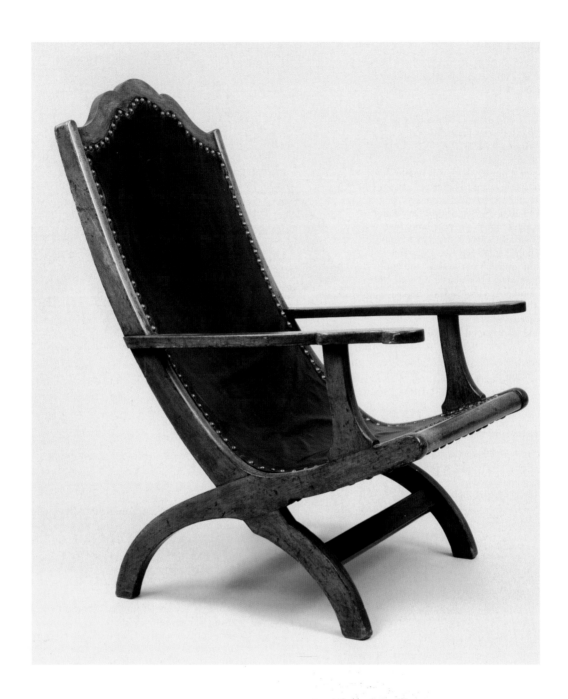

171.
John Hemings (American, 1776-1830+)
Campeachy Chair, before August 1819

Mahogany,
39-7/16 x 24 x 33 inches (100.1 x 61 x 83.8 cm)
Monticello/Thomas Jefferson Foundation, Inc.,
Charlottesville, Virginia (1970-91)

The unusual form of this chair, sometimes called a "lolling," "siesta," "hammock," "Spanish," or "campeachy," had its origins in ancient Egypt. Versions of this design with its X-shaped stretchers were later fashionable in seventeenth-century France and particularly Spain. Especially popular in New Orleans, the form was probably derived from Spanish sources and took the name Campeachy from Campeche in Mexico, where the chair was made. Jefferson admired the design and ordered three in 1808 but these were lost at sea. Before his long-awaited campeachy chair finally arrived in 1819, the capable enslaved joiner John Hemings made his own versions; this one features a scalloped crested rail. The form was very comfortable for Jefferson who wrote, "Age, its infirmities & frequent illnesses have rendered indulgence in that easy kind of chair truly acceptable." (*Worlds of Thomas Jefferson*, 280). **S.S.**

172.

Unidentified Artist, American, Monticello Joinery
Revolving Bookstand, 1810

Walnut
19-3/4 x 26-3/8 x 26-3/8 inches (50.2 x 67 x 67 cm)
Monticello/Thomas Jefferson Foundation, Inc.,
Charlottesville, Virginia (1938-20)

Once thought to be a music stand, this highly
unusual form was likely made to Jefferson's design
and specifications in the Monticello joinery. As
many as five books could be placed on it at a time;
a hole in the bottom suggests the possibility that
the bookstand originally was supported by a tripod
base. The cube-shaped stand has five adjustable
rests for books, four on each of the sides and one
on the top. Jefferson may have placed it beside his
chair in his convenient reading and writing
arrangement in the cabinet. Jefferson owned one of
the largest libraries in America. Visitors recalled
seeing him reading, surrounded by books. **S.S.**

173.

Unidentified Artist, American, Monticello Joinery
Dumbwaiter

Walnut and pine
35 x 18 x 18-3/8 inches (35 x 47 x 47.7 cm)
Monticello/Thomas Jefferson Foundation, Inc.,
Charlottesville, Virginia (1975-45)

Jefferson became accustomed to the Parisian practice of
using "dumbwaiters," small tiers of shelves on casters, for
small dinner parties. These mobile étagères, also known
in England throughout the eighteenth century, enabled
diners to serve themselves. A visitor who dined with
President Jefferson in Washington remembered, "by each
individual was placed a dumbwaiter, containing everything
necessary for the progress of the dinner from beginning
to end, so as to make the attendance of servants entirely
unnecessary." (Cited in *Worlds of Thomas Jefferson*, 282).
Jefferson owned five in Paris. He did not bring them back
to America but instead replaced them with four or more
made in Philadelphia, possibly by Joseph and Henry Ingle.
Five of Jefferson's dumbwaiters survive today, and one of
these was made in Monticello's joinery. The one depicted
here, made in the joinery, was used at Poplar Forest,
Jefferson's plantation in Bedford County, Virginia. **S.S.**

174.

Possibly Matthew Boulton (English, 1798–1809)
Argand Lamp, 1786

Sheffield plate
7 x 3-3/4 inches (17.8 x 9.5 cm)
The Henry Francis Du Pont Winterthur Museum,
Winterthur, Delaware

Jefferson's interest in the practical application of science inspired his fascination with new and innovative products. In London in 1786 he bought three "plated reading lamps" that produced "a light equal as is thought to that of six or eight candles." (*Papers*, 7:518) The invention of an oil lamp with a hollow wick was made by the Swiss inventor Ami Argand. Argand later collaborated with Matthew Boulton and James Watt to improve the design. This lamp is likely "the elegant piece of furniture" that Charles Thomson received as a gift from Jefferson in 1786. (*Papers*, 10:102) Jefferson likely owned a lamp like this one as well as less expensive tole versions made by Parisian makers. **S.S.**

175.

Alexis Marie Rochon (French, 1741–1817)
Micrometer with case and cover, circa 1780

Brass, glass; case: pressed board,
paper; cover: textile, leather
Closed 14 inches (35.6 cm); extended 19 inches
(48.3 cm); Case: 14 x 2-1/6 inches (35.6 x 5.2 cm);
Cover: 14-1/2 x 16-1/2 inches (36.8 x 41.9 cm)
Monticello/Thomas Jefferson Foundation, Inc.,
Charlottesville, Virginia

While Jefferson was in Paris, the Abbé Rochon was making new discoveries in optics at the royal Cabinet de Physique, La Muette, in Passy. At Benjamin Franklin's nearby house, Jefferson saw Rochon exhibit his "lunette," an achromatic telescope with a prismatic micrometer based on the use of double refracting rock crystal. "A telescope of Iceland chrystal [*sic*] by abbé Rochon & Herbage" was included on Jefferson's list of "Mathematical Apparatus." He acquired it through Francis Hopkinson of Philadelphia who acquired it from Franklin. (Stanton, *The Worlds of Thomas Jefferson*, 52). **S.S.**

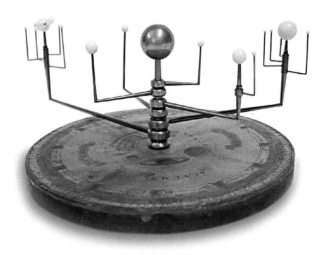

176.

William Jones (American, 1763–1831)
and Samuel Jones (American, active circa 1807)
Portable Orrery, circa 1792-98
Signed: *A NEW PORTABLE ORRERY invented and Made by W. Jones and sold by him in Holborn, London*

Case: 4 x 8-3/4 x 8-3/4 inches (11.2 x 22.3 x 22.3 cm)
National Museum of American History, Smithsonian Institution, Washington, D.C. (Cat 319427 acc.#237044)

Always engaged by mathematics and science, Jefferson owned a fine collection of "Mathematical Apparatus." In London he frequented the shops of the best instrument makers and later sent orders from Monticello. One such purchase was a portable orrery (now lost), an operating model of the solar system, which Jefferson might have brought with him to the President's House. (Stanton, *Worlds of Thomas Jefferson*, 351). **S.S.**

177.

Benjamin Smith Barton (American, 1766–1815)
Jefferson Diphylla, The Twinleaf, 1793

Hand-colored engraving
15 x 10-7/8 inches (37.7 x 28 cm)
American Philosophical Society, Barton-Delafield Collection,
Philadelphia, Pennsylvania

Benjamin Smith Barton, a prominent botanist, was an active member of the American Philosophical Society in Philadelphia. He was the founder of the *Philadelphia Medical and Physical Journal*. In 1803 Barton published the first textbook on botany in the United States, *Elements of Botany*. He advised Meriwether Lewis on preserving specimens on his expedition to explore the Louisiana Territory. In 1792 Barton renamed the twinleaf, an American wildflower, *Jeffersonia Diphylla*, in honor of Thomas Jefferson and his promotion of the natural sciences. **V.C.**

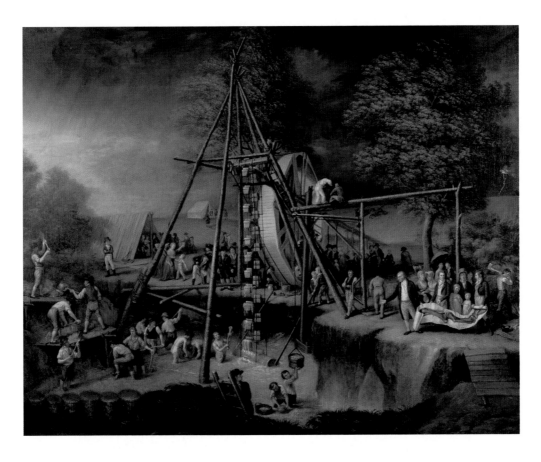

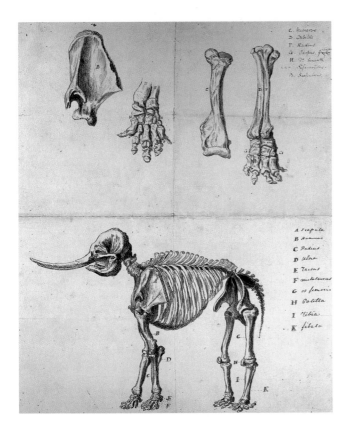

178.

Charles Willson Peale (American, 1741–1827)
The Exhumation of the Mastodon, 1805-08
Signed lower right: *C W Peale 1806*

Oil on canvas
50 x 62 inches (127 x 158.8 cm)
Maryland Historical Society, Baltimore, Maryland

179.

Rembrandt Peale (American, 1778–1860)
Mastodon Skeleton, 1801

Ink on paper
15-1/4 x 12-5/8 inches (38.7 x 32.1 cm)
American Philosophical Society, Philadelphia, Pennsylvania

With the encouragement of Jefferson and funding from the
American Philosophical Society, Charles Willson Peale
mounted an archeological expedition in 1801 near Newburgh,
New York, to dig up the skeleton of an extinct mammoth.
Peale is shown on the right, holding a drawing of a leg bone
and directing the dig while accompanied by members of his
own family. He overcame the difficulties of the swampy site
by designing a mechanical bucket system to draw off the water;
it is the centerpiece of the picture. Rembrandt, the Peale's
elder son, participated in the excavation and reconstruction
of the mastodon skeleton, which he took to England in 1802
and exhibited in London and the provinces. Later, the skeleton
was installed in Charles Willson Peale's Philadelphia Museum,
which was dedicated to representing the exceptional animals,
plants, and persons of America. **P.S.**

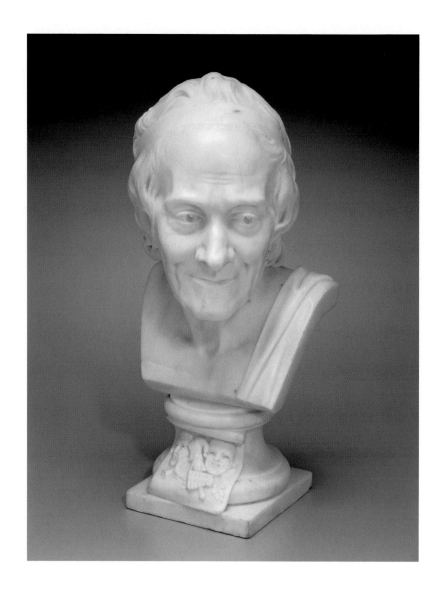

180.

Jean-Antoine Houdon (French, 1741–1828)
Portrait of Voltaire, 1778
Inscribed on center back: *Arouet de Voltaire né à Paris en 1694, et mort en 1778. Houdon f. 1778*

Marble
20-1/4 x 9-1/4 x 9 inches (51.4 x 23.5 x 22.9 cm)
Fine Arts Museums of San Francisco, San Francisco, California. Mr. and Mrs. E. John Magnin Gift (61.31)

One of the men Jefferson considered essential for his "Gallery of Worthies" was the Enlightenment philosopher François Marie Arouet Voltaire (French, 1684-1778), whose writings Jefferson recommended to his nephew. Houdon made several portraits of Voltaire, but there is no record indicating which version Jefferson purchased. This portrait bust shows the same pose and facial expression as Houdon's seated figure of Voltaire. The smile and the mischievous eyes made this perhaps Houdon's most famous portrait. **V.C**

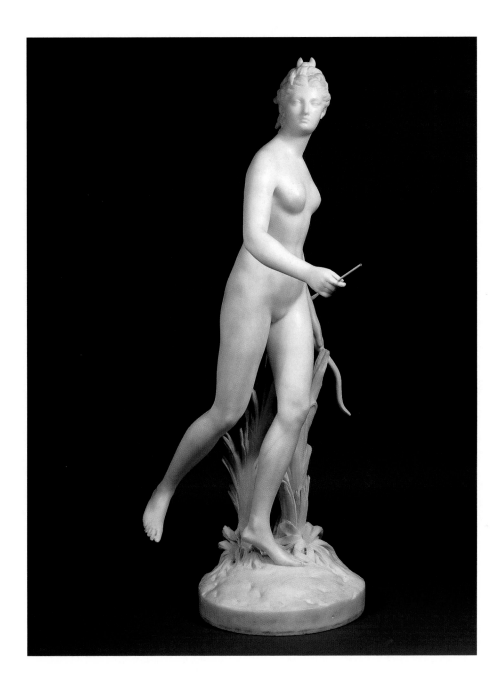

181.

Jean-Antoine Houdon (French, 1741–1828)
Diana Huntress, 1786
Signed on circular base, below right foot: *Houdon F: 1786*

Marble
24-3/8 x 7-7/8 inches (62 x 20 cm)
Dalva Brothers, New York

While in Paris, Thomas Jefferson became an admirer of the sculptor Jean-Antoine Houdon and collected examples of Houdon's portraits of famous men. He also obtained a plaster made after this sculpture, *Diana Huntress.* The goddess of the moon and the hunt is shown nude, lightly balanced on one foot. At the time, there were few European sculptures in the United States and no professional marble sculptors; however, Americans like Robert Livingston, who were interested in the arts, encouraged the new American art academies to import plaster casts of ancient Greek and Roman statues to ensure that their students would acquire the same foundation in classical beauty received by artists at the Academies in Europe. **V.C.**

182.

Benjamin West (American, 1738–1820)
The Fright of Astyanax (Hector Taking Leave of Andromache), 1797
Signed upper left: *From Benjn West Esq./to/Genl Kosciuszko/London June 10th/1797*

Pencil, pen and ink, watercolor and body-color on brown paper
12 x 18 inches (31.5 x 45.4 cm)
The J. Paul Getty Museum, Los Angeles, California

One of the most consequential works of art in Jefferson's collection was Benjamin West's drawing of a scene from the sixth book of *The Iliad* depicting the emotional parting of the warrior Hector from his weeping wife, Andromache, and their young son Astyanax, who is held by his nurse. West, the great Pennsylvania-born painter who trained three generations of American painters, met Thaddeus Kosciuszko in London, and dedicated the picture to him in June 1797. Kosciuszko, the Polish patriot who volunteered his services to General Washington during the American Revolution, gave the picture to Jefferson in 1798. It hung in the parlor at Monticello. **S.S.**

183.

Patrick Gass (American, 1771–1870)
A Journal of the Voyages and Travels of a Corps of Discovery under the Command of Captain Lewis and Captain Clarke, 1807

Book, printed by Zadok Cramer for
David M'Keehan, Pittsburgh
6-3/4 x 4 x 1 inches (17 x 11.4 x 2.5 cm)
Special Collections, Howard-Tilton
Memorial Library, Tulane University,
New Orleans, Louisiana

Thomas Jefferson was the steward of the Lewis and Clark expedition. His long-standing interest in scientific exploration, his desire to find a water route to the Pacific, and his wish to establish trade with Native American peoples, prompted him to send Congress a confidential letter requesting funds to finance the expedition on January 18, 1803. The expedition became all the more essential after the Louisiana Purchase on April 30, 1803. Jefferson chose Meriwether Lewis to lead the expedition, and he in turn asked William Clark to join him. After substantial preparation, they and their party departed from St. Louis in 1804 for the Pacific, returning to St. Louis on September 23, 1806. Following the tradition of travel accounts, such as Denon's *Travels in Upper and Lower Egypt, during the campaigns of General Bonaparte in that country,* an account of the expedition by Patrick Gass, a member of the expedition team, was published in 1807. **S.S./V.C.**

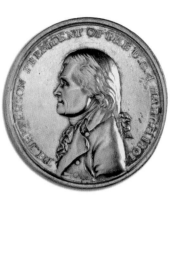

184.

John Reich (American, 1768–1833)
Thomas Jefferson Inaugural Commemorative Medal, 1802

Silver
1-3/4 inches (4.5 cm)
American Numismatic Society, New York

Jean Antoine Houdon's bust of Jefferson from 1789 (**cat. no. 159**) was used as the model for this medal, issued to the public in February 1802. John Reich, a German engraver and recent emigrant to America, was granted this commission almost a year after Jefferson took office. The first medal designed to commemorate the inauguration of a new president, the obverse bears the profile of the new president and on the reverse a female personification of Liberty is accompanied by an eagle and the Declaration of Independence, a celebration of twenty-five years of American independence. **J.S.**

185.

Unidentified Artist, American School
George Washington Peace Medal, 1795

Silver plated copper
4 x 5-3/4 inches (10.36 x 14.76 cm)
National Museum of American History, Smithsonian Institution, Washington, D. C. (14041.0001)

In 1789, following a tradition established by British colonial monarchs, George Washington ordered the creation of peace medals to be presented to Native American tribal leaders to symbolize peaceful relations. The Washington medal was a hand-engraved, silver oval showing the American president with a Native American leader who wears a peace medal on his chest. They smoke a long stemmed pipe, a traditional gesture of peace. At the tribal leader's feet is a tomahawk, an indication that warfare between the two peoples has come to an end. Behind Washington, a farmer tends to his fields, symbolizing prosperity brought about by peace. The obverse shows the seal of the United States established by statute in 1782. **V.C.**

186.

John Reich (American 1768–1833)
Thomas Jefferson Peace Medal, 1801

Bronze
3 x 1/4 inches (7.6 x .6 cm.)
Lent by gracious permission of John Webster Keefe, New Orleans, Louisiana

Like Washington, Thomas Jefferson had peace medals minted with his image. Meriwether Lewis and William Clark carried three sizes of the medal with them on their expedition to present to leaders and warriors who agreed to accept the American governance of the Louisiana Territory. The medal bears Thomas Jefferson's profile on the obverse and clasped hands symbolizing friendship on the reverse. As with his design for Jefferson's inaugural medal, Reich used Houdon's sculpture for his portrait of Jefferson. **V.C.**

The Native Americans and the Louisiana Purchase: Who Paid the Price?

Bill Mercer and Paul Tarver

From the earliest years of the nation, Thomas Jefferson understood that the Louisiana Territory and the indigenous inhabitants of that vast frontier would inevitably become essential to America's future. The territory crossed the Southeast and the Great Plains, two well-developed Native American regions, populated by dozens of tribes. The cultures of the Southeast were ancient and well developed; however, the French, who had claimed those lands, collected little from the Native Americans they encountered. In contrast, the French trappers, who explored the regions of the upper Mississippi and Missouri Rivers in the seventeenth and eighteenth centuries, acquired objects from the Great Plains Indians, a culture that was just beginning to emerge. As a result of this uneven practice of collecting, nothing survives from most of the tribes that inhabited the Louisiana Territory at the time of the Purchase.

Early Interaction in the Southeast

By 1803 the indigenous cultures of the Southeast had undergone dramatic changes resulting from several hundred years of contact with the Spanish and French. In 1539 the Spanish conquistador Hernando de Soto (born 1496 or 1500-1542) landed in present-day Florida. De Soto had become rich exploiting the native cultures of Central and South America, where he played a vital role in the destruction of the mighty Inca empire and gathered a fortune in gold and silver. He came to the unexplored Southeast seeking another empire to plunder, bringing with him an army of approximately six hundred men, an arsenal of weapons and armor, more than two hundred horses, and a herd of pigs and war dogs trained to run down, kill and devour an enemy on command. For the next three years De Soto meandered over thousands of miles of the present-day southeastern United States. While he never found gold and silver, he did find a highly advanced civilization of indigenous agriculturists often referred to as the Mississippian culture or the Southeastern Ceremonial Complex or, more simply, the Mound Builders, a name derived from the hundreds of earth mounds that are today the only visible remains of the culture on the Southeastern landscape.

From their beginnings around 800 A.D., the Mound Builders had expanded across the Southeast from Florida to Texas and from the Gulf Coast to Tennessee. By the time De Soto arrived theirs was ceremonially and artistically the most elaborate cultural tradition north of Mexico. Their society was ruled by regional hereditary chiefs who claimed to be descended from the Sun, a principal deity. Their towns could encompass hundreds of acres of land and were surrounded by defensive palisades. At the center of these communities were a plaza and temple. The chroniclers of the De Soto campaign described the interior of a temple filled with extraordinary art: large and small realistic wooden sculptures, carved chests, shields and a variety of elaborate ritual objects.

De Soto was one of the first and last Europeans to see the society of the Mound Builders in its glory. De Soto's military force was equipped with steel weapons and horses, neither of which had existed in North America. As De Soto and his party brutally pursued golden plunder, the Native Americans resisted, suffering overwhelming casualties. Despite De Soto's ultimate defeat in 1542, the culture of the Southeastern chiefdoms was almost extinct when French explorer and fur trader René Robert Cavelier, Sieur de La Salle (1643–1687) arrived at the mouth of the Mississippi River in 1682.[1]

In the spring of that year, a French expedition led by La Salle left Fort Fronteac on Lake Ontario accompanied by a party of Native Americans who had formed a lucrative fur trading partnership with the French in the Great Lakes area. They canoed down the Mississippi, eventually reaching the mouth of the river in the Gulf of Mexico where La Salle erected a cross claiming the lands on

either side of the river for King Louis XIV (1638-1715) of France, naming it *La Louisiane*. La Salle and the French understood what the English and the Americans eventually appreciated, that control of the Mississippi River meant wealth and power. He returned to France for the supplies needed to establish a colony; however, on the return voyage in 1684 he entered the Gulf of Mexico from the Atlantic—the opposite direction from his previous journey—and was unable to find the Mississippi River. His three ships landed instead near present-day Houston, Texas.[2] It was not until 1718 that Jean Baptiste La Moyne, Sieur de Bienville (1680-1768) succeeded where La Salle had failed, founding the city of La Nouvelle Orléans, New Orleans.

By 1718 the remaining descendants of the Mound Builders in the east formed new coalitions that became the historic tribes we know today as the Cherokees, Creeks, Choctaws, Chitamatchas and many others. There were only a few surviving groups on the western edge of the Mississippian culture area who practiced the ancient traditions of the Mound Builders. Upriver from New Orleans, on the present-day Mississippi–Louisiana border, was the cultural group known as the Natchez, the direct descendants of the Mound Builders and, at the time of De Soto, among the most powerful of the kingdoms along the lower Mississippi River, the southern end of the Louisiana Territory. When the French first built New Orleans, the Natchez lived in smaller, more decentralized communities than their ancestors and were gradually adjusting to a market—rather than a subsistence—based economy. The Natchez became French allies and thrived for a time as middlemen in the early development of the fur trade until they grew frustrated with foreign rule and rebelled. In 1730, with the help of their other Indian allies, the French all but annihilated the Natchez culture. By the time the Americans took control of the Louisiana Territory in 1803, no one remembered the civilization that had constructed the numerous mounds that dotted the Southeast.

Relatively few extant art objects have been ascribed to the Natchez. The two sixteenth-century Natchez pipes (*fig. 1*) in this exhibition are rare examples of proto-historic sculpture in the Mississippi tradition. Each is a carved effigy, one a seated human and the other a panther or large feline, either real or mythical. Like many Native American cultures, the Natchez smoked tobacco as a ceremonial activity, and large pipes such as these would be placed on the ground and attached to a long pipe stem made from a hollow reed. Eventually, tobacco became an important crop, cultivated for sale to European markets.

Further up the Mississippi River valley from the Natchez lands, in what is now Arkansas and Missouri, and westward into Texas and Oklahoma, was the territory of the Caddo, Quapaw and Osage. These cultural groups lived in permanent villages and cultivated crops including corn,

Figure 1: Natchez Peoples, *Effigy Pipe with Human Motif*, proto historic, circa 1500, Limestone, 5 x 3-1/8 x 5-5/8 inches (137 x 77 x 142 cm), Milwaukee Public Museum, Milwaukee, Wisconsin (16208/5390). Catalogue number 187. Natchez Peoples, *Effigy Pipe with Animal (Cougar) Motif*, proto historic, circa 1500, Limestone, 6-1/4 x 3-1/4 x 4 7/8 inches (158 x 85 x 125 cm), Milwaukee Public Museum, Milwaukee, Wisconsin (16209/5390). Catalogue number 188

beans, and squash, in the rich river bottom lands. Their agricultural diet was supplemented by hunting small animals and birds as well as larger game such as deer, bear and buffalo. Each tribe was organized into various clans that commanded the loyalty of individuals.

One of the few early Caddo objects to survive is a small seated human figure from the first half of the nineteenth century (**cat. no. 189**).[3] The figure was carved from a single piece of wood and the surface rubbed with yellow paint. Human hair was added to give it a more naturalistic appearance and, at one time, the figure held a small cloth bundle that may have contained "medicine," sacred materials or charms used in rituals. The original purpose of the piece is uncertain, but it may have been placed in a ceremonial house to function as an object of veneration for a particular clan.

The Quapaw, and their linguistic relatives, the Osage, lived in areas of the Southeast on the edge of the Plains, but were gradually pushed westward, onto the Plains, by European and American expansion. Given their proximity to the French and Spanish posts along the lower and middle Mississippi and its tributaries, they occupied an important position in the early exploration of the interior of North America and the development of the fur trade. As the French built a series of forts and trading settlements up and down the river, they began sending Native American objects across the Atlantic as evidence of the indigenous peoples they encountered. Many of these objects became part of the King's Collection or the Royal Collection of Curiosities at the Château de Versailles.

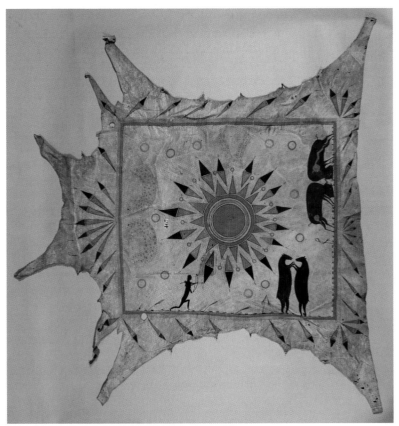

Figure 2: Illinois/Quapaw Peoples, *Painted Robe with Hunt Scene*, Caribou skin, black, red, grey-blue, beige and grey-beige paint, 57 x 55 inches (145 x 141 cm), Musée des Beaux-Arts et d'Archeologie, Besançon, France (853.50.2). Catalogue number 191

The designs found on many robes are too enigmatic to allow a definitive interpretation. On one robe now in Besançon (*fig. 2*), diamond-shaped elements that represent feathers are grouped in a pattern reminiscent of the way feathers hang off a *calumet*, a ritual pipe used by many tribes. A series of paired animals are painted along the outer edge of the framing line. Two bears appear to be the target of a hunter preparing to launch an arrow. Moving counter-clockwise, a pair of buffalo face each other with their heads down, as if rutting. The artist seems to have represented internal organs or spirit lines on each animal. The lines are of different lengths perhaps to indicate that both a male and female are being depicted. The next pair of animals are spotted and represent real or mythical creatures that cannot be identified with any certainty, while the fourth are horses. The design may have a spiritual significance that has been lost over the years.

Collecting of Indian objects by Americans was rare in the eighteenth century. Early objects, particularly those preserved in European collections, provide an indication of the rich artistic tradition that existed prior to the Louisiana Purchase. With the expansion of the United States ever westward and the introduction of the horse, a new Native American culture emerged on the Great Plains.

After the French Revolution the royal collections formed the core of ethnographic collections at public institutions such as the Musée de l'Homme (soon to be moved the new Musée du Quai Branly) in Paris and the Treasury of Chartres Cathedral.[4]

Among the rare pre-1803 objects now residing in French collections are three painted robes recently identified as possibly Quapaw, two from the Musée des Beaux-Arts et d'Archeologie in Besançon and the other from the Musée de l'Histoire Naturelle in Lille.[5] Buffalo robes were traditionally used as outer garments that were wrapped around an individual's shoulders as protection against the elements. The hide was tanned in order to soften it and often the hair was left on. In cold weather the hair side was worn toward the body, while in warmer weather the robe was reversed. Frequently, the hairless side of a robe was painted with designs, which, at times, appear to refer to the wearer's clan or his spiritual relationship to supernatural beings, such as a Thunderbird (**cat. no. 190**). Other robes seem to be autobiographical, commemorating significant events in the life of the robe's owner who would wear it on special occasions to affirm his status and the importance of his deeds (**cat. no. 192**).[6]

Emergence of the Plains Culture

By the time of the Louisiana Purchase, two hundred years of colonization in the eastern half of the continent had been displacing the Native peoples who began moving onto the Great Plains. By the early eighteenth century the horse, introduced to America by the Spanish, began to transform life on the Plains.[7] On horseback, the Plains Indian hunters searching for buffalo traveled much greater distances in far less time. Soon some tribes that originally lived on the edges of the Plains adopted an increasingly nomadic lifestyle, sometimes referred to as the Buffalo or Horse culture.[8] The mounted warriors and nomadic buffalo hunters of the Great Plains, which have become the popular romanticized image of Native Americans, did not exist before this time.

When Thomas Jefferson sent Lewis and Clark to explore the Louisiana Territory in 1803, few Americans had seen the Great Plains. There is, however, extensive archaeological and ethno-historical evidence indicating that the fertile river valleys had long been inhabited by various cultural groups. Some, such as the Wichita, who lived along the Red River; the Oto, Omaha, and Ponca along the middle Missouri; the Pawnee along the Platte; and the

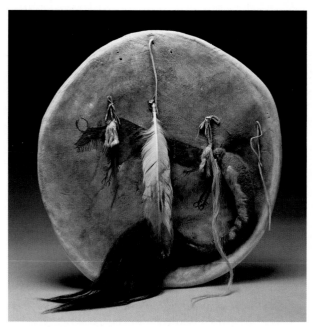

Figure 3: Crow (Absaroke) Peoples, *Shield*, circa 1850, Hide, pigment, wood, feathers, thread, hair, fur, quills, sinew, string, 1-1/2 x 20-1/2 inches (4 x 52 cm), American Museum of Natural History, New York (50/5710 B). Catalogue number 194

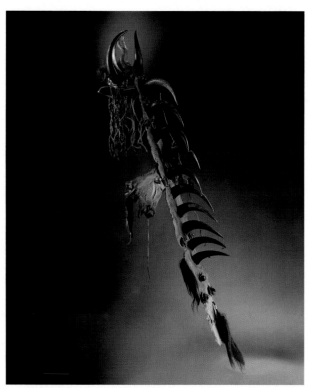

Figure 4: Southern Cheyenne Peoples, *Headdress*, Animal skin, glass beads, buffalo hair, horsehair, buffalo horns, 78 x 29-5/8 x 28-1/2 inches (198 x 75 x 11.5 cm), Department of Anthropology, Smithsonian Institution, Washington, D.C. (11546). Catalogue number 206

Mandan, Hidatsa and Arikara along the upper Missouri, lived in permanent villages, cultivating crops. These tribes supplemented their agricultural practices with seasonal buffalo hunts as the great herds passed near the villages on their annual migration. Other cultural groups living in the Plains region maintained a more nomadic way of life. These tribes, including the Blackfoot, Arapaho, and Gros Ventre, would follow the migrating buffalo herds on foot, and their entire existence depended on a successful hunt. The nomadic tribes would trade excess meat and skins to the village dwellers for their extra agricultural commodities such as corn, beans, and squash.

The social organization of the Plains cultural groups was more egalitarian than hierarchical. The status of each individual, male or female, was determined by their deeds and accomplishments rather than heredity. For men, this meant that skill as a hunter and prowess as a warrior was of primary importance. Plains Indian women attended to the needs of the household. In addition to tending the garden and gathering the wild plant foods that supplemented their diet, women were responsible for butchering the meat obtained through the hunt and drying and processing it for later use. The quality of the objects they made and the intricacy of the decoration was considered a reflection of a woman's virtue, earning prestige within the tribe.

From around 1750 to 1875, the introduction of new materials such as glass beads and cloth, as well as metal implements including awls and sewing needles, which increased productivity, led to tremendous innovation and creativity in designs. Before the introduction of wool and cotton cloth, tanned deerskin was the primary material for garments as well as bags and pouches. Prior to 1800, it was common for women in the eastern Plains and adjacent western Great Lakes regions to dye the leather black with walnut shells (**cat. nos. 197, 198**). Moccasins (**cat. nos. 199, 200**) were among those items of clothing that were typically decorated with porcupine quills sewn onto the soft, pliable leather using a variety of applique stitches and, as they became more available, glass beads (**cat. no. 201**). The first glass beads introduced to Plains Indians were relatively large in size and called *pony beads* because of their association with traders who brought them on the backs of horses. Initially, they were only available in a limited range of colors with white, black, blue, red, green and yellow being the most common (**cat. no. 202**). Although the glass beads never completely supplanted the use of porcupine quills, Plains Indian women did accept them very quickly as they were significantly easier to work with and required less preparation.

The most important item of clothing for a Plains Indian man was the decorated shirt. A man had to earn the right to own such a shirt, which would be worn only on the most important occasions. Shirts symbolized a man's strength as a warrior and his prowess as a hunter

and affirmed a man's status as a leader within the tribe. In this exhibition is an extraordinary Mandan shirt made at the beginning of the nineteenth century, constructed from two tanned elk skins. It is decorated with strips of pony beadwork that extend over each shoulder and along the back of each arm, which is further embellished with heavy leather fringe. On the chest and back are two identical porcupine quilled panels with distinctive geometric designs that would have had symbolic meaning for the owner.[9] The formal outfit would be completed with a pair of leggings (**cat. no. 204**).[10]

The standard item of clothing for Plains Indian women was a dress, either simple and unadorned for daily wear or decorated for special occasions. Dress styles varied from tribe to tribe and changed over time. One of the few extant examples of the side-fold style of dress was originally collected in the early nineteenth century in what is now Minnesota (**cat. no. 205**).[11] One arm is entirely sleeveless and the dress is decorated with horizontal rows of porcupine quills and a row of tin cones at the hem.

While women constructed garments and functional objects for everyday use, men were usually responsible for the decoration of ceremonial objects. Among the Plains Indians, as with the Quapaw, painted buffalo robes were often made to celebrate the important events in a warrior's life (**cat. no. 193**). Another important object in the life of a Plains Indian warrior was the shield. In order to gain spiritual protection and insure success in battle, a young man would seek the aid of supernatural beings through fasting and vision quests in hopes that they would bestow upon him some power to protect him from harm. As a result of his vision, the man might make a shield, adorning it with painted images and offerings emblematic of the spiritual power he possessed, such as a buffalo bull, a symbol of strength frequently found on Crow Indian shields (*fig. 3*). The bull stands stiff-legged with a prominent hump, horns, shaggy hair and a protruding tongue. Partially obscuring the image are other objects symbolizing the warrior's powerful vision including an eagle feather and a buffalo tail.

A large variety of weapons were used throughout North America, including ball-headed clubs that were common in the Woodlands region. Clubs made by tribes such as the Oto and Missouri, Omaha, and Iowa on the eastern edge of the Plains were often elegantly carved from a hardwood, such as ash, with a metal spike set into the ball, as well as figures carved along the handle. In the case of the Omaha club in the exhibition, the ball appears to emerge from the mouth of a small animal, identified as a weasel (**cat. no. 195**).[12] By the mid-nineteenth century, as the use of firearms rendered them obsolete as weapons, ball-headed clubs transcended their use on the battlefield to become symbols of authority and rank.

Headdresses made from a wide variety of materials were part of the ceremonial regalia worn by societies within tribal groups. An impressive headdress, such as the one attributed to the Cheyenne warrior, Tall Bull (died 1869), was an important emblem of a high-ranking official (*fig. 4*). Tall Bull was a leader among the well-known "dog soldiers," the elite warriors of the Plains Indians. He led the Southern Cheyenne, who lived in Kansas and Colorado, against the United States Cavalry and was killed in 1869 at the Battle of Summit Springs. By the 1870s, with the death of leaders like Tall Bull, the United States had all but defeated Native American resistance to western expansion. Unlike the descendants of the Mound Builders, however, the Great Plains Indians and their art, have found a place in the American cultural identity.

Thomas Jefferson: Collecting on the Frontier

For many years before the Louisiana Purchase, Thomas Jefferson had secretly and unsuccessfully tried to send Americans to explore the land west of the Mississippi River. In 1783 he asked Georges Rodgers Clark (1752-1818), hero of the American frontier wars, to scout the area, but Clark lacked time and money. While Jefferson was in Paris he tried to convince John Ledyard (1751-1789) and his partner John Paul Jones (1747-1792), the revolutionary naval hero, to explore the American west by following the northern land route from Europe via Russia and Alaska down to the West Coast.[13] The expedition was stopped short of the goal by suspicious Russian officials.

As secretary of state in 1792, Jefferson received a proposal from André Michaux (1746-1803), the French naturalist, to travel to the sources of the Mississippi River and those rivers that emptied into the Pacific, and report his explorations to the United States government.[14] Jefferson, writing on behalf of the American Philosophical Society in Philadelphia, encouraged Michaux to find the shortest and most convenient route to the Pacific.[15] Unfortunately, Michaux became entangled with a French espionage scheme, which compromised and cut short his expedition. It would not be until 1803 that President Jefferson could successfully engage Captain Meriwether Lewis (1774-1809) and Lieutenant William Clark (1770-1838), younger brother of Georges Rodgers Clark, to chart the new American territory. Although the Lewis and Clark expedition was primarily sent to find a route to the Pacific, exploring natural resources—geological, botanical and animal—Jefferson was particularly interested in Native American tribes. In his instructions to Lewis, Jefferson requested that he observe "their language, traditions, monuments; their ordinary occupations in agriculture, fishing, hunting, war, arts, the implements for these; their food clothing and domestic accommodations."[16]

As early as 1806, Jefferson established what he called his Indian Hall in Monticello to display ethnographic

objects from "tokens of friendship I have received from [the Mandan's] country particularly as well as from other Indian friends."[17] His interest was avid enough to motivate his compilation of an Indian vocabulary that was sadly lost in an accident. For Americans like Jefferson, objects received from their Indian neighbors were tangible records of the New World's indigenous culture and "contributed to the construction of an American Identity."[18] In Jefferson's mind, the Plains Indians would become important trading partners and would eventually become "civilized" citizens of the United States. How this was supposed to succeed in the West when it had failed in the East is not clear. The official view of the Indian position within American society would be spelled out in 1830 when President Andrew Jackson persuaded Congress to pass the Indian Removal Act. Promoted as a bill to protect the Indians, in fact, it permitted the removal of the southeastern tribes from their ancestral lands. Their new home was referred to as "Indian Territory," located in present-day Oklahoma, part of the Louisiana Purchase land. The material culture of the native inhabitants of the Louisiana Territory in 1803 has—for the most part—been lost or buried. While the Mound Builders of the Southeast had endured for one thousand years before their collapse in the early eighteenth century, their culture is virtually unknown to the world today. Their history has been eclipsed by the epic struggle between the United States and the Plains Indians that began with the Louisiana Purchase.

Notes:

1. De Soto was buried in the Mississippi River, a stream of water he has been credited with discovering.
2. After two more years of blunders, including bad relations with the indigenous population, La Salle was murdered by his own party in 1687.
3. John C. Ewers, *Plains Indian Sculpture* (Washington, D.C.: Smithsonian Institution Press, 1986), 44.
4. Many of the Native American collections seized during the Revolution were eventually brought together at the Musée de l'Homme, which opened in 1937. Presently a new state-of-the-art facility, the Musée de Quai Branly, is under construction near the Eiffel Tower and will be the new home for the wealth of ethnographic art at the Musée du l'Homme and other French institutions. It was these collections the New Orleans Museum of Art originally targeted for the exhibition, however, at this time there is a moratorium on all loans while the collections are inventoried, conserved, and prepared for the move. With the help of the administration of the Musée du Quai Branly, we were able to borrow five important eighteenth-century pieces from museums outside of Paris. None of these pieces have been exhibited in America.
5. For information on similar robes that aided in the identification of the three exhibited in New Orleans see George P. Horse Capture et al., *Robes of Splendor* (New York: New Press, 1993).
6. This robe, like the previous two examples, is also stylistically similar to several robes in the Musée de l'Homme collection. For comparison see Horse Capture, 131, 134-35.
7. For a thorough study of this development see John C. Ewers, "The Horse in Blackfoot Indian Culture," *Bureau of American Ethnology Bulletin* 159 (1955).
8. One example of this is the Teton Sioux who left their homeland in Minnesota and migrated westward to the Black Hills after they acquired an ample supply of horses.
9. Colin F. Taylor, *Buckskin and Buffalo* (New York: Rizzoli, 1998), 55.
10. Although this pair of leggings was collected from the Teton Sioux in 1855, the style is characteristic of leggings that date to the early decades of the nineteenth century. On leggings see James A. Hanson, *Little Chief's Gathering* (Crawford, Nebraska: The Fur Press, 1996).
11. This date was established by Norman Feder, *Art of the Eastern Plains Indians: The Nathan Sturges Jarvis Collection* (New York: The Brooklyn Museum, 1964).
12. Ewers, 1986, 136-37.
13. Ledyard and Jones were interested in the fur trade, so Jefferson, who wanted to explore the West, helped finance their scheme to get to the Pacific via Russia, over to Alaska, and down the coast. Ledyard actually traversed Siberia, but suspicious Russian officials, probably considering him a spy, turned him away from his goal.
14. Michaux had arrived in New Jersey, in 1786, where he was charged with finding trees that could be transplanted and be useful to France.
15. Kastner, *Species of Eternity*, 113-42.
16. Kastner, 53.
17. Joyce Henri Robinson, "An American Cabinet of Curiosities Thomas Jefferson's Indian Hall at Monticello," *Winterthur Portfolio* 30 (Spring 1995): 43.
18. Ibid., 46.

187.

Natchez Peoples
Effigy Pipe with Human Motif, proto historic, circa 1500

Limestone
5 x 3-1/8 x 5-5/8 inches (137 x 77 x 142 cm)
Milwaukee Public Museum, Milwaukee, Wisconsin (16208/5390)

188.

Natchez Peoples
Effigy Pipe with Animal (Cougar) Motif, proto historic, circa 1500

Limestone
6-1/4 x 3-1/4 x 4-7/8 inches (158 x 85 x 125 cm)
Milwaukee Public Museum, Milwaukee, Wisconsin (16209/5390)

These ornately carved limestone effigy pipes are believed to date from the proto-historic period of the Natchez civilization around the time of European contact. They were excavated from a Natchez site on the Louisiana–Mississippi border. One pipe has been carved into the form of a seated human while the other may represent a cougar or other type of large feline, either real or mythical. Smoking was often a ceremonial activity throughout much of Native North America, and the large size of these pipes, along with their flat bottoms, indicate that they were probably placed on the ground. The smoke was then drawn through a long pipe stem made from a hollow reed. **B.M./P.T.**

189.

Possibly Caddo Peoples
Human Figure, circa 1800

Wood and pigment
3-5/8 x 2-1/2 x 7 inches (9 x 6 x 17.5 cm)
Department of Anthropology, Smithsonian Institution,
Washington, D.C. (387,577)

This early nineteenth-century seated human figure has been identified with the Caddo culture. After the figure was carved, the surface was rubbed with yellow paint. Human hair was added to give it a more naturalistic appearance. The figure originally held a small cloth bundle that may have contained "medicine" and may have been placed in a ceremonial house to function as an object of veneration for a particular clan. **B.M./P.T.**

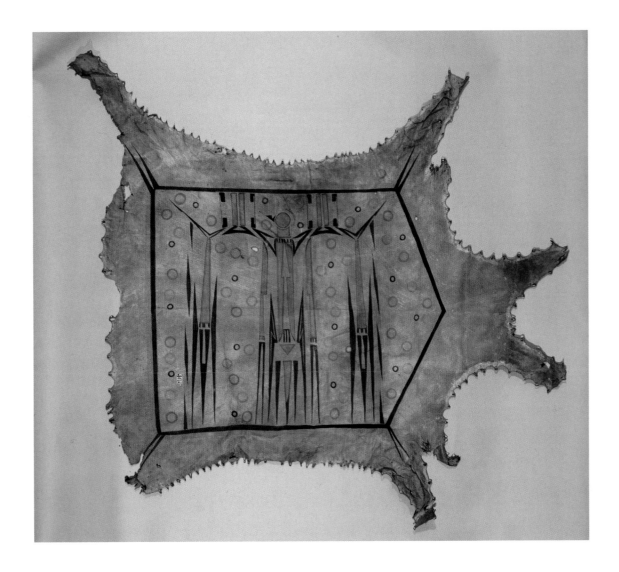

190.

Illinois/Quapaw Peoples
Painted Robe with Thunderbird

Caribou skin, black, red, ochre-yellow, beige,
grey-beige and grey-blue paint
55 x 62 inches (157 x 140 cm)
Musée des Beaux-Arts et d'Archeologie,
Besançon, France (853.50.1)

Rare Native American objects, such as painted robes (**cat. nos. 190–192**) and moccasins (**cat. nos. 199, 200**) collected by eighteenth-century French explorers were preserved in French collections. At a time when writers such as Chateaubriand and Rousseau promoted romantic notions of an ideal Native American culture, these objects fueled French fascination with the New World's indigenous peoples. The central image on this robe is an abstract Thunderbird, head turned in profile and wings outstretched. Numerous black, red, and blue circles surround the Thunderbird emphasizing its celestial nature. The Thunderbird on this robe might have been a reference to the wearer's clan or his spiritual relationship to that supernatural being. **B.M./P.T.**

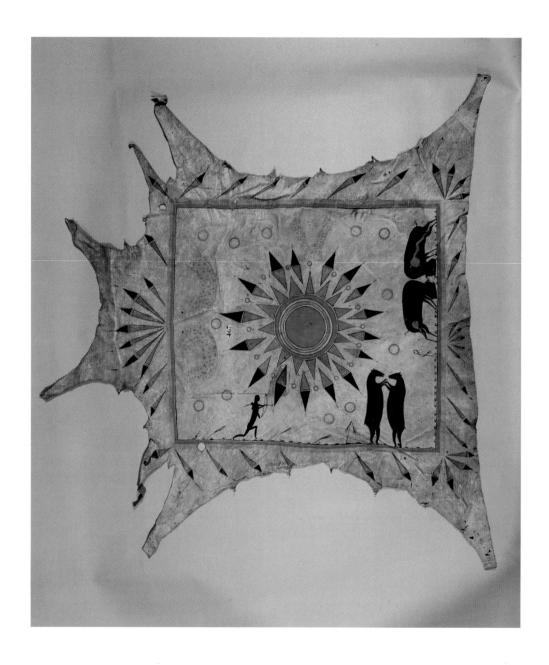

191.

Illinois/Quapaw Peoples
Painted Robe with Hunt Scene

Caribou skin, black, red, grey-blue, beige
and grey-beige paint
57 x 55 inches (145 x 141 cm)
Musée des Beaux-Arts et d'Archeologie,
Besançon, France (853.50.2)

The artist who painted the enigmatic designs on this robe is thought to be from
the Quapaw or a neighboring tribe. The design field is defined by a rectangular
border that also serves as a groundline for several pairs of animals. The significance
of the animals is impossible to decipher and may have been ritualistic in nature.
B.M./P.T.

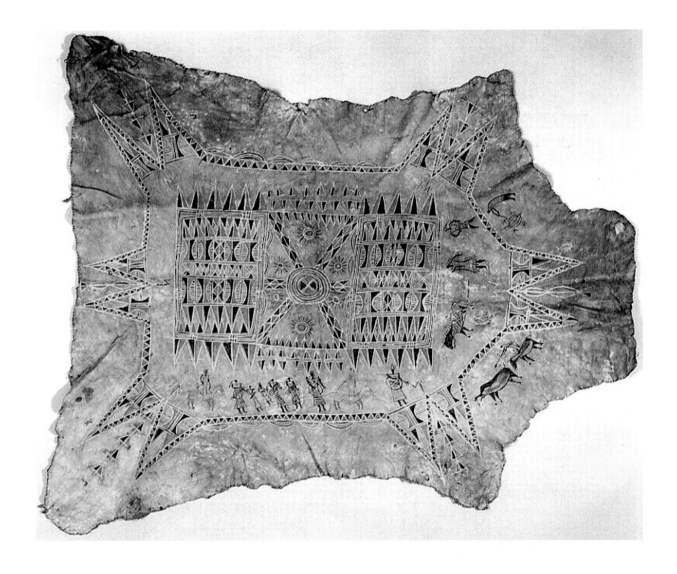

192.

Illinois/Quapaw Peoples
*Painted Robe with Scene of a Hunt with
Geometric Patterns*, 18th–19th century

Animal skin, black, red, white paint
54 x 39-1/2 inches (137 x 100 cm)
Musée de l'Histoire Naturelle, Lille, France
(990.2.3292)

The most striking aspect of this robe is a processional scene located along the bottom edge, which includes seven figures on foot and two on horseback. Some of the figures wear headdresses and long tunics while all appear to be carrying shields and quivers filled with arrows. There are also three additional scenes located along the edges of this robe: a horse followed by two figures on foot and two hunting scenes. In the first hunting scene a mounted figure shoots a rifle at a buffalo bull. In the second scene an individual spears a creature with a round body, which appears to be a large turtle. It is possible that the composition depicts significant events in the life of the robe's owner who would wear it on special occasions to affirm his status and the importance of his deeds. **B.M./P.T.**

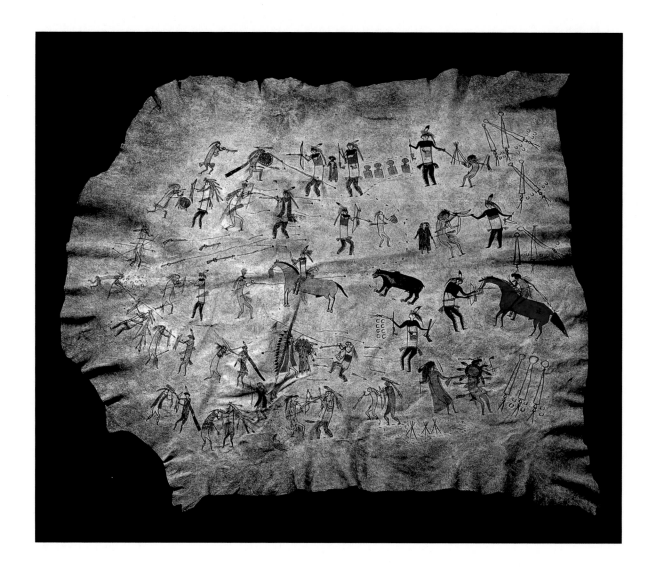

193.

Northern Plains/Upper Missouri Peoples
Painted Skin Robe, circa 1835

Animal skin, pigment
77 x 69 inches (196 x 173 cm)
Department of Anthropology, Smithsonian
Institution, Washington, D.C. (2130)

This robe appears to have been painted to celebrate key events in the life of a warrior, probably the owner of the robe. There are five horizontal rows meant to be read from right to left, the convention for Plains Indian painting. The warrior is shown several times wearing a black and red shirt, black fringed leggings and a red roach headdress adorned with a single eagle feather. At times he is shown carrying a pipe, symbolizing that he was the leader of a raiding party. While in other scenes the warrior engages in combat. **B.M./P.T.**

194.

Crow (Absaroke) Peoples
Shield, circa 1850

Hide, pigment, wood, feathers, thread, hair, fur,
quills, sinew, string
1-1/2 x 20-1/2 inches (4 x 52 cm)
American Museum of Natural History, New York
(50/5710 B)

Shields were extremely important, symbolic objects
to Plains Indian warriors. Used for ceremonial pur-
poses rather than as a weapon, shields were often
decorated with animals and amulets, which symbolized
visions sent to the warrior by supernatural beings.
B.M./P.T.

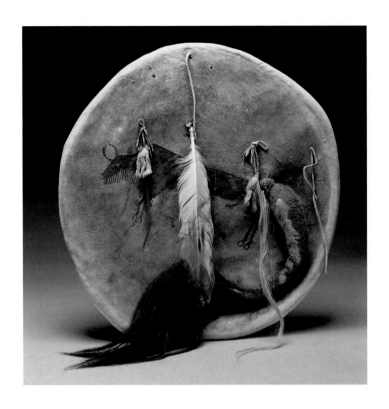

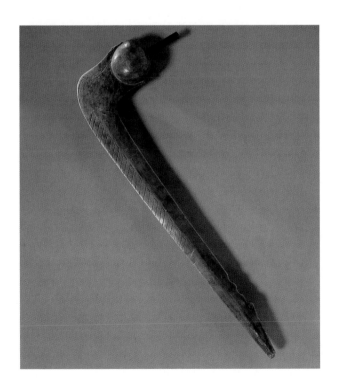

195.

Omaha Peoples
Club, before 1841

Wood, metal
21-1/4 x 8 x 2 inches (53.8 x 20 x 4.8 cm)
Department of Anthropology, Smithsonian Institution,
Washington, D.C. (2649)

The ball-headed club was a common weapon used by the Plains
tribes. The top of the club is carved to resemble a weasel, a
small animal admired for its aggressive nature and fearlessness
in attacking larger animals. Weasels were commonly depicted on
clubs, shields and in medicine bundles. By the mid-nineteenth
century, as the use of firearms rendered them obsolete, ball-
headed clubs transcended their use on the battlefield to become
symbols of authority and rank. **B.M./P.T.**

196.

Sante Sioux Peoples
Pipe Bowl with Two Figures, before 1841

Catlinite, lead inlay
8 x 1-1/4 x 3-3/4 inches (20 x 3 x 9.5 cm)
Department of Anthropology, Smithsonian Institution,
Washington, D.C. (2622)

This catlinite pipe bowl is an outstanding example of Plains Indian sculpture. The delicately carved figures sit facing each other across a table. The scale of the larger man and the peace medal around his neck indicate that he is a chief. He extends a bottle toward the other man who grasps the legs of the table ready to receive a drink. Alcohol was a common trade item during the early fur trade, distributed by the chiefs to their followers making this a common, everyday scene. **B.M./P.T.**

197.

Eastern Sioux or Western Great Lakes Peoples
Knife Case, early 19th century

Black dyed buckskin pouch with fine quillwork
11 x 2-1/2 inches (27.8 x 6 cm)
Department of Anthropology, Smithsonian Institution,
Washington, D.C. (5420)

198.

Eastern Sioux or Western Great Lakes Peoples
Quilled pouch, early 19th century

Black dyed buckskin pouch decorated
with fine quillwork
10-1/4 x 7-1/4 inches (25.8 x 18.1 cm)
Department of Anthropology, Smithsonian
Institution, Washington, D.C. (5425)

Plains Indian women were responsible for making clothing and the necessary accessories that their family required, including knife cases and pouches. Until the first quarter of the nineteenth century, it was common for women to dye the leather black with walnut shells. Porcupine quills were then sewn onto the soft, pliable leather using a variety of applique stitches. **B.M./P.T.**

199.

Huron Peoples
Pair of Moccasins, 18th century

Leather, beads and quills
11 x 4 x 3-1/2 inches (27.5 x 10 x 8.5 cm)
Musée de l'Histoire Naturelle, Lille, France (990.2.3224)

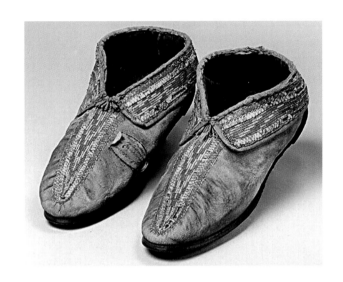

200.

Huron Peoples
Pair of Moccasins, 18th century

Skin, beads and quills
11 x 4 x 3-1/2 inches (27.5 x 10 x 8.5 cm)
Musée de l'Histoire Naturelle, Lille, France (990.2.3225)

Moccasins were among those items of clothing that were typi-
cally decorated with porcupine quills and glass beads as they
became more readily available. These eighteenth-century moc-
casins, perhaps acquired by a French explorer, were made from
one piece of leather. At times, soles and fabric linings were
added to make them more practical for wear in the towns of
the growing frontier. **B.M./P.T.**

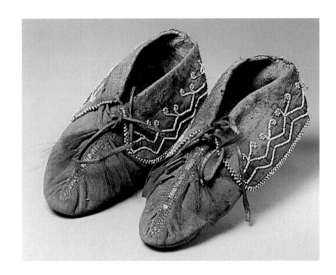

201.

Sioux Peoples
Pair of Moccasins, 1830-50

Leather, glass beads
11 x 4 x 3-1/2 inches (27.8 x 10 x 8.7 cm)
Department of Anthropology, Smithsonian Institution,
Washington, D.C. (178890)

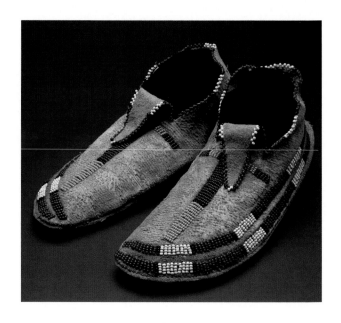

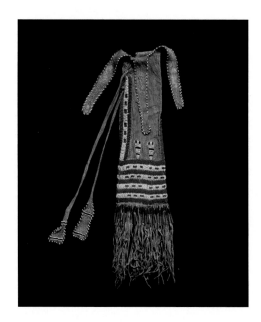

202.

Possibly Arapaho or Cheyenne Peoples
Tobacco Bag, 1830-50

Leather, glass beads
32-1/2 x 8 inches (82.5 x 20 cm)
Department of Anthropology, Smithsonian Institution,
Washington, D.C. (8353)

The first glass beads introduced to Plains Indians were a relatively large size.
They were called *pony beads* because of their association with traders who
brought them on the backs of horses. Initially, they were only available in a
limited range of colors with white, black, blue, red, green and yellow being
the most common. Although the glass beads never completely supplanted the
use of porcupine quills, Plains Indian women did accept them very quickly as
they were significantly easier to work with and required less preparation.
B.M./P.T.

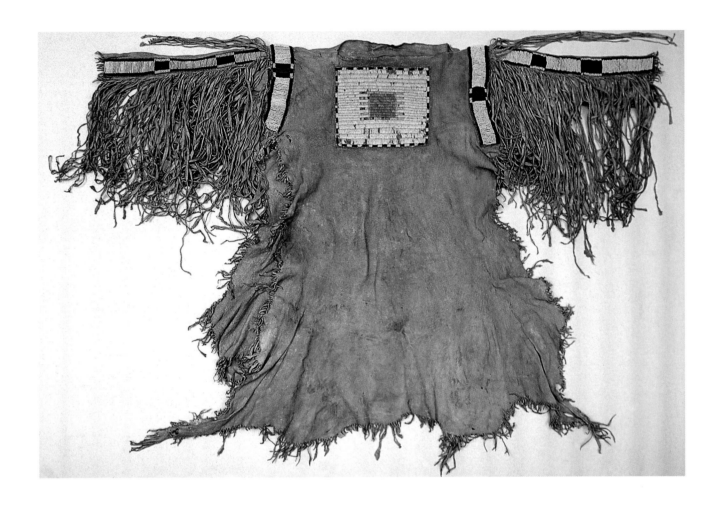

203.

Mandan Peoples
Shirt, circa 1830

Leather, quills and glass beads
43 x 61 inches (109 x 155 cm)
Department of Anthropology, Smithsonian Institution,
Washington, D.C. (630)

Decorated shirts, which symbolized a man's strength as a warrior and
prowess as a hunter, were the most significant item of clothing for
Plains Indian men, worn on only the most important occasions. Their
decorative designs had symbolic meaning for the owner. **B.M./P.T.**

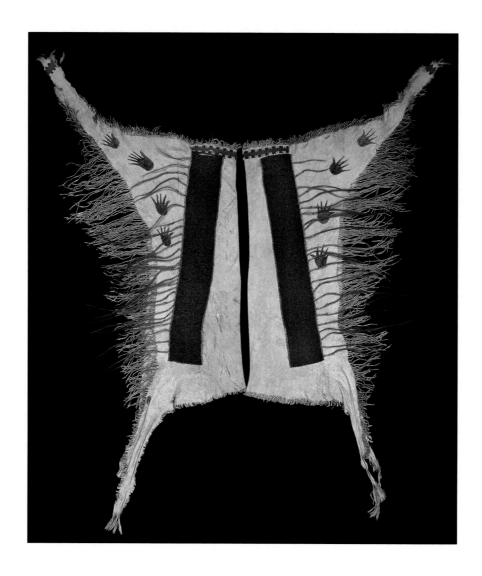

204.

Teton Sioux Peoples
Leggings, circa 1850

Leather, pigment, glass beads, horsehair
43 x 31 inches (109 x 79 cm)
Department of Anthropology, Smithsonian Institution,
Washington, D.C. (1953)

This pair of leggings, although collected from the Teton Sioux in 1855, are characteristic of the style in fashion at the beginning of the nineteenth century. They are made from two deerskins that have been folded and sewn up the outside edge to form a sleeve. The skins were carefully trimmed so that the original contour remained. Each legging is decorated with a strip of blue *pony beads* and further embellished with locks of yellow dyed horsehair and painted hand-prints. **B.M./P.T.**

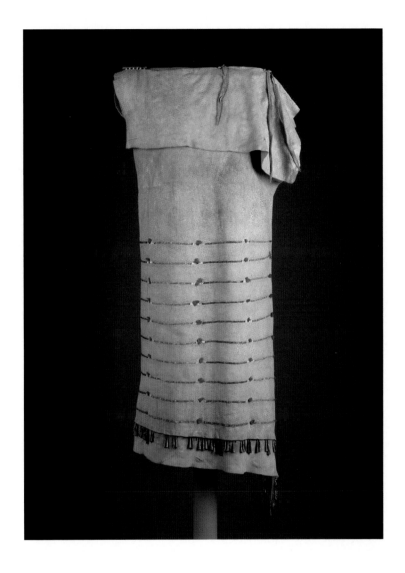

205.

Sioux/Yankton Peoples
Side-Fold Dress, circa 1820

Buffalo hide, dyed bird and porcupine quills,
copper, tinned iron and copper cones, pony
glass beads, yarn pigment, sinew, thong
50 x 16 inches (127 x 40.6 cm)
Brooklyn Museum of Art, Brooklyn, New York,
Henry L. Batterman Fund and the
Frank Sherman Benson Fund (50.67.6)

Side-fold dresses are considered an archaic form once common throughout the
Plains region but quite rare by the early nineteenth century. Only a few examples
remain. This dress was originally collected in the early nineteenth century in
what is now Minnesota. It is constructed so that one arm was entirely sleeveless
and sewn with a seam up one side. It is decorated with horizontal rows of porcupine
quills and a row of tin cones at the hem. **B.M./P.T.**

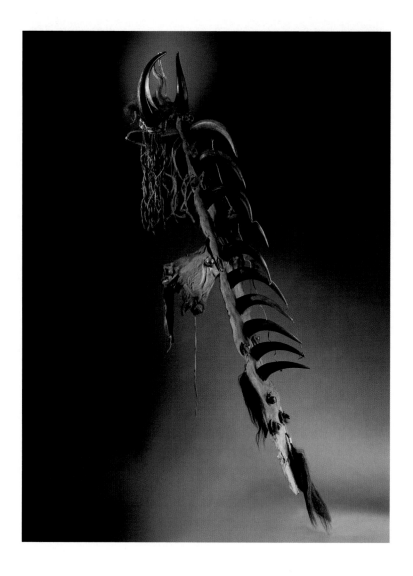

206.

Southern Cheyenne Peoples
Headdress

Animal skin, glass beads, buffalo hair, horsehair, buffalo horns
78 x 29-5/8 x 28-1/2 inches (198 x 75 x 11.5 cm)
Department of Anthropology, Smithsonian Institution, Washington, D.C. (11546)

This impressive headdress belonged to a high-ranking Cheyenne official named Tall Bull, a warrior who died fighting the United States cavalry. The cap is made of buffalo hide with hair still attached. There is an unusual visor and beaded brown band to shield the wearer's eyes, and remnants of the ermine skins that hung from each side remain. The buffalo horns that top the headdress have been carved out while the trailer is decorated with rows of horns. The weight of this headdress was supported by leg skins that tied to his waist. A headdress with such elaborate decorations would have been worn in ceremonies signifying the importance of the warrior. **B.M./P.T.**

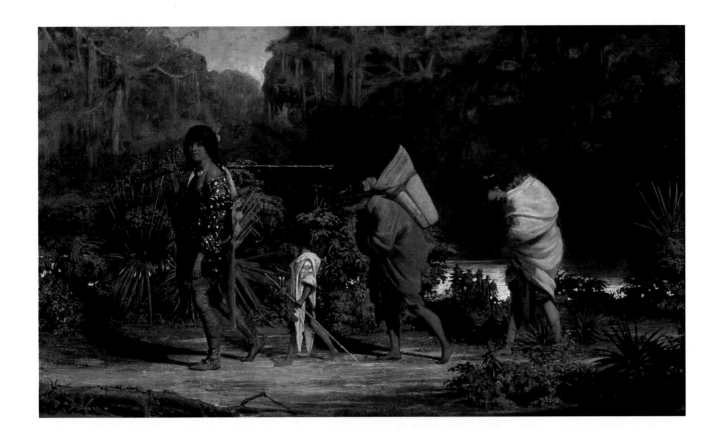

207.

Alfred Boisseau (American, born in France, 1823–1901)
Louisiana Indians Walking Along the Bayou, 1847

Oil on canvas
24 x 20 inches (61 x 101.6 cm)
New Orleans Museum of Art, New Orleans, Louisiana.
Gift of William E. Groves (56.34)

The Parisian painter Alfred Boisseau studied at the prestigious École des Beaux-Arts, as well as in the studio of Paul Delaroche, himself a student of Baron Gros (**cat. nos. 74, 79**). He arrived in New Orleans in 1845, staying for two years. This painting was exhibited at the 1847 Salon in Paris. Congress had enacted the American Indian Removal Act in 1830 with the intention of moving the Southeastern Indians west of the Mississippi River to present-day Oklahoma. The displacement from their ancient homelands is often referred to as the Trail of Tears, and it has been suggested that this painting represents a family of Choctaws marching west. Several groups of Choctaw Indians did begin their journey shortly after 1830 although brutal weather and cholera epidemics decimated them. Many of those who remained refused to move and it was not until 1845 that they began to leave. Small groups remained in Mississippi and Louisiana and Choctaw traders were often seen in the markets of New Orleans where they sold filé, a Native American seasoning used in gumbo, as well as baskets and other goods. It is not known if Boisseau intentionally tried to capture a dramatic march into exile, or if these were subjects he had seen in the old French market in New Orleans. Boisseau's depiction of the clothing, hair styles, jewelry, long rifle and blow gun the boy carries is a rare record of southeastern native culture in its twilight years. The similarity in the marching figures of this painting and Storelli's copy of the Duc de Montpensier's painting of a Cherokee village in southeastern Tennessee, made in 1805 (**cat no. 23**), became obvious during the organization of this exhibition. This raises many questions, which are, for the time being, unanswerable. **P.T.**

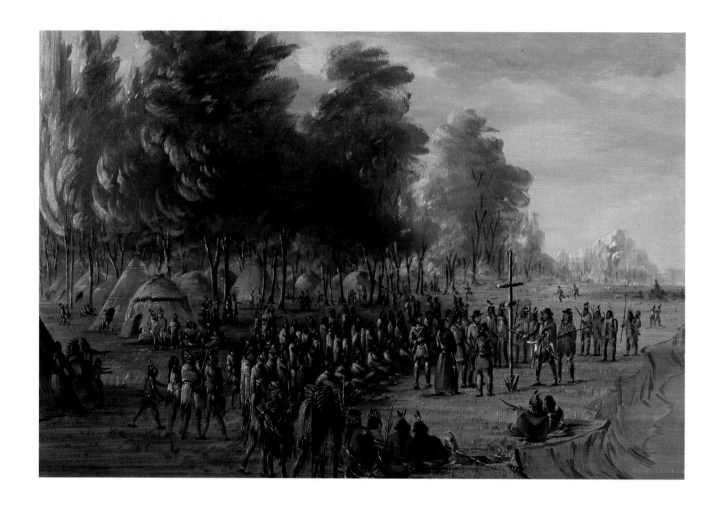

208.

George Catlin (American, 1796-1872)
La Salle Erecting a Cross and Taking Possession of the Land. March 25, 1682, 1847-48

Oil on canvas
14-3/4 x 22-3/8 inches (37.4 x 56.7 cm)
National Gallery of Art, Washington, D.C.
Paul Mellon Collection (1965.335)
Photograph ©2002 Board of Trustees,
National Gallery of Art, Washington

In 1839, George Catlin moved his family to Europe taking with him hundreds of paintings of Plains life and an extensive collection of Native American art. His exhibition and lecture series was popular with audiences in England and France who were drawn to the exoticism of the indigenous American culture. In 1847, after viewing his exhibition in Paris, King Louis-Philippe commissioned a series of history paintings from Catlin illustrating the adventures of René Robert Cavelier, Sieur de La Salle. In the spring of 1682, La Salle and his party paddled canoes down the Mississippi River. When they reached the mouth and disembarked, they erected a cross and claimed all the territory on either side of the river for France. In honor of Louis XIV, he named it *La Louisiane*. Indians from the Great Lakes region accompanied La Salle on his voyage, and the clothing and headdresses of the Native Americans pictured by Catlin are typical of tribes at the northern end of the river, as are the dwellings. It is interesting to contemplate their reactions to this ceremony and the foreigner who has just taken possession of the land, an unthinkable concept in Native American cultures. **P.T.**

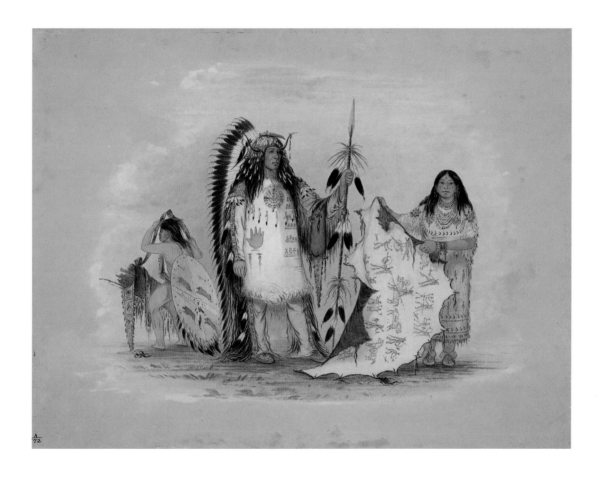

209.

George Catlin (American, 1796-1872)
Mandan War Chief with his Favorite Wife, 1861-69

Oil on card mounted on paperboard
18-1/4 x 24-5/16 inches (46.4 x 61.7 cm)
National Gallery of Art, Washington, D.C.
Paul Mellon Collection (1965.16.72)
Photograph ©2002 Board of Trustees, National
Gallery of Art, Washington

In 1831, George Catlin traveled by steamboat to Fort Union in present-day North Dakota to observe and record Native Americans on the frontier, making sketches for the paintings he made throughout his career. He spent a month visiting the Mandan, one of the agricultural tribes that had settled on the Plains long before the arrival of the horse. Six years after his visit a smallpox epidemic ravaged their villages and the Mandan teetered on the brink of extinction. Catlin's notebooks, paintings and numerous sketchbooks constitute the most detailed description of Mandan culture. This painting details the clothing as well as many daily objects that he observed during his time there. **P.T.**

ARRETÉ

POUR L'ÉTABLISSEMENT DE l'AUTORITÉ MUNICIPALE
A LA NOUVELLE-ORLÉANS.

LAUSSAT,
PRÉFET COLONIAL,
COMMISSAIRE DU GOUVERNEMENT FRANÇAIS;

Considérant que la remise de la Louisiane à la République Française par les Commissaires de S. M. C. entraîne la dissolution des Autorités qui y tenaient immédiatement leur caractère de sa Couronne Royale & dont les attributions & le mode de les exercer étaient essentiellement propres aux institutions de la monarchie Espagnole, & que le CABILDO de cette ville est notamment dans ce cas;

Attendu qu'il importe essentiellement que l'action journalière des Pouvoirs qui maintiennent la police & l'ordre social ne demeurent pas un instant suspendue dans ces changemens de domination;

ARRÊTE:

ART. I. Il est établi à la Nouvelle-Orléans un Corps municipal composé d'un MAIRE, d'un Conseil de douze Membres & d'un Secrétaire Greffier.

II. Demeurent nommés à ces diverses places, savoir:

MM. Boré, MAIRE.

Derbigny, Secrétaire-Greffier.

CONSEIL MUNICIPAL.

MM.

Destrehan, qui fera provisoirement fonctions de premier adjoint du MAIRE.

Sauvée, qui fera provisoirement fonctions de 2me. adjoint du MAIRE.

Livaudais, père;

Petit-Cavelier;

Villeray;

Johns, père;

Fortier, père;

Donaldson;

Faurie;

Allard, fils;

Tureaud;

Jean Watkins;

Et M. Labatut, Trésorier de la ville.

III. Tous lesdits Citoyens entreront en fonctions sur le champ.

Donné à la Nouvelle-Orléans, le 8 Frimaire an XII de la République Française, & 30 Novembre 1803.

Laussat

Par le Préfet Colonial, Commissaire du Gouvernement Français,

Le Secrétaire de la Commission

Daugerol

New Orleans– Site of the Transfer– Prize of the Purchase

Jessie Poesch

On December 26, 1803, Thomas Jefferson, writing from Washington to his daughter Mary mentioned that a "great rain" had prevented the arrival of mail from Natchez, but "On New year's day however we shall hear of the delivery of New Orleans to us."[1] He knew that the United States would have taken formal possession of the Louisiana Territory on December 20, 1803, in New Orleans, yet in this casual reference in a personal letter it was the "delivery of New Orleans" that was the salient accomplishment of the months' long negotiations with Napoleon. In these negotiations, the immediate goal had been for the acquisition of New Orleans because, as he wrote to Robert Livingston, the United States minister to France, on April 18, 1802, it was "New Orleans, through which the produce of three-eighths of our territory must pass to market, and from its fertility it will ere long yield more than half of our whole produce, and contain more than half our inhabitants."[2] Initially, the focus was on the acquisition of New Orleans and the Floridas. Napoleon's extraordinary offer, on April 12, 1803, was for the acquisition of New Orleans and the great tract of land to the west. The Purchase may have been the largest land sale in American history, but, at the time, it was the port and city of New Orleans that was most coveted and prized by the Americans. The acquisition of the port would make commerce from the interior "western" lands to the eastern cities of Philadelphia, Baltimore and New York, both swifter and less expensive.[3]

Jefferson, of course, was equally mindful of the value of the still unknown western territories. He, and many Americans, had foreseen that the American people would steadily push westward and eventually settle the lands beyond the Mississippi. He acutely felt the need to know more about these lands, their potential for commerce, the rivers, the land, the indigenous peoples. In a bold move, even before the negotiations with France were completed, Jefferson and the Congress had authorized the Lewis and Clark expedition. In September 1803, they were on their way.[4]

Jefferson, and other Americans, wanted to know more about New Orleans. A large painting of New Orleans and a remarkable map of the town, both done 1803 to 1804, are informative. The painting shows the harbor and part of the town (**cat. no. 210**). The map places New Orleans in the context of the immediate environs and its relation to the Mississippi valley (**cat. no. 211**). Both were by the little-known artist who signed himself as Boqueta de Woiseri. The artist created prints similar to the painting. Jefferson owned one of these.[5]

The view of New Orleans was taken from the plantation of Pierre Philippe Bernard Xavier de Marigny de Mandeville (1750-1800), present-day Faubourg Marigny, down river from Esplanade Avenue (the plantation was divided into lots in 1808). Marigny probably had been the wealthiest citizen of New Orleans, having made a fortune in land, lumber and construction. The mansion was remembered as being a typical French colonial style structure, with a gallery supported by brick pillars, but the size of two ordinary homes. At this "primitive sort of palace," Marigny entertained the Duc d'Orleans (later King Louis-Philippe) and his brothers, the Duc de Montpensier and the Comte de Beaujolais, during their tour of America in 1798, and generously lent them money. In 1803, Pierre Philippe's son Bernard de Marigny, then only eighteen years old, entertained the French colonial prefect, Pierre Clément Laussat, there.[6]

On his arrival in New Orleans in March 1803, Laussat counted 120 ships, "French, Spanish and mostly Anglo-American—spread out like a floating forest and formed a prospect worthy of the busiest regions on the earth."[7] Laussat came expecting to serve as commissioner of the French government for the retrocession of Louisiana from Spain to France. Due to diplomatic machinations, this did not take place until November.

The Anglo-Americans, fierce commercial rivals of the French and Spanish, increasingly dominated commerce in the Mississippi valley by the time of the Purchase. Not only were their ships in the harbor, but Anglo-Americans

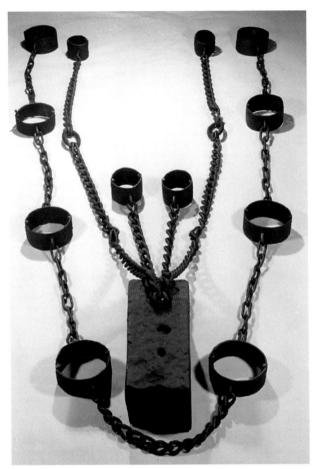

Figure 1: Slave Restraints, circa 1740-80, Iron, neck collars, 156 inches (396.24 cm), Iron block with shackles, 66 inches (167.64 cm), Davis Gallery of African Art, New Orleans, Louisiana

were increasingly present in the city, attracted by what was something of a small international trading entrepôt. The backgrounds of the citizens reflected this internationalism, so did the terms they used for money. French, Spanish, American and English currency values were cited in accounts, documents, and travel journals, while the coinage was largely Spanish-American (**cat. no. 223**). By mid-eighteenth century, the Spanish-American silver coin, the piece of eight, also known as the Mexican dollar, had come into usage in the seaboard colonies as the unofficial currency, as opposed to the official pounds/shillings English system. At the time of the Purchase, most of the coinage in circulation in New Orleans would have been minted somewhere in Spanish-America. With the establishment of the United States, a national coinage was desired. Thomas Jefferson urged the adoption of a rational decimal system, based more or less on the piece of eight. The Mint Act of 1792 established the dollar/ decimal system. (The word dollar derives from the thaler, a Middle-European coin.) A number of theories exist as to the origin of the dollar sign but all seem to suggest

that it came into use in the Spanish regions of America, including New Orleans.[8]

Only a relatively few portraits of eighteenth- and early nineteenth-century citizens of New Orleans survive. Jose Francisco Xavier de Salazar y Mendoza (mid-1700s–1802) is the only known portrait painter in Spanish colonial Louisiana. Born in Merida, Yucatan, Mexico, he came to New Orleans in 1782 with his family, already trained as an artist. (His daughter is known to have made a copy of one of his portraits.) Portraits by him show the prominent— the Catholic bishop (**cat. no. 226**); Almonester, the wealthy patron of the city; a doctor and his family; a surveyor and his wife (**cat. nos. 217a** and **217b**); military men; daughters of the wealthy—all members of the hierarchical and ceremonial society dominant under the Spanish regime.[9] A painting by an unknown artist of the important planter Étienne de Boré also survives (**cat. no. 216**).

The estimates of the population of New Orleans at the time of the Purchase vary from around eight thousand to twelve thousand. Around half of these, at least four thousand, were blacks, including both slaves and free

Figure 2: Benjamin Henry Latrobe (American, 1764-1820), *Sketches of instruments made in New Orleans: two drums, a stringed instrument, an instrument with stick, a square drum and a rattle*, Latrobe Diary, 21 February 1819, Ink on paper, Maryland Historical Society, Baltimore, Maryland

people of color. Recent demographic research has shown that before 1804 the majority of slaves in Louisiana were African-born or descendants of Africans. Gwendolyn Midlo Hall has concluded that "Louisiana colonial officials, both French and Spanish, sought repeatedly to protect the fragile social order by outlawing the importation of slaves born or socialized in the Caribbean, especially the French Caribbean."[10] In the Spanish period, ships coming directly from Africa often docked in various Caribbean islands, such as the British island of Jamaica. Louisiana slave holders or slave traders met these ships, then trans-shipped the slaves to Louisiana. Surviving artifacts, such as iron slave restraints, suggest all too clearly the horrific experiences slaves were subjected to at times, particularly when being transported (*fig. 1*).

Several sketches by Benjamin Henry Latrobe, the architect who visited New Orleans in 1819, provide rare images of musical instruments used by slaves when they congregated and danced on Sundays in Congo Square, a custom allowed by both the French and Spanish, and which continued under the Americans (*fig. 2*). He observed an assembly of between five hundred and six hundred blacks. "An old man sat astride a Cylindrical drum about a foot in diameter, and beat it with incredible quickness with the edge of his hand and fingers The most curi-ous instrument however was a stringed instrument which no doubt was imported from Africa. On the top of the finger board was the rude figure of a Man in a sitting pos-ture, and two pegs behind him to which strings were fas-tened. The body was a Calabash [gourd]."[11] The instru-ments drawn by Latrobe were probably fash-ioned in this country, but based on those the slaves had known in Africa and using similar materials. Twentieth-century African instru-ments are surprisingly similar (*fig. 3*).

In the eighteenth and early nineteenth cen-turies, the African stringed instrument with the body of a gourd was called a *banza* in the French colonies, and a *bahjer* or *banjar* in the English colonies. Jefferson, in his *Notes on the State of Virginia*, observed that, for "negroes, . . . The instrument proper to them is the Banjar . . . its chords being precisely the four lower chords of the guitar." These instruments, used by West African slaves, were developed into the mod-ern banjo as commercial adaptations were made of them in the second quarter of the nineteenth century.[12]

A watercolor of the marketplace along the levee, also by Latrobe, gives us an idea of the lively mix of people who walked the streets of New Orleans and worked in the fields nearby (*fig. 4*). He estimated that there were five hun-dred buyers and sellers. His description suggests how exotic New Orleans seemed to a visitor

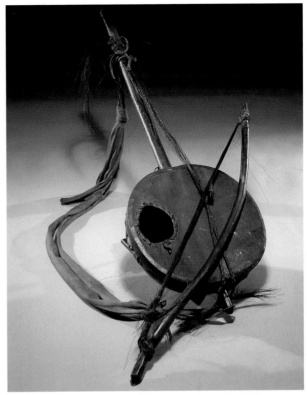

Figure 3: African Artist, *Bow stringed gourd, with bow*, Gourd body with wooden stem, horsehair strings, 20th century, 24 x 9 x 4 inches (60.96 x 15.24 x 10.16 cm), bow, 20 inches (50.8 cm), Collection of N'Ann and Jan Glade, New Orleans, Louisiana

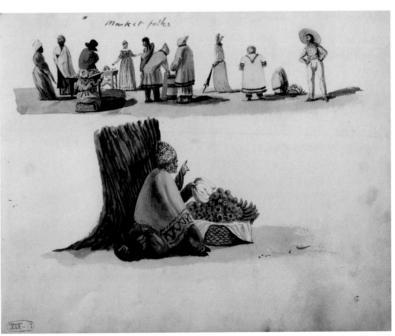

Figure 4: Benjamin Henry Latrobe (American, 1764-1820), *Market folks*, circa 1819, Pencil, watercolor on paper, 9 x 11-7/16 inches (22.86 x 29.89 cm), Latrobe Sketchbook XIV, Maryland Historical Society, Baltimore, Maryland

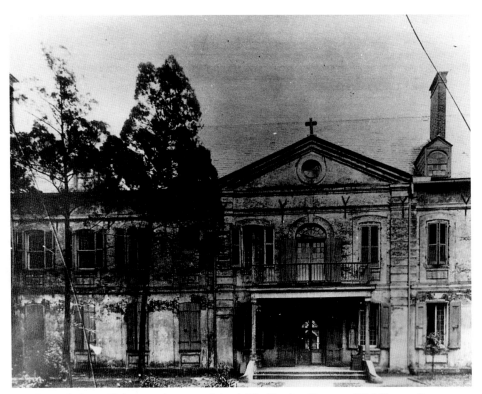

Figure 5: Artist Unknown, American School, *The Ursuline Convent, 1114 Chartres Street, New Orleans*, built by Ignace Francois Broutin and Claude Joseph Villars Dubreuil, 1745-52, Occupied by the Ursulines, 1752-1824, Photo courtesy of Louisiana Landmarks Society Records, Southeastern Architectural Archives, Tulane University, New Orleans

from Philadelphia: "The articles to be sold were not more various than the sellers. White Men and women, of all hues of brown, and of all Classes of faces, from round Yankees, to grisly and lean Spaniards, black Negroes and negresses, filthy Indians half naked. Mulattoes, curly and straight haired. Quateroons [*sic*] of all shades long haired and frizzled, the women dressed in the most flaring yellow and scarlet gowns, the men capped and hatted. . . ." The articles being sold included "wild ducks, fish, poultry of all kinds, oysters, bananas, piles of Oranges, Sugar Cane sweet and Irish potatoes, corn in the Ear and husked apples, carrots and all sorts of other roots, eggs, trinkets, tin ware, dry goods, in fact of more and odder things to be sold in that manner and place than I can enumerate."[13]

Most of the slaves lived and worked on plantations outside the city. These were extensive agricultural business establishments.[14] In addition to the owner's house and a row or more of slave cabins, they often included utilitarian buildings, such as sugar houses, stables, kitchen, hen houses and chicken coops. A map of a relatively modest *habitation* shows a typical layout (**cat. no. 221**).

Free people of color occupied an intermediate social and economic position between the white population and the slaves. Some were highly skilled craftsmen. In one case, a 1787 contract survives; it recorded that a mulatto named Charles, a free man of color, was the builder-con-

tractor for the owner of what is now Destrehan, a handsome plantation house still there, upriver from New Orleans. He was described as a "carpenter, wood worker, and mason by trade" and agreed to construct a "house of sixty feet in length by thirty five in width."[15]

The Catholic church of New Orleans was patriarchal in its structure, but it can be argued that Catholicism in the city was maternal, influenced and guided by the nuns of the Company of Saint Ursula, the French order of nuns who established themselves in New Orleans in 1727 and have been a continuing presence ever since. They were located at their second home, on Chartres Street, at the time of the Purchase. Their property extended all the way to the river. This is the oldest surviving structure of French colonial architecture in the Mississippi valley (*fig. 5*).

Emily Clark has shown that the Ursulines, through their teaching, influenced slavery and race relations, shaped gender roles and expectations, and played a critical part in establishing and defining Catholicism in New Orleans (**cat. nos. 227–232b.**)[16]

A few pieces of late eighteenth- and early nineteenth-century furniture that belonged to the Ursulines have survived.[17] Several are made of native American walnut (*Juglans nigra*). The contours of these pieces, and others of the relatively few surviving examples of Louisiana furniture of this period, parallel those of similar pieces from

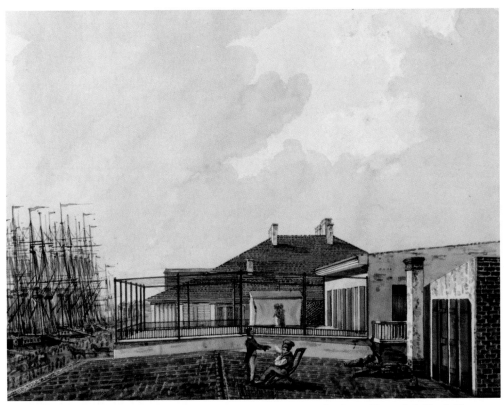

Figure 6: Benjamin Henry Latrobe, *View from Window of my Chamber at Tremoulet's Hotel, New Orleans*, circa January 1819, Pencil, pen and ink, watercolor, 9 x 11-7/16 inches (22.86 x 29.26 cm), Latrobe Sketchbook XIV, Maryland Historical Society, Baltimore, Maryland

France of the same period. While French pieces are often of fruitwoods and elaborately carved, the aesthetic appeal of the Louisiana pieces is in the quality of the fine hardwood and the contours of the forms, as seen in an elegant table, once owned by the Ursulines (**cat. no. 231**). Armoires, Continental storage pieces, are one of the few Louisiana furniture types that have survived in any number. These few examples give us an idea of the types of furniture made and used in New Orleans. Surviving Louisiana pieces of furniture are relatively scarce in comparison to furniture from the Anglo-American colonies of the eastern seaboard. The population density was much less. In the decade before the Purchase, in 1790, New York City had a population of 33,331, Philadelphia, 42,520, while New Orleans, the only town of some size in an agrarian region, had less than 8,000. Hurricanes, fever epidemics, floods and fires also took their toll.

"Campeachy" chairs, more correctly, Campeche chairs, with sling seats, are associated with New Orleans of the period. The anglicized name derives from the Mexican port, Campeche, a part of the Yucatan peninsula, known for its trade in logwood. Such chairs were imported into New Orleans from Mexico and the West Indies, often via Havana, according to a new study by Cybéle Gontar.[18] Latrobe, ever-observant, made a watercolor sketch of a virtually flat-roofed Spanish-type building, on which a

man was casually seated in such a chair (*fig.* 6). This may have been a typical scene in New Orleans, but to Latrobe, used to the Atlantic seaboard, everything he saw "had an *odd* look. For 25 years I have been a traveller . . . it was impossible not to stare, at a sight wholly new even to one who has travelled much in Europe and America."[19]

Jefferson, always curious, had heard of these chairs and wanted one. He may have acquired one earlier, but there is firm evidence that he was given one by Thomas Bolling Robertson, the first congressman from Louisiana, who, in 1818, returned from Washington to New Orleans. On August 2, 1819, Robertson informed Jefferson that he was sending him a Campeachy chair from New Orleans, "Many years ago you asked me to send you one of these chairs." Jefferson had received it by November 7, 1819, when he wrote to thank Robertson for it.[20] According to a well-founded tradition, Jefferson gave this chair to James Madison (*fig.* 7). Gontar has surmised that this chair, now at the James Madison Museum, probably served as the model for similar chairs made by John Hemings, Jefferson's slave and a skilled craftsman, in the joinery at Monticello (*fig.* 8; see also **cat. no. 171**).

Estate inventories and other legal documents, descriptive comments of travelers, occasional information in surviving letters, such as the Robertson-Jefferson exchange, paintings and sketches, all expand our knowledge of artifacts

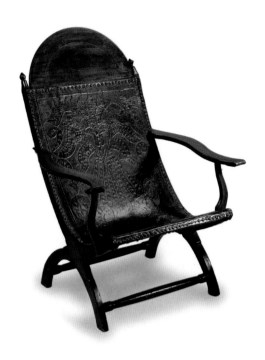

Figure 7: Probably Mexican, *Campeche chair*, early 19th century, James Madison Museum, Orange, Virginia

and furnishings used in Louisiana. Archaeological digs, another source, frequently yield pottery fragments and other small objects. A French faïence plate, with the Tree of Liberty, is one such find, unusual in a city with a strong royalist feeling (**cat. no. 224**). Might it have been brought over in the luggage of a member of Laussat's official party?

The secret Treaty of San Ildefonso, in which Carlos IV of Spain promised Napoleon that Spain would cede Louisiana to France, was signed on October 1, 1800 (**cat. no. 237**). It was more than two years later, after a complex international diplomatic chess game had been played between Spain, France, Britain and the United States, with islands in the West Indies and the Louisiana Territory as pawns, that Pierre Clément de Laussat arrived in New Orleans, on March 16, 1803, expecting to act as colonial prefect, the highest ranking civilian official in the colony. But in the next month, on April 30, the purchase of Louisiana by the United States was agreed upon in France. Therefore, rather than taking charge in the colony, Laussat was appointed by Napoleon, on June 6, 1803, to receive Louisiana from Spain and then to officiate when it was handed over to the United States. This news did not reach him until August 18, by which time the colonists had already learned of this from newspapers and letters. On November 30, 1803, the transfer from Spain to France took place with much ceremony. During the brief interregnum of barely three weeks, November 30 to December 20, Laussat was in charge. He kept his staff,

and the presses, busy; twenty-seven of his proclamations, establishing French rule, survive (**cat. nos. 212, 213**). He issued at least eight on the very first day.

The next day Laussat "received visitors—the intendant, the governor, and the marquis, together with a brilliant retinue; the chief military staff; and the clergy—all of whom arrived on foot at my house. . . ." The remainder of the day was "one continuous holiday" as Laussat then gave a dinner and a ball, followed by an early morning supper. Toasts were made: first, white champagne, to the French Republic and to Bonaparte; second, pink champagne, to Charles IV and Spain; and the third, white champagne to the United States and to Jefferson. Afterwards the guests gambled and danced the night away. English quadrilles interrupted every third French one. The Spanish official, the Marquis de Casa Calvo, who had served earlier in Louisiana, and was sent again for the occasion, led a minuet. There were waltzes. At seven o'clock the next morning, the *danse des bateaux* and *galopade* were still going strong (*fig. 8*).[23]

This was but one of several events. On December 4, a solemn high mass was held. On December 8, Casa Calvo gave a *soirée* in honor of the French; a concert and dances, and, at two o'clock in the morning, a cold collation "in lavish abundance" took place. "A dazzling quantity of candles lit up superb decorations." Laussat and his wife did not leave until eight o'clock in the morning. Then, on December 16, Laussat, feeling "It would not have been French for me to remain in his debt," returned the compliment and gave another party. (There had been some friction between Laussat and the Spanish officials, but this was skillfully smoothed over.) Once again, the guests danced "boleros, *gavottes*, English dances, French and English quadrilles, and *galopades*. . . . As a local touch, twenty-four gumbos were served, six or eight of which were sea turtle. Throughout the night, a buffet with plenty of Bavarian sweets was served with tea, coffee, chocolate, and consommés." Guests left at eight o'clock the next morning.

On December 13, William C. C. Claiborne, then governor of the Territory of Mississippi, arrived in New Orleans. He was to receive Louisiana for the United States and to have the sole authority to govern the ceded territory. General James Wilkinson, with troops, had arrived the day before.[24] The official transfer took place on December 20, 1803, in the Sala Capitular of the Cabildo on the Place d'Armes (now Jackson Square). The day "was beautiful and the temperature as balmy as a day in May." The American representatives presented their powers to Laussat. The treaty of transfer, Laussat's powers, and the act of exchange of ratifications were read. Laussat declared that he "was transferring the country to the United States" and repeated solemnly the terms in which his powers were conceived, handed over the keys of the city "tied together with tricolor ribbons" to Wilkinson, then Laussat "absolved from their oath of allegiance to France

Le Bon Genre, N°. 111.

Mademoiselle Busc et Monsieur Corset.

Figure 8: Mademoiselle Busc et Monsieur Corset, 20th-century engraving by E. Doisteau after original Le bon genre print of 1822, Hand-colored engraving, 7-15/16 x 10-5/16 inches (20 x 26.4 cm), Dance Division, the New York Public Library for the Performing Arts, New York

the inhabitants who chose to remain under the domination of the United States." Minutes were read, signatures affixed. The French colors were then lowered and the American flag raised. "When they reached the same level, both banners paused for a moment. A cannon shot was the signal for salvos from the forts and the batteries."

At three in the afternoon, Laussat gathered some 450 people for dinner. Then, "With the Madeira wine, everyone drank to the good health of the United States and Jefferson; with the Malaga and Canary Islands wine, to Carlos IV and Spain; with pink and white champagne, to the French Republic and Bonaparte. Finally, the last toast offered was to the eternal happiness of Louisiana, as a salvo of sixty-three rounds of cannon came to an end." A "high tea" was served at seven; a ball followed. "The drawing rooms were taken over by games of *écarté braque*, chess, *béte médiateur, bouillotte*, and after supper, *creps*."[25] Laussat's administration of twenty days was over. The serious formal ceremonies, and the seemingly frivolous parties served to mark the occasions for the officials and the populace, occasions that represented major changes in government, occasions which, understandably, created anxieties. Some must have sensed that the young American republic would gradually play a more important role in international affairs.

Claiborne's task of establishing the United States gov-

ernment in the new territory was not easy.[26] Borders were ill-defined; he was unfamiliar with the language, manners, customs, legal and religious arrangements. It was the first territory in which Americans were numerically a minority. Claiborne assured the populace that all laws and municipal regulations in force at the time of the transfer would remain in operation, and that the new government would be permanent. He needed to establish security. Judicial procedures had to be gradually adapted to conform with the laws of the United States. His own responsibilities were not totally clear; his appointment was temporary. General Wilkinson was not an easy partner, and there were frictions between them. On March 9 and 10, 1804, another ceremony was held in St. Louis, officially transferring upper Louisiana to the United States, at the same time establishing the Territory of Orleans—essentially present-day Louisiana, but still with questions of borders—and the District of Louisiana. But the Territory of Orleans was still very different from previously defined new territories, such as the Northwest Territory, the Mississippi Territory or the Indiana Territory. These had been sparsely settled frontier areas, primarily agricultural and with fairly similar ethnic compositions. New Orleans was a small city with a very polyglot population. Slavery was a well-established practice.

The mother superior of the Ursulines, unclear of their

rights under a government where church and state were now separate, wrote to Thomas Jefferson on March 21, 1804, asking that they be allowed to retain their property in order to continue their mission, their teaching. ". . . This request . . . is not dictated by personal interest nor ambitious aims. Separated from the world and its pomps and vanities . . . bound by a solemn vow to use their time in the formation of youth, they cannot help but be anxious to know if they will be able with certainty to count on continued enjoyment of their revenues which will enable them to fulfill their obligations."[27] On May 15, 1804, Jefferson wrote a personal note in reply, assuring them that the new government would provide "all the protection which my office can give it." (**cat. no. 232**)

Some French officials remained in office for a time, until replaced by Americans. The French officer, A. J. Vinache, chief of the Battalion of Engineers, was still in Louisiana in March 1804, but was expecting to leave soon (**cat. no. 214**). Laussat remained as the unofficial agent of the French government, settling accounts and completing inventories, with Vinache's assistance, until early May 1804. He then left to become colonial prefect of Martinique—the birthplace of Napoleon's Josephine. Most of the Spanish had withdrawn within a year after the transfer, but the Marquis de Casa Calvo and another official, with sixty men as retainers, delayed their departure for more than two years.[28]

Claiborne's initial appointment was open-ended. Jefferson had hoped to appoint Lafayette or Monroe as governor of the Territory of Orleans. When this proved impossible, others vied for the position. Jefferson then decided in favor of Claiborne, who was officially appointed on August 20, 1804 (**cat. no. 215**). Claiborne guided the new territory, with ups and downs, until Louisiana was formally admitted to the Union on April 30, 1812, as the eighteenth state—a slave-holding state. Next elected as governor, Claiborne served four more years. He died in New Orleans on November 23, 1817, only a few weeks before he was scheduled to take his seat as a United States senator.

Claiborne succeeded in establishing essential United States services and procedures. More and more Americans poured into the city, but the "Americanization" of New Orleans and lower Louisiana took hold only slowly. Among the French-speaking, there was a continuing affection for things French. The handsome Nicolas Girod house, at 500 Chartres Street, built 1814 to 1815, for example, has the appearance of a fine French provincial structure. According to unsubstantiated local legends, Girod, mayor of New Orleans from 1812 to 1815, and other local New Orleaneans, had a continuing regard for Napoleon, even after the once-brilliant general suffered defeat. Tradition has it that Girod said he would offer his French Quarter home to Napoleon—either in 1815 when news came that the former emperor had escaped from Elba or, later,

that it could serve as a refuge after an elaborate plan to rescue the unhappy exile from St. Helena had been concocted by a group of New Orleaneans. The latter plan was thwarted by Napoleon's death.[29] The house is now popularly called Napoleon House. A sideboard, believed to have come from the house, is an excellent example of Empire taste (**cat. no. 225**). This imposing sideboard reflects the emergence of the form as one of the most important of the late eighteenth and early nineteenth centuries. Such sideboards became storage cabinets for napery, flatware and serving pieces while their broad flat tops accommodated dishes and platters of food about to be served.

The Louisiana Purchase provided the United States full access to commerce on the Mississippi River and the port of New Orleans. The acquisition more than doubled the size of the United States and opened up expansion to the West. The formation of states within this territory and their assimilation into the United States, however, was not without trauma, as the troubling issue of slavery came increasingly to the fore.

The new United States government had passed the Ordinance of 1787, establishing territories in lands beyond the original thirteen colonies and providing a procedure for assimilating new states. Four territories were established in 1787. In 1791, Vermont became a state—clearly a free state; in 1792, Kentucky, a slave state; in 1796, Tennessee, also a slave state; in 1803, Ohio, a free state.[30]

In 1812, Louisiana, the first state from the Louisiana Purchase, came in as a slave state; in 1816, Indiana, free; in 1817, Mississippi, slave; in 1818, Illinois, free; in 1819, Alabama, slave. Up to this time, partly by chance, there was an even balance between the admission of free and slave states. In 1819, there were eleven free states and eleven slave.

A major crisis came with the question of Missouri, the second state to become a candidate from within the Louisiana Purchase. The complex Missouri Compromise, fashioned by Henry Clay, established a line above which all states would be free, and those below, slave. This solved the problem for the time being. Maine became a free state in 1820, and in 1821 Missouri was admitted as a slave state, thus maintaining the balance of power.

In the subsequent thirty-five or so years, as the population expanded and the nation added new territories, nine more areas achieved statehood. Among these, Arkansas, in 1836, accepted as a slave-holding state, and Iowa, in 1846, a free state, were from within the Louisiana Purchase.

The next big crisis came in 1854, when Congress passed the Kansas-Nebraska Bill. Both were above the line set in the Missouri Compromise. This essentially repealed the Missouri Compromise and provided for decisions—to be slave or free—to be made by the settlers themselves. In Kansas chaos occurred, with a bloody mini-civil war erupting. Minnesota, within the Louisiana Purchase, came in as a free state in 1858. Lincoln was elected in 1860.

Southern states were seceding. Kansas was not admitted to the Union until January 19, 1861, as a free state, a small victory for the North, and the sixth state from within the Louisiana Purchase to be accepted. A little more than two months later, on April 12, 1861, the Confederate forces fired on Fort Sumter. The four tragic years of Civil War finally ended in 1865. Only in the years after this did the other six states from within the Purchase—Nebraska, Colorado, North Dakota, South Dakota, Montana and Wyoming—join the nation. By then, as Shelby Foote so astutely observed, common usage had changed from "the United States *are*," to "the United States *is*."[31]

Notes:

1. Edwin Morris Betts and James Adam Bear. Jr., *The Family Letters of Thomas Jefferson* (Columbia: University of Missouri Press, 1966), 250-54.

2. Andrew H. Lipscomb, ed., *The Writings of Thomas Jefferson* (Washington, D.C.: Thomas Jefferson Memorial Association, 1904), 10:312-16.

3. The French observer, Victor Collot, in 1796, made two tables showing in some detail the difference between the overland routes and those via New Orleans by water. Victor Collot, *A Journey in North America* (Firenzi: O. Lange,1924), 1:118-19.

4. Stephen Ambrose, *Undaunted Courage. Merriwether Lewis, Thomas Jefferson and the Opening of the American West* (New York: Simon and Schuster, 1996), 70-117.

5. Gloria Gilda Deák, *Picturing America, 1497-1899* (Princeton: Princeton University Press, 1988), 1:177-179; 2: figs. 266 and 270; Wendy Shadwell, *American Printmaking. The First 150 Years* (Washington, D.C.: Smithsonian Institution Press, 1969), 48 and fig. 92; and I. N. Phelps Stokes and Daniel C. Haskell, *American Historical Prints, Early Views of American Cities, Etc.* (New York: New York Public Library, 1933), 53, plate 40.

6. Grace King, *Creole Families of New Orleans* (New York: The Macmillan Company, 1921), 7-21 and 23-33; Louis Philippe, *King of France, 1830-1848, Diary of My Travels in America*, trans. Stephen Becker (New York: Delacorte Press, 1977), 89-note 24, 166, 170.

7. Pierre Clément de Laussat, *Memoirs of My Life*, trans. Sister Agnes-Josephine Pastwa, (Baton Rouge: Louisiana State University Press, 1978), 20.

8. Richard C. Doty, *The Macmillan Encyclopedic Dictionary of Numismatics* (New York: Macmillan Publishing Co., Inc., 1982) entries on the bit, decimal coinage, dollar, piece-of-eight, and real; Eric P. Newman, "The Dollar Sign, Its Written and Printed Origins," in John M. Kleeberg, ed., *America's Silver Dollars*, Coinage of the Americas Conference at the American Numismatic Society, New York, 1992, 1-49.

9. John Mahé II and Roseanne McCaffrey, *Encyclopaedia of New Orleans Artists 1718-1918* (New Orleans: The Historic New Orleans Collection, 1987), 336. His daughter is known to have made a copy of one of his portraits. For insights into the ceremonial and bureaucratic characteristics of the Spanish regime: Francis Bailey, *Journal of a Tour in Unsettled Parts of North America in 1796 and 1797*, ed., Jack D. L. Holmes (Carbondale: Southern Illinois University, 1969), 172-175, and Samuel Wilson, Jr., "Almonester: Philanthropist and Builder in New Orleans," in *The Spanish in the Mississippi Valley 1762-1804*, ed. John Francis McDermott (Urbana: University of Illinois Press, 1974), 219-222. For the importance of Trudeau's surveys: Edward Haas, "Odyssey of a Manuscript Collection: Records of the Surveyor General of Antebellum Louisiana," *Louisiana History* 27 (1986), 5-26.

10. Gwendolyn Midlo Hall, "Myths about Creole Culture in Louisiana," *Louisiana Cultural Vistas* 12 (Summer 2001), 78-89.

11. Edward C. Carter II, John C. Van Horne, and Lee W. Formwalt, eds., *The Journals of Benjamin Henry Latrobe 1799-1820 From Philadelphia to New Orleans* (New Haven: Yale University Press, 1980), 203-204. Bailey, writing in 1797, also described the Sunday activities of the black population, 173-174.

12. Jay Scott Odell and Robert B. Winans, "Banjo," *The New Grove Dictionary of Music and Musicians*, 2nd edition (London: Macmillan Publishers, 2001); Thomas Jefferson, *Notes on the State of Virginia*, intro., Thomas Perkins Abernethy (New York: Harper and Row, 1964). 135.

13. Edward C. Carter II, John C. Van Horne, and Charles E. Brownell, eds., *Latrobe's America, 1795-1820. Selections from the Watercolors and Sketches* (New Haven: Yale University Press, 1985), 356.

14. Barbara Sorelle Bacot, "The Plantation," in Bacot and Jessie Poesch, eds., *Louisiana Buildings, 1720-1940, The Historic American Buildings Survey* (Baton Rouge: Louisiana State University Press, 1997), 87-173.

15. Building Contract of Charles, Free Mulatto, with Robin de Logny, in St. Charles Parish Notarial Book, 1787, January 3, 1787. No. 750, folios 89-91, translated by Samuel Wilson, Jr., in Wilson, "Destrehan Plantation, St. Charles Parish," *Louisiana Architect* 8 (March, 1969), 8-9.

16. Emily J. Clark, "A New World Community: The New Orleans Ursulines and Colonial Society, 1727-1803" (Ph.D. diss., Tulane University, 1998).

17. Jessie Poesch, *Early Furniture of Louisiana* (New Orleans: Louisiana State Museum, 1972), figs. 8-12, pp. 20-27.

18. Cybéle Gontar, "The Louisiana Campeche Chair: Origin, History and Transference" (Masters thesis, Cooper-Hewitt, National Design Museum and Parsons School of Design, Fall 2001), 34-41 and appendices—these include examples of ship manifests.

19. Carter, et al, *Latrobe's View*, 358.

20. Gontar, "Louisiana Campeche Chair," 60-70; Robert L. Self and Susan R. Stein, "The Collaborations of Thomas Jefferson and John Hemings, Furniture Attributed to the Monticello Joinery," *Winterthur Portfolio* 33 (Winter 1998), 239-242; Susan R. Stein, *The Worlds of Thomas Jefferson* (New York: Harry N. Abrams, Inc., 2002), 280-281.

21. Antoinette Faÿ-Hallé and Christine Lahaussois, *Le grand livre de la faïence française* (Paris: Office du Livre,1986), 133, for somewhat similar examples. For the symbolism of the Tree of Liberty: Marie-Louise Biver, *Fêtes révolutionnaires à Paris* (Paris: Presses Universitaires de France, 1979), 87-96; Suzanne Desan, *Reclaiming the Sacred. Lay Religion and Popular Politics in Revolutionary France* (Ithaca: Cornell University Press, 1990), 1-15 and 123-169; Paul Hayes Tucker, *Monet in the 90's* (New Haven: Yale University Press), 41.

22. Florence M. Jumonville, *Bibliography of New Orleans Imprints 1764-1864* (New Orleans: The Historic New Orleans Collection, 1989), 21-29.

23. Laussat, *Memoirs*, 80-86.

24. Joseph T. Hatfield, *William Claiborne: Jeffersonian Centurion in the American Southwest* (Lafayette: University of Southwestern Louisiana, 1976), 102-111.

25. Laussat, *Memoirs*, 88-91; there is an excellent summary of this short French occupation in Marc de Villiers du Terrage, *The Last Years of French Louisiana* (Lafayette: University of Southwestern Louisiana, 1982) 492-512.

26. Marietta Marie LeBreton, "A History of the Territory of Orleans, 1803-1812" (Ph.D. diss., Louisiana State University, 1969); Hatfield, *Claiborne*, 96-257.

27. Typescript copy of this letter in the Ursuline Convent Museum and Archives.

28. Hatfield, *Claiborne*, 213.

29. Samuel Wilson, Jr., "Girod House," in Wilson, *The Architecture of Colonial Louisiana, Jean M. Farnsworth and Ann M. Masson*, comps. and eds. (Lafayette: University of Southwestern Louisiana, 1987), 358-361; Federal Writers' Project, *The WPA Guide to New Orleans*, intro., The Historic New Orleans Collection (New York: Pantheon Books, 1983—originally published 1938), 26 and 266-67.

30. This vastly simplified summary is gleaned from standard history books and encyclopaedias. The maps and summaries in Richard N. Current, T. Harry Williams, Frank Freidel and W. Elliot Brownlee, *The Essentials of American History*, 3rd ed. (New York: Alfred A. Knopf, 1980) are particularly useful.

31. Shelby Foote, *The Civil War. A Narrative* (New York: Vintage Books, 1986—first published 1974), Vol. 3, 1041.

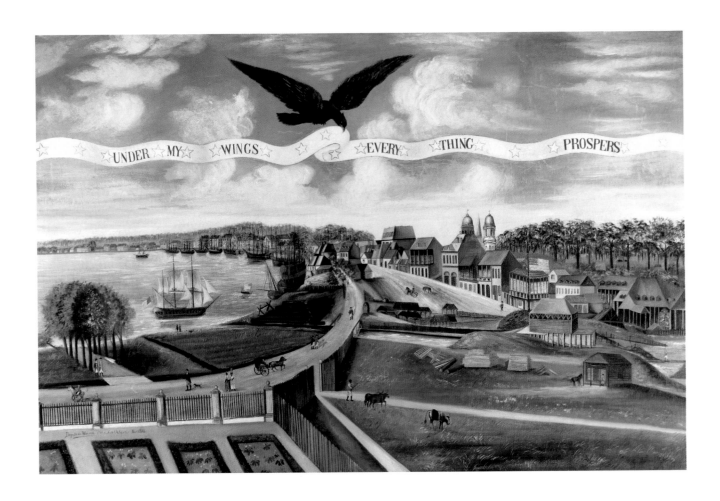

210.

John L. Boqueta de Woiseri (French?, active in America, 1797–1815)
A View of New Orleans Taken from the Plantation of Marigny, 1803

Oil on canvas
58 x 84 inches (148.6 x 213.4 cm)
Chicago Historical Society, Chicago, Illinois (P&S-1932.0018)

The port and city of New Orleans, the prize acquisition of the Louisiana Purchase, is celebrated in this painting. The American flag flies over Fort St. Charles in the foreground. Above, an eagle bears in its beak a ribbon, triumphantly inscribed "Under my wings everything prospers."

The formal gardens of the Marigny Plantation are seen on the far right. This was the estate of Pierre Philippe Bernard Xavier de Marigny de Mandeville (1750-1800) who probably had been the greatest landowner and richest citizen of New Orleans. From a French-American family originally in Canada, he accepted Spanish domination of the colony. One of Marigny's sawmills, built on stilts, two piles of cut lumber and a pile of logs on the levee, figure prominently in the right foreground, indicating one of the sources of his income. Sailboats crowd the harbor. Most are substantial square-rigged vessels. Cypress, shipped to Havana, was a major export. Deer and bear skins, beaver furs, rice and cotton were other exports. European-manufactured goods were imported. The twin towers of the Cathedral of St. Louis are seen in the distance, behind a variety of colonnaded and galleried buildings.

The somewhat mysterious artist signed himself variously. On May 24 and June 4, 1803, in the only New Orleans newspaper, *Le Moniteur de la Louisiane*, he simply identified himself as *Le Sieur Boquet* (Mr. Boquet) and as *nouvellement arrivé en cette ville*. Perhaps he was "newly arrived," or perhaps it simply meant that he had arrived after having been absent. (Records for this period are incomplete. *Le Moniteur* was first published as a weekly from 1794 to 1796, then revived in 1797, but only partial runs survive.)

On February 21, 1804, by then living in Philadelphia, Boquet announced in that city's newspaper, *General Advertiser*, that he would offer two engravings by subscription, one a plan of New Orleans, the other a view of the city. These were "By him dedicated by permission, to Thomas Jefferson, Esq., President of the United States, and submitted to the Senate and House of Representatives." They would be ready for delivery in about six months. He further stated that he had resided "at New Orleans a number of years," and that the two works in question had "cost the author above six years assiduous and unremitted labor and close application." This suggests he was in New Orleans as early as 1797. Here he identified himself as "John L. Boquet de Woiseri, Designer, drawer, geographer and Engineer." Thomas Jefferson's *Summary Journal of Letters* lists two letters from Boquet to Jefferson, June and August 1804, but unfortunately these have not been found. A print of the view of New Orleans, however, is known to have hung in Jefferson's dining room at Monticello.

It is not clear as to what the honorific "de Woiseri" refers to or how he acquired it. By an obscure inheritance? J. L. Boquet or J. L. Boqueta de Woiseri, is listed in New York city directories from 1807 to 1811, and he appears to have been in New York until 1815 or 1817. He also made an important composite print of the American cities Philadelphia, New York, Baltimore and Charleston. It is not known where Boquet came from or where he was trained. It is tempting to think he may have been a member of the Boquet family of painters and engravers who practiced in France in the late eighteenth and early nineteenth centuries. One of these was J. L. Boquet who was in St. Domingue around 1791-1793, suggesting a link between the French West Indian colony and New Orleans. **J.P.**

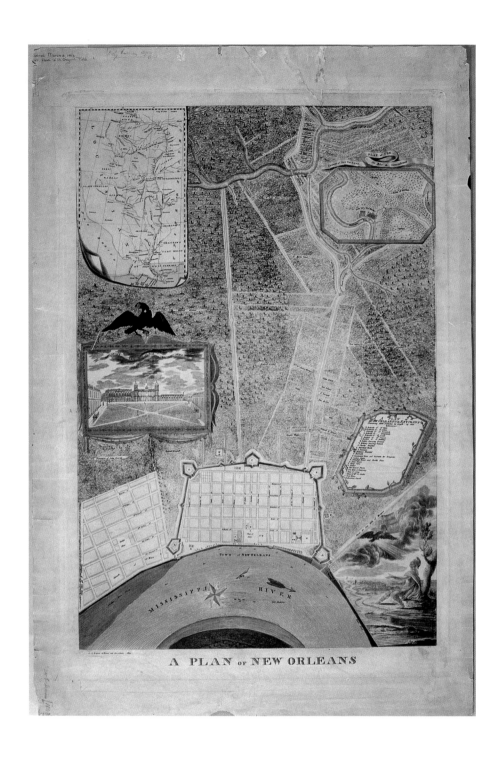

211.

John L. Boqueta de Woiseri (French?, active in America, 1797–1815)
A Plan of New Orleans, 1803

Hand-colored engraving on paper
34 x 23 inches (86.4 x 58.4 cm)
Louisiana State Museum, New Orleans, Louisiana

In its component parts, this map celebrated the Purchase and provided information about New Orleans, its immediate environment and its relationship to the lands along the length of the Mississippi River. The plan of the town, now the French Quarter, situated at the great curve of the Mississippi, is at the center base. On the left are the beginnings of uptown, with St. Charles and "del Campo" (present-day Camp) streets. Gravier's plantation is above. On the right are the footprints of Marigny's plantation house and sawmill, and an angled channel, "Canals for sawmills of Marigny." Insets amplify the information. The major structures of the city are listed on one, including the "Nunnery," that is, the Ursuline convent.

Another inset shows the Plaza de Armas (now Jackson Square) more or less as it appeared in 1803, with the cathedral, the Cabildo—the mansard roof was not added until the mid-nineteenth century—and the unfinished Presbytere. This is the cathedral as built 1790 to 1795, financed by the generosity of Don Andres Almonester y Roxas, a native of Spain, and designed by Don Gilberto Guillemard, a native of France who had served with the Spanish in Louisiana over twenty years. Almonester, alongside Marigny, was one of the wealthiest men in the city. The cathedral has been modified several times in the two hundred years since it was erected. It remains as the centerpiece of one of the most attractive urban centers in the United States. Properties on either side of the square were buildings owned by Almonester.

Near the upper right corner, a scroll over an inset reads, "Plan of environs of New Orleans. Six miles in circumference." This illustrates the relationship of New Orleans to the crescent of the river, to Bayou St. John and Lake Pontchartrain. In the lower right corner, a vignette depicts a seated figure, a classicized image of an Indian, perhaps to suggest a river god. Alongside, the winding contours of a river recede into the distance. Above this, an eagle triumphantly holds an American flag in its beak.

Finally, the artist ambitiously portrayed the length of the Mississippi, from Belize at its mouth to its beginnings in Minnesota. Sketchy information about lands occupied by various native-American tribes are roughly indicated. While the information on the east side of the Mississippi is fairly accurate—Flat Heads, Choctaws, Chickasaws and Natchez, that to the west is incomplete, with only the Kanza and Arkansa indicated, and a "Route of the French to Western Indians" noted. Even as this map was completed, Meriwether Lewis and William Clark, at the behest of Jefferson and the Congress, were already beginning their expedition of the unknown territory along the Missouri and beyond to the Pacific. By including this condensed map of the heartland drained by the Mississippi, the artist conveyed the importance of the port city, which would serve the entire Mississippi valley, newly acquired as a part of the United States. **J.P.**

212.

Pierre Clément Laussat (French, 1756–1835)
Arreté Pour l'Établissement de l'Autorité Municipale à La Nouvelle Orleáns
(Decree for the Establishment of the Municipal Authority in New Orleans),
November 30, 1803

Ink on paper
13 x 7-3/4 inches (33 x 19.7 cm)
Special Collections, Howard-Tilton Memorial Library,
Tulane University, New Orleans, Louisiana (MS 660)

On the first day of French rule during the interregnum, November 20 to December 20, 1803 (after Spain retroceded control to France, who would cede it to America three weeks later), Colonial Prefect Laussat nominated new members of the municipal council, with Étienne de Boré as mayor. The woodcut emblem of the French colonial administration, *La Louisiana*, which was designed by Pierre-Paul Prud'hon (**cat. nos. 80, 81, 121**), shows a seated female holding a caduceus in one hand and a branch in the other. She represents, as a double allegory, *Liberté* and the *République Française*. The caduceus, the symbol also associated with the antique god Hermes/Mercury, may be a symbol of wealth and prosperity; the tree branch represents liberty. Alongside, on the right, is the French cock, long associated with Gaul. There are also palm trees, a ship, barrels, and leafy vegetation, suggesting the commerce and agriculture of the colonial territories. The wood block was no doubt brought with Laussat from France to Louisiana. (Jumonville, *Imprints*, #67) **J.P.**

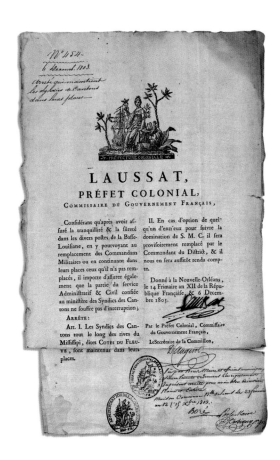

213.

Pierre Clément Laussat (French, 1756–1835)
Proclamation indicating the French will maintain the military forces to protect the river, December 6, 1803

Ink on paper
13 x 7-3/4 inches (33 x 19.7 cm)
New Orleans Public Library, City Archives, New Orleans, Louisiana

This, and all the documents issued by Laussat give the date in the French revolutionary calendar, i.e., 14 *Frimaire au XII République Française* as well as in the traditional usage, 6 Decembre 1803. Frimaire—the third month, the month of frost, November 21 to December 20—of the twelfth year (1803-04) of the French Republic. The Gregorian calendar was restored by Emperor Napoleon on January 1, 1806. (Jumonville, *Imprints*, #85) **J.P.**

214.

Antoine-Joseph Vinache (French, active in New Orleans
circa 1803–1804)
*Petition from A. J. Vinache, Chief of the Battalion of Engineers,
Assistant Director of Fortifications, attached to the Colonial
Commissioner of the French Republic of Louisiana to the
Gentlemen Louisiana Officers of the City,* March 31, 1804

Ink on paper
12 x 8 inches (31.8 x 20.3 cm)
New Orleans Public Library, City Archives,
New Orleans, Louisiana

In flowery language, Vinache requests, in essence, a letter of
commendation for his services performed in Louisiana. Vinache,
a member of Laussat's mission to Louisiana, led the French militia
at the time of the transfer. A beautifully executed map by him of
New Orleans as it was at the time of the Purchase, survives. In
January 1804, after the Americans had taken over, he made a
detailed inventory of all the public buildings, including the Govern-
ment House, the barracks, and the Custom House. This is written
on an official document of the Fortification Service of the French
Republic, rather than on one of the Colonial Service of France.
The classically gowned double-allegorical figure, *Liberté* and the
République Française, wearing a Phrygian cap (another emblem of
Liberty), is shown standing. She holds a Liberty branch upright
in her left hand. The globe, a map of a fort, a wheel, cannons,
and the various flags, apparently represent the wide-ranging
power of the Republic under Napoleon. **J.P.**

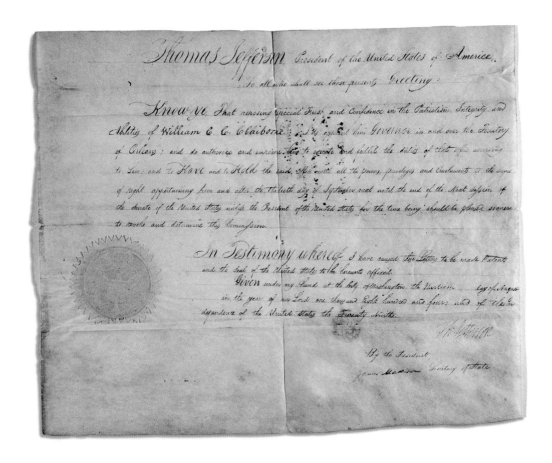

215.

Thomas Jefferson (American, 1743–1826)
Commission to William C. C. Claiborne, August 30, 1804
Signed: *Thomas Jefferson, President; James Madison, Secretary of State*

Ink on parchment, attached paper seal of the United States
13 x 16 inches (32.6 cm. x 40.2 cm)
Kuntz Collection, Special Collections, Howard-Tilton Memorial
Library, Tulane University, New Orleans, Louisiana (MS 600)

Claiborne's initial appointment to govern the newly ceded
territory of Louisiana was temporary. After serving nine
months, he was reappointed to become the governor of
the Territory of Orleans—the portion of the Louisiana
Purchase south of a line drawn at the 33E north latitude:
"Know ye That reposing special Trust and Confidence in
the Patriotism, Integrity and Abilities of William C. C.
Claiborne I do appoint him Governor in and over the
Territory of Orleans; . . ." following a usage somewhat
similar to that of the French Republic, the year 1804 is
identified as the twenty-ninth year of United States
Independence: "Given under my hand at the City of
Washington the thirtieth day of August in the year of our
Lord one thousand Eight hundred and four; and of the
Independence of the United States the Twenty-Ninth." **J.P.**

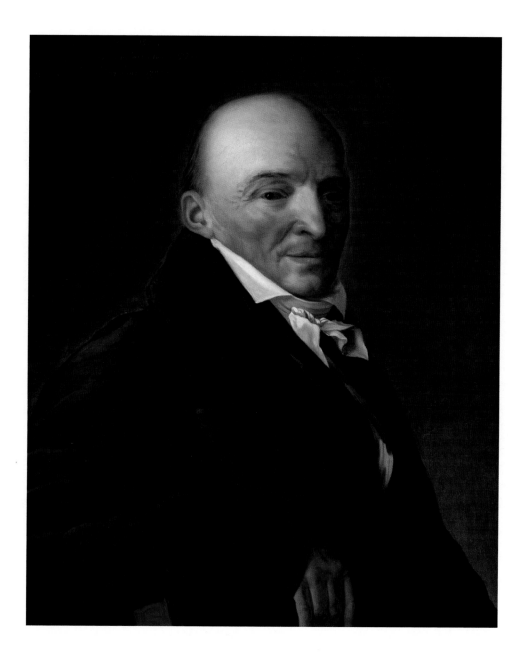

216.

Unidentified Artist, New Orleans School
Étienne de Boré, circa 1800-05

Oil on canvas
25 x 24-1/4 inches (64.8 x 61.6 cm)
Tulane University Art Collection, New Orleans, Louisiana

Étienne de Boré (1741-1820) was the first person in Louisiana to succeed in granulating sugar, thus laying the foundation of the sugar industry. Born of French parents in Illinois, he was educated in France, then became a member of the king's household troops. He returned to Louisiana while the colony was under Spanish rule, having married Marguerite Marie Destrehan, the daughter of the former royal treasurer of France, whose family had large land holdings in Louisiana. In 1781 he established a plantation upriver from New Orleans, now Audubon Park. After he and other planters had had repeated failures with indigo crops, he resolved to experiment with sugar. Purchasing cane from two Spaniards, Solis and Mendez from Havana, and using their techniques, he succeeded in 1795 in making granulated sugar from cane juice. He and other planters prospered. In November 1803, he was appointed by the French Prefect Laussat as the mayor of New Orleans; he served until May 1804, then under the new American regime. **J.P.**

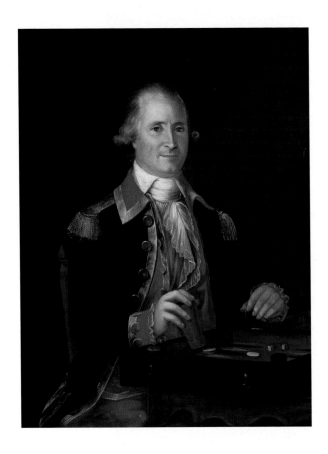

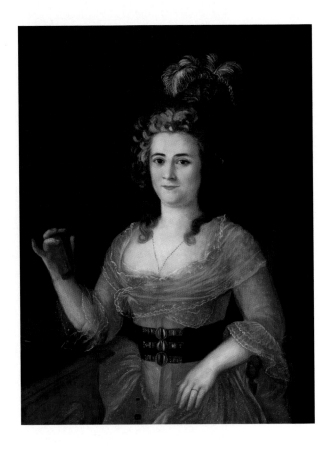

217a.

Jose Francisco Xavier de Salazar y Mendosa
(born in Mexico, mid-1700s–1802)
Don Carlos Laveau Trudeau, circa 1795

Oil on canvas
35-3/4 x 27 inches (90.8 x 69.9 cm)
Tulane University Art Collection. Gift of the Children of
Mrs. Angela Labatut Puig, New Orleans, Louisiana

217b.

Jose Francisco Xavier de Salazar y Mendosa
(born in Mexico, mid-1700s–1802)
Señora Charlotte Peyraud Trudeau, circa 1795

Oil on canvas,
35-3/4 x 27 inches (90.8 x 69.9 cm)
Tulane University Art Collection, Gift of the Children of
Mrs. Angela Labatut Puig, New Orleans, Louisiana

Don Carlos Trudeau (circa 1750-1816), a native of Louisiana, served as royal surveyor of Spanish Louisiana, then surveyor general, from approximately 1786 until his resignation December 13, 1805. He served under a succession of Spanish governors, briefly under the French, and during the first years of the American regime. The continued migration of westward-moving Americans prompted a large number of applications for land grants, necessitating land surveys. Unlike some Spanish officials, he chose to remain in Louisiana as an American and later served as president of the New Orleans City Council.

In this pair of portraits, Don Carlos and Señora Trudeau face each other, seated at a backgammon table, as if in a moment of leisure. He holds the dice cup; she holds her backgammon piece. Their dress suggests their official and upper-class status. He is in full military uniform. She wears a tightly corseted low-cut gown and sports an elaborate feather headdress. **J.P.**

218.

Carlos Trudeau (Louisiana, circa 1750–1816)
Land Survey, No. 668: Establecimiento Sn Bernardo – Bayou Yelosky
For Pedro Luis Laronde, March 10, 1794
Signed: *Carlos Trudeau*

Ink on green paper,
11-3/4 x 7-1/4 inches (29.8 x 18.4 cm)
Special Collections, Howard-Tilton Memorial Library, Tulane
University, New Orleans, Louisiana
(Manuscript 23)

219.

Carlos Trudeau (Louisiana, circa 1750–1816)
Land Survey, No. 720: Distrito de Opélussas, Barrio, Bellevue,
For Joseph Cormier, March 14, 1796
Signed: *Carlos Trudeau*

Ink on green paper
11-3/4 x 7-3/4 inches (29.8 x 18.4 cm)
Special Collections, Howard-Tilton Memorial Library, Tulane
University, New Orleans, Louisiana
(Manuscript 23)

These are two of the many survey plats done by or under the supervision of Don Carlos Trudeau (Charles LeVeau Trudeau). When the Spanish took firm control over the French colony of Louisiana in 1770, the recording of land grants was incomplete. They regularized the surveying and granting of lands. When the Americans took over, the official land surveys were taken by the Spaniards to Pensacola, then Havana. As surveyor, Trudeau was allowed to retain possession of copies of the surveys. After the Purchase, his personal copies were all-important in solving land questions in Louisiana, since, as Edmund F. Haas noted, they were "the sole remaining records in the territory available to check land fraud." **J.P.**

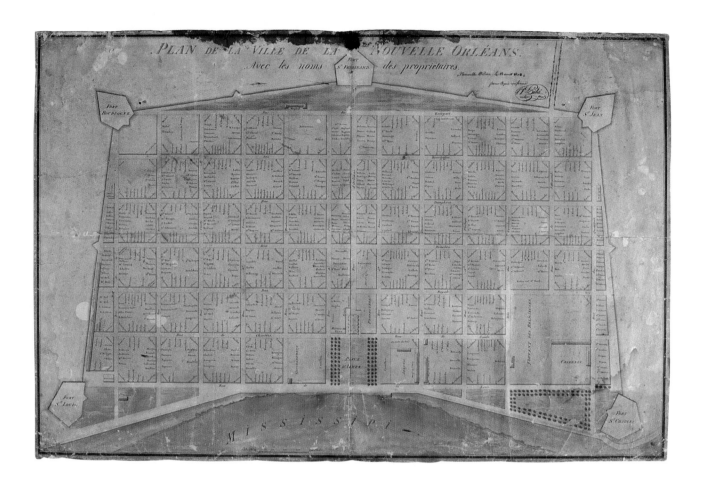

220.

Joseph Pilié (active in New Orleans, early 19th century)
*Plan de la Ville de la Nouvelle Orléans / Avec les noms des
proprietaires*, August 18, 1808

Ink wash on paper
23 x 30-1/4 inches (59.7 x 76.8 cm)
Special Collections, Louisiana Collection, Howard-Tilton
Memorial Library, Tulane University, New Orleans,
Louisiana (99.0002)

By 1808, virtually every lot of the original area of New Orleans
(today's French Quarter) was occupied. A sampling of the owner's
names suggests the diverse origins of the citizens, i.e., Anderson,
Donaldson, Kenner, Morgan and William are among the many of
English or American background. Kennedy, McCarty, McNeil and
Mulligan were no doubt Irish, Urquhart and Dow, Scotch. Destrehan,
Duplessy, Gentilly, Glapion, Landry and Trevigne are among the
numerous names of French origin. Fernandez, Gonzales, Sanchez
and Sarpy are among the relatively few suggesting Spanish origin.
By 1808 most would have become American citizens. **J.P.**

221.

Artist Unknown, New Orleans School
Plan / d'une habitation/ de Mr Fis Merieult/ situé au quartier de Oppeloussas/Paroisse St. Landry. (Plan of a plantation belonging to Francois Merieult, situated in the Opeloussas section, St. Landry Parish), December 15, 1811

Ink, color wash and watercolor on paper
19 x 15 inches (49.5 x 38.1 cm)
Southeastern Architectural Archives, Howard-Tilton Memorial Library, Tulane University, New Orleans, Louisiana (98.0011)

This map shows a typical layout of a plantation, with two rows of slave cabins at a discreet distance from the other buildings. The main house, a French-type galleried cottage, is flanked symmetrically at the rear by two identical garconniers (quarters for the owner's sons). Swamps extend into the background. The owner was a New Orleans merchant. **J.P.**

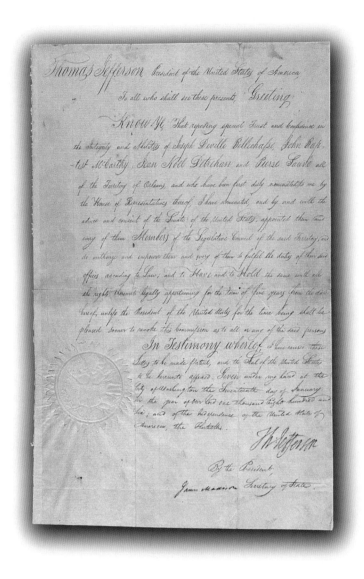

222.

Thomas Jefferson (American, 1743–1826)
Appointment of Four Prominent Louisianians to the Legislative Council, January 17, 1806
Signed: *Thomas Jefferson* and *James Madison*

Ink on paper
15-3/4 x 10 inches (40 x 25.4 cm)
Destrehan Plantation/ River Road Historical Society, Destrehan, Louisiana

The Ordinance of 1787 established a procedure by which newly acquired territories were readied for statehood. In keeping with the statute, a provisional government was established for the Orleans Territory. In this document, dated January 17, 1806, he appointed four prominent local citizens to form the Legislative Council of the Territory of Orleans. They were Joseph deVille Degoutin Bellechase (1761–circa 1840), John Baptiste McCarthy (1750–1808), Jean Noel d'Estrehan de Tours (1754–1823) and Pierre Sauvé (born 1749). **V.C.**

223.

*Selection of Coins in Circulation in Louisiana: 9 Deniers, 1 Sou,
1/2 Sou, circa 1803*

Silver and copper
American Numismatics Association, Colorado Springs, Colorado

A variety of money values are cited in contemporary accounts, such as livres, francs, dollars, piastres, pesos, escalins. Coinage was always in short supply. In a coin-hungry society, any coinage was legal tender, no matter how old, and values were based upon the weight of the coin. The Spanish-American silver coin, the piece of eight, or dollar, was valued at eight reales. These were sometimes literally cut up into fractional pieces, or "bits" of four reales, two reales (the basis of the quarter becoming "two bits"), and one reale. The Spanish dollars were minted in Mexico City as well as in other Latin-American cities. French copper sous were circulated in Louisiana and the French West Indies. **J.P.**

224.

Unidentified Artist, French School
Plate with Tree of Liberty, Late 18th–early 19th century

Faïence
Diameter: 8-1/4 inches (21 cm)
Dr. and Mrs. Jack Holden, Baton Rouge, Louisiana

Probably around, or before, October 1793, when the new French Revolution calendar was adopted, the Tree of Liberty became one of the symbols of the Revolution. It appeared as a branch on official documents, and also at some of the new festivals organized to replace the many Christian festivals—a process of dechristianizing society. Something like sixty thousand trees were planted, and hundreds of broadsides issued with the tree as a symbol of the new Republic. It even appeared on plates such as this, found in an archeological dig on Bourbon Street in New Orleans. **J.P.**

225.

Attributed to Joseph B. Barry
(American, circa 1760–1838)
Sideboard, circa 1815

Mahogany and poplar with mahogany veneer
44 x 24 x 62 inches (113 x 62.2 x 157.5 cm)
Collection of Mr. and Mrs. Carl Hawley Butler III, Columbus, Mississippi

This handsome sideboard, in a high-style Empire taste, is believed to have been in the house of Nicolas Girod, mayor of New Orleans from 1812 to 1815, at 500 Chartres Street, in New Orleans. Interior details in the house, still standing, reflect the new Empire taste. Because of the local legends that it might have provided a refuge for the exiled emperor, it is now known as the Napoleon House. The sideboard reflects the influence of the Dublin-born cabinetmaker Joseph B. Barry (circa 1760-1838; worked 1804-1822), who arrived in Philadelphia during the 1790s and had by 1804 opened his own shop at 148 South Third Street. Barry became one of Philadelphia's most prominent cabinetmakers and was a competitor of such New York practitioners as Ducan Phyfe (1768-1854) and Charles-Honoré Lannuier (1779-1819, **cat. nos. 150, 151**) and was instrumental in introducing the new Egyptian style to affluent Phildelphians. In this particular piece, the square clipped upper terminals of the carved acanthus leaf bases of the console stiles are handled in a manner consistent with Philadelphia furniture styles. Barry was a master in the handling of richly figured solid woods and veneers, a skill readily observed in this example. **J.P.**

226.

Jose Francisco Xavier de Salazar y Mendoza (born in Mexico, mid-1700s–1802)
Bishop Luis Ignacio Maria de Peñalver y Cárdenas, 1801

Oil on canvas
85 x 52 inches (216 x 132 cm)
Louisiana State Museum, New Orleans, Louisiana

The importance of the Catholic church in New Orleans is implied in this portrait of Bishop Peñalver in the grand manner. As the cartouche indicates, it was commissioned by Charity Hospital. Born and trained in Havana, Cuba, Peñalver (1749-1810) was named the first Roman Catholic bishop of Louisiana and the Floridas in 1793. Protestant visitors to the city often commented on the elaborate processions, involving officials of church and state, on high religious holidays. They also noted the "dissapation [*sic*]," singing, dancing, sports and theater productions that took place after the religious ceremonies on Sundays. **J.P.**

227.

Unidentified Artist, Spanish Colonial School
Virgin and Child, circa 1770

Polychromed wood
15 inches (39.4 cm)
Ursuline Convent Museum and Archives, New Orleans, Louisiana

This small statue was in the chapel of the Ursuline convent for many years. The Child holds the cross. When held by the Child it is a symbol and portent of His ultimate sacrifice. **J.P.**

228.

Various Authors
Annals of the Ursuline Sisters of New Orleans, 1727–1853

Ink on paper, bound
7 x 9-1/4 inches (19 x 23.5 cm)
Ursuline Convent Museum and Archives, New Orleans, Louisiana

The New Orleans Ursulines kept records each year of their business and property transactions, attendance records of their pupils, etc. Many are short, terse entries. Sometimes there are loving and fulsome biographies marking the death of a sister. As Emily Clark has observed, "The documents portray a community of women who were not simple gentle bystanders, but important historical actors who shaped the city of New Orleans and its people in countless ways." **J.P.**

229.

Pierre-François La Fitau (French, 18th century)
Lettres Spirituelle de Messire Pierre-François Lafitau, Paris, 1760

Bound volume, printed by C. Hérissant, Paris
7 x 4 inches (17.8 x 10.2 cm)
Ursuline Convent Museum and Archives, New Orleans, Louisiana

This prayer book was given to the Ursuline Sisters by Bishop DuBourg sometime between 1812 and 1826. The Company of Saint Ursula was a teaching order. In New Orleans, from the beginning, and throughout the colonial period, they educated women and girls of European, Indian and African descent, enslaved and free. Between 1797 and 1803, 245 individuals attended boarding school at the Ursulines. Due to their influence, the literacy rate of women in colonial New Orleans was one of the highest in early America. **J.P.**

229.

Unidentified Artist
Rosary, early 1800s

Wooden beads, some carved, with some plain replacements, metal
44 inches (111.8 cm)
Ursuline Convent Museum and Archives, New Orleans, Louisiana

A rosary, a string of beads, represents a series of prayers, a garland of roses, a form of devotion to the Virgin Mary, consisting of fifteen decades of Ave Marias, each of which is preceded by a Paternoster and ended with a Gloria Patri. Worn as a part of a nun's habit, this rosary was passed down from one Ursuline sister to the other, so several sisters could have worn this rosary. The "Our Father" beads were originally carved, but some have been replaced with plain beads. **J.P.**

231.

Unidentified Artist, New Orleans School
Rectangular table, circa 1780–1800

American black walnut (*Juglans nigra*), joined and pegged construction
26-3/4 x 33-1/4 x 25 inches (68 x 84.5 x 63.5 cm)
Private Collection, New Orleans

The springing curves of the legs of this table, which once belonged to the Ursulines, have an organic quality enhanced by the carefully carved cloven-hoofed, or stag's feet, *pied de biche*. The makers of this and other similar tables in a simplified Louis XV style are unknown. The records of the Ursulines reveal that they purchased wood from time to time and that carpenters were employed. **J.P.**

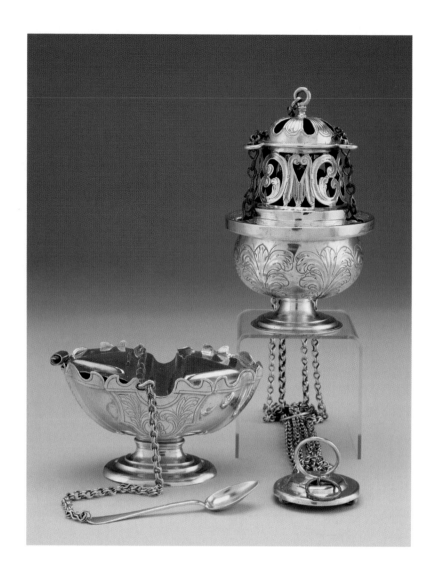

232a.

Unidentified Artist, Spanish Colonial School
Incense Thurible, late 18th or early 19th century
Marked ARATO

Hand-wrought silver
Thurible: 7-3/4 x 4 inches (19.7 x 11.4 cm);
Chain l: 26-3/4 inches (67.9 cm)
Ursuline Convent Museum and Archives,
New Orleans, Louisiana

232b.

Unidentified Artist, Spanish Colonial School
Incense Boat, late 18th or early 19th century
Marked ARATO

Hand-wrought silver
3 x 6-3/4 x 3 inches (8.9 x 17.1 x 8.9 cm); Chain l: 9 inches (22.9 cm);
Spoon: 5-1/4 x 1-1/8 inches (13.3 x 2.9 cm)
Ursuline Convent Museum and Archives, New Orleans, Louisiana

The Ursuline sisters, throughout the vicissitudes of life in a frontier setting and changes in official administrations from French to Spanish, French and then American, adhered closely to the religious rituals and principles of their French-founded order. At Mass, the thurible, or censer, with chains, was the receptacle for burning incense. The boat held the incense. The rising smoke traditionally symbolizes prayers ascending to heaven, Psalm 141:2: "Let my prayer be set forth before thee as incense; and the lifting up of my hands as the evening sacrifice." **J.P.**

Washington May 15 1804

To the Soeur Therese de S.t Xavier farjon Superior, and the Nuns of the order of S.t Ursula at New Orleans.

I have recieved, holy sisters, the letter you have written me wherein you express anxiety for the property vested in your institution by the former governments of Louisiana. the principles of the consti- tution and government of the United states are a sure guarantee to you that it will be preserved to you sacred and inviolate, and that your institution will be permitted to govern itself according to it's own voluntary rules, without interference from the civil authority. whatever diversity of shade may appear in the religious opinions of our fellow citizens, the charitable objects of your institution cannot be indifferent to any; and it's further- ance of the wholesome purposes of society, by training up it's younger members in the way they should go, cannot fail to ensure it the patronage of the government it is under. be assured it will meet all the protection which my office can give it.

I salute you, holy sisters, with friendship & respect.

Th: Jefferson

233.

Thomas Jefferson (American, 1743–1826)
Letter to the Soeur Therese de St. Xavier Farjon Superior; and the Nuns of the order of St. Ursula of New Orleans, Washington, May 15, 1804

Ink on paper
9-1/2 x 7-3/8 inches (24.1 x 18.7 cm)
Ursuline Convent Museum and Archives, New Orleans, Louisiana

Jefferson personally answered a letter from the mother superior of the Ursulines in which she had expressed anxiety as to their continuing right to their property, assuring them, " . . . The principles of the constitution and government of the United States are a sure guarantee to you that it will be preserved to you sacred and inviolate, and that your institution will be permitted to govern itself according to its own voluntary rules, without interference from the civil authori- ty. . . ." **J.P.**

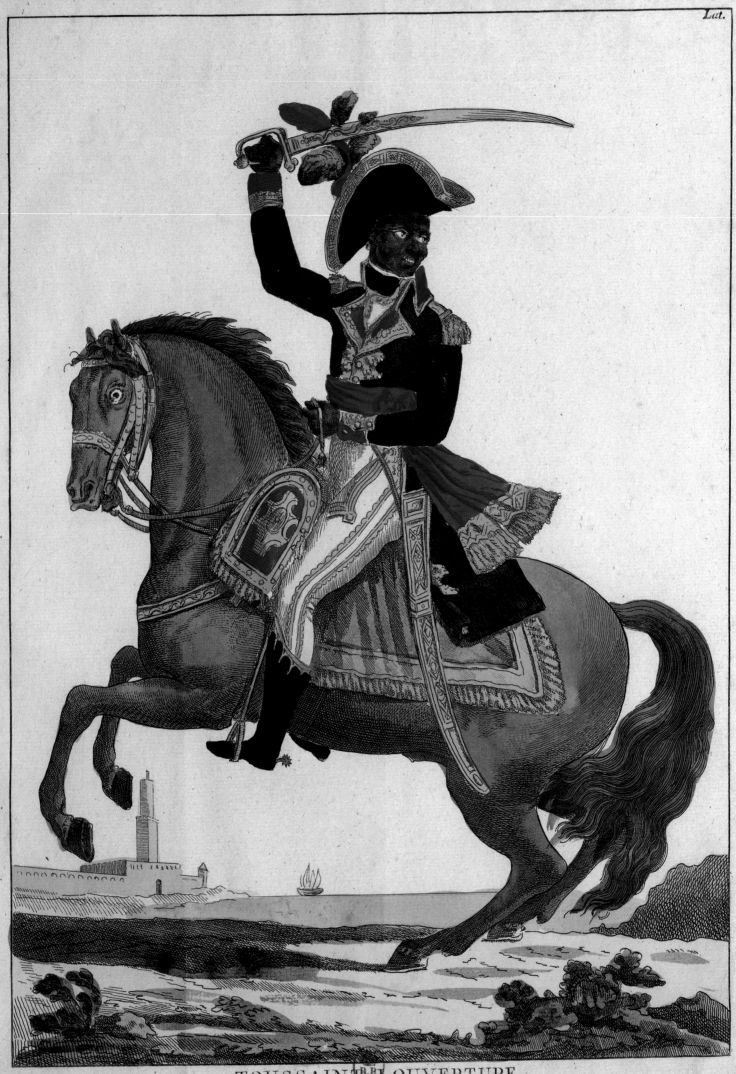

TOUSSAINT LOUVERTURE

Chef des Noirs Insurgés de Saint Domingue.

A Paris chez Jean, rue Jean de Beauvais. N° 10.

FRANCE, SLAVERY, AND THE LOUISIANA PURCHASE

Patrice Higonnet

It is hard to imagine a map of the United States that would not include Louisiana. The inweaving of this former French colony into the American Republic has for us the look of some fated event. Louisiana is today a part of America's manifest destiny, an inalienable part of a nation that links sea to shining sea. And yet, Louisiana's history—and America's as well—might have unfolded very differently. Had Napoleon been of a different frame of mind—less cynical, and less contemptuous of blacks— this territory might have been the focus of a dramatic and dynamic, libertarian movement that could well have transformed the history of America, of France, and of the entire Caribbean world, from Venezuela to New Orleans, via Haiti, Jamaica and Cuba.

In a nutshell, the point here is to ask if the post-revolutionary French state of the late 1790s could have redirected the economic foundation of the French colonial empire (including Louisiana) from slave labor to paid labor in some kind of free, black and white French and Republican commonwealth. That the French could have held on to the vast territories that stretched to the west of the Mississippi seems unlikely, but one could imagine New Orleans and Louisiana remaining French very much as Cuba remained Spanish for another century.

The starting point of this "counter-factual" speculation begins with an understanding of the intensity and thrust of French colonialism in the eighteenth century and, after 1789, of its continuation during revolutionary and Napoleonic times.

In the eighteenth century, France and Britain struggled for world domination in what can be imagined as a second "Hundred Years War," as a conflict that raged—with many interruptions—from 1688 to 1815, from the Glorious Revolution and the battle of the Boyne to the Battle of Waterloo and Napoleon's definitive exile to Saint-Helena. For the French, the war of American Independence was to be the high point of that long struggle; just as the preceding conflict—known as the Seven Years War of 1756-1763—had been for them a great disaster. (That conflict, incidentally, began at Pittsburgh in 1754 when an unknown young officer named George Washington

and a handful of Virginian militiamen defeated a small French force that had come down the Ohio from Canada. The French press, at that time, it will be noted also, vociferously claimed that this young Anglo-American had in fact treacherously ambushed his foes.)

In 1763, in the wake of worldwide defeat, French Louisiana became Spanish; whilst India, on the other side of the globe, fell prey to Britain. But in Paris, during the 1770s and 1780s, the reverses of the Marquis de Montcalm (1712-1759) at Quebec and—before that—of the Marquis Joseph Dupleix (1697-1763) in Madras did not seem irreversible. India might yet, thought the French, become French once again and so might North America. And in any instance, the French presence in the Caribbean was not so severely affected: in 1789, Haiti remained the world's most profitable colony. Egypt we should add also attracted French attention in the 1770s and 1780s: might it not soon become the connecting link between a rejuvenated French empire in the West in the Americas, and an altogether new and eastern empire?

In the early 1790s, the French revolutionaries who now directed their country's foreign policy redirected the ideological message of their nation's imperial goals. France's new, civilizing and libertarian mission was now harnessed to traditional goals of commerce, trade, and power. Many of the Girondins—that is to say, of the anti-Robespierrist Republicans who ruled in Paris from the early spring of 1792 to the late spring of 1793—were prominent members—Jacques Pierre Brissot (1754-1793) especially—of the French antislavery society, modeled in 1788 on the English antislavery society of William Wilberforce (1759-1833). Why not suppose, thought many of these Jacobins, that French colonial victories might bring about the end of the slave trade, indeed, of slavery itself, and—going further—the collapse of the oppressive Spanish empire which at that time included New Orleans.

As it happens, Brissot's schemes came to naught, both as regards either Spanish possessions or Edmond Charles Genet, Citizen Genet's piratical schemes in North America. But French colonial and libertarian schemes did not die for all that. On the one hand, on February 4,

Figure 1: Joseph-Maris Vien, fils (French, 1761–1848) after Robert Lefèvre (French, 1761-1848), *Portrait of Bonaparte as First Consul*, 1803, Oil on canvas, Musée National du Château de Versailles (MV 4633).
Catalogue number 31
©Réunion des Musées Nationaux / Art Resources, NY

1794, the Montagnard Jacobins decreed the abolition of slavery in the French colonies, the first of the great western nations to do so. And on another less ideological but more forceful hand, in 1798, Bonaparte—who had once thought of finding employment in the Turkish army—landed his imperializing army in Egypt and marched on to Cairo. For the socially conservative but still Republican politicians who ruled in Paris, sending this obstreperous young general and his hungry troops to the banks of the Nile, that is to say, far from the French capital, was in itself—from their point of view—a very good idea; and who was to say? His expedition might after all succeed and provide France with a stepping stone to Bombay and the reconquest of India.

As we know, however, after some initial and spectacular successes, Bonaparte did not in the end move on from Cairo to Bombay. But he did succeed in his move back to Paris, where on 18th Brumaire (November 9, 1799), he became First Consul and de facto the dictator—if in time—of the French Republic (*fig. 1*).

Now the stage was set for a renewed French and now Bonapartist drive for colonies. But where and how? In what ideological context would the French make their moves? And here was the pivotal question that Napoleon would have to resolve: would he go forward in the Jacobin context of 1794 when slavery had been abolished? Or would he instead renounce this past and restore slavery? More specifically, this was to ask if Louisiana might become part of a free Franco-African commonwealth of a kind. Or would it go on instead as a slave society?

In brief, the story as it unfolds here will be that Napoleon—largely from racial prejudice—made the wrong decision. He no doubt should have struck a compromise with the now free blacks of Saint Domingue (the modern Haiti). But his resolve as regarded France's Caribbean islands—and her African and Asian possessions also—was to repress rather than to encourage former black slaves, which choice meant in turn that he was then doomed to fail dramatically as a colonialist everywhere. Restated, because of Napoleon, Haiti became independent; other French islands were captured by the British; and all of this left him no choice in turn but to cede Louisiana to the newly created United States.

But history might have been otherwise. A "counter-factual account" of what might have been (i.e., the durable recasting of Louisiana as a free black and French-run colony rather than as a slave state in the new American Union) brings to mind various questions: could the French—had they decided on this course—have counted on the support of free blacks? To this we can answer: Yes. Were French possessions in the new world capable of functioning as free black societies? The answer here would be: Probably. And was there in the post-revolutionary France of 1800 a political base that would have supported such a libertarian American policy? Perhaps.

II

Louisiana at the end of the eighteenth century was in its social structure much more like the Caribbean islands than the neighboring slave states of the Anglo-American South. In its theory and—up to a point—in its practice, southern American society was dichotomous: whites were free and blacks were not. Free blacks of course existed, and many "blacks" (like Thomas Jefferson's African-American children) were in truth more white than black. But the organizing principle of social life was, as it were, drawn in black and white.

Louisiana by contrast, in both practice and theory, was a three-caste system as were most of the Franco-Spanish black colonies. Cuba, for example, was one-third white, one-third slave, and one-third free people of color. The Spanish authorities, moreover, were keenly aware that the social balance of Louisiana was precariously set: other workable social-political solutions might well be found, and they tried in consequence to freeze the system as it

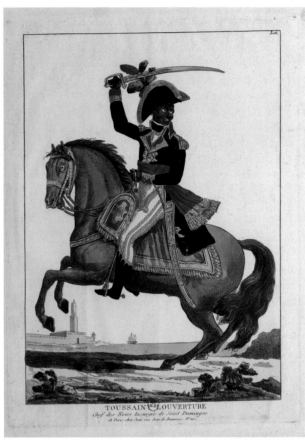

Figure 2: Unidentified Artist, French School, *Toussaint Louverture, Commander of the Black Insurgents of Saint Domingue*, 1803, Bibliothèque Nationale de France, Paris (N2 cliché no. 92 B128.211). Catalogue number 252a

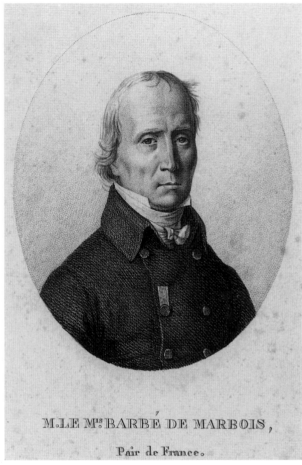

Figure 3: Unidentified Artist, French School, *Portrait of François Marquis de Barbé-Marbois (1735–1847)*, Engraving on vellum, Musée de la Coopération Franco-Américaine, Château de Blérancourt, France (CFAa 541). Catalogue number 248
©Réunion des Musées Nationaux / Art Resources, NY

was from fear of what might happen next: in 1786, for example, they forbad the importation of new slaves as they forbad in May 1790 the arrivals of any persons of African origin, whether free or unfree. For good measure in 1792, they also declared illegal any migration, white or black, from all British Caribbean possessions, so many interdicts that did not keep a thousand migrants free and unfree to flee to New Orleans from Haiti between 1790 and 1800. (Ten thousand more arrived from there after the American annexation of the Louisiana Territory.)[1]

In brief, then, Spanish colonial policy in Louisiana—like the American polity that succeeded it—was geared to the (frail) domination of the white planter class, but other social arrangements could have been found if political circumstance had differed, and Haiti was in the 1790s the best example of such an alternative.

Toussaint Louverture (circa 1744-1803) has now become a quasi-mythical personage (*fig. 2*). Born in 1743, this former slave who defeated both British and French invaders, but only to die a tragic death in a mountainous, cold, and Napoleonic prison, has become the auratic and even legendary father of his Caribbean nation. But it is possible

to think of him more modestly also as did Henry Adams who described him as "gentle and well-meaning in his ordinary relations, vehement in his passions, and splendid in his ambitions. . . . Toussaint," adds Adams, "was a wise, though a severe ruler so long as he was undisturbed . . ."[2] And it may even be better yet to think of him as a shrewd politician who had perfectly understood the world-historical message of the French Revolution as it emerged after the fall of Robespierre and during the Directory in 1795 to 1799. Like the French Republicans who moved around Emmanuel Joseph Sieyès (1748-1836), he too realized that the message of the new republics—in France or Haiti—were they to survive, would have to be at once ideologically universalist and pragmatically "bourgeois."

So it was that Toussaint, for example, deliberately adopted the radical, Jacobinical language, forms, and ideological message of 1789, as it had been amplified by the Jacobins in 1794 with the abolition of slavery: Toussaint had white companions and advisers, like Colonel Malenfant

who was sent from Paris to Haiti by the ruling Directory. Nor, of course, was this envoy an anomaly: the impact of French revolutionary principles ran deep in Haiti. Symbolically, it matters that many of the French and Republican soldiers that had been sent to Haiti were puzzled and upset to hear black soldiers singing French revolutionary songs.[3] And, of course, what had happened in Haiti—namely the creation of a neo-African but free and Frenchified society—might well have happened in Louisiana. In his memoir of 1829 entitled *Histoire de la Louisiane et de sa cession*, François Marquis de Barbé-Marbois *(fig. 3)* (who had been a consul in the United States, a French official in Haiti, and who was to be a minister both under Napoleon and Louis XVIII) thought, for example, that a French occupation of Louisiana would inevitably have meant the end of slavery in that colony, regardless of what Paris wanted: Louisianian slave owners would have rebelled, perhaps, but emancipation would have occurred in any case, especially as "public reason" felt that this should be so.[4]

But Toussaint was a realist: like Nelson Mandela and the African National Congress in their own times, Toussaint in the late 1790s did not think that black political supremacy implied the dispossession of whites, whose agricultural and commercial skills were at the time irreplaceable. So it was also, therefore, that Toussaint ordered the execution of the defeated and intransigent General Moyse—whom he had once adopted as his nephew—a truly revelatory gesture since Moyse's goal had been in northern Haiti to confiscate both white-owned lands as well and the newly acquired estates of black generals, so as to distribute them, together with state-owned lands, to landless black families. As the black militant C. L. R. James was to put it, Moyse was the soul of the insurrection. His death was a turning point for James, but we can see it also in another light.

For James, with Moyse's execution, Toussaint broke the morale of the black masses, and labored to reassure the whites.[5] But we can interpret Toussaint as a pragmatic if occasionally ruthless politician who had a prudential eye to the colony's economic development and to its geopolitical situation as well. Free Haitian blacks had many natural enemies, surrounded as they were by slave empires, of Spain in Cuba, Britain in Jamaica, and of the United States. They needed to be prudent. An alliance with the French Republic, which presupposed a pro-white economic policy, made "realpolitik" sense from Toussaint's perspective.

Toussaint understood this, and so did the French and the English. On October 13, 1801, in an amazingly revealing letter to the court of Saint James, Napoleon's minister of foreign affairs, Charles-Maurice de Talleyrand Périgord (1754-1838) (whose master had by that time decided to oppose Toussaint) warned London that the alternative to a French reconquest that aimed to restore slavery might be a libertarian Haitian solution that the French would have no choice but to accept. In his instruction to the

French ambassador, Talleyrand urged him to explain to his British counterpart that "if the first consul had to postpone this expedition to some other year, (France) would then be obliged to recognize Toussaint (diplomatically), to forego Santo Domingo, and to constitute French blacks, which would no doubt be disadvantageous to French commerce but which would do a great deal for the French Republic's military might . . . A black government of Santo Domingo legitimated by France would invariably be a formidable power base in the new world . . . because this new state once constituted would sooner or later wield the scepter of the new world, and the consequences of such a shock would be incalculable for England, whereas for France, such a development would merely fit into the effects of the Revolution."[6] The message was clear enough and it was clearly understood as well: after a visit to Prime Minister Henry Addington's private residence, Otto, the French ambassador wrote back to Paris that the British prime minister also believed that "the interests of the two governments are absolutely identical: it is to destroy jacobinism, and especially the jacobinism of blacks."[7] And conversely, on the other ideological shore, English abolitionists like Wilberforce and Stephen (who wrongly thought of Napoleon as the heir rather than the enemy of the Revolution) hoped instead that France would prevail over Britain in the Caribbean since a French victory—they thought—would mean the end of slavery in that corner of the globe.[8]

III

On 18th Brumaire (November 9, 1799) Napoleon seized power in France (**cat. no. 30**). For some few months, Napoleon was obliged to manage his hand carefully. The Republican friends of Sieyès, who had become second consul, could not yet be blatantly ignored. His victory at Marengo on June 14, 1800, when he was almost defeated, consolidated his position decisively, however, and he was now able to pursue his colonial dreams as he wished.

A first step taken with the help of Talleyrand, who had outlived the disgraceful notoriety he had incurred with the XYZ affair (**cat. no. 241**), was to secure a free hand by liquidating old disputes with the United States, which was done on September 30, 1800, when French and American diplomats signed the Treaty of Mortefontaine that was ratified with some modifications by the American Senate on December 19, 1801. The next step was to strike an agreement with Spain so as to recover possession of the Louisiana Territory. To this, Madrid readily accepted for a variety of reasons: first, they did not think they had much choice; second, Italian principalities struck them as adequate compensation. Finally, it seemed a good idea from a Spanish point of view, to place France as a buffer between the newly republicanized thirteen colonies and their own Mexican and Caribbean empires. In 1795, Spain

had ceded to France the eastern half of Santo Domingo, and the acceptance of French sovereignty in Louisiana as well as in west and east Florida fitted nicely into Spain's wider and precautionary goal. On October 1, 1800 (one day after Mortefontaine), France and Spain agreed that the French flag should once again be raised at New Orleans (**cat. no. 237**). (Bonaparte had also pressed to get Florida in exchange for more Italian principalities, but Florida was too close to Cuba, and, there, Manuel de Godoy (1767-1851) rebuffed him.)

Economically and strategically, the acquisition of Louisiana made excellent sense from a French colonial perspective: on the one hand, Port-au-Prince in the south and New Orleans in the north would become the two great naval bases of French power in the new world. In addition, North American agricultural produce, when shipped downriver from the Mississippi basin would then be exported to Haiti, to Guadeloupe and to Martinique, whose sugar and other colonial staples would then be exported to France and re-exported from there to central Europe and to the Levant.

So far so good. But politically, how was this to be done? Would France accept Toussaint's offer to support French military goals in exchange for the recognition of Haiti's internal autonomy as a free black society? Or would the French instead choose to begin by undoing the emancipation of February 1794 and restore slavery instead?

To choose freedom in Haiti would necessarily have implied freeing blacks in Louisiana also. An empire divided against itself could not stand. Conversely, to chose repression at Port-au-Prince also meant that Louisiana—now a vital part of a new French slave empire—would also remain a slave colony, and one, incidentally, that the French would defend at all costs against both America and Britain. In either of these two fateful instances, the historical future of the territory was now at stake.

But as every schoolboy knows, Bonaparte chose repression in Haiti and then lost. Louisiana, having now become suddenly useless, was ceded for a pittance to the United States, to the dismay, incidentally, of the Spaniards whose calculations were instantly reversed.

Initially, as has been said, Bonaparte did not make his intent completely clear. On December 25, 1799, for example, in a proclamation addressed to the "Braves Noirs de Saint-Domingue" the First Consul promised to uphold the decree of 16 Pluviose (on the abolition of slavery). Later, he likewise wrote a mendacious letter to Toussaint asking him to "assist the Captain-General [Leclerc, who was Bonaparte's brother-in-law (*fig. 4*)] with your counsels, your influence, and your talents. What can you desire? The liberty of the blacks? You know that in all the countries where we have been, we have given it to the peoples who did not have it."[9] But in his *Observations* of 1824, Colonel Vincent, who had been on the spot at the time, gave a more accurate rendition of Bonaparte's true

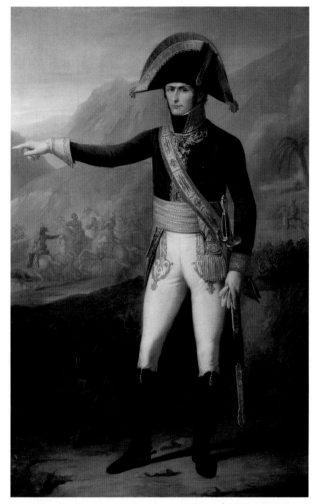

Figure 4: François Joseph Kinson (French, 1770–1839), *Portrait of General Charles Victor Emmanuel Leclerc, General in Chief of the Army of Saint Domingue in 1802,* 1804, Oil on canvas, Musée National du Château de Versailles, France (MV 1217). Catalogue number 251 ©Réunion des Musées Nationaux / Art Resources, NY

feelings: "one can't repeat too often that the first consul never wanted to negotiate with blacks."[10]

It would be hard to imagine tactics of counter-insurgency that were more brutal than those that Bonaparte's emissaries deployed against the free blacks of Haiti. To destroy Toussaint Louverture and restore slavery, Leclerc proposed for example to destroy "all the negros in the mountains, men and women, keeping only infants less than twelve years old [we must not leave] in the colony . . . a single man of color who has worn an epaulette."[11] And Leclerc's successor, General Rochambeau (1725-1807)— whose father ironically had commanded French troops during America's War of Independence, and of whom even Leclerc wrote that he did not like blacks—was even worse: particularly egregious was his decision to buy fifteen hundred especially trained "slave-dogs" in Cuba at 500 to 600 francs a piece. "The slavery of blacks in these parts," he

wrote, "must be proclaimed anew; and the Black Code made much more severe. I even think that for a while, masters should have a right of life and death over their slaves."[12] Needless to say, blacks (whether wholly of African origin or not) soon understood what was at stake and fought to the death to oppose French reconquest. Typically, in May 1802, a Haitian commander named Delgrès, blew himself up with his fort and troops rather than surrender to the French.

Why did Bonaparte choose this repressive course? Curiously, Josephine (Napoleon's wife and an ageing Creole beauty born in the Martinique) appears to have nothing to do with the case. Equally curious is Henry Adam's explanation, namely that Napoleon refused to negotiate with Toussaint for fear that he would be likened to this man, whom he labeled "that gilded African." Corsica, some might reason—or so Henry Adams assumed—was not all that different from Dahomey. Toussaint's regime might be compared to his own as "a sort of negro travesty on the consular *régime*." Here was a "parallelism," thought Adam, that roused Napoleon's anger, and precipitated a conflict that had vast influence on human affairs."[13] Perhaps. In any instance, however, there can be no ambiguity about Napoleon's feelings as regarded race, and it is worth noting that the decision to reconquer Haiti and Guadeloupe as slave colonies went along with anti-African legislation in France itself: On 30 Floréal (May 29, 1802) Paris and coastal cities were forbidden to blacks and persons of mixed African and European origin. On June 25, 1802, such persons were forbidden to land in France at all; and on January 8, 1803, mixed African and European marriages were forbidden also.

But re-enslaving former slaves who have recently been freed is no easy task. Haitian resistance, combined with the effect of tropical diseases on Leclerc's soldiers—and on himself—soon brought Bonaparte's imperialist fantasies to an abrupt halt. The French had intended to conquer and enslave Haiti, but a free Haiti conquered them instead. And, in consequence, French policy veered from one geopolitical extreme to the other nearly from one day to the next, an abrupt reversal that should not surprise us since Bonaparte was used to cutting his losses sharply, as when he had abandoned his army in Egypt, cut off as it was from France by Nelson's victory at Aboukir.

On January 7, 1803, news arrived in Paris that Leclerc was dead; his army, decimated; and the colony, ruined. On April 12, Monroe arrived in Paris. On April 30, 1803, Napoleon sold Louisiana to the United States. On May 18, war broke out again between France and England. And on December 20, New Orleans was handed over to the Americans. Bonaparte's eyes now turned once again towards Malta, Egypt, and India: France had lost a colonial empire in the West, but she would gain one in the East. Meanwhile, on April 7, 1803, Toussaint, captured in June 1802 by treachery, died of cold and misery in the fort of Joux, set in the mountainous French Jura, close to the Swiss border.

America's role in all of this, we might add, was not exemplary. At first, Jefferson's envoys had desultorily assisted Toussaint; but the proclamation of Haiti as a "quasi-state" that asserted its internal autonomy gave the (slave-owning) author of the Declaration of Independence some pause: when the French ambassador to the United States Louis André Pichon suggested that a joint effort to subdue Toussaint might be in the interests of both France and America, Jefferson seemed conditionally interested at least. As Pichon reported back to Paris, New Englanders might look forward to an increased trade with free blacks, but that same prospect was anathema to American southerners.[14]

Basically, Jefferson's America wanted a free hand on the continent: "If the French are really going to land ten thousand men in Louisiana," Jefferson explained to Pierre Samuel Dupont de Nemours (1739-1817) in 1802, "from that moment we must marry ourselves to the British fleet and nation."[15] What would he have said if Napoleon had decided to send ten thousand soldiers to Louisiana where slaves might have had been freed after the elaboration of some similar arrangement with Toussaint?

Bonaparte's repressive policy could not have failed more dramatically. But did he really have a choice? Was there in France at the time an audience that might have supported the creation (or re-creation) of a Caribbean colonial empire that would have respected the Jacobins' abolition of slavery? To this question, we can propose two responses, one anecdotal, and the other more structural.

Anecdotally, we know that in Paris, individual figures here and there were hostile to the restoration of slavery. For example, Mme de Staël (1766-1817)—who was the leading intellectual figure of her day—favored the re-conquest of the colonies, but was opposed to the reestablishment of servitude. Opponents of the slave trade—like Benjamin Constant (1767-1830)—were numerous in France. Very curious also are the "quasi-libertarian" statements of former colonialists. Just as prudential South African whites recently reasoned that political concessions were the only way to salvage established social and economic positions, so did many French planters in 1799 to 1800 favor the status quo as Toussaint had defined it. France would not succeed, they thought, in restoring slavery, and trying to do so would make for chaos, which of course is precisely what occurred. At stake here, for example, are the pronouncements of a former colonial agent, Page (1762-1805). Haitian independence was inevitable, he thought. France should accept the verdict of revolutionary politics on this issue, in Haiti and in Africa as well.[16] Much the same was prophetically argued by Paul Alliot-Vauneuf in a report presented to an assembly of planters and colonial officials. The reconquest of the island was a difficult assignment. Disease there was rampant, and "supposing that our armies

succeeded in reconquering this colony by the force of arms, what would result from it? The assassination of all the whites who are still there; the devastation of all the plantations and "habitations"; and the destruction of more than one hundred thousand of our soldiers."[17]

Structurally, the issue is of course ambiguous. Once Bonaparte had come to power in Paris, the prospect of a libertarian and biracial, post-revolutionary French commonwealth was doomed. But was Bonaparte's coming to power itself inevitable? Obviously, no definitive answer to that question is ever to be found. But the Directorial period—which is the least studied moment of the history of France before, during and after the Revolution of 1789—was politically fluid still; and we cannot rule out the idea that a bourgeois and parliamentary, but nonetheless Republican, solution might have emerged in France after the fall of Robespierre in July 1794. Had General Bonaparte died at Arcole, had General Hoche not succumbed to tuberculosis, the fate of North America—and Louisiana—might well have been very different from what in fact occurred.

None of the players (the French, the English, or the Americans), wrote Henry Adams, "grasped the whole truth, or felt their own dependence on Toussaint's courage. If he and his blacks should succumb easily to their fate, the wave of French empire would roll on to Louisiana and sweep far up the Mississippi; if St.Domingo should resists, and succeed in resistance, the recoil would spend its force on Europe, while America would be left to pursue her democratic destiny in peace."[18]

And one can go one step further. The victorious French empire that Adams had in mind was the one that Napoleon envisaged. But yet another and altogether different French empire might have been founded after 1800, and the effect of that libertarian historical trajectory in Haiti and in Louisiana would truly have amazed the world.

Notes:

1. Joseph Zitomersky, "Culture, classe ou Etat? Comment interpréter les relations raciales dans la grande Louisiane francaise avant et après 1803?" in Dorigny and Rossignol, La France et les Amérique au temps de Jefferson et de Miranda (Paris: Société des études Robespierristes, 2001), 70.

2. Henry Adams, A History of the United States during the Administration of Thomas Jefferson 1801-1805 (New York: Boni, 1930), 1: 382.

3. As at Cret-à-Pierrot, an incident described in Yves Benot, La Démence coloniale sous Napoléon (Paris: Decouverte, 1992), 80.

4. "La disposition des esprits est favorable à l'affranchissement; c'est en vain que les colons et les planteurs veulent aller à l'encontre d'un mouvement que la raison publique approuve." See Barbé's Histoire de la Louisiane et de sa cession, 129, cité in Benot, La Démence, 331, note 1.

5. C. L. R. James, The Black Jacobins (Vintage: New York, 1963), 278.

6. "Vous ferez sentir que si le premier consul devait remettre cete expédition à une autre année, il se verrait dans la nécessité de reconnaitre Toussaint, de renoncer à Saint-Domingue et d'y constituter des Noirs français, ce qui sans doute ne serait pas avantageux au commerce de la république, mais pourrait l'être beaucoup a sa puissance militaire. . . . (L)e gouvernement des noirs reconnu a Saint-Domingue et légitimé par la France serait dans tous les temps un point formidable d'action dans le Nouveau Monde. . . . (car) cette nouvelle puissance ayant été une fois constituée et reconnue, le sceptre du Nouveau Monde serait tot ou tard tombé dans ses mains et les conséquences d'une pareille secousse sont incalculables pour l'Angleterre, tandis que pour la France, elles se seraient confondues avec celles de la révolution." Benot, Démence coloniale, 82.

7. Benot, Démence, 59-60. "L'intéret des deux gouvernements est absolument le meme: c'est de détruire le jacobinisme, et celui des noirs surtout."

8. Benot, Démence, 63. See also Robert Isaac Wilberforce and Samuel Wilberforce, The Life of William Wilberforce by his Sons (London: J. Murray, 1838), 3: 42

9. Adams, History, 393.

10. Cited by Benot, Démence, who quotes Vincent's Observations of 1824: "on ne saurait trop le répéter, le premier consul n'a jamais voulu traiter avec les noirs."

11. Adams, History, 415.

12. Benot, Démence, 83. "L'esclavage des Noirs doit etre proclamé de nouveau dans ces parages; et le Code noir rendu beaucoup plus sévère. Je pense meme que pour un temps les maitres doivent avoir le droit de vie et de mort sur leurs esclaves."

13. Adams, History, 383.

14. Marie-Jeanne Rossignol, "A la recherche d'une diplomatie post-révolutionnaire: Louis-André Pichon, chargé d'affaires à Washington 1801-1804," in Marcel Dorigny et Rossignol, La France et les Amériques au temps de Jefferson et de Miranda (Paris: Société d'études robespierristes, 2001), 21.

15. Adams, History, 411.

16. Cited in Benot, Démence, 52.

17. Cited in Benot, Démence, 53. "En supposant que nos armées puissent reconquérir cette colonie par la force des armes, quels en serait le résultat? L'asassinat de toute la couleur blanche qui existe encore; la dévastation de toutes les plantations et les habitations, et la destruction peut-être de plus de cent milles hommes armés."

18. Adams, History, 390-91.

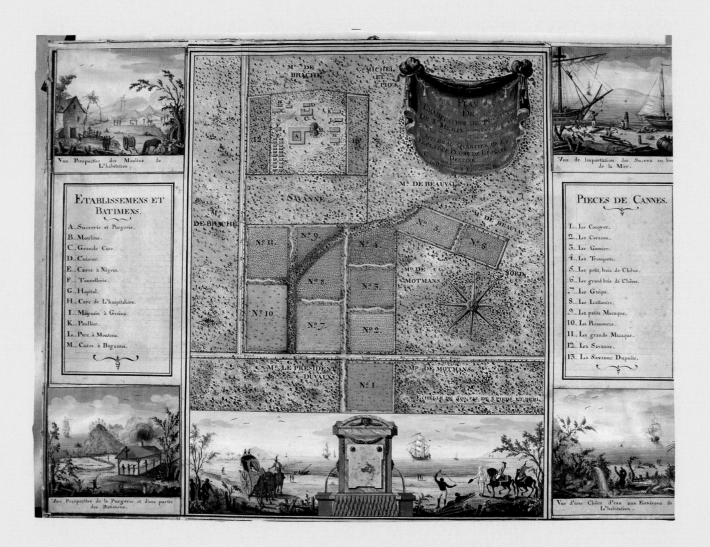

Vue Perspective des Moulins de
L'habitation.

Vue de l'exportation des Sucres au bord
de la Mer.

ETABLISSEMENS ET BATIMENS.

A..Sucrerie et Purgerie.
B..Moulins.
C..Grande Case.
D..Cuisine.
E..Cases à Nègres.
F..Tonnellerie.
G..Hopital.
H..Case de L'hospitalière.
I..Magasin à Grains.
K..Poullier.
L..Parc à Moutons.
M..Cases à Bagasses.

PIECES DE CANNES.

1..Le Cocoyer.
2..Le Caracou.
3..Le Gomier.
4..La Trompette.
5..Le petit bois de Chêne.
6..Le grand bois de Chêne.
7..Le Guipa.
8..Le Lattanier.
9..La petite Macaque.
10..La Ressource.
11..La grande Macaque.
12..La Savanne.
13..La Savanne Dupuits.

Vue Perspective de la Purgerie et d'une partie
des Batimens.

Vue d'une Chûte d'eau aux Environs de
L'habitation.

234.

United States Senate Authorization of the Louisiana Purchase
(Instrument de ratification par le président des États Unis,
Jefferson instruite de cession de la Louisiane), April 30, 1803
Signed by Thomas Jefferson in Washington, October 21, 1803

10 x 15-3/4 inches open, double page (25.4 x 40 cm)
Ministère des Affaires Etrangères, Paris (1800 0010 (11))

Three documents cemented the purchase of the Louisiana Territory
from France by the United States: the Treaty and two conventions
for payment. On April 30, 1803, the Treaty, written in French, was
initialed by the chief negotiators of the Purchase: François Marquis
de Barbé-Marbois (1735–1847), Robert Livingston (1746–1813) and
James Monroe (1758–1831). The English translation was signed on
May 2. The two governments were to ratify the Treaty and exchange
copies by October 30. Jefferson presented the Treaty to the Senate
for authorization on October 17, which passed by a vote of twenty-
four to seven. On October 21, Jefferson signed this Instrument of
Ratification for the Treaty and the two conventions. **V.C.**

235.

Louisiana Purchase Convention for Payment of Sums Due to U.S. Citizens, 1803
Signed by Napoleon Bonaparte

Parchment, bound in silk velvet covers with silk cords and gold skippet attached
Document: 15-1/4 x 10-1/4 inches (38.74 x 26.04 cm);
Skippet: 5-1/4 inches diameter (15.34 cm)
National Archives, College Park, Maryland

This is one of the two conventions arranging payment for the Louisiana Purchase. In this convention signed by Napoleon Bonaparte, the United States agreed to assume financial claims made by its citizens against France for loss of property resulting from the "quasi-war" during the Adams administration. **V.C.**

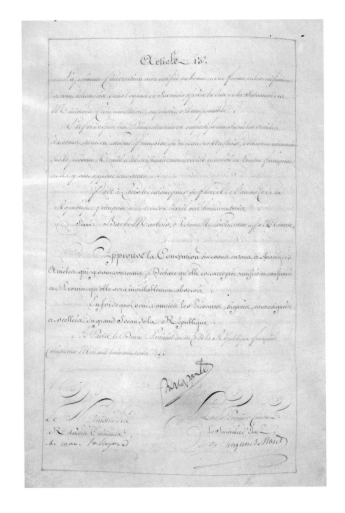

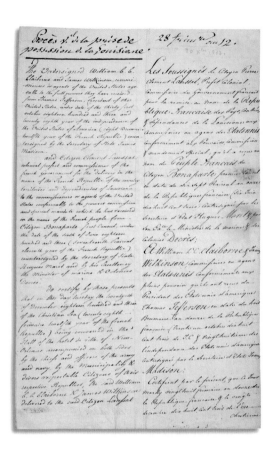
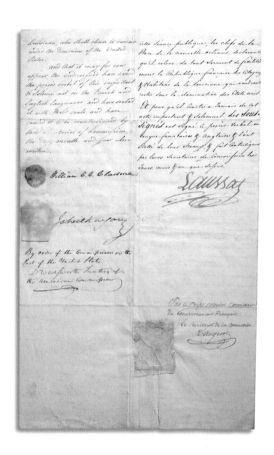

236.

Official Report of the Transfer of the Louisiana Territory (Proces verbal de prise de possession de la Louisiane),
December 20, 1803
Signed by William C. C. Claiborne, James Wilkinson and Pierre Clément Laussat

14-15/16 x 7-4/5 inches (38 x 20 cm)
Ministère des Affaires Etrangères, Paris (1803 00010 (16))

The *proces verbal* transferring the governance of the Louisiana Territory from France to the United States is written in both languages. It was signed by the French prefect Pierre Clément Laussat (French, 1756–1835) and American generals William C. C. Claiborne (1775–1817) and James Wilkinson (1757–1825) on December 20, 1803, at the Cabildo, the seat of government in New Orleans. Jefferson appointed Claiborne and Wilkinson as the territorial commissioners of Louisiana. Jefferson officially commissioned Claiborne to serve as governor in 1804 after failing to convince the Marquis de Lafayette (**cat. no. 5**) to move to New Orleans to take the position. **V.C.**

237.

Treaty of San Ildefonso, ratified by the King of Spain, October 1, 1800

14-1/3 x 9 inches closed (36.5 x 24.3 cm)
Ministère des Affaires Etrangères, Paris (1800 0005)

Signed on October 1, 1800, the Treaty of San Ildefonso was a secret agreement by which Spain retro-ceded the Louisiana Territory to France. In exchange, Bonaparte was to give the Grand Duchy of Tuscany to the Duke of Parma. Under the terms of the agreement, Bonaparte was not to cede the territory to a third party. The terms of the Treaty of San Ildefonso remained a secret to the United States for about two years. After the Louisiana Purchase Treaty was signed, Spain lodged a protest with Jefferson, a situation that the president recounted to Livingston: ". . . Spain had entered with us a protestation against our ratification of the treaty, grounded 1st on the assertion that the First Consul had not executed the conditions of the treaties of cession: & 2nd that he had broken a solemn promise not to alienate the country to any nation. We answered that these were private questions between France & Spain, which they must settle together; that we derived our title from the First Consul & did not doubt his guarantee of it." **(cat. no. 238) V.C.**

238a.

Thomas Jefferson (American, 1743–1826)
Letter to Robert Livingston informing him that James Monroe has been dispatched to Paris, February 3, 1803

Ink on paper,
9-3/4 x 8-1/4 inches (24.76 x 20.95 cm)
Museum of the City of New York, New York. Gift of Goodhue Livingston (47.173.263 Box 155 Cabinet 3)

In this letter of February 3, 1803, Jefferson informed Robert Livingston that James Monroe had been dispatched to Paris to facilitate the treaty negotiations. He writes, "we must know at once whether we can acquire N. Orleans or not." Monroe's popularity with the Federalists, as Jefferson explains, "crushed at once and put an end" to their attempts to block Senate approval of the purchase of Louisiana. **V.C.**

238b.

Thomas Jefferson (American, 1743–1826)
*Letter to Robert Livingston informing him that troops have moved
into New Orleans to keep the peace during the transfer of the
Louisiana Territory to the United States*, November 4, 1803

Ink on paper
9-3/4 x 8-1/4 inches (24.76 x 20.95 cm)
Museum of the City of New York, New York. Gift of Goodhue
Livingston (47.173.263 Box 155 Cabinet 3)

After imparting a bit of gossip concerning the marriage of
Elizabeth Patterson of Baltimore to Bonaparte's younger brother,
Jérôme, Jefferson detailed the serious debates in the United
States concerning the Louisiana Purchase. He assured Livingston
that although there remained Federalists who opposed the
Purchase, they were unable to secure enough votes to block
its ratification. **V.C.**

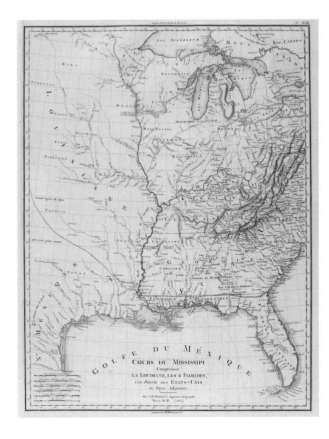

239.

Robert Livingston (American, 1746–1813)
Letter to Joseph Bonaparte Arranging Payment for the Louisiana Purchase, May 8, 1804

Ink on paper
9 x 8 inches (24.5 x 20 cm)
Musée de la Coopération Franco-Américaine,
Château de Blérancourt, France (MNB 50 D 4)
©Réunion des Musées Nationaux / Art Resources, NY

Once treaty negotiations were complete, Livingston wrote in French to Joseph Bonaparte, the brother of the First Consul, concerning payment. The United States received loans from Baring and Company in London and Hope and Company in Amsterdam to finance the Purchase. **V.C.**

240.

J. B. Poirson (French, 18th–19th century)
Map of the Louisiana Territory, 1803

Color engraving on paper
31 x 24 inches (80 x 60 cm)
Musée de la Coopération Franco-Américaine,
Château de Blérancourt, Paris (CFA b 3)
©Réunion des Musées Nationaux / Art Resources, NY

Although the exact limits of the western border of *Louisiane* were never defined with precision, this 1803 French map gives an impression of the immense size of the territory. **V.C.**

241.

Artist Unknown, British School
*Property Protected à la Françoise:
the XYZ Affair*, 1798

Hand-colored engraving on paper
10-1/4 x 16-15/16 inches (26 x 43 cm)
Lilly Library and Art Museum, Indiana
University, Bloomington, Indiana (3085)

This British caricature of 1798 pokes fun
at the bribery scandal known as the XYZ
affair. Talleyrand, the French foreign
minister, demanded a bribe from American
commerce negotiators through three inter-
mediaries identified as Messrs. X, Y, and
Z. The incident so outraged President
John Adams that the two countries nearly
went to war. In this engraving, a female
personification of America is sacked by
five Frenchmen while five figures repre-
senting other European nations watch.
V.C.

242.

Laurent Dabos (French, 1761–1835)
*The Restitution of Louisiana to France including
Signatures and Portraits*, 1801
Signed on lower left: *Citoyen Dabos, artiste peinture,
rue de la Loi no 1256 Paris*

Oil on canvas
23-1/4 x 22 inches (59 x 56 cm)
Musée Marmottan, Paris (1216)
©Musée Mamottan, Paris, France / Giraudon-Bridgeman
Art Library

This painting includes a number of objects that
commemorate the Treaty of San Ildefonso. The objects,
including facsimiles of documents and portraits of Charles
VI, the king of Spain, and First Consul Bonaparte, seem as
if they were held under broken glass, a kind of painting
known as *trompe l'oeil*, meaning "to fool the eye." **V.C.**

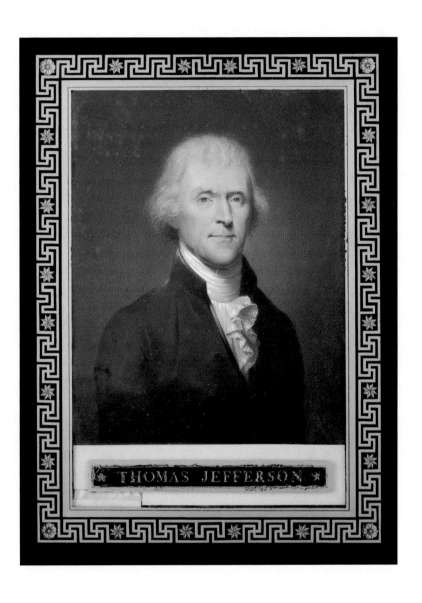

243.

Bouch (French, 18th-19th century) after Rembrandt Peale (American, 1778–1860)
Portrait of Thomas Jefferson, 1801

Pierre noire and chalk on paper
20-7/8 x 17 inches (53 x 43 cm)
Musée National du Château de Malmaison, Rueil-Malmaison, France (MM58-7-2)
©Réunion des Musées Nationaux / Art Resources, NY

This drawing is a copy of a print after the portrait of Thomas Jefferson by Rembrandt Peale now in the Peabody Institute, Baltimore. The picture was probably a gift to Bonaparte by Livingston and Monroe during the Louisiana Purchase negotiations. The American president's simple dress was austere in comparison to men's fashion in consular France. **V.C.**

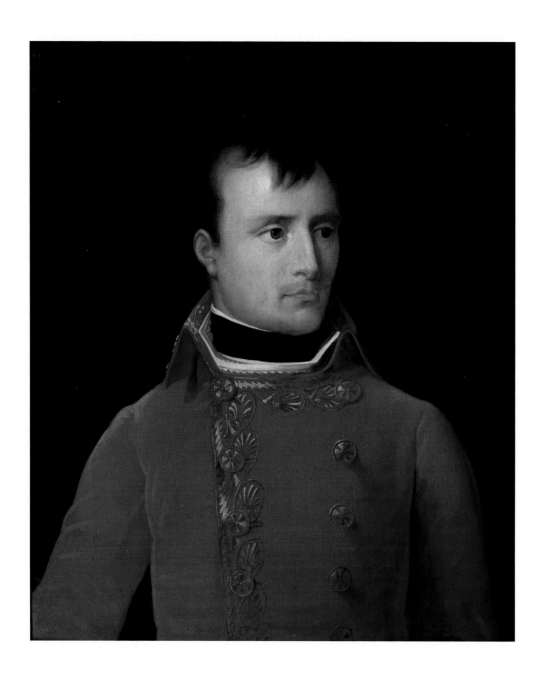

244.

Attributed to Joseph Franque (French, 1774–1860)
Portrait of Bonaparte as First Consul, circa 1803

Oil on canvas
25 x 20-1/5 inches (65 x 53 cm)
Musée Marmottan-Monet, Paris
Musée Mamottan, Paris, France /
Giraudon-Bridgeman Art Library

Bonaparte rarely posed for pictures, but many artists answered the need for images of the French leader by using other portraits as their models. This painting appears to be based on the full-length portrait by Baron Gros now at the Legion of Honor in Paris. He is shown as First Consul, in the distinctive red consular uniform. **V.C.**

245.

Gilbert Stuart (American, 1755–1828)
Portrait of Chancellor Robert Livingston, 1794

Oil on canvas
35-7/16 x 26-7/8 inches (91 x 68.3 cm)
The Museum of the City of New York, New York.
Gift of Evelyn Byrd Hawkins in memory of her
husband, Dexter Clarkson Hawkins (66.65)

As Jefferson's minister to France from 1801 to 1805, Livingston (1746–1813)
was a key figure in the negotiations for the Louisiana Purchase. He had
long been a player in New York politics, having served as delegate to the
Second Continental Congress and chancellor of the state's supreme
court. He also was part of the committee that drafted the Declaration of
Independence, and the person who administered the oath of the president
to George Washington in 1789. **P.S.**

246.

Robert Livingston (American, 1746–1813)
Portrait of Napoleon Bonaparte
Inscribed: *Drawn by Uncle Robert Livingston. Given to us by Papa*

Stipple engraving on paper
7-15/16 x 4-2/5 inches (10.2 x 13.8 cm)
Residence of the American Ambassador, Paris

This is an engraving after Robert Livingston's portrait of Napoleon, presumably executed while Livingston was in Paris (1801–04). Napoleon wears the uniform of a colonel of the Foot Grenadiers and his famous bicorne hat. The inscription implies that the original drawing was reproduced in engravings for the family. **V.C.**

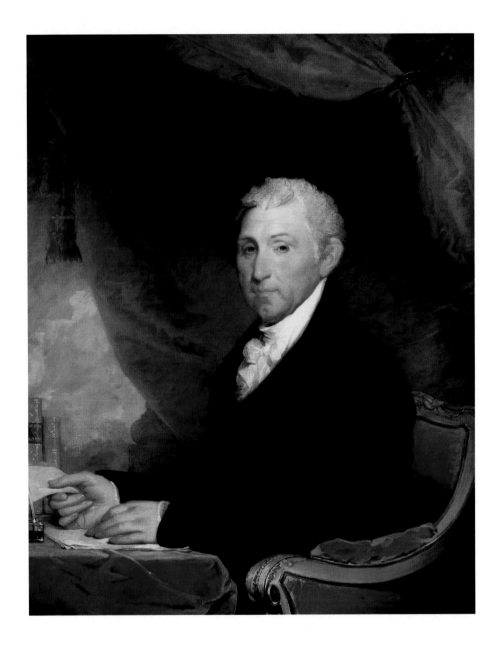

247.

Gilbert Stuart (American, 1755–1828)
Portrait of James Monroe, 1818-24

Oil on canvas
40-1/4 x 32 inches (102.2 x 81.3 cm)
The Metropolitan Museum of Art, New York.
Bequest of Seth Low, 1929 (29.89)
©1981 The Metropolitan Museum of Art

Stuart made a sub-specialty of painting statesmen seated beside tables draped in cardinal red, a habit that became one of the first visual templates for representing America's new leadership. This picture was part of a set of similarly formatted portraits of the first five presidents. In 1794, before Monroe was president, he succeeded Jefferson, his fellow Virginian, as President Washington's minister to France following the Reign of Terror and during the ascent of Napoleon. **P.S.**

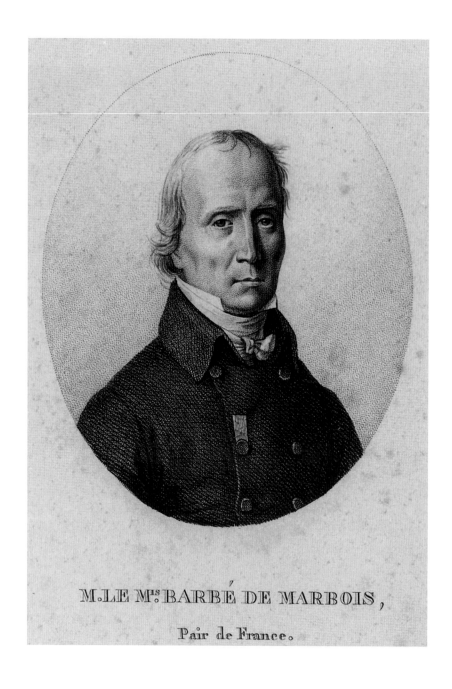

M.LE Mˢ BARBÉ DE MARBOIS,

Pair de France.

248.

Unidentified Artist, French School
Portrait of François Marquis de Barbé-Marbois (1735–1847)
Engraving on vellum
7-3/4 x 11 inches (19.7 x 28.1 cm)
Musée de la Coopération Franco-Américaine, Château de
Blérancourt, France (CFAa 541)
©Réunion des Musées Nationaux / Art Resources, NY

During the American Revolution François Marquis de Barbé-Marbois (1735–1847) served as a French consul to the United States and married an American woman. He also had served in Saint Domingue and knew firsthand the difficulty of administering a colony so far from France. Under Napoleon, Barbé-Marbois was the French minister of the treasury and the chief French negotiator and signatory of the Louisiana Purchase. **V.C.**

249.

Gilbert Stuart (American, 1755–1828)
Portrait of Albert Gallatin, Secretary of the Treasury, 1803

Oil on canvas
29-3/8 x 23-7/8 inches (74.61 x 60.64 cm)
The Metropolitan Museum of Art, New York. Gift of
Frederic W. Stevens, 1908 (08.90)
©1983 The Metropolitan Museum of Art

A follower of the teachings of Rousseau, the Swiss-born Gallatin
(1761–1849) immigrated to America in 1780. His reputation as a
financier led Jefferson to appoint him secretary of the treasury in 1801
and put him in charge of the daunting task of financing the Louisiana
Purchase in 1803, the same year in which Stuart painted this portrait
in Washington. **P.S.**

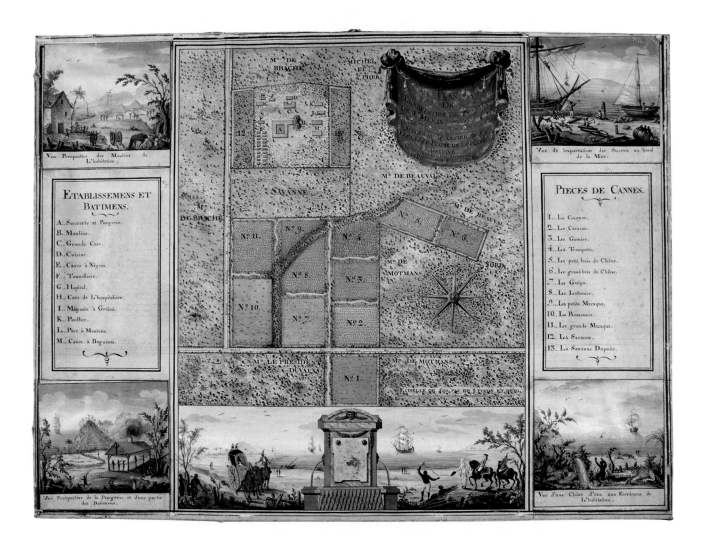

250.

S. de Beauvernet (French, 18th century)
Map of the Housing Facilities of Févret de Saint-Mémin, Saint-Domingue, with Vignettes of Life on the Island, circa 1760

Gouache on paper
18 x 25 inches (47 x 64 cm)
Musée de la Coopération Franco-Américaine, Château de Blérancourt, France (CFA c 187)
©Réunion des Musées Nationaux / Art Resources, NY

This gouache provides a record of the living quarters of a sugar production complex in mid-eighteenth-century Saint Domingue. The map includes vignettes of daily life on the island before the successful slave rebellion. Some of these scenes illustrate societal and racial divisions, at times contrasting white leisure and black labor. This image conveys an idea of the social pressures on the island preceding the revolution led by Toussaint Louverture. **V.C.**

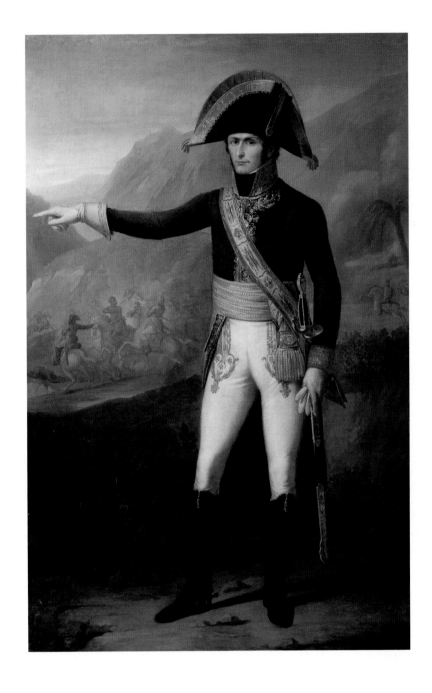

251.

François Joseph Kinson (French, 1770–1839)
Portrait of General Charles Victor Emmanuel Leclerc,
General in Chief of the Army of Saint Domingue in
1802, 1804

Oil on canvas
81 x 50 inches (207 x 127 cm)
Musée National du Château de Versailles, France
(MV 1217)
©Réunion des Musées Nationaux / Art Resources, NY

Napoleon sent his brother-in-law, General Charles Victor Emmanuel Leclerc (1772–1802), to Saint Domingue in 1802 to regain control of the French colony from slave revolutionaries. Leclerc was accompanied by his wife, Pauline Bonaparte. This is a posthumous portrait that portrays the ill-fated general as commander of the army, which can be seen in combant in the distance beneath his outstretched arm. Leclerc, along with most of his men, succumbed not in battle but to the ravages of yellow fever. **V.C.**

252a.

Unidentified Artist, French School
Toussaint Louverture, Commander of the Black Insurgents of Saint Domingue, 1803

Hand-colored engraving on paper
13-1/2 x 9-3/5 inches (44 x 32 cm)
Bibliothèque Nationale de France, Paris (N2 (cliché no. 92 B128.211))

252b.

Unidentified Artist, French School
Toussaint Louverture Saying Goodbye to his Family, 1803

Engraving on paper
20-1/6 x 13-1/3 inches (50.8 x 33.85 cm)
Bibliothèque Nationale de France, Paris (Qb1 1803, M104.797)

252c.

Unidentified Artist, French School
Toussaint Louverture Dying in Prison, 1803

Engraving on paper
17-1/3 x 12-3/5 inches (44 x 32 cm)
Bibliothèque Nationale de France, Paris (Qb1 27 Avril 1803, M104.798)

As an ex-slave and general, François-Dominique Toussaint Louverture (circa 1744–1803) was a powerful symbol for the blacks of Saint Domingue who sought their freedom from French rule. In this group of prints, he is shown first as the victorious general in a composition modeled after David's equestrian portrait of Napoleon (**cat. no. 34**). In hopes of quieting the rebellion, the French arrested Toussaint and sent him to prison in France. In the second print he takes final leave from his distraught family. He died in prison in France in April 1803. His arrest made him a martyr in Saint Domingue, where the French finally admitted defeat later that same year. His ashes are now entombed in the Pantheon in Paris. **V.C.**

SELECTED BIBLIOGRAPHY

Adams, Henry. *A History of the United States during the Administration of Thomas Jefferson 1801-1805*. New York: Boni, 1930.

Adams, William Howard, ed. *The Eye of Thomas Jefferson*. Exh. Cat. Washington: National Gallery of Art, 1976.

Adams, William Howard, ed. *Jefferson and the Arts: an Extended View*. Washington: National Gallery of Art, 1976.

Age of Neo-classicism. Exh. Cat. London: Arts Council of Great Britain, 1972.

Ambrose, Stephen. *Undaunted Courage. Meriwether Lewis, Thomas Jefferson and the Opening of the American West*. New York: Simon and Schuster, 1996.

Asprey, Robet B. *The Rise and Fall of Napoleon Bonaparte*. 2 vols. New York: Basic Books, 2000.

Boime, Albert. *Art in the Age of Bonapartism, 1800–1815*. Chicago: University of Chicago Press, 1990.

Busman, Richard L. *The Refinement of America: Persons, Houses, Cities*. New York: Knopf, 1992.

Chevallier, Bernard and Christophe Pincemaille. *Douce et incomparable Joséphine*. Paris: Éditions Payot & Rivages, 1999.

Chevallier, Bernard and Christophe Pincemaille. *L'impératrice Joséphine*. Paris: Éditions Payot & Rivages, 1996.

Cooper, Wendy A. *Classical Taste in America 1800–1840*. Exh. Cat. New York: Abbeville, Press, 1993.

Coe, Ralph T. *Sacred Circles: Two Thousand Years of North American Indian Art*. Exh. Cat. Kansas City, MO: Nelson Gallery Foundation, 1976.

Crow, Thomas. *Emulation: Making Artists for Revolutionary France*. New Haven: Yale University Press, 1995.

Deák, Gloria Gilda. *Picturing America 1497–1899*. 2 vols. Princeton: Princeton University Press, 1988.

DeConde, Alexander. *This Affair of Louisiana*. Baton Rouge: Louisiana State University Press, 1976.

Denon, Vivant. *Dominique-Vivant Denon: l'oeil de Napoléon*. Exh. Cat. Paris: Réunion des musées nationaux, 1999.

Dorigny, Marcel and Marie-Jeanne Rossignol. *La France et les Amerique au temps de Jefferson et de Miranda*. Paris: Société des études Robespierristes, 2001.

Draper, James David. *The Arts Under Napoleon: An Exhibition of the Department of European Sculpture and Decorative Arts, with loans from the Audrey B. Love Foundation and other New York collections*. Exh. Cat. New York: The Metropolitan Museum of Art, 1978.

Ellis, Joseph J. *Thomas Jefferson: Genius of Liberty*. New York: Viking Studies in Association with the Library of Congress, 2000.

Gaehtgens, Thomas W. and Heinz Ickstadt, ed. *American Icons: Transatlantic Perspectives on Eighteenth- and Nineteenth-Century American Art*. Santa Monica: Getty Center for the History of Art and Humanities: Distributed by the University of Chicago Press, 1992.

Garnier, Michaël. *Bonaparte et la Louisiane*. Paris: S.P.M. and Kronos, 1992.

Grigsby, Darcy Grimaldo. *Extremities: Painting Empire in Post-Revolutionary France*. London: Yale University Press, 2002.

Halliday, Tony. *Facing the Public: Portraiture in the Aftermath of the French Revolution*. Manchester: Manchester University Press, 1999.

Herold, J. Christopher. *Bonaparte in Egypt*. New York: Harper & Row, 1962.

Higonnet, Patrice. *Sister Republics: the Origins of French and American Republicanism*. Cambridge, MA: Harvard University Press, 1988.

Holtman, Robert B., ed. *Napoleon and America*. Pensacola, FL: Perdido Bay Press, 1988.

Honour, Hugh. *The European Vision of America*. Exh. Cat. Cleveland: Cleveland Museum of Art, 1975.

Hubert, Nicole. "A Propos des portraits consulaires de Napoléon Bonaparte: Remarques complémentaires," *Gazette des Beaux-Arts* 108 (July/August 1986): 23-30.

James, C. L. R. *The Black Jacobins: Toussaint L'Ouverture and the San Domingo Revolution*. New York: Vintage, 1963.

Jefferson, Thomas. *The Papers of Thomas Jefferson, 29 vols*. Princeton: Princeton University Press, 1950.

Jouanin, Christian, Marie-Blanche D'Arneville, Jérémie Benoit, Bernard Chevallier, Pierre-Jacques Chiappero,and Guy Ledoux-Lebard. *L'Impératrice Joséphine et les Sciences Naturelles*. Exh. Cat. Paris: Éditions de la Réunion des musées nationaux, 1997.

Kaplan, Lawrence S. *Jefferson and France: An Essay on Politics and Political Ideas*. New haven and London: Yale University Press, 1967.

Kastner, Joseph. *A Species of Eternity*. New York: Knopf, 1977.

Kennedy, Roger. *Orders from France: the Americans and the French in a Revolutionary World*. New York: Knopf, 1989.

Kerber, Linda K. *Women of the Republic: Intellect and Ideology in Revolutionary America*. Chapel Hill: Published for the Institute of Early American History and Culture by the University of North Carolina Press, 1980.

Laussat, Pierre Clément de. *Memoirs of My Life*. Sister Agnes-Josephine Pastwa, trans. and intro. Baton Rouge: Louisiana State University Press, 1978.

Le Bourhis, Katell. *The Age of Napoleon: Costume from Revolution to Empire, 1789-1815*. Exh. Cat. New York: Metropolitan Museum of Art H.N. Abrams, 1989.

Lentz, Thierry. *Le Grand Consulat: 1799–1804*. Paris: Fayard, 1999.

Lilley, Edward. "Consular Portraits of Napoleon Bonaparte." *Gazette des beaux-arts* 106 (November 1985): 143-56.

Lipscomb, Andrew H., ed. *The Writings of Thomas Jefferson*. Washington, D.C.: Thomas Jefferson Memorial Association, 1904. vol. 10.

Miller, Lillian B. *Patrons and Patriotism: the Encouragement of the Fine Arts in the United States, 1790–860*. Chicago: The University of Chicago Press, 1966.

Onuf, Peter S. *Jefferson's Empire: the Language of American Nationhood*. Charlottesville; London: University Press of Virginia, 2000.

Onuf, Peter S., ed. *Jeffersonian Legacies*. Charlottesville; London: University Press of Virginia, 1993.

Poesch, Jessie. *The Art of the Old South: Painting, Sculpture, Architecture & the Products of Craftsmen 1560–1860*. New York: Alfred A. Knopf, 1983.

Rebora, Carrie and Paul Staiti, eds. *John Singleton Copley in America*. Exh. Cat. New York: The Metropolitan Museum of Art, 1995.

Rice, Howard C. Jr. *Thomas Jefferson's Paris*. Princeton: Princeton University Press, 1976.

Robertson, James Alexander., ed. and trans. of contemporary accounts. *Louisiana Under the Rule of Spain, France, and the United States 1785-1807*. 2 vols. Cleveland: Arthur H. Clark Company, 1911.

Rosenberg, Pierre, Frederick J. Cummings, Antoine Schnapper, and Robert Rosenblum. *French Painting 1774–1830: The Age of Revolution*. Exh. Cat. Detroit: Detroit Institute of Arts, 1975.

Schnapper, Antoine, Arlette Sérullaz, Lina Propeck, and Elisabeth Agius-d'Yvoire. *Jacques-Louis David 1748–1825*. Exh. Cat. Paris: Réunion des musées nationaux, 1989.

Self, Robert L. and Susan R., Stein. "The Collaboration of Thomas Jefferson and John Hemings. Furniture Attributed to the Monticello Joinery." *Winterthur Portfolio* 33 (Winter 1998), 231-48.

Shackelford, George Green. *Thomas Jefferson's Travels in Europe, 1784–1789*. Baltimore: Johns Hopkins University Press, 1995.

Shadwell, Wendy. *American Printmaking, The First 150 Years*. Washington, D.C.: Smithsonian Institution Press, 1969.

Stein, Susan R. *The Worlds of Thomas Jefferson*. New York: Harry N. Abrams, Inc. 2002.

Villiers du Terrage, Marc, *The Last Years of French Louisiana*. Lafayette: University of Southwestern Louisiana, 1982.

INDEX OF ARTISTS

PHOTOGRAPH CREDITS

Cat. 48:
Photograph by Laurent-Sully Jaulmes, image provided by UCAD (Union Centrale des Arts Decoratifs), Paris

Cats. 82 & 83:
Photograph by Studio Basset, image provided by Image Bank – Lyon Textile Museum, Lyon, France

Cats. 115, 116, 117, 118:
Sebastien Miller, Paris

Cat. 143:
Photograph by Richard Carafelli, 2002, National Gallery of Art, Washington, D.C.

Cat. 146:
Photograph by Lyle Peterzell, 2002, National Gallery of Art, Washington, D.C.

Cat. 194:
Photograph by J. Beckett, AMNH, 2002

Cat. 225:
Photograph by Neal Alexander, New Orleans, Louisiana

Cats. 29, 40, 51, 58, 86, 89, 99, 100:
Photograph by Patrice Maurin-Berthier, Saint-Cloud, France

Unless otherwise noted, photography by Judy Cooper, New Orleans Museum of Art

AUTHORS OF THE CATALOGUE ENTRIES

V.C.
Victoria Cooke, Curator of European Painting, New Orleans Museum of Art

B.M.
Bill Mercer, Curator of Native American Art, Portland Art Museum

D.O.
David O'Brien, Assistant Professor of Art History, University of Illinois at Urbana-Champaign

J.P.
Jessie Poesch, Professor Emerita of Art History, Tulane University

P.S.
Paul Staiti, Professor of Art History, Mount Holyoke College

S.S.
Susan R. Stein, Curator, Monticello/Thomas Jefferson Foundation, Inc.

J.S.
Jamie Stephens, Curatorial Assistant, New Orleans Museum of Art

P.T.
Paul Tarver, Registrar, Curator of Native American and Pre-Columbian Art, New Orleans Museum of Art

S.T-L.
Susan Taylor-Leduc, Independent Scholar

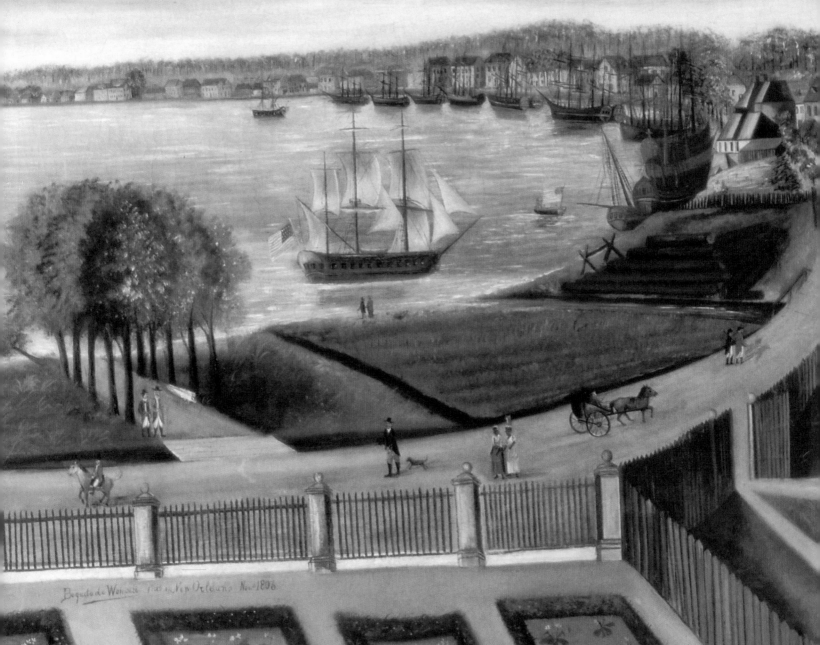